Matthew Arnold, John Ruskin,
and the Modern Temper

Matthew Arnold, John Ruskin, and the Modern Temper

EDWARD ALEXANDER

Ohio State University Press : Columbus

LIBRARY OF CONGRESS CATALOGING IN PUBLICATION DATA
Matthew Arnold, John Ruskin, and the modern temper.
Bibliography: p.
1. Arnold, Matthew, 1822-1888. 2. Ruskin,
John, 1819-1900. I. Title.
PR4023.A63 821' .8'09 73-9605
ISBN 0-8142-0188-1

For Leah, Rebecca, and David

Table of Contents

Acknowledgments

In the course of writing this book I have incurred many obligations that I would like to acknowledge here.

To certain scholarly and critical works dealing with Arnold and Ruskin my debt is greater than can be demonstrated in notes. Primary among such works are the great Library Edition of Ruskin, edited by E. T. Cook and Alexander Wedderburn, Kenneth Allott's edition of Arnold's poems, Lionel Trilling's *Matthew Arnold*, Dwight Culler's study of Arnold's poetry, and the studies of Ruskin by Derrick Leon and John D. Rosenberg.

For affording me access to manuscript materials, I am indebted to Professor Arthur Kyle Davis, Jr., Mr. David Masson, Professor F. L. Mulhauser, Mrs. Jeanne Pingree, Professor Arnold Whitridge, Miss Marjorie Wynne, and to Harvard University, Pierpont Morgan Library, Library of Congress, University of Texas, British Museum, Yale University, Bodleian Library, Houghton Library, Texas Technological College, New York University, New York Public Library, the Berg Collection, Johns Hopkins University, Historical Society of Pennsylvania, Huntington Library, Colby College, Cornell University, Vassar College, Imperial College, and Leeds University.

I am indebted to the American Council of Learned Societies for a fellowship that enabled me to spend time on research for this book, and to the Graduate School Research Fund of the University of Washington for grants that paid for microfilming and typing.

For help and suggestions of various kinds I am indebted to Professor Edward Bostetter, Professor John L. Bradley, Mr. Herbert P. Cahoon, Mr. James S. Dearden, Professor Walter E. Houghton, Professor Rodney Kilcup, Mr. Howard Leichman, Professor Fraser Neiman,

Mr. Norman Podhoretz, Professor Samuel N. Rosenberg, and Professor Helen Gill Viljoen.

For permission to quote from articles of mine published under their auspices, I am indebted to: Columbia University Press ("Roles of the Victorian Critic" in *Literary Criticism and Historical Understanding*, ed. P. Damon, 1967); *Victorian Newsletter* ("Art amidst Revolution: Ruskin in 1848," Fall 1971; and *English Language Notes* ("Arnold, Ruskin, and the Hanwell Insane Asylum," September 1971).

I am indebted also to the Clarendon Press, Oxford, for permission to quote from *The Letters of Matthew Arnold to Arthur Hugh Clough*, ed. Howard F. Lowry (1932).

Introduction

One main reason why I am so little available for letters is that these educational questions have laid their hold upon me—in great measure from accident, in the first instance—and I cannot shake it off, nor perhaps ought I to wish to. What is a poem or an essay more or less, compared with the civilisation of the English middle class?—Matthew Arnold, unpublished letter of 26 October 1878 to T. H. Ward

If there are any advantages to living at the present time, perhaps a sharpened and more intelligent curiosity about past cultures that endured crises that in some respects resemble our own is one of them. Northrop Frye, borrowing a metaphor and an idea from Matthew Arnold, once wrote that "the culture of the past is not only the memory of mankind, but our own buried life, and study of it leads to a recognition scene, a discovery in which we see, not our past lives, but the total cultural form of our present life."[1] I have been drawn to the idea of a comparative study of Matthew Arnold and John Ruskin because over a century ago they grappled, in thoughtful and often fruitful ways, with intellectual and spiritual quandaries that today beset large numbers of people who are involved in the cultural enterprise yet suspect that it has been discredited by many events of recent history. At the present time the disinterested life of the mind is being called into question not only by the Philistines and Jacobins, who have always been skeptical of its value, but by those who until recently were supposed to be its paid practitioners. Many writers and scholars have suddenly discovered that intellect is no guarantee of sanctity, and that

culture and morality may conflict. Armed with this knowledge, they launch inquisitorial searches into the "relevance" of their colleagues' work, request said colleagues to document their contributions to moral and political sanitation, and occasionally induce sensitive and innocent men to believe that a liberal vocation is a selfish indulgence of asocial impulses.

It would be misleading to suggest that the problem of the artist's and the thinker's independence is, or can be, precisely the same in the 1970s as it was in the 1870s, or even in the 1930s; ideas, as Lionel Trilling once pointed out, do not have perfect autonomy and should not be conceived of as batons handed from runner to runner in a relay race that spans centuries.[2] But if we treat an idea as, in part, the response to a particular situation, and keep in mind the inevitable differences between the Victorian situation and our own, we can, I think, learn something from the past and participate in that recognition scene which according to Frye is one of the chief rewards of historical scholarship.

The demand that art and learning subserve practical interests was widespread during the Victorian period, and caused much division of purpose among Victorian writers and artists. At least it caused division of purpose among the writers and painters who interest us today. The extremes of acquiescence in utilitarianism or of outright disavowal of it, the Spasmodic poets who passionately encountered the problems of modern life or a James McNeill Whistler who disdained them, will for the foreseeable future be less likely to arouse our curiosity than the figures who seemed to fluctuate between the extremes of commitment and detachment.

Tennyson, the greatest poet of the age, spent much of his energy and more of his time trying to reconcile socially imposed conceptions of the poet's public duties with his own deep-seated tendency toward rest, luxuriance, and imaginative escape. In a pair of 1830 poems called "The Poet" and "The Poet's Mind" he could celebrate simultaneously both the Shelleyan conception of the poet as servant of reform of church and state, and the antithetical Coleridgean idea of the poet's sanctity and his separation from the ordinary concerns of hu-

manity. If, on the one hand, he spoke in verse of such questions as evolution, the nebular hypothesis, feminism, chancery procedure, industrial insurance, and the provision of coaling stations,[3] he was also the poet of the irrational despair expressed in "Tears, Idle Tears," the poet who, in *In Memoriam*, told everyone, in Arnold's words, "his misery's birth and growth and signs, / And how the dying spark of hope was fed, / And how the breast was soothed, and how the head, / And all his hourly varied anodynes."[4]

In a writer like John Henry Newman the conflict between public duty and personal development took the form of a debate, never fully resolved, between the idea that knowledge must be subservient to morality and religion, and the contrary idea that knowledge and particular branches of knowledge are autonomous. On the one hand, Newman could argue that "Christianity, and nothing short of it, must be made the element and principle of all education," that Revealed Truth had given the aim and direction to Knowledge, and that when the university ministers, as it should, to the Church, "then classical poetry becomes the type of Gospel truth, and physical science a comment on Genesis or Job, and Aristotle changes into Butler, and Arcesilaus into Berkeley"; he could warn against sciences such as history judging religious matters by secular standards, and could chastise Catholic historians who allowed mere historical facts "to destroy super-historical truth."[5] But he could also maintain, and most eloquently, that knowledge is capable of being its own end, and that knowledge which subserves other interests, which is a means to any end beyond itself, is not liberal knowledge but servile knowledge and therefore not the highest or most suitable attainment of free men, however needful to ordinary pursuits.

Arnold and Ruskin, like many of their contemporaries, were torn between their inclination, as artists, toward—to use Newman's terms —liberal activities, and their obligation, as citizens, to undertake useful activities. But in them the division of purpose was so deep as to cause a whole series of radical upheavals culminating in the abandonment of one career for another. They were—if anybody ever was —naturally inclined, or "called," to the life of art, to the celebration

of beauty and, through that, to the discovery of truth. But a growing concern with social and political questions—first as they impinged on the creation of art but then for their own sake—eventually diverted them from their original vocation and thrust them not only into the new activities of social and political controversy but into new roles, new occupations, and even new selves.

There was an important continuity but also a damaging discontinuity between their careers as artists and as social critics. Both men assumed that the criticism of art was the best preparation for the criticism of society; and we shall see how their different conceptions of the good work of art determined their different conceptions of the good society. But they were always plagued by the suspicion that, in turning their attention to society, in performing "useful" activities, whether as critics of education, politics, and economics, or as teachers of art and inspectors of schools and even builders of roads, they had neglected their true work and forsaken their true selves. "Goethe says somewhere," wrote Arnold, "that people make an entirely false world and then call upon you to be useful in it;—it is well that occasionally one should recalcitrate and try to make the world itself a little less false."[6] In 1862 Arnold and Ruskin were more intensely and completely involved in the business of social criticism than they had ever been. Arnold was completing his very forceful attack on the Revised Code for Education and busy getting his pamphlet into the hands of influential persons. Ruskin was fresh from his onslaught against the political economists in the *Cornhill Magazine* and in the midst of a renewed assault on the same enemy in *Fraser's*. Yet we find Arnold complaining, in the very month (March) that his article appeared, that "I sometimes grow impatient of getting old amidst a press of occupations and labour for which, after all, I was not born";[7] and Ruskin, in August of the same year, bitterly rejecting a friend's misguided congratulations on his achievements: "You say I have effected more revolution than other writers. My dear Doctor, I have been useful, in various accidental minor ways, by pretty language and pleasant hints . . . but of my intended work I have done nothing."[8]

But beyond the feeling that the move from art to society had been

a choice of the wrong role, the wrong occupation, and the wrong self, lay the deeper fear that they might have overcome their alienation from society only at the cost of alienation from their own souls and the consequent sacrifice of all true joy in life. Ruskin in 1863 found himself "tormented between the longing for rest and for lovely life, and the sense of the terrific call of human crime for resistance and of human misery for help—though it seems to me as the voice of a river of blood which can but sweep me down in the midst of its black clots, helpless."[9] Arnold, in a poem written about a year later entitled "Palladium," expressed the feeling that he was but rarely in communication with his own soul. Describing the wooden image of Pallas that stands above the battlefields of Troy where Hector struggles valiantly yet blindly, as if he had forgotten that ultimately it is the Palladium and not his own frantic efforts that guarantees Troy's preservation, Arnold proposes an analogy between the Palladium forgotten by its purported defenders and the soul almost forgotten by its unwitting owners:

> So, in its lovely moonlight, lives the soul.
> Mountains surround it, and sweet virgin air;
> Cold plashing, past it, crystal waters roll;
> We visit it by moments, ah, too rare!
>
> (9–12)

In "Thyrsis," a poem that Arnold probably conceived in the very same month of March 1862 when he published his attack on the Revised Code for Education, we find a more explicit linkage between the artist's involvement in social questions and the sacrifice of his soul and his happiness. Speaking of the Oxford landscape, which represents for him the true poetic life, Arnold alleges that in leaving it Thyrsis (Arthur Hugh Clough) sacrificed not only his poetry but his soul and his happiness by immersing himself in social questions:

> Some life of men unblest
> He knew, which made him droop, and filled his head.
> He went; his piping took a troubled sound

Of storms that rage outside our happy ground;
He could not wait their passing, he is dead.

(46–50)

That Arnold was able to project his own dilemma into the formal medium of poetry and that he was able to blame Clough for choosing to do what Ruskin simply could not help doing already suggests the pattern of contrasts that is as important in a comparison of Arnold and Ruskin as the similarities. Although both men made similar moves from art to society and politics, and both recognized the diminution of soul and loss of joy that this might entail, Ruskin saw no alternative to total immersion of his soul in the miseries of the world that he wished to alleviate whereas Arnold believed it was possible to find some middle ground between the detachment he had left behind and the social commitment he had undertaken. The distinction between the stances they adopted as social critics was an epistemological as well as a psychological one. Whereas Ruskin believed that one could not truly fathom the darkness and suffering of the world unless one participated in them, Arnold was certain that total involvement in the world's miseries, far from enabling one to see them clearly, deprived one of the sense of perspective and of the relationship of parts to whole that comes only with moral poise and intellectual detachment. Another way of describing the pattern of contrasts that accompanies and impinges on the pattern of similarities in the movement of Arnold and Ruskin from artistic to social concerns is to say that Ruskin was a romantic and Arnold a classical Victorian; that one brought from his experience of art a belief in concrete particularity, in passionate involvement, in the greatness of failure and sorrow; whereas the other brought a belief in the grandeur of generality, in the wholeness and steadiness that come from detachment, and in the nobility of perfection and happiness.

In *The Long Revolution*, Raymond Williams has asserted that "it is with the discovery of patterns of a characteristic kind that any useful cultural analysis begins, and it is with the relationship between

these patterns, which sometimes reveal unexpected identities and correspondences in hitherto separately considered activities, sometimes again reveal discontinuities of an unexpected kind, that general cultural analysis is concerned."[10] I have tried, in this study, to discover some of the patterns to which Williams alludes by instituting a series of comparisons between the careers and the writings of Arnold and Ruskin during a limited number of years. I have tried to combine comparative biography with a comparison of ideas without falling into the error of judging the ideas according to the personal circumstances out of which they grew. Recognizing the importance of the fact that two such formidable artists turned, at a certain point in their lives, from art to society, from liberal and poetic pursuits to useful and rhetorical ones, I have tried to show that their views on culture, society, politics, and economics invite comparison because they are eminently the views of artists who are seeking the means of sharing with others the beauty and truth which they have themselves glimpsed. Both men believed that, as Arnold said in *Culture and Anarchy*:

> The great men of culture are those who have had a passion
> for diffusing, for making prevail, for carrying from one end
> of society to the other, the best knowledge, the best ideas of
> their time; who have laboured to divest knowledge of all that
> was harsh, uncouth, difficult, abstract, professional, exclu-
> sive; to humanise it, to make it efficient outside the clique
> of the cultivated and learned, yet still remaining the *best*
> knowledge and thought of the time, and a true source, there-
> fore, of sweetness and light.[11]

The quarrel that Arnold and Ruskin conducted with the society of their day was of great importance in itself, but I have also tried to analyze it as the external aspect of the quarrel that they conducted with themselves. As Marianne Moore has said, "There never was a war that was not inward"; and the quarrels that Arnold and Ruskin held with themselves over the role of the modern artist as social critic are at least as interesting and revealing as their public quarrels with

the advocates of utilitarianism and of aestheticism. For this reason I have drawn heavily on biographical materials in order to fathom the quality and intensity of the personal crises that their historical moment and their restless consciences created for Arnold and Ruskin.

The comparative method, however suspect in certain quarters today, was widely used for literary purposes in the Victorian period, not merely for "scientific" reasons based on dubious analogies between literature and anatomy but for the sound philosophical reasons that impelled Carlyle to compare Johnson and Hume, Mill to compare Bentham and Coleridge, Arnold to compare Hebraism and Hellenism. "In order to make our past meaningful," Ralph Cohen has written, "it is necessary to create in it a recognition of the choices men had."[12] Comparison implies a judgment in which two things are measured by each other. It therefore offers an escape from, or at any rate a substitute for, absolute standards of judgment; and it provides some control on the temptation to generalize about a period by simple induction from the ideas and activities of one person who functioned in it. Comparison also offers, to be sure, the temptation to disembody ideas from the special circumstances and ambiences in which they arose. I can only say that I have tried to avoid this danger by anchoring my comparisons in chronology and fact, and by dealing as far as possible with the simultaneous reactions of Arnold and Ruskin to particular aspects of the crisis that gripped English thought and society between 1848 and 1867. But ideas do have a way of bursting the bonds of their origins: that is why man's attraction to them has sometimes been taken as a sign of his freedom.

Matthew Arnold, John Ruskin,
and the Modern Temper

"Devoting me to God," meant, as far as my mother knew herself what she meant, that she would try to send me to college, and make a clergyman of me: and I was accordingly bred for "the Church." My father, who—rest be to his soul—had the exceedingly bad habit of yielding to my mother in large things and taking his own way in little ones, allowed me, *without saying a word, to be thus withdrawn from the sherry trade as an unclean thing; not without some pardonable participation in my mother's ultimate views for me. For, many and many a year afterwards, I remember, while he was speaking to one of our artist friends, who admired Raphael, and greatly regretted my endeavours to interfere with that popular taste,—while my father and he were condoling with each other on my having been impudent enough to think I could tell the public about Turner and Raphael,—instead of contenting myself, as I ought, with explaining the way of their souls' salvation to them—and what an amiable clergyman was lost in me,—"Yes," said my father, with tears in his eyes—(true and tender tears, as ever father shed,) "he would have been a Bishop."*—John Ruskin, *Fors Clavigera* (April 1875)

My sons do not yet work as they should do, and I often think that nothing would so raise their energies as sending them out to you, where they must work or starve. There is no earthly thing more mean and despicable in my mind than an English gentleman destitute of all sense of his responsibilities and opportunities, and only revelling in the luxuries of high civilization, and thinking himself a great person.—Dr. Arnold to J. P. Gell (principal of a college in Van Diemen's Land), 1840

Choosing a Profession

For most Victorians the choice of a profession was both a more complicated and a more painful process than it had been for previous generations of Englishmen. For one thing, it had become for the first time a genuine choice, a matter of individual decision rather than social custom and class membership; for another, a man's vocation was now more than ever before considered to be the chief determinant of his way of life. Secular and religious prophets joined to proclaim work the primary duty and indeed the sole justification of life. Carlyle invoked Scripture to warn his contemporaries to "work while it is called Today, for the Night cometh, wherein no man can work."[1] Of the students of Matthew Arnold's father, the great schoolmaster Thomas Arnold, it was said that "every pupil was made to feel that there was a work for him to do—that his happiness as well as his duty lay in doing that work well."[2] Through the novels of George Eliot the public was to become familiar with a new kind of character whose life was very nearly coextensive with his work. He might work with his hands like Adam Bede or with his head like Tertius Lydgate, but he defined himself by his choice of vocation and by his commitment to it. As Caleb Garth tells the vacillating Fred Vincy in *Middlemarch* (whose story is set in the 1830s):

> "You must be sure of two things: you must love your work, and not be always looking over the edge of it, wanting your play to begin. And the other is, you must not be ashamed of your work, and think it would be more honourable to you to be doing something else. You must have a pride in your own work and in learning to do it well, and not be always saying, There's this and there's that—if I had this or that to do, I might make something of it. No matter what a man is

—I wouldn't give two pence for him . . . whether he was
the prime minister or the rick-thatcher, if he didn't do well
what he undertook to do."[3]

In one sense Arnold and Ruskin stand out from other Victorians
by virtue of the fact that they never did irrevocably commit them-
selves to a vocation. For years, and even decades, after he has become
an inspector of schools, we find Arnold desperately trying to change
his position and vaguely planning to get back to his true vocation of
poet; and Ruskin is forever on the verge of forsaking his criticism,
and writing itself, in order to paint (or sometimes to geologize or to
botanize). Their own indecision spurred both their critics and their
friends to remark uncharitably on their propensity to wander into
fields where they were not genuinely at home. There was some truth
as well as much malice in Whistler's charge that all the political
economists thought Ruskin a great art critic whereas all the artists
thought him a great political economist; and when Jowett described
Arnold as "the Balliol man who had not got on," he was giving gen-
tle expression to the feeling that Arnold had somehow squandered
his power by expending it in incursions into alien territory.[4]

Arnold and Ruskin came from very different backgrounds. Ruskin,
though he was born and bred in London, was the inheritor of an es-
sentially Scottish tradition that combined (this is perhaps hard for us
to comprehend today) a fundamentalist Evangelicalism with genu-
ine literary and artistic culture.[5] Matthew Arnold was the son of a
father famed as an educator, a theologian, a political controversialist
and a reformer who, though he spoke for the "Liberal" or "Broad"
church faction of the Church of England, was as serious and intense
in his religion as were the Evangelical Ruskins in theirs. Both young
men were sent to Oxford, with which they were to retain strong if
ambivalent emotional ties throughout life, and to which both were
to return in maturity as professors. Ruskin matriculated as a gentle-
man-commoner at Christ Church in October 1836 and was in residence
there until 1840; Arnold won an open scholarship to Balliol in No-
vember 1840 and took up residence in October of the following
year.[6]

Whereas Ruskin's parents sent him to Christ Church with the explicit purpose of making an Evangelical clergyman out of him, Dr. Arnold, according to his son Tom, "never thought of prescribing to [Matthew] in any way either the field within which or the aims toward which, he should set his genius to work."[7] Yet we can hardly doubt that Matthew recalled the many occasions upon which his father had reminded members of the sixth form at Rugby that "what we must look for here is, 1st, religious and moral principles; 2ndly, gentlemanly conduct; 3rdly, intellectual ability."[8] Nor is it possible to doubt that Dr. Arnold impressed upon his son when he entered Oxford the scheme of priorities for education that he had long inculcated in his own family: "Rather than have physical science the principal thing in my son's mind, I would gladly have him think that the sun went round the earth, and that the stars were so many spangles set in the bright blue firmament. Surely the one thing needful for a Christian and an Englishman to study is Christian and moral and political philosophy. . . ."[9]

Ruskin entered Christ Church carrying a heavy burden of parental, more especially fatherly, expectation. "His ideal of my future," Ruskin was to write of his father in *Praeterita*, "was that I should enter at college into the best society, take all the prizes every year, and a double first to finish with; marry Lady Clara Vere de Vere; write poetry as good as Byron's only pious; preach sermons as good as Bossuet's, only Protestant, be made, at forty, Bishop of Winchester, and at fifty, Primate of England."[10] Whatever were John James Ruskin's expectations of his son, he had, according to Ruskin's biographer Derrick Leon, chosen in Christ Church the least likely instrument for their fulfillment. Christ Church was already being eclipsed in academic prestige by Balliol, which was to produce all the most brilliant men from 1831 to 1841; so that although Ruskin was at Oxford when it was spawning a host of intellectual and spiritual movements, "with such men as Clough, Matthew Arnold, Stanley and Jowett, all his contemporaries, Ruskin made no acquaintance."[11] Though he was an extremely serious as well as religious young man, Ruskin seems to have been entirely indifferent to, or contemptuous of, the Oxford Movement, whose leader Pusey he was later to describe as a "sickly

and rather ill put together English clerical gentleman who never looked one in the face or appeared aware of the state of the weather."[12] Unlike many other young men of his era, his faith was not unsettled by exposure to university education, and he did not vex his parents by refusing to attend chapel; in fact, he never missed.

Yet, by a curious irony, his very seriousness militated against his entering the clerical profession. His seriousness—one of his friends said he had the makings of a Robespierre in him—led him in other directions. It led him to geology and a meeting with Darwin, to architecture and the Oxford Society for Promoting the Study of Gothic Architecture,[13] and to poetry. "I must," he wrote in 1838, "give an immense time every day to the Newdigate, which I must have. . . ."[14] He did, indeed, have it, but not until his third try, in 1839, an "Eastern" poem called "Salsette and Elephanta." On June 12 he recited the poem in the Sheldonian, and seemed to have found his vocation as a poet.

In those days the vocations of poet and cleric often nourished each other, and winning the Newdigate Prize was as much a foreshadowing of the second as of the first. But now there came an interruption in Ruskin's education due to ill health, and a period of extended travel with his parents on the Continent for the purpose of regaining his strength. In November 1841 he was again able to work, albeit at home, and in April of the following year, having given up the hope of honors, earned a pass degree from Oxford.

During his illness Ruskin had been beset by his first grave doubts about becoming a clergyman. They are expressed at great length in a letter of 22 September 1841 to his former tutor, the Reverend Thomas Dale. At first Ruskin asks whether it is not even criminal to direct energies elsewhere than toward saving souls. "Nor can any distinction be made between laymen and churchmen with regard to the claims of this duty, but every one who believes in the name of Christ is called upon to become a full and perfect priest. Our daily bread once gained, every faculty of mind and body must be called into full action for this end only, nor can I think that any one can rightly believe, or be himself in a state of salvation, without holding himself bound,

foot, hand, and brain, by this overpowering necessity." Granted all this, however, the question arises of whether there may not be various means by which the great goal of soul-saving is realized. Ruskin thinks there are, but he does not know how those who are free to choose their employment are to be regulated in their choice:

> They have two questions to ask: "What means are there by which the salvation of souls can be attained?" and "How are we to choose among them?" For instance, does the pursuit of any art or science, for the mere sake of the resultant beauty or knowledge, tend to forward this end? That such pursuits are beneficial and ennobling to our nature is self-evident, but have we leisure for them in our perilous circumstances? Is it a time to be spelling of letters, or touching of strings, counting stars or crystallising dewdrops, while the earth is failing under our feet, and our fellows are departing every instant into eternal pain?

Here for the first time Ruskin poses the question, which was to plague him throughout his career, about whether the pursuit of art or science as liberal activities, "for the mere sake of the resultant beauty or knowledge," is morally justifiable. Here too for the first time he proposes (though he does not adopt) a solution of the dilemma according to which the artist may have an indirect spiritual and moral influence even if he does not occupy himself immediately in moral and priestly tasks:

> . . . Is not the character and kind of intellect which is likely to be drawn into these occupations, employed in the fullest measure and to the best advantage in them? Would not great part of it be useless and inactive if otherwise directed? Do not the results of its labour remain, exercising an influence, if not directly spiritual, yet ennobling and purifying, on all humanity to all time? Was not the energy of Galileo, Newton, Davy, Michael Angelo, Raphael, Handel, employed more effectively to the glory of God in the results and lessons it has left, than if it had been occupied all their life-

time in direct priestly exertion, for which, in all probabil-
ity, it was less adapted and in which it would have been
comparatively less effectual?

After these solemn speculations, Ruskin at last reduces the question
to the proportions of his personal dilemma : "I myself have little
pleasure in the idea of entering the Church, and have been attached
to the pursuits of art and science, not by a flying fancy, but as long as
I can remember, with settled and steady desire. How far am I justified
in following them up?"[15]

While he hangs between the vocation of writer on the one hand
and clergyman on the other, Ruskin takes pains to discover the ab-
sence of moral urgency in other men's writings and to affirm its pres-
ence in his own. He expresses impatience with Carlyle's lectures *On
Heroes* as "absolute bombast." He deplores in *The Old Curiosity
Shop* (1840) Dickens's lapse from "his former clear truth" into "dis-
eased extravagance" and "perpetual mannerism." He reacts violently
to a clerical friend who, in his ignorant condescension to the artist,
had expected to find "refreshment" in Ruskin's poems:

> . . . And so, my cool fellow, you don't find any "refresh-
> ment" in my poems. . . . "Refreshment," indeed! Hadn't
> you better try the alehouse over the way next time? It is very
> neat of you—after you have been putting your clerical steam
> on, and preaching half the world to the de--- . . . and back
> again—to pull up at Parnassus expecting to find a new sta-
> tion and "refreshment" rooms fitted up there for your espe-
> cial convenience—and *me* as the young lady behind the
> counter to furnish you with a bottle of ginger-pop. . . .[16]

Upon receiving his degree, Ruskin was faced more squarely than
ever before with the problem of choosing his life's work. But, per-
haps unfortunately for him, his father's wealth allowed his choice of
a career to remain a perpetual "problem" that never became a com-
pelling necessity. Ruskin, having taken his pass degree, again won-
dered what he should be or do, "my father ready to let me do any-

thing; with my room always luxuriously furnished in his house,—my expenses paid if I chose to travel."[17] The great decision was thus postponed while Ruskin and his parents planned their summer in Switzerland.

But during this summer in Europe Ruskin had a revelation, an experience of nature through the medium of art that seemed to dedicate *him* and eliminate the necessity of conscious choice. While at Fontainebleau Ruskin found himself one day in a cart road among young trees and lay down to sleep. Unable to fall asleep, he became interested in the pattern formed by the branches against the blue sky and began to draw a little aspen tree in his sketchbook. As he worked, his languor disappeared and "the beautiful lines insisted on being traced." The tree seemed to grow by its own power before his eyes, its lines composing themselves "by finer laws than any known of men. At last, the tree was there, and everything that I had thought before about trees, nowhere." He now recognized—an earlier discovery made in drawing ivy on Tulse Hill had pointed him in this direction —that the secret of capturing the beauty of nature lay not in rearranging and generalizing natural phenomena but in dutiful submission to organic, natural design in all its concrete, detailed particularization: "The woods, which I had only looked on as wilderness, fulfilled I then saw, in their beauty, the same laws which guided the clouds, divided the light, and balanced the wave. 'He hath made everything beautiful, in his time,' became for me thenceforward the interpretation of the bond between the human mind and all visible things; and I returned along the wood-road feeling that it had led me far;—Farther than ever fancy had reached, or theodolite measured."[18]

In this experience lay the germ of *Modern Painters*, for it gave Ruskin the philosophical weapons he needed to demonstrate that Turner and "modern painters" generally depicted nature more truthfully than did the idealizing, generalizing "ancient masters." For the time being, at least, Ruskin had found his vocation and also a philosophy of art that would sustain him through the first two volumes of *Modern Painters*. But it is an exaggeration to assert, as Collingwood does,

that "thenceforward his path was marked out . . . he was not to be a poet . . . not to be an artist . . . not a man of science" but a critic of art who would bring to the world the message that great artists were impelled by sincerity to utter truth.[19] On the contrary, in March of 1844, less than a year after his anonymous publication of the first volume of *Modern Painters*, we find Ruskin again wrestling defensively with the question of whether he should be an art critic or an Evangelical clergyman. A clerical correspondent, the Reverend Osborne Gordon, has asked him whether the cultivation of taste is an adequate justification of a man's life. He replies by asserting that *Modern Painters* is no selfish cultivation of his own critical acumen but rather an "ardent endeavour to spread the love and knowledge of art among all classes." Besides, he adds—tempting the gods to punish him, as indeed they did (*Modern Painters* was not completed for another sixteen years)—everything he hopes to do in his artistic endeavor "will be accomplished, if my health holds, in two or three years at the very utmost." Finally, if Osborne doubts Ruskin's ability to exert an elevating moral influence by preaching on the beauty of the creation, of which he knows something, why is the clergyman so confident of Ruskin's ability to preach on the beauty of a system of salvation about which he knows nothing? "If I have not power of converting men to an earnest feeling for nature, I should have still less of turning them to earnestness in religion."[20]

The problem of choosing between art and religion rankled in Ruskin's mind up until the time that it was replaced by, or rather transformed into, the problem of choosing between art and social criticism. As late as 1851, Ruskin could write:

> . . . I never was so doubtful as to what my remainder of life would probably be devoted to: I always, before, had some faint idea of becoming a clergyman either abroad or at home: but after the experiences I have had of the effects of my intercourse in a casual way with society for the last three years, I have given up all thoughts of it. I can do nothing right but when I am quiet and alone: But still I cannot settle my mind, because I always feel that though I am not fit to

be a clergyman, it is my own fault that I am not: i.e. though
I don't love people, and am made ill by being disturbed, and
am over excited in discussion and so on—I ought to love
people more—and ought to like to see them—and to do them
good—and I can never tell but some change might come
over my religious feelings which could make What is now
my poison become my food. . . .[21]

In one sense, Ruskin never ceased to be a clergyman *manqué*, a fact
noted at least in its external aspect in this 1853 account of one of his
lectures in the *Edinburgh Guardian*:

> Mr. Ruskin's elocution is peculiar; he has a difficulty in
> sounding the letter "R"; but it is not this we now refer to, it
> is to the peculiar tone in the rising and falling of his voice at
> measured intervals, in a way scarcely ever heard except in the
> public lection of the service appointed to be read in churches.
> These are the two things with which, perhaps, you are most
> surprised,—his dress and his manner of speaking,—both of
> which . . . are eminently clerical. You naturally expect, in
> one so independent, a manner free from conventional re-
> straint, and an utterance, whatever may be the power of his
> voice, at least expressive of a strong individuality; and you
> find instead a Christ Church man of ten years' standing, who
> has not yet taken orders. . . .[22]

It was not until Ruskin began to see, late in the fifties, that the logi-
cal culmination of his deep religious impulse was not a clerical career
but a prophetic one, that he was able, not exactly to conceive of the
"poison" of social service as his proper food, but to swallow it, out of
a sense of duty.

In the Arnold family social duty was always intimately connected
with religion. If it is true that Thomas Arnold did not exert overt
pressure on his son to become engaged in the serious enterprise of
moral and political reform, we may nevertheless assume that both his
precept and example had a compelling effect on young Matthew. The
reform of the public schools for which Thomas Arnold is now best

known was but one aspect of his reforming activity, which embraced both state and church; and when Matthew arrived at Oxford, his father's struggle against John Henry Newman and the Oxford Movement over the nature of the Church of England and of Christianity and over the church's social role, was at its zenith. If for some reason Matthew had forgotten or resisted either his father's precepts or his example, he was reminded of both shortly after arriving at Balliol. For Dr. Arnold, who had been laboring in Roman history since 1833, was appointed regius professor of modern history at Oxford in August 1841, just two months before his son went into residence at the university, and in January 1842 gave his first course of lectures.[23] Dr. Arnold's inaugural lecture, moreover, left no doubt of the urgency of the tasks that faced the current generation of men, for in it he argued that modern history gave signs of being the last step in civilization. Modern nations might well be the "last reserve of the world"; if they were, the world's fate was in their hands, and "God's work on earth will be left undone if they do not do it."[24]

Yet no one at Balliol College seemed less likely to undertake "God's work on earth" than the eldest son of Dr. Arnold himself. Even at Rugby Dr. Arnold had been aware of the rift that was opening between himself and his son. "I do not see," he said when Matthew was in the sixth form, "how the sources of deep thought are to be reached in him. I fear that he is not likely to form intimate friendships, being too gregarious an animal: he does not like being alone. . . . Matt likes general society, and flitters about from flower to flower, but is not apt to fix." The great schoolmaster was shocked in 1840 by the news that his gay and carefree son had won an open scholarship to Balliol: "I had not the least expectation of his being successful, and the news actually filled me with astonishment. I have great hopes that success will act wholesomely on him."[25] But these hopes must have seemed impossible of fulfillment, for most of Matthew's activities at Oxford looked like positive acts of defiance against his father's commitment to intellect, to piety, to conscientious work. Few at Oxford, reported his fellow student Max Müller, "detected in Arnold the poet or the man of remarkable genius." His most obvious

failing was want of seriousness. "A laugh from his hearers or readers seemed to be more valued by him than their serious opposition, or their convinced assent."[26]

Dr. Arnold died suddenly in June 1842, and although his death profoundly affected his son—Arthur Stanley recalled that "the first thing which struck [Matthew] when he saw the body was the thought that their sole source of *information* was gone . . . and the strange feeling of their being cut off for ever"[27]—it does not appear to have purified him of foppishness, irresponsibility, and even (a notable contrast with the young Ruskin) impiety. In July of 1844 Clough, Dr. Arnold's prize pupil of Rugby days, reported that "Matt has gone out fishing when he ought properly to be working"; and in 1847 we hear from the same source that "Matt is full of Parisianism; theatres in general, and Rachel in special: he enters the room with a chanson of Beranger's on his lips—for the sake of French words almost conscious of tune: his carriage shows him in fancy parading the rue de Rivoli;—and his hair is guiltless of English scissors: he breakfasts at twelve, and never dines in Hall, and in the week or 8 days rather (for 2 Sundays must be included) he has been to Chapel *once*. . . ."[28] Charlotte Brontë, invoking her easy familiarity with the invisible world, drew the inevitable conclusion after witnessing Matthew Arnold's "seeming foppery" that "the shade of Dr. Arnold seemed to me to frown on his young representative."[29]

If, in religious and spiritual matters, the young Matthew Arnold did not think and act as his father would have wished—Miss Brontë also noted that "his theological opinions were very vague and unsettled"[30]—neither did he embrace the religion of his father's Tractarian enemies. He did for a long time attend regularly the Sunday afternoon sermons of Dr. Arnold's greatest adversary, John Henry Newman, at St. Mary's, and for the rest of his life would recall that "religious music—subtle, sweet, mournful."[31] But, his brother Tom recalls, "so far as I know, Newman's *teaching* never made an impression upon him."[32]

That Matthew Arnold should have gone to Newman's sermons for their music rather than their doctrine suggests the underlying cause

for his youthful resistance to the influence of his father. As early as 1836 Arnold was writing poems and beginning to think of himself as a poet.[33] At Rugby he won prizes for Latin Verse in 1838 and for the best English poem, "Alaric at Rome," in 1840; and in 1843, four years after Ruskin had achieved the same distinction, Arnold won the Newdigate Prize for his poem *Cromwell*, his only published work prior to 1849. His father, however, had always ranked history and philosophy far above imaginative literature, and the single poem Dr. Arnold wrote—in honor of the founder of the Junior Common Room at Corpus Christi—prompted his son to remark: "Ah, my poor father! He had many excellencies, but he was not a poet."[34] Poetry at this time attracted Arnold, as a few years earlier it had attracted the far more serious young Ruskin, partly because it was a free or liberal activity, pursued for its own sake and not as a means to something beyond itself, be that something political, social, or religious. If, therefore, Arnold was to preserve his poetic gift, he had to lead a life that was free, untrammeled by the requirements of morality, politics, and religion. Arnold in later life always associated the true life of poetry with his days at Oxford, and "that life at Oxford," he told his brother in 1857, was "the *freest* and most delightful part . . . of my life. . . ."[35] Whereas Dr. Arnold had during his lifetime epitomized the effective, practical personality, Matthew Arnold impressed people by his aesthetic rather than his moral qualities. "He was beautiful as a young man," wrote one of his classmates.[36]

The effort that Ruskin made in the early forties to validate the activities of art and science as distinct from (if ultimately conducive to) religion had now to be undertaken by Arnold on behalf of poetry. Only in Arnold's case the task was not so much to justify the writing of poetry as opposed to the saving of souls, as to distinguish between the duties of the poet and those of the citizen. From the time that he was elected a fellow of Oriel College in March 1845, Arnold's chief adversary in this task was the man he would ironically address in 1848 as "Citizen Clough, Oriel Lyceum, Oxford."[37] In Clough, with his strong desire for social and political commitment and involvement, Arnold saw the threat that was posed to poetry and to the free life of imagination by the conviction that right doing was a substitute for

right thinking and that the obligations of the citizen determined those of the poet.

What particularly distressed Arnold in viewing Clough and his poetry was his friend's insufficient devotion to his craft and his readiness to make it a mere instrument for problem-solving. In a playful letter of 1845, filled mainly with effervescent praise for George Sand, Arnold pauses to reflect that "never without a Pang do I hear of the growing popularity of a strong minded writer." For in such a case the writer is likely to direct his vision outward, and in consequence "lose his self-knowledge, and talk of his usefulness and imagine himself a Reformer, instead of an Exhibition." Let us, he warns Clough, "keep pure our Aesthetics by remembering its one-sidedness as doctrine." Confusing the duties of the poet with those of the citizen, then, is harmful both to poetry and to politics because it tends, paradoxically, to make each an instrument of the other. As Arnold reads Clough's poetry, he becomes more and more aware of "the deficiency of the *beautiful* in your poems, and of this alone being properly *poetical* as distinguished from rhetorical, devotional or metaphysical." Arnold admits that the production of the beautiful in poetry is a problem to him as well, but at least he sees that it is for this that the artist must strive. Good citizenship is no substitute for good poems; political activity is not the same as creative activity; the good man is not necessarily the good artist; and, Arnold frankly tells his friend, "I doubt your being an *artist*."[38]

Yet, as Arnold's admission that he too finds it hard to produce "the beautiful" in poetry suggests, for him as for Ruskin the commitment to art as a good in itself, independent of its value in soul-saving, religious or political, was not unqualified and raised serious problems for the conscience. One of these problems is in fact dramatically and —from the point of view of a detached observer—ironically introduced in the very next paragraph of Arnold's letter. No sooner has he finished berating poor Clough for not being enough of an artist than Arnold looks outward to the world and excitedly reports from it:

> Later news than any of the papers have, is that the National Guard have declared against a Republic, and were on the

brink of a collision with the people when the express came away.—I trust in God that feudal industrial class as the French call it, you worship, will be clean trodden under.[39]

The French Revolution of 1848 had begun, and the preacher of aesthetic purity who in 1847 had become the private secretary to the marquis of Lansdowne, lord president of the Privy Council, was now shocking his friends with overheated résumés of the very latest confidential reports on the insurrection. Political turmoil in the stormy world outside of the sacred preserves of art now threatened to undermine the aesthetic creeds of Arnold and Ruskin even before they had been fully formed.

I received a copy of the Cenci, as from yourself from Hunt. There is only one part of it I am judge of; the Poetry, and dramatic effect, which by many spirits now a days is considered the mammon. A modern work it is said must have a purpose, which may be the God—an artist must serve Mammon—he must have "self-concentration" selfishness perhaps. You I am sure *will forgive me for sincerely remarking that you might curb your magnanimity and be more of an artist, and "load every rift" of your subject with ore. The thought of such discipline must fall like cold chains upon you, who perhaps never sat with your wings furl'd for six Months together.*—John Keats to Shelley, 16 August 1820

The tempest of the Paris Revolution in February 1848 was heard of in New Zealand soon after I landed in the colony. What a time of boundless excitement for the young and unsteady was that year of 1848! Battles in the streets of great cities, constitutions torn to rags, insurrection everywhere, resignations of crowns, Chartist meetings, wars changing the frontiers of states, Italy rising against Austria, Hungary striking for independence, Russia sending her legions across the Carpathians, Rome turned into a republic—this was the sort of "foreign intelligence" that my friends at home expected to find, and usually did find, in their morning papers. Even I, at the distance of half the globe, having steeped myself in French revolutionary literature before leaving England, watched for the tidings of those mighty events, and seemed to feel the reverberation of those shocks. My brother, to whom literature then and always meant more than politics, wrote two admirable sonnets on the Revolution in France. Yet, with banter irrepressible, in the thick of the wild hubbub, he addressed to Clough a letter with the superscription, "Citizen Clough, Oriel Lyceum, Oxford."—Thomas Arnold the Younger

Art and Revolution

The year 1848 was a momentous one for England and for all of Europe. There was revolution in France, Italy, and Germany, and near revolution in the form of Chartist riots in England. Karl Marx, who was shortly to seek refuge in London, published the *Communist Manifesto*, and John Stuart Mill his *Principles of Political Economy*. The world of Arnold and Ruskin was in upheaval, and they were to be deeply moved by the events they read of and witnessed.

The violent events in France that Arnold described to Clough in his letter of 24 February 1848 were in fact the prelude to the abdication of Louis Philippe, the "bourgeois" Orleanist monarch, who like his Bourbon predecessor eighteen years earlier now went into exile in England. The seventy-five-year-old king abdicated in favor of his ten-year-old grandson, the comte de Paris. But the French mob had already tasted so much blood—it had forced the king to dismiss his chief minister, Guizot (esteemed by Lord Acton and John Morley as the greatest statesman of the nineteenth century), before he himself was deserted by the National Guards—that it would accept nothing short of a Second Republic, which was presently proclaimed.

The underlying causes of this latest installment of the French Revolution were a grave economic crisis, an unpopular foreign policy, and a stubborn resistance by the government to parliamentary and to industrial reform. In spite of a movement for parliamentary reform that had begun before 1840, Guizot's government had refused to extend the franchise, so that this purported government of the middle class and the *juste milieu* seemed to embrace only the new aristocracy of industrial wealth, an aristocracy that Tocqueville called "one of the harshest that has yet appeared on earth." Largely as a result of the influence of this class within the government, no social legislation

of importance, apart from the 1841 Factory Act to restrict the use of child labor, had been promulgated.[1]

Similar, though not identical, causes of discontent existed in England, but contrary to Dr. Pangloss, the same causes do not always have the same effects. The Chartist movement was not born in response to the revolutionary upheavals in Germany, Italy, and France. In fact, as early as May 1838 the London Working Men's Association had formulated its demands for political and social equality in a "People's Charter" containing six points: annual parliaments, universal male suffrage, equal electoral districts, removal of the property qualification for membership in parliament, secret ballot, and payment of members. Over the years the Chartists achieved some small successes and suffered many great failures, largely as the result of an unfortunate choice of leaders. From 1845 to 1847 the fortunes of the movement, or at least of its leader Feargus O'Connor, seemed to be on the upsurge. He had become a European figure, had been feted in Belgium, had been congratulated for his work by Engels and Marx, and in July 1847 had been elected as the first Chartist member of Parliament.[2] But in December of 1847 a new National Petition for the People's Charter proved a failure, and on 1 January 1848 it became public knowledge that the Chartists' entire party fund did not amount to £60.[3]

But after the first news of revolution, that from Italy, reached England, signatures to the national petition began to stream in; and by the end of February, when the news from Paris arrived, Chartist enthusiasm was soaring. The revolutions in Paris and Central Europe aggravated the country's economic crisis, and it seemed to some that England was ripe for revolution. A serious riot broke out in Glasgow on 5 March, followed by rioting in all the great manufacturing centers. But the Chartist leaders were both too divided and too vacillating to exploit their opportunity. On 4 April the thirty-nine delegates who comprised the national convention met near Tottenham Court Road to petition for the charter, and on 10 April a monster rally was scheduled for Kennington Common in South London, from whence a procession was to carry a petition to the Houses of Parliament.

There was widespread fear of revolution: the royal family left London to take refuge on the Isle of Wight, and Wellington stationed troops throughout the city.[4] But Matthew Arnold, an eye-witness of these events, saw them in truer perspective:

> The *National* of yesterday reports that London was *en pleine insurrection*. . . . I saw Emerson the other day, and had a very pleasant interview. . . . He said Carlyle was much agitated by the course of things; he had known, he said, a European revolution was inevitable, but had expected the old state of things to last out his time. He gives our institutions, as they are called, aristocracy, Church, etc., five years, I heard last night. . . . I was at the Chartist convention the other night, and was much struck with the ability of the speakers. However, I should be sorry to live under their government— nor do I intend to—though Nemesis would rejoice at their triumph. The ridiculous terror of people here is beyond belief. . . .[5]

Arnold was right. O'Connor informed his followers that the police had banned their procession and that they were to disperse. At 4:45 on 10 April Arnold was able to report to Clough that

> the Chartists gave up at once in the greatest fright at seeing the preparations: braggarts as they are, says my man: and Fergus O'Connor and Co—after giving themselves into custody expressed the greatest thankfulness to the Government that their polite offer was not taken advantage of on condition of their making the crowd disperse.—Then came 1/2 an hour after, the hard rain. The petition is quietly progressing in cabs, unattended, to Westminster.[6]

Thus did Chartism come to its funereal end. Arnold was not to witness a mass political rally of such dimensions again until the Hyde Park riots of 1866.

But the events of 1848 could be neither forgotten nor ignored. Arnold's "man," his employer Lord Lansdowne, told the House of

Lords on 22 March of the following year that a change had come over the world "which entirely reversed the order of things throughout Europe. After that which took place at Paris—I mean the revolution with all its consequences—the danger which arose was not as before the interference of governments with the independence of States, but that a democracy without a throne would overturn all the crowns of Europe."[7]

In the years before 1848 the silence of Arnold and Ruskin on social and political questions was so nearly complete as to offer evidence for the accusation that literary men, although they are bored by the tasks of reform, adore revolution; that they ignore the despair of their fellow men until it turns into rage and violence; and that they are disinclined to speak of society at all until they can shriek with Byron that "revolution / Alone can save the earth from hell's pollution."[8] The period from 1840 on had, after all, been the "hungry forties," a period of sharp class conflict brought on by new industrial conditions. The new poverty and the miseries it engendered became the subject of Carlyle, in *Chartism* (1839) and *Past and Present* (1843), of Engels in *The Condition of the Working Class in England in 1844*, and of Benjamin Disraeli, the future prime minister, in *Sybil* (1845).

University men in their early twenties have, after all, been known to pay some heed to social questions; yet before 1848 the writings, private and published, of Arnold and Ruskin are virtually bare of such references. Given his father's intense and even morbid obsession with social and political questions, Matthew's initial indifference to them may have been another instance of youthful revolt. Yet it seems astonishing that so knowledgeable a young man should have been so unaffected by, for example, the unprecedented disaster that befell Ireland in the years from 1845 on, during which time over half a million people died from the starvation and disease caused by the famine while English politicians reaffirmed their belief in the sanctity of laissez-faire. Benjamin Jowett, Arnold's contemporary and a Balliol tutor not noted for the intensity of his social convictions, could later recall, "I have always felt a certain horror of political economists

since I heard one of them [Nassau Senior] say that he feared the famine of 1848 in Ireland would not kill more than a million people, and that would scarcely be enough to do much good."⁹ Yet Arnold, who worked for Lord Lansdowne during the very years (1847–49) when he was a great proprietor in Ireland, ventured no comment on the great hunger there until April 1848 when he expressed his disapproval of "Saxon landlords" and "a Saxon Ch.[urch] Estab[lishmen]t" and his hope that the English would be wise enough to refrain from shedding Irish blood in defense of such things.¹⁰

Ruskin, traveling in Italy in 1840, viewed the Italian poor mainly as objects of aesthetic distaste: "Beggars all day intolerable,—howling, dark eyed brats of children, to be got rid of by a centime, however. . . ."¹¹ In 1845 he told his father he could not become a real poet because of the great chasm that separated him from the distresses of common life: "I don't see how it is possible for a person who gets up at four, goes to bed at ten, eats ices when he is hot, and beef when he is hungry, gets rid of all claims of charity by giving money which he hasn't earned, and those of compassion by treating all distresses more as picturesque than as real: I don't see how it is at all possible for such a person to write good poetry. . . ."¹²

To some extent, Ruskin's seeming indifference to social questions during these years was a function of his conception of art. If the artist's vocation was to be a worthy substitute for the clergyman's, then the artist must be possessed of what Arnold would many years later call high seriousness: "Art, properly so called, is no recreation; it cannot be learned at spare moments, nor be pursued when we have nothing better to do. It is no handiwork for drawing-room tables, no relief of the ennui of boudoirs; it must be understood and undertaken seriously, or not at all."¹³ This pledge of seriousness comes at the outset of the second volume of *Modern Painters* (1846) and is part of another attempt by Ruskin to justify to himself and to others, "from a moral point of view," the utility of the artistic enterprise. For like Newman in his university discourses a few years later Ruskin felt obliged to justify the liberal activity of art as really more useful than so-called useful activities.

Ruskin announces that his purpose is nothing less than "to summon

the moral energies of the nation to a forgotten duty, to display the use, force, and functions of a great body of neglected sympathies and desires. . . ." Few activities could seem more useful, and yet because "men in the present century understand the word Useful in a strange way," Ruskin must remind them that man's use and function are "to be the witness of the glory of God" and to spread that glory by obedience and happiness. It is the baneful influence of the "men who insolently call themselves Utilitarians" that leads Ruskin's contemporaries to speak and think as if food, clothing, and shelter were alone useful. In fact, warns Ruskin, the long continuance of peace and prosperity are national dangers that induce spiritual illness, and an abundance of bread, water, and peace may cause men to forget their dependence on God. Ruskin's outlook in 1846 was thus hardly one that conduces to sympathy with those men who happen to lack bread, water, and peace; but it is to Ruskin's credit that in the second (1848) edition of this volume he appended a note to the paragraphs just cited in which he remarked that "recent events have turned them into irony."[14]

The events of 1848 burst upon Ruskin like a thunderbolt and nearly unsettled the foundations of his being. Though he was not brought into immediate contact with the events of Paris by opening, as Arnold did, the latest dispatches to Lord Lansdowne, and though he did not stand in the streets, as Arnold did, among the Chartist demonstrators, Ruskin felt the cataclysmic events more deeply; and we shall see how it is the greater intensity of his reaction to them that marks the first important divergence between Arnold and Ruskin in gauging the pressure of society upon art.

Compared with Arnold's, Ruskin's reaction to the Continental upheavals of 1848 may seem belated since it is not even mentioned in his published correspondence until April. But we must recall that 1848 was also the year of Ruskin's disastrous marriage (on 10 April, the day of the great Chartist rally) to Euphemia Chalmers Gray. At first, therefore, European revolutions enter his consciousness only as an irritating obstacle to a European honeymoon: "I don't think a prison would do for us at all, my love," he told Effie, "—a cavern—or a

desert island, are very well and a desirable family property—but a mere cell, with a sentinel before the door and nothing before the window but a flower pot or two . . . would be perhaps something too sober a way of passing the honeymoon."[15] But Ruskin was very quickly to recognize that far more than his honeymoon was imperiled by the revolutions. He had always believed that contentment was necessary for his work and his enjoyment, "for discontent not only makes us unhappy in the dwelling on the privation we particularly lament, but it shuts out all the pleasures which are waiting round about us to come in, if we would let them."[16] But now, suddenly, he found his contentment removed. The revolutions, once they penetrated his consciousness, nearly overwhelmed him, for they threatened not merely the destruction of the old order but of European civilization itself and of his sacred occupation along with it. The work whose seriousness he had so recently proclaimed had now been rendered precarious and even frivolous in his eyes:

> I should be very, very happy just now but for these wild storm-clouds bursting on my dear Italy and my fair France, my occupation gone, and all my earthly treasures . . . perilled amidst "the tumult of the people," the "imagining of vain things." . . . But these are thoughts as selfish as they are narrow. I begin to feel that all the work I have been doing, and all the loves I have been cherishing, are ineffective and frivolous—that these are not times for watching clouds or dreaming over quiet waters, that more serious work is to be done, and that the time for endurance has come rather than for meditation, and for hope rather than for happiness.[17]

The doubts about his artistic occupation that Evangelical religious earnestness had first instilled in Ruskin were now aggravated by the social and political turmoil of Europe. Whereas earlier he had feared that art might obscure his duty to God, now he feared that the vocation of art critic was incompatible with his duty to man. On 1 May 1848 revolutionary events in distant Italy caused Ruskin to write in

despair from the family home at Denmark Hill to the painter George Richmond: "When will you come and see me, and tell me whether it is of any use to write or think about painting any more, now, or whether there will be no painting to be loved but that 'which more becomes a man than gilt his trophy'? I feel very doubtful whether I am not wasting my life, and very sad about all. Alas poor Milan, and my beloved spire, and now Verona in the thick of it."[18] These are certainly not the sentiments of someone who has all at once become passionately concerned with the plight of his fellow men and who feels his own fate, safe and secure though he be, to be wrapped up in theirs; rather, they express the private dilemma of someone whose attention has been diverted from his natural course to the troubled world outside of himself and who fears that the course of history tends more and more to render his occupation obsolete. It is not primarily the Italians Ruskin mourns for—he was soon to assert that they were only being punished for their sins[19]—but himself.

Nevertheless, Ruskin's growing awareness of society does coincide with his increasing interest in architecture at the expense of painting. As early as the Continental tour of 1846, his diary began to be filled with as many notes on architecture as on painting. But it was not until his sense of vocation had been unsettled by a new awareness of social questions that he decided to undertake a book-length study of architecture, an eminently social form of artistic expression. In August of 1848 Ruskin left for a tour of Normandy, where he studied French architecture and also a people and a society in the midst of a revolution. For perhaps the first time in his life his researches in art proceeded hand in hand with a sensitive observation of social conditions and human relations. Writing to his father from Lisieux in August, he was more than ever delighted with the beauty of the country and its buildings, yet "more disgusted than ever with its inhabitants" despite the fact that most people he met with deplored the recent tumult and disorder.[20] But Paris and Rouen, which he visited in October, moved him not only to disgust at their gloom and hideousness but to pity for their people's sufferings, to fear that the workmen would shortly resort to violence to relieve their distress, and

to the desperate hope that the country might be saved if the upper classes could bring themselves to acknowledge their common humanity with the lower:

> Vagabonds and ruffians—undisguised—fill the streets, only waiting—not for *an* opportunity but for *the best* opportunity of attack. And yet even from the faces of these I have seen the malice and brutality vanish if a few words of ordinary humanity were spoken to them. And if there were enough merciful people in France to soothe without encouraging them, and to give them some—even the slightest— sympathy and help in such honest efforts as they make— few though they be—without telling them of their Rights or their injuries—the country might still be saved.[21]

Immediately upon his return from France, in the winter of this cataclysmic year of revolution, Ruskin set himself to the composition of *The Seven Lamps of Architecture*, a statement of the principles of architecture illustrated mainly by examples of Gothic and Italian Romanesque work. The book, published in May 1849, was, indeed, an attempt to enumerate the principles of success in architecture. But it was also a continuation of Ruskin's exploration of the difference between liberal and utilitarian enterprises and of his attempt to discover and then to justify his vocation of art critic in a time of social strife and revolutionary upheaval.

Unlike earlier propagandists of Gothic like Pugin, Ruskin did not set out with a violent prepossession against the whole of modern civilization. This was already evident in his championship of Turner and the Moderns and in his frequent insistence on the compelling interest of modern subjects in literature. Yet in the preface to *Seven Lamps* he points out that two forces are at work in the modern world destroying the very subjects of his book. He tells his readers that he has been forced to postpone the completion of *Modern Painters* because it was imperative that he record his impressions of all the "medieval buildings in Italy and Normandy, now in process of destruction, before that destruction should be consummated by the Re-

storer, or Revolutionist." In "The Lamp of Memory" he speaks at length of the importance of preserving, "as the most precious of inheritances," the architecture of past ages. But preservation is not to be confused with restoration. Restoration, argues Ruskin, is a contradiction in terms, and means really "the most total destruction which a building can suffer." Great buildings can no more be "restored" without the breath of life of the artists and the society that created them than dead men can be resurrected.[22]

But if part of the hateful work of destruction was carried out by those with a misguided zeal for the past, the other part was carried out by those who liked to identify themselves with the immediate needs of the present, the revolutionary mob. Having chastised the restorers, Ruskin says, "Of more wanton or ignorant ravage it is vain to speak; my words will not reach those who commit them, and yet, be it heard or not, I must not leave the truth unstated, that it is again no question of expediency or feeling whether we shall preserve the buildings of past times or not. *We have no right whatever to touch them.* They are not ours. They belong partly to those who built them, and partly to all the generations of mankind who are to follow us." The mob whose indifference to both past and future Ruskin deplores is not only the mob that overthrew Louis Philippe; rather, "the people who destroy anything causelessly are a mob, and Architecture is always destroyed causelessly."[23] Yet it was certainly the political events of 1848 that sharpened Ruskin's sense of the growing incompatibility between his work and the immediate needs, or supposed needs, of the world springing up about him and invading his consciousness.

The introduction to *The Seven Lamps* and its first chapter, "The Lamp of Sacrifice," offered an apologia for the disinterested activity of mind at a time when distress and political turmoil seemed to call for more practical and utilitarian endeavor. Ruskin begins by saying that failure in art is more often attributable to "a confused understanding of the thing actually to be done" than to "insufficiency of means or impatience of labour." In other words, an obsession with means obscures the ends, and the artist becomes so concerned with

what is practicable that he grows oblivious of "goodness and perfection in themselves." Nor is it only in art that men too readily satisfy themselves with what they think can be done instead of pondering what should be done: "As far as I have taken cognizance of the causes of the many failures to which the efforts of intelligent men are liable, more especially, in matters political, they seem to me more largely to spring from this single error than from all others, that the inquiry into doubtful, and in some sort inexplicable, relations of capability, chance, resistance, and inconvenience, invariably precedes, even if it do not altogether supersede, the determination of what is absolutely desirable and just."[24]

Thus does Ruskin announce at the outset that it is not only in art but in the management of the state that free, disinterested speculation on ends is ultimately more useful than short-sighted calculation of expedient means. His own inquiries into the principles of success in both areas of endeavor therefore can and will be conducted simultaneously. "What is true of human polity seems to me not less so of the distinctively political art of Architecture."[25]

In architecture, as in other realms that require the harmonious co-operation of technical with imaginative powers, of body with soul, or of doing with thinking, Ruskin maintains that it is the unfortunate tendency of the modern age and of "the necessities of the day" to submerge the higher part and to elevate the lower, materialistic part. These supposed necessities cannot even be numbered, for "they rise, strange and impatient, out of every modern shadow of change." We must respond to them not by asserting the inviolability of principles based merely on past practice, nor by dealing piecemeal with the host of new requirements and new abuses, but by determining "some constant, general, and irrefragable laws of right" based upon man's nature and thus immune from changes due to increase or decrease in man's knowledge. These laws, which are but particular versions— Ruskin cannot stress this too often—of the laws of all human action, shall, he says, be called the Lamps of Architecture.[26]

What, Ruskin finally asks in his introduction, is to be our estimation of the man who, in a time of revolutions abroad, of hunger and

Chartist turmoil at home, devotes himself to the elucidation of such laws? His own justification is, and must be—Ruskin is writing of himself—precisely that in the disinterested pursuit of the true laws of any branch of human work one is discovering the unity of all human exertion and thus celebrating the power and majesty of God. For Ruskin the rules of aesthetics and the laws of ethics are the same. In recommending any action, he says, "we have choice of two separate lines of argument: one based on representation of the expediency . . . of the work . . . the other based on proofs of its relations to the higher orders of human virtue, and of its acceptableness . . . to Him who is the origin of virtue." Ruskin himself has chosen always to take "the higher line of argument" not only because it is the best road to ultimate truth but because no other mode of treating a subject, no other justification of a man's vocation, is adequate to the present moment of history:

> The aspect of the years that approach us is as solemn as it is full of mystery; and the weight of evil against which we have to contend, is increasing like the letting out of water. It is no time for the idleness of metaphysics, or the entertainment of the arts. The blasphemies of the earth are sounding louder, and its miseries heaped heavier every day; and if, in the midst of the exertion which every good man is called upon to put forth for their repression or relief, it is lawful to ask for a thought, for a moment, for a lifting of the finger, in any direction but that of the immediate and overwhelming need, it is at least incumbent upon us to approach the questions in which we would engage him, in the spirit which has become the habit of his mind, and in the hope that neither his zeal nor his usefulness may be checked by the withdrawal of an hour, which has shown him how even those things which seemed mechanical, indifferent, or contemptible, depend for their perfection upon the acknowledgment of the sacred principles of faith, truth, and obedience, for which it has become the occupation of his life to contend.[27]

Having made this eloquent plea for the very temporary attention of the good man whose time and energy are mainly devoted to practical exertions for the relief of human misery, and having promised that "neither his zeal nor his usefulness" will be checked by his study of *The Seven Lamps*, Ruskin proceeds, paradoxically, to argue in chapter 1, "The Lamp of Sacrifice," that it is precisely *uselessness* that distinguishes architecture from mere building. Architecture "concerns itself only with those characters of an edifice which are above and beyond its common use"; it adds just those arches, trefoils, cable mouldings, "which are useless" to good building. The Lamp of Sacrifice is exactly the anti-utilitarian principle that had already been championed in *Modern Painters*. It is the name Ruskin uses for the generous and religious spirit in man, and in the architect, which moves him to "the offering of precious things merely because they are precious, not because they are useful or necessary." Ruskin, in making himself the audacious champion of this spirit of contempt for economy and utility, was setting himself against "the prevalent feeling of modern times, which desires to produce the largest results at the least cost." Three years before Newman in his *Discourses on University Education* eloquently defended intellectual culture as a good in itself and its own end, Ruskin was challenging the principle of utility and, implicitly, the reigning political economy. The objects of his attack quickly capitalized upon the terminology of the debate and joined the *Economist* in labelling Ruskin "this expounder of a useless art."[28]

Following a line of argument which will recur in his later work —most notably in the attack on utility in *Unto This Last*—Ruskin argues that sacrifice must be conceived of as a good in itself, irrespective of its consequences. The worthiness of an activity is not measurable by its result. Men should, for example, sacrifice their wealth to the decoration of God's house instead of their own; yet "it is not the church we want, but the sacrifice . . . not the gift but the giving."[29] The principle of intrinsic value here asserted was dear to Ruskin's heart; and yet, like the preacher he never quite became, he could not resist undermining the principle by asserting, much as he had already

done in *Modern Painters* II, that in the long run the Lamp of Sacrifice is more expedient than expediency itself:

> While, however, I would especially deprecate the imputation of any other acceptableness or usefulness to the gift itself than that which it receives from the spirit of its presentation, it may be well to observe, that there is a lower advantage which never fails to accompany a dutiful observance of any right abstract principle. While the first fruits of his possessions were required from the Israelite as a testimony of fidelity, the payment of those first fruits was nevertheless rewarded, and that connectedly and specifically, by the increase of those possessions. Wealth, and length of days, and peace, were the promised and experienced rewards of his offering, though they were not to be the objects of it.

Thus, although religion may not need the service of the arts, "the arts will never flourish until they have been primarily devoted to that service."[30]

Ruskin is here writing about the vocation of architect, not that of art-critic; but Ruskin was a writer peculiarly incapable of separating his personality from his work, and it is not, I think, extravagant to see in the practical lessons enjoined on the architect by the Lamp of Sacrifice the principles by which Ruskin at this time justified to himself a vocation in which he never felt easy. The critic, like the architect, should always do his best, should put forth all his strength without thought of getting "money's worth"; and the critic, like the architect, should consider that the beauty of his work is enhanced by its visible evidences of great, disinterested labor. For Ruskin, like those "good men" whom he had called from the vineyard, wanted some assurance that "useless" work would ultimately prove the most useful work of all.

Yet between the opening chapter on the Lamp of Sacrifice and the concluding chapter on the Lamp of Obedience we hear relatively little from Ruskin in *The Seven Lamps* about the social or humanitarian function of the critic of architecture. The main impulse at work

in *The Seven Lamps* is aesthetic or naturalistic rather than humanitarian or moral. Readers of Ruskin or of his critics have become familiar with the book's often quoted assertions about work that anticipate *The Stones of Venice*; and yet through most of *The Seven Lamps*, the distinctions enforced are aesthetic ones, and it is assumed that, as Ruskin remarks in "The Lamp of Beauty," the ugly and the unnatural are one.[31]

Questions of art's utility and of the responsibility of the artist to society do appear on the peripheries of the discussion in the five chapters separating the first and the last. There is, for example, in "The Lamp of Truth" the emphasis on reuniting "the arts and all other subjects of human intellect, as matters of conscience." There is also the assertion that majestic art sympathizes "with the effort and trouble of human life." Above all, there is the famous injunction in "The Lamp of Life," to "ask, respecting all ornament . . . Was it done with enjoyment—was the carver happy while he was about it?"[32]

But a careful reading even of these passages shows that their moral emphasis, though genuine, is qualified by, if not subordinate to, an aesthetic standard that is naturalistic rather than moral. All architectural beauty, Ruskin asserts in "The Lamp of Power," "is imitated from natural forms." Noble buildings sympathize with "the vast controlling powers of Nature herself." The principle of Organic Form afforded to Ruskin in 1848 and 1849 a kind of temporary refuge from the demands of a utilitarian and mechanical society. As yet unwilling to make social utility the standard of art and life, he looked to a nature that sought beauty through order as an ultimate standard.

The Seven Lamps of Architecture represents a transitional stage rather than a revolution in Ruskin's career. The turmoil of 1848 has not made him forsake his vocation of art-critic, but it has made him question this vocation. He is not as yet primarily interested in social and political problems, but they have invaded his consciousness to the point where he feels obliged to justify his own vocation in relation to that of men who have joined in worldly struggle, and to explain his apparent detachment from that struggle. His argument is still primarily with himself, for he does not as yet know where his

true vocation and his true existence lie. In "The Lamp of Life" he states the dilemma in terms very like those Arnold was shortly to use in "The Buried Life":

. . . When we begin to be concerned with the energies of man, we find ourselves instantly dealing with a double creature. Most part of his being seems to have a fictitious counterpart, which it is at his peril if he do not cast off and deny. Thus he has a true and false (otherwise called a living and dead, or a feigned or unfeigned) faith. He has a true and a false hope, a true and a false charity, and, finally, a true and a false life. His true life is like that of lower organic beings, the independent force by which he moulds and governs external things; it is a force of assimilation which converts everything around him into food, or into instruments: and which, however humbly or obediently it may listen to or follow the guidance of superior intelligence, never forfeits its own authority as a judging principle, as a will capable either of obeying or rebelling. His false life is, indeed, but one of the conditions of death or stupor, but it acts, even when it cannot be said to animate, and is not always easily known from the true. It is that life of custom and accident in which many of us pass much of our time in the world; that life in which we do what we have not proposed, and speak what we do not mean, and assent to what we do not understand; that life which is overlaid by the weight of things external to it, and is moulded by them, instead of assimilating them; that, which instead of growing and blossoming under any wholesome dew, is crystallised over with it, as with hoarfrost, and becomes to the true life what an arborescence is to a tree, a candied agglomeration of thoughts and habits foreign to it, brittle, obstinate, and icy, which can neither bend nor grow, but must be crushed and broken to bits, if it stand in our way. All men are liable to be in some degree frost-bitten in this sort; all are partly encumbered and crusted over with idle matter; only, if they have real life in them, they are always breaking this bark away in noble rents, un-

til it becomes, like the black strips upon the birch tree, only
a witness of their own inward strength.[33]

The trouble was that Ruskin did not yet know which of his anti-
thetical impulses represented his true, and which his false, life. We
have already seen in his letters of this period a fear that what he had
for some time supposed to be his own true life and occupation had
been rendered frivolous and futile by the new world that was being
conceived in violence. In "The Lamp of Life" he concluded his argu-
ment against the mechanical and utilitarian conceptions of work by
asking, albeit uneasily, whether many occupations in life were not
actually intended to be useless: "Perhaps all that we have to do is
meant for nothing more than an exercise of the heart and of the will,
and is useless in itself. . . ."[34] But in the final chapter of *The Seven
Lamps* he again tried, almost desperately, to justify his own calling in
the very terms of social utility that he had rejected in his first chapter.

"The Lamp of Obedience," more than any other of *The Seven
Lamps*, indicates Ruskin's awareness of a need to relate his own work
to the revolutionary events of 1848. Although he has been pursuing
"a subject that at first appeared to bear but slightly on the grave in-
terests of mankind," Ruskin has in fact been drawing a great politi-
cal lesson from his investigation into the conditions that are requisite
to great architecture. For his investigation has furnished him and his
readers with conclusive proof of "how false is the conception, how
frantic the pursuit, of that treacherous phantom which men call Lib-
erty. . . ." What men need is not Liberty but Law, and the visible
embodiment of Law is work. Turning to those accusing critics—and
they are but echoes of the self-accusing voices of John Ruskin—who
question the immediacy of dissertations on architecture in the wake
of revolutions, Ruskin launches into an exposition of the good social
effects that submission to national architectural laws and a uniform
inculcation of those laws through education would have. These would
include fellowship, patriotism, social sympathy, and public-spirited-
ness among the first consequences. There would also be increased
economy, greater domestic comfort, more sightly and harmonious

streets and buildings. But before articulating these consequences in any detail, Ruskin brings himself up short:

> But it would be mere enthusiasm to endeavour to trace them farther. I have suffered myself too long to indulge in the speculative statement of requirements which perhaps we have more immediate and more serious work than to supply, and of feelings which it may be only contingently in our power to recover. I should be unjustly thought unaware of the difficulty of what I have proposed, or of the unimportance of the whole subject as compared with many which are brought home to our interests and fixed upon our consideration by the wild course of the present century. But of difficulty and importance it is for others to judge. I have limited myself to the simple statement of what, if we desire to have architecture, we MUST primarily endeavour to feel and do: but then it may not be desirable for us to have architecture at all.[35]

Perhaps, after all, Ruskin confesses, he has fallen into the common error of overestimating the importance of his own vocation. Nevertheless, he is at least certain of the need for architecture as a national employment, and he is "confirmed in this impression by what I see passing among the states of Europe at this instant." All the horror, tumult, and misery that now oppress the nations of Europe "are traceable, among the other secondary causes through which God is working out his will upon them, to the simple one of their not having enough to do." Ruskin does not deny the hardships suffered by the workers nor the recklessness of their revolutionary leaders, nor the absence of moral character in the upper and governing classes, but he maintains that underlying them all is "the commonest and most fruitful cause of calamity in households—idleness." Men, of whatever class, are not to be bettered, Ruskin now maintains (he was soon to alter this view), by education: "the chief thing they need is occupation."[36]

Thus does Ruskin justify his obsession with architecture in a period

of revolution. The true philanthropist will be he who ceases merely to warn potential revolutionaries that—what is indeed true—they are fools who will in the end make themselves and others miserable, and who instead finds them "some other employment than disturbing governments." Ruskin's prescription of an occupation as the outlet for the idle energy which otherwise expresses itself in revolution is less important as an anticipation—though it is that too—of "The Nature of Gothic" than as an indication of Ruskin's two obsessive concerns at the time he composed *The Seven Lamps of Architecture*: his own choice of an occupation and his justification of that choice at a time of revolution, when nothing seemed less needed than disinterested inquiry into the causes of a past greatness that was fast being swept out of the world:

> I have paused, not once nor twice, as I wrote, and often have checked the course of what might otherwise have been importunate persuasion, as the thought has crossed me, how soon all Architecture may be vain, except that which is not made with hands. There is something ominous in the light which has enabled us to look back with disdain upon the ages among whose lovely vestiges we have been wandering. I could smile when I hear the hopeful exultation of many, at the new reach of worldly science, and vigour of worldly effort; as if we were again at the beginning of days. There is thunder on the horizon as well as dawn. The sun was risen upon the earth when Lot entered into Zoar.[37]

If we now try to compare Arnold's response to the events of 1848 with Ruskin's, we must say that Arnold saw more and felt less than did his contemporary. He had a greater awareness than Ruskin of the economic and political changes that were enveloping Europe, but a less intense response to them. He could already describe the crisis of industrial capitalism in terms that Ruskin would not encompass for another decade, but he could not yet sympathize with the distress of an individual worker. He understood, only too well, the threat that social and political upheaval posed to the imaginative life, but he

did not share Ruskin's fear that his occupation was gone and his world destroyed. Paradoxically, however, he at once saw, as Ruskin did not, that an adequate response to this new world of revolutionary urgency required not just a redefinition of one's calling but a strategy for personal survival, for the retention of one's mental balance.

Mrs. Humphry Ward, Arnold's niece, has offered as evidence of the excitement with which Matthew Arnold followed the revolutionary spectacle of 1848 a letter of 28 February that he wrote to his brother Tom shortly after the abdication of Louis Philippe. The letter, very long, begins with a detailed description of the great room in Lansdowne House in which Arnold has been working and then of the penetration of the shouts from the streets into the quiet of the house and into its serene courtyard; and "above all cries comes one whereat every stone in this and other lordly mansions may totter and quake for fear: 'Se . . . c . . . ond Edition of the Morning *Herald* —L . . . a . . . test news from Paris:—arrival of the King of the French.' " Arnold buys his paper and proceeds to give his brother a very detailed, very accurate, and very impartial, if not very calm, account of events in France from the time of Guizot's 1847 declarations "against the spirit of Revolution all over the world" up until the present moment. The flavor of the letter may be suggested by its concluding paragraphs:

> They gathered all over Paris: the National Guard, whom Ministers did not trust, were not called out: the Line checked and dispersed the mob on all points. But next day the mob were there again: the Ministers in a constitutional fright called out the National Guard: a body of these hard by the Opéra refused to clear the street. They joined the people. Troops were brought up: the Mob and the National Guard refused to give them passage down the Rue le Pelletier, which they occupied: after a moment's hesitation, they were marched on along the Boulevard.
>
> This settled the matter! Everywhere the National Guard fraternized with the people: the troops stood indifferent. The King dismissed the Ministers: he sent for Molé; a shade bet-

ter: not enough: he sent for Thiers—a pause; this was several shades better—still not enough: meanwhile the crowd continued, and attacks on different posts, with slight bloodshed, increased the excitement: finally *the King abdicated* in favor of the Count of Paris, and fled. The Count of Paris was taken by his mother to the Chamber—the people broke in; too late—not enough:—a republic—an appeal to the people. The royal family escaped to all parts, Belgium, Eu, England: *a Provisional Government named.*

You will see how they stand: they have adopted the last measures of Revolution.—News has just come that the National Guard have declared against a Republic, and that a collision is inevitable.

If possible I will write by the next mail, and send you a later paper than the *Herald* by this mail.[38]

We find in this letter much curiosity and excitement but no signs of a genuine political commitment; and Arnold's ambivalent sympathies are well suggested by his fluctuation between "Mob" and "people" as the appropriate label for the class he would later blandly style "the Populace." Arnold does refer to the possibility that revolution may spread to England, but the reference, like the letter itself, is in a tone that is, if not exactly jocular, far from solemn.

But if Arnold described the French upheaval as a bystander rather than a partisan, this did not mean he was perfectly neutral about the issues involved. In the letter he had written to Clough on the eve of the Revolution, he had expressed strongly hostile views toward the bourgeois regime—"I trust in God that feudal industrial class as the French call it, you worship, will be clean trodden under"—although there too he had beaten a quick retreat into mock-seriousness: "Tell Edward I shall be ready to take flight with him the very moment the French land, and have engaged a Hansom to convey us both from the possible scene of carnage."[39]

For the pieties of laissez faire capitalism Arnold had already acquired the contempt that he and Ruskin were later to exhibit in such works as *Culture and Anarchy* and *Unto This Last.* Having noticed in

the *Times* a leading article that severely criticized the new French government for socialistic schemes (in particular, national workshops guaranteeing work for the unemployed) that not only ignored "the laws which . . . govern human wealth and human labour" but went "absolutely contrary to the laws of nature itself,"[40] Arnold impatiently asked Clough:

> —Don't you think the eternal relations between labour and capital the Times twaddles so of have small existence for a *whole society* that has resolved no longer to live by bread alone. What are called the *fair profits* of capital which if it does not realize it will leave it's [*sic*] seat and go elsewhere, have surely no absolute amount, but depend on the view the capitalist takes of the matter. If the rule is—everyone must get all he can—the capitalist understands by *fair profits* such as will enable him to live like a colossal Nob: and Lancashire artisans knowing if they will not let him make these, Yorkshire artisans will, tacent and sweat. But an apostolic capitalist willing to live as an artisan among artisans may surely divide profits on a scale undreamed of Capitalisto nobefacturo. And in a country all whose capitalists were apostolic, the confusion a solitary apostle would make, could not exist.

The *Times* editorialist says that socialistic promises are condemned by "inevitable necessity" to failure. But for Arnold there is no necessity in economic "laws" any more than in other man-made laws and institutions. "If there is necessity anywhere, it is in the Corruption of man. . . ." A week later Arnold went so far in demonstrating his conviction on this question as to tell rioters in Trafalgar Square that the true object of their rage was not royalty but economic and social oppression: "I have been a constant attender on the emeutes here—endeavouring to impress on the mob that not royalty but aristocracy—primogeniture—large land and mill owners were their true enemies here."[41]

In nearly all of Arnold's letters of this spring about the new repub-

lic in France, we can find expressions of approval and even of qualified enthusiasm for the idea of a social, and almost socialistic,[42] democracy. He calls the French common people the vanguard of Europe because, unlike their English counterparts, they are capable of being moved by ideas rather than by mere appeals to selfish interest. The secret of France's power was that in France ideas and intelligence were the properties not of a class but of a whole people. The French, he tells his mother, have become "the most civilised of European peoples" because they at least proclaim an ideal of citizenship and consciously aspire to reach it. Nor was Arnold oblivious of the fact that the man who articulated the ideals of the Second Republic was the poet who had become minister for foreign affairs, Alphonse de Lamartine. "My man [Ld. Lansdowne] remarks that Poets should hold up their heads now a Poet is at the head of France."[43]

Still, Arnold knew that Lamartine had already more or less abandoned poetry for politics, and become "more clergyman than Poet." His awareness of the fact (and of the prominence of windy orators and journalists in the new government) can hardly have failed to influence his thoughts about the relation between the momentous events abroad that threatened to spread their influence to England and his own poetic vocation. After all was said and done, the value of the French movement was "always not absolute but relative" and was therefore best expressed in poetry rather than in socialist tracts that substituted for the pretended absolutes of the *Times* another set of absolutes, equally timebound: "I prefer to read their relative not their absolute literature. Which last is tiresome . . . Seditious songs have nourished the F[renc]h people much more than the Socialist: philosophers. . . . "[44]

It was literature alone that enabled one to understand the Revolution and also to grasp its spiritual limitations. Arnold is at this time much impressed by Carlyle's *Examiner* article of March 4 on Louis Philippe just because it is not journalism or philosophy, but poetry: ". . . How solemn, how deeply *restful* it strikes on one amidst the heat and vain words that are everywhere just now—Yet the thoughts extracted and abstractedly stated, are every newspaper's: it is the style

and feeling by which the beloved man appears. Apply this, Infidel, to the Oriental Poem."[45]

The "Oriental Poem" to which Arnold directed Clough's attention was the *Bhagavad Gita*. From it Arnold was learning, or rather trying to learn ("the Oriental wisdom, God grant it were mine") the secret of survival in, without escape from, the world of social and political action: "The Indians," he told Clough on March 4, "distinguish between . . . abandoning practice, and abandoning the fruits of action and all respect thereto. This last is a supreme step. . . . "[46] That Arnold was already attempting to put into practice this distinction between being in the world and being of it is evident from a letter he wrote to his mother three days later. In one sentence he praises Carlyle's article because "he alone puts aside the din and whirl and brutality which envelop a movement of the masses, to fix his thoughts on its ideal invisible character." In the very next sentence he reports that "I was in the great mob in Trafalgar Square yesterday, whereof the papers will instruct you."[47]

Unlike Ruskin, who was also deeply moved by the cataclysms of 1848, Arnold at once began to cast about for the means of survival in what looked like a period of storm. Ruskin, in *The Seven Lamps*, urged architects to flee the modern city because "there is that in their miserable walls which bricks up to death men's imaginations." He told them to escape the supposed obligations of citizenship by going into the hills, and reminded them that "there was something in the old power of architecture, which it had from the recluse more than from the citizen."[48] Entire withdrawal from the physical scenes of human misery into mountains or monasteries became, and was always to remain, Ruskin's imagined alternative to immediacy of involvement in the plight of his fellow men. Arnold also saw that the artist's vocation and happiness were threatened by the universal din and whirl and brutality, and by the life of the modern city where most men "their lives to some unmeaning taskwork give, / Dreaming of nought beyond their prison-wall."[49] But Arnold believed that the integrity of his vocation hinged not on physical withdrawal but on a spiritual detachment that would preserve the wholeness of his being.

We recall how, as early as 1845, Arnold had spoken of the danger that the popular writer might "lose his self-knowledge, and talk of his usefulness and imagine himself a Reformer." Arnold, intensely curious about the political events of 1848 but shortly to publish his first volume of poetry, was determined to resist this danger. "Certainly," he tells Clough in March 1848, "the present spectacle in France is a fine one: mostly so indeed to the historical swift-kindling man, who is not over-haunted by the pale thought, that, after all man's shiftings of posture, restat vivere. Even to such a man revolutions and bodily illnesses are fine anodynes when he is agent or patient therein: but when is a spectator only, their kind effect is transitory."[50] Now and throughout his life Arnold looks upon those who spiritually immerse themselves in revolutions as persons seeking to escape from self-knowledge and from the real, inward struggle of life through the distraction of action for its own sake. On 10 March he admitted to his mother that "I was myself tempted to attempt some political writing the other day, but in the watches of the night I seemed to feel that in that direction I had some enthusiasm of the head perhaps, but no profound stirring. So I desisted. . . . "[51] Arnold's reluctance to become either a full-time student or a wholehearted partisan of the revolution arose not so much from objection to any particular aspect of the revolution as from his conviction of the limitations of political action and of its tendency to distract men from their proper study and Arnold from his proper vocation.

Despite the admirable qualities of the French, the intelligence of their masses and the promise held out by their reforms, Arnold could not bring himself to say "that these people in France have much dreamed of the deepest wants of man, or are likely to enlighten the world much on the subject."[52] The truth of the human condition, he still believed, was to be sought through poetry. It was, in fact, in this very month of March 1848 that Arnold addressed to Clough a pair of poems, entitled "To a Republican Friend," in which he tried to distinguish the desirable reforms that might be encompassed by revolution from the wild expectations that it could transform the human condition in a moment, in the twinkling of an eye.

It is a pity, though it tells us something of the relationship that existed between Arnold and Clough, that only one of all Clough's letters to Arnold has been preserved. But we may infer from Arnold's letters of this time that Clough's enthusiasm for the Revolution was immeasurably greater than his own. Clough's admission of 10 March 1848 that "If it were not for all these blessed revolutions, I should sink into hopeless lethargy"[53] provides a choice illustration of Arnold's contention that writers often commit themselves to action as an escape from self-knowledge and confuse their own desire for psychic anodynes with a desire to change the world. In the first of his poems to his Republican friend, Arnold expresses sympathy with Clough's ideals and those of the French Revolution, if they do indeed comprise a love of fundamental human virtues, a loathing of the optimistic sophistries of those who are well-off, and a desire to help "the armies of the homeless and unfed." But in the second poem Arnold warns against a too sanguine expectation of what revolutions can achieve. He is moved more to patience than to optimism when

> Seeing this vale, this earth, whereon we dream,
> Is on all sides o'ershadowed by the high
> Uno'erleaped Mountains of Necessity,
> Sparing us narrower margin than we deem.
>
> Nor will that day dawn at a human nod,
> When, bursting through the network superposed
> By selfish occupation—plot and plan,
>
> Lust, avarice, envy—liberated man,
> All difference with his fellow-mortal closed,
> Shall be left standing face to face with God.
>
> ("To a Republican Friend: Continued," 5–14)

Louis Bonnerot has found in this poem an expression of Arnold's disbelief in the power of man to suppress social injustice and misery.[54] But Arnold is only saying that danger lurks in the belief that the millennium lies ready to hand and that revolution is the way to

reach it. We may say that he is already approaching the position of Edmund Burke, provided we are willing to recognize that Burke favored reform but opposed revolution because "it is with infinite caution that any man ought to venture upon pulling down an edifice, which has answered in any tolerable degree for ages the common purposes of society, or on building it up again, without having models and patterns of approved utility before his eyes."[55]

The debate between Arnold and Clough over the measure of devotion that the French Revolution of 1848 merited was but one aspect of a wider debate between the two men in 1848 over the nature of the poet. For the greater one's belief in the efficacy of revolution, the less would be his conviction in the integrity and autonomy of poetry; the stronger his faith in political action, the weaker would be his attachment to the vocation of poetry. Lionel Trilling long ago pointed to the apparent paradox whereby "Arnold, perhaps the most serious poet of his time, stood among the Chartist crowds and went to Chartist meetings and was impressed by them."[56] But we have already seen how aware Arnold was of the inherent conflict between social or political involvements and the calling of the poet; and even in 1848, as he stood amidst rioters and contemplated revolutions, his letters to Clough expressed his determination to keep his aesthetics pure.

In these letters Arnold indulges freely in criticism of those shortcomings in Clough's poetry and even in Clough's life that are attributable to his incapacity for detachment from "the world." Yet the world continued to sound in Arnold's own ears, and it is at least arguable that his creed of detachment becomes more strident as he sees even his own rather modest expectations of reform shattered. On 10 April he witnessed the death of Chartism. Later, on 24 June, civil war (almost, indeed, class war) raged for three days in Paris, during which time many were killed, 15,000 were arrested, and 4,000 deported. Republican France was now dead in all but name, and Arnold's reaction to the catastrophe was hardly stoical: "What a nice state of things in France. The New Gospel is adjourned for this bout. If one had ever hoped any thing from such a set of d----d grimacing

liars as their prophets one would be very sick just now. I returned and saw under the sun etc.—but time and chance happeneth unto all." When current events do not go as one wishes them to, the desire to view them only *sub specie aeternitatis* is nearly invincible; and we may be sure that Clough's best interests are not the exclusive concern of Arnold when he surrounds this lament for republicanism with an injunction to his friend to find a vocation, and a warning that poetry is not morality, religion, or rhetoric, that "the Muse willingly *accompanies* life but . . . in no wise does she understand to *guide* it." In a slightly later letter to his friend Arnold refers, albeit cryptically, to the political troubles in the Danube valley during the earlier part of the year, then guiltily chides both his friend and himself for their vain interest in contemporary events by noting that "the difference between Herodotus and Sophocles is that the former sought all over the world's surface for that interest the latter found within man."[57]

Arnold, then, like Ruskin in 1848, vacillated between a creed of artistic autonomy on the one hand and a desire to respond in some morally and socially adequate way to the political turmoil of the moment. Like Ruskin he wanted to believe that art is a liberal activity that can nevertheless pass the test of social utility. His struggle to discover at this period what Robert Stange has called "a balance between involvement and removal" or "the razor-edge of sympathetic detachment"[58] is evident in the poems he wrote in 1848 about the vocation of the poet and the nature of poetry. In these we see Arnold trying to distinguish, as he does in the letters to Clough, between poetry and rhetoric, between making something and merely thinking aloud; and we also see him trying to define the right relationship between the poet and society. But in studying these poems we must remember that for Arnold as for Ruskin the rules of art were but specialized versions of the rules of life, and research into either was expected to yield wisdom about both.

The letter cited above, in which Arnold scolds himself and his friend for attending to current political struggles in Europe instead of following Sophocles' example and remembering that the proper study of mankind is man, contains the first draft of a three-line tribute

to Epictetus that Arnold was in August or September incorporating into the poem entitled "To a Friend." The poem, almost certainly (like the pair on the French Revolution of 1848) addressed to Clough, begins with the clearest admission we have from Arnold that the political turmoil of 1848 had shaken more than his political convictions, and that he, like Ruskin, had been forced by the recent events to reconsider the nature of his vocation:

Who prop, thou ask'st, in these bad days, my mind?

Arnold proceeds to enumerate his chief "props" as Homer the blind prophet, Epictetus the Stoic philosopher, and Sophocles,

> . . . whose even-balanced soul,
> From first youth tested up to extreme old age,
> Business could not make dull, nor passion wild;
>
> Who saw life steadily, and saw it whole. . . .
> (9–12)

Already, at age twenty-six, Arnold saw the task of life as the attainment of a middle way between the existence of the slave oppressed by law and the madman indifferent to it. Clough, whom Arnold was now calling "a great social fanatic,"[59] and others who jumped precipitately into social and political affairs jeopardized not only their poetic integrity of vision but the balance of their souls.

Arnold is nothing if not complex, and we would gravely misinterpret "To a Friend" if we supposed that it counseled withdrawal from the world. Avoidance of "business" did not, in Arnold's view, necessarily save a man from "dullness," though it was more likely to expose him to the wildness of passion. That is why his letters of 1848 so often insist upon the importance of an occupation for the poet:

My dear Love
 "By our own spirits etc etc."
 I desire you should have some occupation—I think it desirable for everyone—very much so for you. Besides since

the Baconian era wisdom is not found in deserts: and you again especially need the world and yet will not be absorbed by any quantity of it.[60]

Dr. Arnold had once remarked of Coleridge that "his mind was a little diseased by the want of a profession, and the consequent unsteadiness of his mind and purposes."[61] Dr. Arnold's son is now recalling how the question of the poet's occupation and his survival also weighed upon the consciousness of Coleridge's friend Wordsworth. The first line of this letter to Clough comes from another poem written in the aftermath of a revolution, Wordsworth's "Resolution and Independence." The poet, contemplating the unhappy fate of Chatterton and of Burns, was asking how poets manage to survive; and the line that Arnold quotes for Clough's edification comes from the following stanza:

> I thought of Chatterton, the marvellous Boy,
> The sleepless Soul that perish'd in its pride;
> Of Him who walk'd in glory and in joy
> Behind his plough, upon the mountain-side:
> By our own spirits are we deified;
> We Poets in our youth begin in gladness;
> But thereof come in the end despondency and madness.
>
> (43–49)

Wordsworth wrote this poem in 1802, not long before his marriage to Mary Hutchinson. He was becoming aware of new responsibilities in life and fearful that someone like himself who had thus far "liv'd in pleasant thought, / As if life's business were a summer mood," was unfitted to meet them. Poets, he knew, could be particularly cursed as well as particularly blessed. "A young poet," as Wordsworth himself described the action of his poem, "in the midst of the happiness of nature is described as overwhelmed by the thoughts of the miserable reverses which have befallen the happiest of men, *viz.* poets."[62] Arnold, though his letter offers advice to Clough, is drawing upon Wordsworth's experience to map out his own path as a poet

and a man; and his allusion to "Resolution and Independence" as well as the celebration of the "even-balanced soul" in "To a Friend" make it clear that he saw the alternative to the poet's right definition of his calling as nothing less terrifying than madness.

Like Ruskin in *The Seven Lamps*, Arnold allowed his own obsession with defining his occupation to lead him, in a time of revolutionary turmoil, to recommend a steady occupation as a means of bringing a balance and an order into men's lives. This personal order could save one from submersion in the chaos of the social world because it was a version of, though not identical to, the order of nature itself. We have already seen how, in the final chapter of *The Seven Lamps*, Ruskin proposes the law of work as the alternative to the phantom of liberty. But if we go back to examine the argument by which Ruskin there justifies the elevation of law and obedience at the expense of liberty, we can see how similar was the pattern of association of the ideas of nature, law, and work in the minds of Arnold and Ruskin in 1848.

In Ruskin and Arnold's time, the idea or the myth of nature was widely used, in very much the way that "social science" is used today, to cover the nakedness of partisan commitments with what Max Weber has called "protective authority." Having repeatedly invoked the principle of Organic Form to test architecture, Ruskin in the concluding section of *The Seven Lamps* tested the modern fiction of liberty by asking whether it existed in nature; and of course he discovered that it did not: "There is no such thing in the universe. There can never be. The stars have it not; the earth has it not; the sea has it not. . . . " Indeed, the lesson that the whole visible creation proclaims is "not Liberty, but Law." Ruskin, in this turbulent period, tried to sanction his own search for an ordered and balanced course by seeing in it an aspiration toward the condition of nature:

. . . Though restraint, utter and unrelaxing, can never be comely, this is not because it is in itself an evil, but only because, when too great, it overpowers the nature of the thing restrained, and so counteracts the other laws of which that

nature is itself composed. And the balance wherein consists
the fairness of creation is between the laws of life and being
in the things governed, and the laws of general sway to
which they are subjected. . . . [63]

The idea of an ordered nature as the support of the balanced soul,
and the invocation of both to buttress the ideal of work, also provide
the basis for two poems that Arnold wrote in 1848, "Religious Isola-
tion" and "Quiet Work." The former, written in July or August "To
the Same Friend," was another adjuration to Clough, whom Arnold
always considered "too content to *fluctuate*,"[64] to act on his convic-
tions and to choose an occupation. As Ruskin, while affirming the
supremacy of law in the universe, distinguished between the laws gov-
erning individual life and the laws of "general sway," so Arnold
could say:

> What though the holy secret, which moulds thee,
> Mould not the solid earth? though never winds
> Have whispered it to the complaining sea,
>
> Nature's great law, and law of all men's minds?—
> To its own impulse every creature stirs;
> Live by thy light, and earth will live by hers!
>
> (9–14)

"Quiet Work," the first poem in the 1849 volume (*The Strayed
Reveller*) and in most subsequent editions of Arnold's poems, begins
with an invocation of nature:"One lesson, Nature, let me learn of
thee. . . . " The workings of nature offer to the poet a model of two
duties, often supposed antithetical, being harmoniously fulfilled:

> Of toil unsevered from tranquillity!
> Of labour, that in lasting fruit outgrows
> Ear noisier schemes, accomplished in repose,
> Too great for haste, too high for rivalry!
>
> (5–8)

Arnold had in June of 1848 sought refuge from his disappointment at the failure of republicanism in France in the recitation of Ecclesiastes' dictum—"I returned and saw under the sun etc."—and now he looked to nature and specifically, like Ruskin, to the ordered course of the stars for a paradigm of human work that was detached from, yet a response to, the turmoil of revolutionary politics:

> Yes, while on earth a thousand discords ring,
> Man's fitful uproar mingling with his toil,
> Still do thy sleepless ministers move on,
> Their glorious tasks in silence perfecting;
> Still working, blaming still our vain turmoil,
> Labourers that shall not fail, when man is gone.
> (9–14)

I have so far restricted myself to discussion of those poems that were almost certainly composed by Arnold in 1848, but it would be wrong to conclude the discussion of Arnold's idea of his vocation during his formative years without an examination of the most detailed treatment of the idea of poetry published in the 1849 volume, "Resignation: To Fausta." This is more especially the case when we are trying to compare Arnold's development with Ruskin's, for "Resignation" shows more clearly than any other poem of this period not only where Arnold's reactions to the events of 1848 corresponded to Ruskin's but where they went beyond his. "Resignation," in addition to being an exploration of the poet's function, is a search for the means of preserving one's soul intact in the midst of a world infected by evil.

The poem may have been begun, according to Kenneth Allott, as early as 1843, but it probably was not completed until 1848, and Arnold placed it at the end of the volume. He may have done so to call attention to the fact that the poem purports to resolve questions about the poetic calling that are raised but not settled in poems that appear before it in the volume, such as "The New Sirens" and "The Strayed Reveller." These poems define two types of poet with two different kinds of relationship to experience, suggest the rewards and the costs of both kinds of poetry, and choose neither; "Resignation," on the

other hand, is a clear affirmation of the spiritual condition Arnold now holds to be essential both to poetic achievement and human endurance.

The thematic center of the poem is a debate between the speaker, presumably Arnold as poet, and Fausta, or Arnold's elder sister, Jane (although it must be noted that Fausta herself does not actually speak, but has her thoughts "scanned" by the speaker himself). The subject of the debate is exactly that which had begun to prey on the minds of Arnold and Ruskin in 1848: to what extent, if any, and in what way, may the artist detach himself from society and the common cares of ordinary men?

Although the choice between the life of imaginative sympathy and the life of imaginative detachment is the chief one to be made in the poem, two other alternatives—which may be seen as the plausible alternatives exaggerated into extremes—are briefly sketched and as quickly rejected. These are what in "To a Friend" Arnold has called wildness and dullness and what in a later poem he will call the life of the madman and that of the slave. On the one extreme stand the devotees of unthinking action, the true believers who are troubled by no doubts or perplexities. Like those sanguine believers in revolution whom Arnold chastised in "To a Republican Friend," these pilgrims, warriors, Goths, and Huns "to themselves propose / On this side the all-common close / A goal which, gain'd, may give repose" (15–17). At the opposite extreme within the boundaries of the poem stand the gypsies, who are exaggerations of the speaker's stoicism as the militant fanatics are exaggerations of Fausta's activism. Far from supposing that violent action in this world can transform the human condition, as do the militants, they lack altogether the historical sense that would make them violent with dissatisfaction over their miserable state that grows worse with the years and with the increasing harshness of the laws against trespassing.

Having shown his awareness that resignation, like all things that are potentially good, can be carried to bad extremes, the speaker of the poem is free to expound the true ideal of resignation toward which the poet should aspire. This ideally resigned poet has *not* with-

drawn from the activities and burdens of the world; in fact, the code
of resignation permits him to move mountains, to rule "on the proud
heights of sway," to loose "a thousand chains," and to bear "immor-
tal pains." Only his true life must lie elsewhere:

> Action and suffering though he know—
> He hath not lived, if he lives so.
>
> (152–53)

Attempting to explain this paradox—if indeed it can be explained—
Arnold ticks off some of the temptations that the poet must know yet
to which he must not succumb. There is, for example, political power.
Perhaps with the sorry example of Lamartine in mind, Arnold repeats
in verse the warning he had uttered some years earlier to Clough
against the poet fancying himself a reformer:

> He sees, in some great-historied land,
> A ruler of the people stand,
> Sees his strong thought in fiery flood
> Roll through the heaving multitude;
> Exults—yet for no moment's space
> Envies the all-regarded place.
>
> (154–59)

The resigned poet resists too the temptations offered by human life in
love and in domesticity; and he does not feel excluded from these
pleasures because he does not crave them. Looking as from a height
on the various activities of mankind, he sees them melt into a distant
vision of the long process of the ages. He sees past and future as well
as present; and all merge into "one general life, which does not cease,
/ Whose secret is not joy, but peace."

Kenneth Allott has argued that in viewing the life of nature as one
of resigned acceptance of eternal change Arnold "is here separating
himself from the Wordsworthian view . . . of the joy offered in na-
ture."[65] But this is to assume that for Wordsworth nature always epit-
omizes joy and emotion and not what Arnold calls

That life, whose dumb wish is not missed
If birth proceeds, if things subsist;
The life of plants, and stones, and rain. . . .

 (193–95)

In fact, in the very poem that Arnold recommended to Clough in August 1848 as a primer for young poets, "Resolution and Independence," Wordsworth had used this image of unfeeling nature as the symbol of that resistance to excessive feeling which poets need to acquire if they are to endure. The providential message sent to Wordsworth arrives via an old leech-gatherer, who is compared in the poem to that most unfeeling and joyless thing in nature, "a huge Stone." Naturally, the first question that occurs to the poet, who has been musing on the sad fate of earlier poets, is: "what kind of work is that which you pursue?" The occupation of leech-gathering is represented as a kind of dutiful submission to that law of nature whose secret, in Arnoldian terms, is not joy but peace, not passion but just as certainly not the madness of "mighty Poets in their misery dead."

Lionel Trilling has pointed out[66] that what Arnold admired in Wordsworth was just this celebration of the moral dignity that derives from stoical courage and unfeelingness, and is linked not with joyous nature but with the Lucy who "neither hears nor sees, / Roll'd round in earth's diurnal course / With rocks and stones and trees!"[67] Arnold recommended "Resolution and Independence" to Clough because he wanted his friend to learn from Wordsworth's leech-gatherer that men in general, and poets in particular, cannot endure with their sensibility wholly exposed. As Wordsworth, tired by an unchartered freedom, gained resolution by seeing in his mind's eye the leech-gatherer pacing "About the weary moors continually, / Wandering about alone and silently," so Arnold now visualized his ideal poet not exactly as a gypsy but as deriving some comfort from the gypsy's submission to the law of things in the quotidian life of nature.

But Fausta, who apparently speaks for that romantic tradition which Arnold is gradually discarding, and which stressed the poet's liberty from restraint, is offended by this link between the poet's resig-

nation to natural law and the gypsy's submission to deadening routine:

> *Those gipsies*, so your thoughts I scan,
> *Are less, the poet more, than man.*
> *They feel not, though they move and see.* . . .
>
> (203–5)

The poet, she insists (or is imagined to insist), is characterized by his liberty from the "iron round" that binds other men and by his superiority to the common life of men.

The speaker does not so much reject Fausta's notion as he qualifies it. Unlike the subjective or Coleridgean type of poet, the speaker recognizes that the external world does not depend for its existence upon human emotions or the poet's creative powers: "This world in which we draw our breath, / In some sense, Fausta, outlasts death" (229–30). Even the grandest of human wishes are therefore tainted with vanity. The ideal poet achieves his security by virtue of a "natural insight" that can discern what others, including both the speaker (Arnold) and Fausta, must, alas, learn through experience: the meaning of spiritual self-sufficiency.

> . . . though fate grudge to thee and me
> The poet's rapt security,
> Yet they, believe me, who await
> No gifts from chance, have conquered fate.
> They, winning room to see and hear,
> And to men's business not too near,
> Through clouds of individual strife
> Draw homeward to the general life.
>
> (245–52)

"To men's business not too near" is for Arnold a counsel not of withdrawal from the common life but of spiritual independence from its risks, which comprise both dullness and wildness. This section of the poem concludes with an injunction to view life and one's own calling

in it under the aspect of eternity and as part of an ordered universe.
Those who ignore the demands of the present, or rather who attach
to them only their limited importance—Arnold may already be antici-
pating the hostile reaction to his uncontemporary and "irrelevant"
poetry—are

> Like leaves by suns not yet uncurled;
> To the wise, foolish; to the world,
> Weak; yet not weak, I might reply,
> Not foolish, Fausta, in His eye,
> To whom each moment in its race,
> Crowd as we will its neutral space,
> Is but a quiet watershed
> Whence, equally, the seas of life and death are fed.
>
> (253–60)

Arnold began "Resignation" when he was twenty-one, and con-
cluded it at twenty-six. Both his circumstances and the lines just quoted
suggest that in defining his vocation in a time of social and political
turmoil he was thinking not only of Wordsworth but of Milton, who
at age twenty-three could lament that "My hasting days fly on with
full career, / But my late spring no bud or blossom shew'th," and
nevertheless express confidence that he would inevitably attain "that
same lot, however mean, or high, / Toward which Time leads me,
and the will of Heav'n; / All is, if I have grace to use it so, / As ever
in my great task-Master's eye."[68] Arnold, fearful of the shortsighted-
ness that was the penalty of obsession with the contemporary, fearful
of having his work and his life enlisted in transient endeavors, sought
like Ruskin to align himself with an order both natural and divine,
natural *because* divine, that was above politics and society.

The concluding paragraph of "Resignation," like the final chap-
ter of *The Seven Lamps of Architecture*, is a justification of the writ-
er's work as an instance and an assertion of the natural principle of
order and obedience in the universe that the modern love of change
and of action both ignores and denies. "We may observe," wrote Rus-
kin in "The Lamp of Obedience," "that exactly in proportion to the

majesty of things in the scale of being, is the completeness of their obedience to the laws that are set over them. Gravitation is less quietly, less instantly obeyed by a grain of dust than it is by the sun and moon; and the ocean falls and flows under influences which the lake and river do not recognize. So also in estimating the dignity of any action or occupation of men, there is perhaps no better test than the question 'are its laws strait?' "[69] For Arnold as for Ruskin the ultimate evil was still man's violation of the natural order that guided the movements and actions not only of lifeless things but of man himself insofar as he approached the condition of unthinking and inanimate things; and no amount of liberty or of revolutionary action could remove that evil. Invoking once more the image of a nature that seems to bear rather than rejoice, rebuking once more man's "intemperate prayer/ . . . For movement, for an ampler sphere," Arnold concludes the poem with the earliest of many warnings he was to give throughout his career, even at times when he was least withdrawn, least stoical, that action may be an escape from, rather than an alleviation of, the human condition:

> Not milder is the general lot
> Because our spirits have forgot,
> In action's dizzying eddy whirled,
> The something that infects the world.
>
> (275–78)

*Of all decades in our history, a wise man
would choose the eighteen-fifties to be young
in.*—G. M. Young, *Victorian England: Portrait
of an Age*

*Ah, love, let us be true
To one another! for the world, which seems
To lie before us like a land of dreams,
So various, so beautiful, so new,
Hath really neither joy, nor love, nor light,
Nor certitude, nor peace, nor help for pain;
And we are here as on a darkling plain
Swept with confused alarms of struggle and flight,
Where ignorant armies clash by night.*

<div align="right">

Matthew Arnold, "Dover Beach" (1851)

</div>

*The more I watch the world, the more I feel that all men are blind and
wandering. I am more indulgent to their sins, but more hopeless. I feel
that braying in a mortar with a pestle will not make the foolishness
depart out of the world. . . .*—John Ruskin, letter of 9 January 1852

chapter three

Past and Present

If the minds of poets and artists were wholly and simply determined by their social and historical circumstances, then we could assume that the doubts and distractions that beset Arnold and Ruskin as they pursued their respective callings in the turbulent forties would have subsided in the fifties. For the new decade was characterized, both in the eyes of contemporary observers like Bagehot and recent historians like Asa Briggs, by an atmosphere of optimism based upon prosperity, national security, trust in institutions, belief in a common moral code, and in free discussion and inquiry. W. L. Burn has, to be sure, warned against "playing the game of selective Victorianism" in describing this period, and has given evidence of a darker side to the picture of quiet contentment often painted; but he too asserts that by the fifties, "the fabric of society . . . could be taken for granted."[1] Yet in the early fifties we find Arnold and Ruskin not only less certain than ever before of the rightness of their calling but firmly opposed to the dominant tendencies of the age, determined to swim against the stream even when they are not quite sure which direction the stream is taking.

We have already explored the reasons why, in the late forties, Arnold and Ruskin felt the need to detach themselves from what seemed to be the demands of their historical moment; and they were fully aware of the price that might have to be paid for such detachment. Late in 1848 Arnold could write to Clough: "I have been at Oxford the last two days and hearing Sellar and the rest of that clique who know neither life nor themselves rave about your poem gave me a strong almost bitter feeling with respect to them, the age, the poem, even you. Yes I said to myself something tells me I can, if need be, at last dispense with them all, even with him: better that, than be

sucked for an hour even into the Time Stream in which they and he plunge and bellow."[2] Ruskin in 1849 wrote to his friend Henry Cole that he would not succumb to the supposed inevitabilities of the Time Spirit: "There is much truth in what you say respecting the inevitable tendencies of the age; but a man can only write effectively when he writes from his conviction—and may surrender the hope of being a guide to his Age, without thinking himself altogether useless as a Drag."[3]

The changed mood of England in the fifties caused no abatement in the determination of Arnold and Ruskin to resist the blandishments of the *Zeitgeist*. Arnold's mode of resistance took the form of that strategy of withdrawal which he had begun to develop in the forties, whereas Ruskin's resistance began to take the form of direct defiance. Writing to his sister Jane in January 1851, Arnold (still in the employ of Lord Lansdowne) expressed his determination to "retire more and more from the modern world and modern literature, which is all only what has been before and what will be again, and not bracing or edifying in the least. I have not looked at the newspapers for months, and when I hear of some new dispute or rage that has arisen, it sounds quite historical. . . . "[4] Ruskin, commenting later in the same year on the great popular enthusiasm for the Hungarian patriot Kossuth, on the new openness with which "Communism" is being avowed, and on the terrible abuses in government that justify lower-class political movements, wonders whether his feeling is humanitarian or merely contentious: "However, I must mind and not get too sympathising with the Radicals. Effie says with some justice that I am a great conservative in France, because there everybody is radical, and a great radical in Austria, because there everybody is conservative. I suppose that one reason why I am so fond of fish . . . is that they always swim with their heads against the stream. I find it for me the healthiest position."[5] The oppositional spirit that animated Arnold and Ruskin in the beginning of the new decade was one of hostility not mainly to the status quo, or to reform, but to modernity itself. If in 1848 they refused to become fashionable Jeremiahs devoting themselves full time to denunciation of a corrupt civilization, so

now they refused to become fashionable Pollyannas. To fathom the depth of their conviction we need to look at the particular personal circumstances out of which, to some extent, the conviction grew.

The political excitement that Arnold had felt in the spring of 1848 had by 1849 been replaced by a studied skepticism about political action and the emotions it inspires. Arnold now finds the great people of the aristocratic world to which as Lord Lansdowne's secretary he had access both stupid and hard-hearted, but he trains himself to pity instead of hating these people because "I do not think any fruitful revolution can come in my time; and meanwhile, thank God, there are many honest people on earth, and the month of May comes every year."[6] The young man who a year earlier had harangued mobs in Trafalgar Square now tries to avoid all newspapers and talk of current events. In September he asks Clough:

> Why the devil do I read about Ld. Grey's sending convicts to the Cape, and excite myself thereby, when I can thereby produce no possible good. But public opinion consists in a multitude of such excitements. Thou fool—that which is morally worthless remains so, and undesired by Heaven, whatever results flow from it. And which of the units which has felt the excitement caused by reading of Lord Grey's conduct has been made one iota a better man thereby, or can honestly call his excitement a *moral* feeling.[7]

Getting clear of the temptation of political commitment did not, however, mean that Arnold was comfortably settled into the poetic vocation. In fact, he continued to be afflicted by doubt as to whether his age afforded the right conditions for the creation of poetry. In the very month (February 1849) that *The Strayed Reveller* appeared he urged Clough to "reflect . . . how deeply *unpoetical* the age and all one's surroundings are." In the following month he thought himself getting "quite indifferent about the book" and gave away his only copy. His friends urged him to speak in his poems more from himself, which however he had "less and less . . . the inclination to do: or even the power." He was gladdened as well as irritated by complaints

in *Fraser's Magazine* for May 1849 that the subjects of his poems were uninteresting; for "as I feel rather as a reformer in poetical matters, I am glad of this opposition. If I have health & opportunity to go on, I will shake the present methods until they go down. . . . " But he knew, as he was later to write in "The Function of Criticism at the Present Time," that "for the creation of a master-work of literature two powers must concur, the power of the man and the power of the moment"; and he suspected that his own historical moment was not the right one: "My dearest Clough these are damned times—everything is against one—the height to which knowledge is come, the spread of luxury, our physical enervation, the absence of great *natures*, the unavoidable contact with millions of small ones, newspapers, cities, light profligate friends, moral desperadoes like Carlyle. . . . " A few weeks later, he told Clough he was thinking of doing voluntarily what his father had thought of forcing him to do ten years earlier: emigrating to Van Diemen's Land.[8]

The year 1849 was a time of Arnold's deepest involvement with, and also, in September, his final parting from, the French girl "Marguerite," whom he had met in Switzerland the year before. The "Switzerland" poems, composed for the most part in September, described not so much the love affair as the proof that its failure gave to Arnold of his coldness, of his isolation, of the imminent passing of his youth, and of his need for an ordered course of existence in the world. These discoveries about himself could not but affect Arnold's sense of his poetic vocation, for always his inquiries into the nature of poetry were also inquiries into the nature of life. More than ever before, as we have seen from his letters of this period, Arnold was convinced of the dismal, unpoetical quality of the world. But he had now discovered for himself what he had earlier preached to Clough: that "since the Baconian era wisdom is not found in desarts"—nor, he might have added, in Swiss mountains—and that "you should have some occupation . . . and you . . . need the world."[9]

Toward the end of the year Arnold composed a number of poems that tried to apply his new, if distressing, self-knowledge to the solution of his long-standing problem of the relation between his voca-

tion as poet and his role in the world. The longest of the group is "Stanzas in Memory of the Author of 'Obermann,' " begun in September and completed in November. Arnold had been attracted to Senancour, the author of *Obermann*, because he had had all his hopes destroyed by "the fiery storm of the French Revolution"—not, of course, the one that had so agitated Arnold the year before, but the "original" one of 1789—and in the wake of that destruction, tried from the perspective of a nearly perfect spiritual isolation, to see the world as it really was, to see it, as Arnold wrote two years later, "in its true *blankness*, and *barrenness*, and *unpoetrylessness*."[10]

In the poem that troubled outside world which we have seen Arnold trying to eject from his daily awareness at this time appears once again. Neither Wordsworth nor Goethe, the other great seers of modern times, can have quite the immediacy for Arnold that Senancour does because "Wordsworth's eyes avert their ken / From half of human fate" and Goethe's youth (though not his manhood) was spent in a tranquil world. Arnold's generation, "brought forth and reared in hours / Of change, alarm, surprise," is more readily drawn to Senancour, who despite, or perhaps because of, his chilled feeling and icy despair, saw clearly the "hopeless tangle of our age."

Arnold now goes on to expand a paradox previously urged in "Resignation." Here as in the earlier poem we are told that the poet can see the world more clearly and fully as a detached spectator than as a committed participant; but here we are also told that only in solitude and isolation from the world can joy—the "glow" and "thrill" of life—be found; or rather, for Arnold states only the negative case, it is certain that joy is not to be found in the world or among men.

> Ah! two desires toss about
> The poet's feverish blood.
> One drives him to the world without,
> And one to solitude.
>
> *The glow*, he cries, *the thrill of life*,
> *Where, where do these abound?*
> Not in the world, not in the strife
> Of men, shall they be found.

He who hath watched, not shared, the strife,
Knows how the day hath gone.

(93–102)

Arnold therefore expresses the wish to join Senancour in his icy mountain solitude. But after several stanzas of imaginative ascent toward Senancour, Arnold suddenly dismisses the prospect of escape from the world into a (rather Tennysonian) realm of aesthetic contemplation as a deceptive dream and succumbs to what his recent experience of failure in love had led him to see as his fate: "I go, fate drives me; but I leave / Half of my life with you."

What this poem tells us of Arnold's life is that although he keeps referring to the compulsion of "Fate" or of "some unknown Power," he entered "the world" imaginatively before the pressure of events —marriage and the need for subsistence—forced him into it. "I in the world must live," he dolefully announces, but the example of Senancour himself—somewhat inconsistently, it must be said—suggests to him the possibility of preserving his soul intact even while functioning in the world. He imagines now a slightly more Christian version of what in March 1848 he had called the Indian distinction "between . . . abandoning practice, and abandoning the fruits of action and all respect thereto."[11] Those who can embrace this Indian virtue of detachment even in the midst of practical life are "the Children of the Second Birth, / Whom the world could not tame"; and whatever their religion or social station or vocation, they are united by this bond, "that all have been / Unspotted by the world." Armed with this determination, Arnold bids "a last farewell" to Obermann; and many have seen in this farewell to youth and emotion and joy a foreshadowing of Arnold's more gradual and less dramatic farewell to poetry.

Before Arnold was literally forced into the world, then, he felt himself fragmented—"my poems are fragments . . . I am fragments"[12]—by opposing impulses, conscious of diverse powers, uncertain of his direction and vocation, yet convinced that for every man there *was* a dominant impulse, a prevailing power, a correct path

and vocation. In "Human Life," probably written toward the end of 1849, Arnold wonders whether any mortal has ever at the conclusion of life been able to tell God without fear of contradiction: "I have kept uninfringed my nature's law; / The inly-written chart thou gavest me, / To guide me, I have steered by to the end" (4–6). Like the early Tennyson who was tempted by the life of luxuriance, rest, lotos-eating, Arnold confesses a desire to evade "too exact a steering" in hopes that he will be "lured" to "some fair coast." We see here that Arnold never really wavered from his father's conviction that for every man there was a special work to do; nor did he doubt that Fate would eventually direct him to *his* special work, for "Man cannot, though he would, live chance's fool." But his sense of what was sacrificed in being committed to a destined work at the expense of a free, open existence was already strong:

> Even so we leave behind,
> As, chartered by some unknown Powers,
> We stem across the sea of life by night,
> The joys which were not for our use designed;
> The friends to whom we had no natural right,
> The homes that were not destined to be ours.
>
> (25–30)

An ordered course may be better than an unchartered freedom, but it is not granted except at a price.

Although he is later to speak of a best self and an ordinary self, or of a buried life and a surface existence, Arnold is at the beginning of the new decade more likely to conceive of a multiplicity of selves and of the near impossibility of knowing consciously which one he was to adopt and become. "Self-Deception" sums up the quandary not only of Arnold but of the new professional middle class of the Victorian period, convinced it had a mission yet not knowing exactly where it lay. Arnold invents a myth according to which men, in a pre-existence, are allowed to outfit themselves with the powers they would like to wield in their earthly existence:

> Long, long since, undowered yet, our spirit
> Roamed, ere birth, the treasuries of God;
> Saw the gifts, the powers it might inherit,
> Asked an outfit for its earthly road.
>
> <div align="right">(5–8)</div>

Man causes some of his own trouble by trying to grasp every gift he sees instead of being prudently selective; but God seems almost to encourage man's confusion:

> . . . alas! he left us each retaining
> Shreds of gifts which he refused in full.
> Still these waste us with their hopeless straining,
> Still the attempt to use them proves them null.
>
> And on earth we wander, groping, reeling;
> Powers stir in us, stir and disappear.
> Ah! and he, who placed our master-feeling,
> Failed to place that master-feeling clear.
>
> <div align="right">(17–24)</div>

Arnold concludes with a cry of desperation, as if he knows not whether he will ever find any vocation or self, much less the right vocation and the right self: "Ah, *some* power exists there, which is ours? /*Some* end is there, we indeed may gain?"

The true complement to "Self-Deception" in the 1852 volume of poems is not "The Buried Life," which offers a more optimistic version of the creation myth, but "Self-Dependence," which purports to answer the questions raised throughout the volume by means of the nature images that had already done service in this effort in the earlier volume. The poem begins with the speaker's expression of disgust with his own dilemma of indecision:

> Weary of myself, and sick of asking
> What I am, and what I ought to be,
> At this vessel's prow I stand, which bears me
> Forwards, forwards, o'er the starlit sea.
>
> <div align="right">(1–4)</div>

He then looks, as he has done since childhood, to the stars for calm
and for guidance. The message that their seemingly lawful and or-
dered course conveys to him may seem curiously anachronistic for
1850, when Tennyson was telling everyone, in *In Memoriam*, how his
faith in any kind of universal order had been undermined by the
well-authenticated rumor that the stars "blindly run," but it is at least
consistent with the message the stars had given to Arnold in "Quiet
Work" (and to Ruskin in "The Lamp of Obedience"):

> In the rustling night-air came the answer:
> "Wouldst thou *be* as these are? *Live* as they.
>
> "Unaffrighted by the silence round them,
> Undistracted by the sights they see,
> These demand not that the things without them
> Yield them love, amusement, sympathy.
>
> "And with joy the stars perform their shining,
> And the sea its long moon-silvered roll;
> For self-poised they live, nor pine with noting
> All the fever of some differing soul.
>
> "Bounded by themselves, and unregardful
> In what state God's other works may be,
> In their own tasks all their powers pouring,
> These attain the mighty life you see."
>
> (15–28)

The stars embody an ordered nature in which is inherent not merely
the peace that seemed to be its "secret" in "Resignation" but even the
true Wordsworthian "joy," a quality that Arnold will soon demand
from literature; and they do so by being free of consciousness, both
of themselves and others, and by living, as Arnold had previously (in
"Religious Isolation") urged Clough to do, by their own light.

The famous concluding stanza of the poem, which in editions
from 1854 to 1881 was separated from the rest of the text by extra
spacing or asterisks, is Arnold's version of Carlyle's message in *Sartor
Resartus*. In that work Carlyle, through the mouth of Professor

Teufelsdröckh, had vowed to reject "the folly of that impossible Pre-
cept, *Know thyself*; till it be translated into this partially possible
one, *Know what thou canst work at*."[13] Arnold now translated this
wisdom into a compelling injunction to himself:

> O air-born voice! long since, severely clear,
> A cry like thine in mine own heart I hear:
> 'Resolve to be thyself; and know that he,
> Who finds himself, loses his misery!'
>
> (29–32)

Arnold's imaginative apprehension of a "Fate" determining his
destiny in disregard of his will, of a Power forcing him to desert the
life of art and emotion for the prison of "the world," went well in ad-
vance of the pressure of actual circumstances in his life. So too did the
imaginative resolution of this dilemma in the form of injunctions to
"be thyself" precede any approach to a resolution in actual life. In one
sense, of course, both the problem and its solution as they are con-
ceived in Arnold's imagination, extend beyond any apparent ana-
logues in his life. But if we are to understand the crisis in Arnold's
life that was leading him toward a decisive turning point in 1853, we
must try to see where and how the realms of imagination and of life
had begun to impinge on each other.

In the sub-poetic world one widely recognized means of bringing
order into a fluctuating existence is to marry; and in June 1851 this is
precisely what Arnold did. He had been courting Frances Lucy
Wightman throughout 1850, until August when Justice Wightman
forbade further communication between his daughter and Arnold
until the young man could offer some guarantee of his ability to sup-
port a wife. Arnold's sources of income were still his secretaryship
(to a man nearing the end of his career) and a fellowship that would
end with his marriage; and we may suppose that the extreme reluc-
tance with which Arnold had committed himself to "the world" was
visible to some others besides himself. By 21 December, however,
Arnold was able to inform Miss Wightman that Lingen, his old tu-

tor at Oxford, was advising him about inspectorships and how to use Lord Lansdowne's influence in obtaining one of them.[14]

By January of the new year, then, Arnold sensed what worldly fate was in store for him, although his appointment as inspector of schools would not come until April and the marriage did not take place until June. In January he wrote to his sister Jane, who had herself been recently married, a moving and revealing acknowledgement of his simultaneous resistance and resignation to his worldly destiny:

> How strong the tendency is, . . . as characters take their bent, and lives their separate course, to submit oneself gradually to the silent influence that attaches us more and more to those whose characters are like ours, and whose lives are running the same way with our own, and that detaches us from everything besides, as if we could only acquire any solidity of shape and power of acting by narrowing and narrowing our sphere, and diminishing the number of affections and interests which continually distract us while young, and hold us unfixed and without energy to mark our place in the world; which we thus succeed in marking only by making it a very confined and joyless one. The aimless and unsettled, but also open and liberal state of our youth we *must* perhaps all leave and take refuge in our morality and character; but with most of us it is a melancholy passage from which we emerge shorn of so many beams that we are almost tempted to quarrel with the law of nature which imposes it on us.[15]

The gloomy predictions of Arnold's poems of 1849-50 were now in process of being fulfilled, and his recognition of the similarity between the fate he had feared and the one that was now being realized led him, out of consideration for the young woman who seemed to be the innocent instrument of that fate, to postpone their publication until 1852.[16] Although Arnold's brother found it "very difficult to fancy the 'Emperor' married," Stanley reported that Arnold was "greatly improved by his marriage—retaining all the genius and no-

bleness of mind . . . with all the lesser faults pruned and softened down."[17] But Arnold knew that his new life could never be more than a mocking reflection of the imaginative order he had sought in his poetry; and one of the best proofs of the disparity between the resolution he had now found in life and that toward which his poetry had been striving is to be found in the famous conclusion to "Dover Beach."

The poem was probably composed in late June 1851, two weeks after Arnold's marriage, although it was not published until 1867. Like many of Arnold's poems, it has the form though not the substance of a dramatic monologue, and insofar as it is permissible to identify poetic characters with actual persons, we may say that the woman addressed by the speaker is Arnold's bride. Viewing the great panorama that is the glory of Dover, including as it does the beach, the cliffs, the sea, and the lights of Calais, the speaker calls his companion to the window to share with him the audible pleasures of the ebb and flow of the tide. Thus far all is well. But he then returns imaginatively, as Arnold was often to do in these years, to a phenomenon of the distant past that affords a prototype of the modern spiritual state:

> Sophocles long ago
> Heard it on the Aegaean, and it brought
> Into his mind the turbid ebb and flow
> Of human misery; we
> Find also in the sound a thought,
> Hearing it by this distant northern sea.
>
> (15–20)

The thought that the movement of the sea suggests to Arnold is that of the retreat of religious faith and its various subsidiary faiths:

> The Sea of Faith
> Was once, too, at the full, and round earth's shore
> Lay like the folds of a bright girdle furled.
> But now I only hear

> Its melancholy, long, withdrawing roar,
> Retreating, to the breath
> Of the night-wind, down the vast edges drear
> And naked shingles of the world.
>
> (21–28)

The beauty and the music of nature have proved to be illusion and discord, just as the Sophocles who in "To a Friend" "saw life steadily, and saw it whole" now hears only sadness and sees in his mind's eye only misery. The comfort Arnold had so often[18] in earlier poems sought in nature is now withdrawn; he deplores, much as in "Stanzas from the Grande Chartreuse," the loss of his religious faith and conceives of the loss as a deprivation of those very qualities that had been ascribed to nature when she had been invoked as a substitute for supernatural sanction:

> Ah, love, let us be true
> To one another! for the world, which seems
> To lie before us like a land of dreams,
> So various, so beautiful, so new,
> Hath really neither joy, nor love, nor light,
> Nor certitude, nor peace, nor help for pain. . . .
>
> (29–34)

Finding himself in a world that lacks not only those qualities he had in many poems celebrated in nature—"neither joy . . . nor peace"—but all other qualities that rest on faith, Arnold turns briefly for consolation to that terrestrial embodiment of an ordered existence, his beloved wife. But he knows that the hope of finding truth in personal relations, in "love," must be vain in a world that destroys the very conditions that could endow love with meaning. If such poems as "Self-Dependence" and "Stanzas in Memory of the Author of 'Obermann' " seem to point ahead to Arnold's resignation to the world, even to his marriage, then "Dover Beach," written so soon after that marriage, expresses his continued resistance to the idea that stoical submission to one's worldly fate can bring peace and even joy.

In the final statement of the poem, which will cease to move us as a description of our own plight only when the joys of Utopia shall have made us indifferent to the trivial pleasures derivable from poetic melancholy, Arnold forgets all notions of consolation and resignation, perceives himself deserted by faith and by nature and stranded in the midst of that troubled modern world he had been trying to flee or to resist since late in 1848. The revolution of 1848 and the siege of Rome by the French in 1849[19] now join in Arnold's consciousness with Thucydides' famous image of the "night-battle" to produce what Dwight Culler has called "the central statement which Arnold makes about the human condition":[20]

> And we are here as on a darkling plain
> Swept with confused alarms of struggle and flight,
> Where ignorant armies clash by night.
>
> (35–37)

In 1851 the loss of religious faith, as "Dover Beach" proclaims, was afflicting others besides Arnold. Tennyson had publicly expressed his quandaries in the previous year, and in the month before Arnold wrote "Dover Beach," John Ruskin was writing to his friend Henry Acland: "You speak of the Flimsiness of your own faith. Mine, which was never strong, is being beaten into mere gold leaf, and flutters in weak rags from the letter of its old forms; but the only letters it can hold by at 'all are the old Evangelical formulae. If only the Geologists would let me alone, I could do very well, but those dreadful Hammers! I hear the clink of them at the end of every cadence of the Bible verses—. . . . "[21]

The causes that undermined Ruskin's religious faith were different from those that disturbed Arnold. Ruskin's faith still rested on the idea of factual and historical accuracy in the Bible, and so he could become wild with impatience at exactly the characteristic of Scripture that Arnold relished: its poetry. The poetry of the prophecies, the mysterious manner of revealing doctrines, tormented him: "I don't want poetry *there*. I want plain truth—and I would give all the poetry in Isaiah and Ezekiel willingly, for one or two clearer dates."[22] Rus-

kin was also able to retain a living belief in the divinity of that "other" book of revelation, the natural world, long after the religious dimensions of Arnold's naturalism had evaporated.

The important link between Ruskin's crisis of religious faith and Arnold's is that Ruskin's religious convictions for a time afforded him the kind of armor against excessive sensibility to the world and its suffering that Arnold sought in stoicism, whether in its Hindu or Christian form. At the beginning of the new decade, Ruskin was as yet not only not a committed social reformer, but took great care to separate himself from those scientific men who had given up all thought of a future life and set their hearts upon efforts to improve this world: "To believe in a future life is for me the only way in which I can enjoy this one, and that not with a semi-belief which would still allow me to be vexed at what occurred to me here, but with such a thorough belief as will no more allow me to be annoyed by earthly misfortunes than I am by grazing my knee when I am climbing an Alp."[23] Ruskin was already fearful of jeopardizing his happiness by staking it on the outcome of his own worldly strivings or on efforts to improve the worldly happiness of others; but unlike Arnold he did not allow this fear to become the very subject of his work, and did not set himself the task of elaborating a stoical code that would allow him to be in the world yet not of it.

While Arnold in 1849 and 1850 was engaged in a subjective exploration of the meaning of his failure in love, Ruskin was in Venice, ignoring his wife, oblivious of his personal failure as a husband, and entirely engrossed in studying the stones of Venice. He began his work on the new book within a few months of publication of *The Seven Lamps* because he felt that, once again, his subject—Venice—was itself rapidly disappearing, and because the present condition of England convinced him that in the stones of Venice lay a necessary lesson for his countrymen. Like the Arnold of 1849-50 he was obsessed with the question of the relation of art to society and of the workman to his work; but his published work, unlike Arnold's poetry, looked outward toward the public aspect of these questions instead of translating them into questions of the writer's own destiny.

The stones in the title of *The Stones of Venice*, the first volume of which appeared in March 1851, had, over and above their literal significance, the meaning of touchstones, magical detectors, of the sort Arnold was later to seek for poetry, of the presence or absence of quality: "And if I should succeed, as I hope, in making the Stones of Venice touch-stones, and detecting, by the mouldering of her marble, poison more subtle than ever was betrayed by the rending of her crystal . . . I believe the result of the inquiry may be serviceable for proof of a more vital truth than any at which I have hitherto hinted." Writing at one of the many periods in history when a crude utilitarian progressivism makes concern with the contemporary the necessary sign of seriousness in artistic and intellectual work, Ruskin must justify his retreat to the past by producing a lesson for the present: "Since first the dominion of men was asserted over the ocean, three thrones, of mark beyond all others, have been set upon its sands: the thrones of Tyre, Venice, and England. Of the First of these great powers only the memory remains; of the Second, the ruin; the Third, which inherits their greatness, if it forget their example, may be led through prouder eminence to less pitied destruction."[24]

In *The Crown of Wild Olive* (1866) Ruskin said that in *The Stones of Venice* he had "from beginning to end, no other aim than to show that the Gothic architecture of Venice had arisen out of, and indicated in all its features, a state of pure national faith, and of domestic virtue; and that its Renaissance architecture had arisen out of, and in all its features indicated, a state of concealed national infidelity, and of domestic corruption."[25] The first volume of *The Stones of Venice* is primarily devoted to an analysis of "the best structure of stone and brick building," but its introductory chapter already announces the great principle of "the relation of the art of Venice to her moral temper . . . and that of the life of the workman to his work."[26] Yet the explicit application of the lesson of Venetian history to the condition of Victorian England does not come until 1853, in the famous central chapter on "The Nature of Gothic." At the beginning of *The Stones of Venice* Ruskin is content merely to sketch a brief history of the nation whose "secret spring" of exertion has always been her com-

mercial instinct and to leave his readers to draw their own analogies. He divides the history of the Venetian states into two periods. The first, when they were governed "by the worthiest and noblest man whom they could find among them," lasted 900 years and included the rise of Venice and her noblest achievements. The second lasted 500 years, included the central epoch of the life of Venice, from the middle of the thirteenth century to the beginning of the fifteenth century, but also the commencement of her fall in 1418.

Both the art and the power of Venice, Ruskin now asserts—proof is largely to come later—derived from her religious faith. Ruskin's readers (who in 1851 were very few) might have read a warning to England in his observation that "the most curious phenomenon in all Venetian history is the vitality of religion in private life, and its deadness in public policy." For when the strength of individual religion waned both prosperity and the arts also failed. The history of the ducal palace is the physical embodiment of the history of Venice and of the religious conflicts occurring there. As Ruskin the geologist had read in rocks the history of whole species, so now he tried to read in the stones of Venice a segment of European history. In the decline of the Roman Empire, he claims, two opposed forces, the Lombards and the Arabs, brought revivifying energy to the corpse of Christianity:

> The work of the Lombard was to give hardihood and system to the enervated body and enfeebled mind of Christendom; that of the Arab was to punish idolatry, and to proclaim the spirituality of worship. The Lombard covered every church which he built with the sculptured representations of bodily exercises—hunting and war. The Arab banished all imagination of creature form from his temples, and proclaimed from their minarets, "There is no god but God." Opposite in their character and mission, alike in their magnificence of energy, they came from the North and from the South, the glacier torrent and the lava stream: they met and contended over the wreck of the Roman empire; and the very centre of the struggle, the point of pause of both, the

dead water of the opposite eddies, charged with embayed fragments of the Roman wreck, is VENICE.[27]

But Ruskin claimed to see more than history in these stones of Venice. "A strange, unexpected, and I believe, most true and excellent *Sermon* in Stones—" was Carlyle's description of his gift copy of the first volume of *The Stones of Venice*. For Ruskin asserted that all art was a reflection of the religious and moral ethos of the society that produced it. Thus the contrast between the Venetian painters Giovanni Bellini and Titian is not a mere aesthetic difference explainable by reference to different kinds of formal choices; neither is it a difference in their natural characters. Rather, it is owing to the fact that Bellini was born in 1423 and Titian in 1480, and that "between the years of their births the vital religion of Venice had expired." That formalism lingered on in the absence of faith is evident from Titian's picture of the Doge Antonio Grimani kneeling before faith in the ducal palace. "The figure of faith is a coarse portrait of one of Titian's least graceful female models."[28] No matter where Ruskin explores Venice, in the ducal palace, in paintings, in tombs, he finds evidence of a downward turning point after 1423. Nor is this true only of Venice. Foscari became doge in that year, "and in his reign the first marked signs appear in architecture of that mighty change . . . to which London owes St. Paul's, Rome St. Peter's, Venice and Vicenza the edifices commonly supposed to be their noblest, and Europe in general the degradation of every art she has since practised."[29]

In his reading of Venetian history in Venetian art, Ruskin seemed to have found the solution to his conscientious qualms of the previous decade. By becoming an art-critic rather than a clergyman, and then by writing of architecture while Europe was embroiled in revolutions, Ruskin believed that he had to some extent been selfishly indulging his own most pleasurable impulses in disregard of moral and social responsibility. His uneasiness about this apparent irresponsibility was revealed in the awkward justification he offered in *The Seven Lamps*, for diverting men's attention from more pressing matters into the consideration of what states of moral temper are neces-

sary to the production of good architecture. Now, in *The Stones of Venice*, he argued that criticism of art was nothing other than criticism of society and morality. The art of a country was of necessity the index of its moral temper and also of its social and political virtues; and the fate of nations was, and is, determined by their moral and religious temper. This being so, the critic of style is also, and inevitably, a critic of society and of morality, and even a religious prophet as well. His chief occupation, the perception of beauty, far from being selfish sensual indulgence, is eminently moral because it is a process of measuring the quality of emotional life in the artist and in the civilization that produced him.[30] It is related to immediate questions of character and conduct because it helps living men to discern the moral and religious patterns of history and so save themselves from the fate of their impious predecessors. By, for example, comparing simple Gothic tombs with elaborate Renaissance monuments, they will be enabled to see how a decline in taste resulted from an increased fear of death, that is, from a decline in religious faith.

Ruskin was making his most ambitious attempt yet to reconcile the occupation of art critic with the demands of utilitarianism and religion. In the second volume of *Modern Painters* where, as we have seen, he was very conscious of the utilitarian outlook, he had distinguished between the utilitarian functions of the senses and those that "answer not any purposes of mere existence" but "are an end in themselves." But in Venice in 1849–50 Ruskin found his "aesthetic" senses overwhelmed by beauty and so, as John Rosenberg has pointed out,[31] atoned for the spell the city had cast over him by plotting its moral decline in the Renaissance. In any event, the first volume of *The Stones of Venice* shows Ruskin trying to have it both ways. He does not plunge into direct criticism of contemporary English society, but indulges his love of beauty at extravagant length; yet he makes the whole enterprise subservient to utility and religion. Charlotte Brontë remarked that "his earnestness even amuses me in certain passages, for I cannot help laughing to think how utilitarians will fume and fret over his deep, serious and (as they will think) fanatical reverence for Art."[32] Better yet, *The Church of England Quarterly*

paid particular tribute to Ruskin for having eschewed the ready temptation to become yet another member of the class of idle rich, in order to dedicate art to the glory of God: "We cannot conclude our notice of this remarkable volume without expressing our delight in the contemplation of one with all the allurements to idleness, and the profitless pleasures of fashionable life, which beset the path of a man in his known position, devoting his early and best energies to the illustration and advancement of art, and making all things subservient to the glory of God, dealing out his censures with severity, chiefly on those who have mistranslated the works of the Great Artificer. . . ."[33]

When he began work on the second volume of *The Stones of Venice*, Ruskin was more than ever before convinced of the social utility and religious value of his enterprise. Ironically, he commenced working on the volume that was to become famous for its indictment of the English industrial and commercial system and its celebration of Gothic architecture on the very day that the Great Exhibition of the Works of Industry of all Nations opened in the Crystal Palace:

> *May 1st, 1851.* DENMARK HILL. Morning. All London is astir, and some part of all the world. I am sitting in my quiet room, hearing the birds sing, and about to enter on the true beginning of the second part of my Venetian Work. May God help me to finish it to His glory, and man's good.[34]

The 13,000 exhibits of the Great Exhibition were divided into four groups: raw materials, machinery, manufactures, and fine arts. By far the most popular section, however, was the Machinery Court, to which Queen Victoria herself was attracted by a machine that produced fifty million medals a week and by the electric telegraph that enabled her to address her subjects in Edinburgh and Manchester. The purpose of the Exhibition was "to present a true test and living picture of the point of development at which the whole of mankind has arrived . . . and a new starting point, from which all nations will be able to direct their further exertions." But some perversely chose to look backward rather than forward; and for these men there

stood, apart from the rest of the Exhibition, "looking dark and solemn," Pugin's Medieval Court "for the display of the taste and art of dead men."[35]

We can hardly doubt that Ruskin had the Great Exhibition much in mind as he worked on the second and third volumes of *The Stones of Venice*. Two days after he had begun to work, the *Times* of 3 May deplored the absence of a Turner from the year's Academy exhibition: "We miss those works of INSPIRATION!" Ruskin's response indicates his awareness of the Great Exhibition and his estimate of its value:

> *We* miss! Who misses? The populace of England rolls by to weary itself in the great bazaar of Kensington, little thinking that a day will come when those veiled vestals and prancing amazons, and goodly merchandise of precious stones and gold, will all be forgotten as though they had not been; but that the light which has faded from the walls of the Academy is one which a million Koh-i-noors could not rekindle; and that the year 1851 will, in the far future, be remembered less for what it has displayed, than for what it has withdrawn.

The contrast between the care and expense being lavished upon the Crystal Palace and its contents, and the indifference with which his contemporaries witnessed the destruction of the glories of Venetian painting and architecture exacerbated Ruskin and intensified his sense of mission:

> In the year 1851, when all that glittering roof [of the Crystal Palace] was built, in order to exhibit the paltry arts of our fashionable luxury—the carved bedsteads of Vienna, and glued toys of Switzerland, and gay jewellery of France—in that very year, I say, the greatest pictures of the Venetian masters were rotting at Venice in the rain, for want of roof to cover them, with holes made by cannon shot through the canvas.
>
> There is another fact, however, more curious . . . namely, that at the very period when Europe is congratulated on

the invention of a new style of architecture, because four-
teen acres of ground have been covered with glass, the great-
est examples in existence of true and noble Christian archi-
tecture are being resolutely destroyed. . . . [36]

Not long after setting to work on the second volume of *The Stones
of Venice*, Ruskin discovered that it would be necessary for him to
make another extended visit to Venice. He completed a pamphlet on
behalf of the Pre-Raphaelites in July and set off for the Continent
with Effie in August, vacationing in Switzerland before starting work
in Venice in September. Although he still considered that *The Stones
of Venice* was but an interruption of his main work[37] and spent much
time enjoying Venetian society with Effie, Ruskin had all of his heart
and head in this book. It was, after all, work that he instinctively
liked, and not—as would be the case with *Unto This Last* and *Mun-
era Pulveris*—work forced on him by a sense of duty: " . . . There
is the strong instinct in me which I cannot analyse to draw and de-
scribe the things I love—not for reputation, nor for the good of
others, nor for my own advantage, but a sort of instinct like that for
eating or drinking. I should like to draw all St. Mark's, and all this
Verona stone by stone, to eat it all up into my mind, touch by touch."
He continued to separate himself from "a different species from me
—men of the world, caring for very little about anything but Men."
Ten years later, in the midst of his economic controversies, he could
recall with nostalgia the times when he had been working in Venice
"from six in the morning till ten at night, in all the joy of youth."[38]
 Yet the period from September 1851 to June 1852, during which
Ruskin felt so deeply the joy of creation, was not without its distresses,
distresses that would express themselves indirectly through the great
sixth chapter of *The Stones of Venice*, "The Nature of Gothic." Rus-
kin's fury at the Great Exhibition and its immense popularity affords
one illustration among many of his growing sense of isolation, much
like Arnold's at this time, from the course of modern English civiliza-
tion. In January, Ruskin told his father, "The more I watch the world,
the more I feel that all men are blind and wandering." He felt help-
less to dissipate the ignorance and stupidity that seemed to him the

main causes of misery because "braying in a mortar with a pestle will not make the foolishness depart out of the world. . . . "[39]

Joyous as he was in his work at this time, Ruskin already had the fear, later confirmed, that the further he pressed his discoveries, the more clearly he understood and articulated their practical conse-quences, the greater would be his isolation from his fellows. Whether he wrote on Turner or on Venice, Ruskin was already convinced that he was a man who knew what others did not know and felt what they could not feel. In February he wrote to his father about his habit of being "in advance of the mob" that "in all things now—I see a hand they cannot see; and they cannot be expected to believe or follow me: and the more justly I judge, the less I shall be attended to."[40]

The other occasion of Ruskin's distress during the generally exuber-ant period of composition of *The Stones of Venice* was the bad state of English society. In November of 1851 he was much struck by read-ing in *Galignani* three news stories incompatible with, yet oddly ex-planatory of, each other. Readers of Arnold's "The Function of Criti-cism at the Present Time" or of Carlyle's *Past and Present* or, indeed, of Ruskin's *Sesame and Lilies* will know that in Victorian times news-paper stories had an almost magical way of arranging themselves in significantly paradoxical groups; and Ruskin was now the beneficiary of one of these revealing coincidences:

> I was rather struck yesterday by three paragraphs in *Galig-nani*—in parallel columns—so that the eye ranged from one to the other. The first gave an account of a girl aged twenty-one, being found, after lying exposed all night, and having given birth to a dead child, on the banks of the canal near (Maidstone, I think—but some English county town); the second was the fashions for November, with an elaborate account of satin skirts; and the third, a burning to death of a child—or rather, a dying after burning—because the sur-geon, without an order from the parish, would neither go to see it nor send it any medicine.[41]

Ironically, the Ruskin who during the "hungry forties" succeeded pret-ty well in keeping his mind hermetically sealed against awareness of

the plight of the poor, now, in the prosperous, complacent fifties, began to take some interest in economic questions.

The first result of this new interest was not "The Nature of Gothic" but three letters written to the *Times* on taxation, representation, and education. Though addressed to the paper, they were—like all of Ruskin's writings at this time—submitted first to John James Ruskin's censorship; and they did not pass the censor: "I shall see to letters for *Times* on my return, as you so wish it. My feelings of attacks on your books and on your newspaper writing differ from yours in this way. I think all attacks on your books are only as the waves beating on Eddystone Lighthouse, whereas your politics are Slum Buildings liable to be knocked down; and no man to whom authority is a useful engine should expose himself to frequent defeat by slender forces."[42]

From the first letter, we can see that despite the link that he had forged in the first volume of *The Stones of Venice* between art and society, Ruskin still felt uneasy about his unworldly vocation and under some obligation to justify it: "Neither my circumstances nor my health admit of my entering into public life—and having little sympathy with the present course of English policy, and less power to resist it, I am forced, while my own country is multiplying errors and provoking dangers, to pass my days in deciphering the confessions of one which destroyed itself long ago."[43] Nevertheless, a system of taxation that paralyzes commerce at the same time that it inflames the populace obliges him to break his silence. The voice that emerges from this silence, after uttering one or two gratuitous anti-Semitic remarks, proposes a luxury tax, a graduated income tax, and a property tax. The second abortive letter, less "radical" in its proposals, stresses the importance of weighing as well as counting votes: since it is no longer possible to keep the common people from thinking about governments, the question is how to give the people no more than their proper weight in the state.

The third letter, the only one printed in Ruskin's lifetime, was devoted to the Principles of Education and was incorporated, as an appendix, in the final volume of *The Stones of Venice*. That Ruskin cared deeply about its subject is clear from a letter of 26 April 1852 to

his father: "I have not any more notice—in any of your letters, of the last on education, which you seem at first to have been much pleased with. I liked that, myself—and some time or other I must recast it in some way, for I want to *have at* our present system—I don't know any thing which seems to me so much to require mending."[44] The existing system of classical education is blamed by Ruskin for mistaking erudition for education. Ruskin holds that the education of every man should teach him three things: "First, Where he is. Secondly, Where he is going. Thirdly, What he had best do, under those circumstances." Ruskin finds that the existing European system either ignores or despises all three branches of knowledge. It despises Natural History, and promotes the study of words above the study of things; it despises Religion, preferring theology, or talk about God, which loosens the elements of religious faith, to the binding or training of men to God's service; and finally, and most important, it despises Politics, or "the science of the relations and duties of men to each other."[45]

The turmoil of 1848 might have receded into the background of Ruskin's awareness during the intervening four years, but it had not vanished. He now called upon the educational system to forestall further revolution by teaching every schoolboy "the impossibility of equality among men; the good which arises from their inequality; the compensating circumstances in different states and fortunes" and, in general, the virtues of a hierarchical class system. While Ruskin himself still luxuriated in the glories of the Venetian past, he called upon English educators to teach their pupils of the Peninsular as well as the Peloponnesian War, of modern Italy as well as of old Etruria; in short, to instruct them in contemporary history and present duty.

Once again, as we have seen him do in private letters, Ruskin dissociates himself from those among his contemporaries who seek perfection of the earthly city as a substitute for the heavenly one in which they no longer believe. But to recognize that earth can never be heaven is not to admit that it can never be made better than it is:

> For though I have not yet abandoned all expectation of a
> better world than this, I believe this in which we live is not

so good as it might be. I know there are many people who suppose French revolutions, Italian insurrections, Caffre wars, and such other scenic effects of modern policy, to be among the normal conditions of humanity. I know there are many who think the atmosphere of rapine, rebellion, and misery which wraps the lower orders of Europe more closely every day, is as natural a phenomenon as a hot summer. But God forbid! There are ills which flesh is heir to, and troubles to which man is born; but the troubles which he is born to are as sparks which fly *upward*, not as flames burning to the nethermost Hell.[46]

Ruskin expresses sympathy with the movement to educate the lower classes. But for them as for other classes, education has to mean not the acquisition of a body of knowledge but instruction in what will fit them to do their work and to be happy in it. Finally, anticipating Arnold's concerns of the sixties, Ruskin urges a system of national education, because it is the duty of the state to educate as well as to clothe and feed every child. "But in order to the effecting this, the government must have an authority over the people of which we now do not so much as dream; and I cannot in this place pursue the subject farther."[47]

Matthew Arnold, in March of 1852 when Ruskin wrote this letter, was no longer at leisure merely to deplore the existing educational system and then drop the subject. For Arnold was by this time employed as one of Her Majesty's inspectors of schools. He had been appointed to the position in April of the previous year, but did not begin work until October. On September 1 he and Fanny Lucy embarked on a honeymoon trip through France, Italy, and Switzerland. They were in Verona and Venice at the same time as the Ruskins, but traveled in a very different sphere of society. Fanny Lucy wrote to her sister of the excitement of seeing at a distance the Austrian emperor and Marshal Radetsky;[48] the Ruskins were invited to a reception for the first and were themselves the object of courtly attention by the second. By October, while the Ruskins continued to enjoy masked

balls and gala nights at the opera and private parties in honor of royalty, the Arnolds had returned to England where Matthew began the dreary and vexatious work of school inspection.

Outwardly, there could be few more striking contrasts than that between Arnold and Ruskin in the fall of 1851 and the subsequent winter. While Ruskin pursued his artistic work with greater joy in creation than he had experienced, and grudged losing a single day to extraneous concerns, Arnold found himself beleaguered by an existence that required almost incessant travel and that seemed spiritually as well as practically incompatible with the creation of poetry.

Like Ruskin's, Arnold's political awareness had been dormant since 1848 but not dead; and like Ruskin, Arnold now saw the political significance of education in an era of revolutionary transition. "I think," he wrote after starting his work, "I shall get interested in the schools after a little time; their effects on the children are so immense, and their future effects in civilising the next generation of the lower classes, who, as things are going, will have most of the political power of the country in their hands, may be so important." For all his poetic speculation about entering the world, Arnold was as yet hardly aware of how irrevocably he had done so. Within a few days of beginning the job he was to hold for thirty-five years, he was anticipating retirement from it: "We shall certainly have a good deal of moving about; but we both like that well enough, and we can always look forward to retiring to Italy on £200 a year. I intend seriously to see what I can do in such a case in the literary way that might increase our income. But for the next three or four years I think we shall both like it well enough."[49]

As late as 1886 Arnold could tell A. J. Mundella, a former vice president of the Committee of the Privy Council on Education, about his "routine work" as an inspector that "the permanent officials know I cared little about my performances." His irritation with the routine was apparent from the first. "I have had a hard day," he writes to his wife in December 1851. "Thirty pupil teachers to examine in an inconvenient room and nothing to eat except a biscuit, which a charitable lady gave me." Later in the month when Clough was thinking

of applying for a position at the Education Office, Arnold described the occupation as "hard dull work low salary stationariness, and London to be stationary in. . . . "[50]

We have already seen how, at this time, the fear of passing youth and of growing isolation from the course of modern English society had tinged Ruskin's general cheer with some apprehension, but far from troubling his work on *The Stones of Venice* was leading him to a new awareness of society that was to enrich the second volume of that work. Given the new circumstances of Arnold's existence in 1851–53, it is hardly surprising that the same fears should have moved to the center of his consciousness. But, perhaps because he worked in poetry and not prose, he found greater difficulty than Ruskin in making these fears the means of discovering new materials for imaginative exploitation.

G. M. Young once concluded a description of the new literary generation growing up in 1850 by saying that "over them all droops the fading youth of Matthew Arnold, in the full decrepitude of twenty-eight."[51] The image, comical as it is, gives an accurate picture of Arnold's own idea of himself at the time of his entry into the world. He had already, as we have seen, said farewell to his youth in bidding farewell to Marguerite and to Senancour. But "what a difference there is between reading in poetry and morals of the loss of youth, and experiencing it! And after all there is so much to be done, if one could but do it." "How life rushes away, and youth. One has dawdled and scrupled and fiddle faddled—and it is all over."[52]

Arnold hears the injunction from the Gospel of St. John, filtered through the voice of Carlyle, to "Work while it is called Today, for the Night cometh, wherein no man can work." He urges Clough to "be bustling about it; we are growing old, and advancing towards the deviceless darkness; it would be well not to reach it until we had at least tried *some* of the things men consider desirable." There is so much to be done if one could but do it! But Arnold now feels that he cannot. When *Empedocles on Etna*, the volume of poems that had for the most part been written before he actually entered the world, appears in October 1852 Arnold is "fighting the battle of life as an In-

spector of Schools." He greets the newly published volume with the grim "Caution to Poets":

> What poets feel not, when they make,
> A pleasure in creating,
> The world, in *its* turn, will not take
> Pleasure in contemplating.

He sees now where the poems are all wrong, which he did not see the year before, only "I doubt whether I shall ever have heat and radiance enough to pierce the clouds that are massed round me. Not in my little social sphere indeed, with you and Walrond: there I could crackle to my grave—but vis à vis of the world. . . . "[53]

Part of the "wrongness" of the poems consisted precisely of their clarity of vision into the modern world: "Woe was upon me if I analysed not my situation: and Werter[,] Rene[,] and such like[,] none of them analyse the modern situation in its true *blankness* and *barrenness*, and *unpoetrylessness*."[54] Arnold, like Ruskin, found that the disinterested effort to see things as they really are and then to describe what one sees causes the disinterested seer to become isolated from his fellow men. This was the price that had been paid by the hero of the title poem of the unsatisfactory volume in question, Empedocles.

In his analysis of Empedocles' character, Arnold writes:

> He sees things as they are—the world as it is—God as he is: in their stern simplicity. The sight is a severe and mind-tasking one. . . . But he started towards it in hope: his first glimpses of it filled him with joy; he had friends who shared his hope and joy. . . . But his friends are dead: the world is all against him, and incredulous of the truth: his mind is overtasked by the effort to hold fast so great and severe a truth in solitude: the atmosphere he breathes not being modified by the presence of human life, is too rare for him.

In February 1853 Arnold tells Clough that *"congestion of the brain is what we suffer from—I always feel it and say it—and cry for air*

like my own Empedocles." The rarity of an air unbreathed by his fellow men now seems to freeze Arnold's spirits and to paralyze his pen: "I am past thirty, and three parts iced over—and my pen, it seems to me is even stiffer and more cramped than my feeling."[55]

As Arnold's sense of isolation, of passing youth, of the paralysis of his feeling and his art grew more intense, he began to reconsider his earlier view of the nature of the poet and the function of poetry. In June, commenting on the latest episode in Clough's interminable quest for a suitable occupation, Arnold recognizes, sadly, that great careers are hardly possible in modern times, even when one is willing to sacrifice "repose dignity and inward clearness" in the search for them. He complains, again like his own Empedocles,[56] that the world now caters to the masses at the expense of the naturally gifted individual. But here he reverses what has begun to sound like a Carlylean lament for heroic times, and adds that "it is as well perhaps that it should be so—for hitherto the gifted have astonished and delighted the world, but not trained or inspired or in any real way changed it —and the world might do worse than to dismiss too high pretentions, and settle down on what it can see and handle and appreciate." The air of present times does lack nourishment, and men like Arnold and Clough may well see themselves as gifted Romans in a declining Empire: "Still nothing can absolve us from the duty of doing all we can to keep alive our courage and activity."[57]

In the midst of his deepest despair the once carefree son of Dr. Arnold begins to embrace his father's code of duty and social responsibility. The world has not been made to please poets; at least it has not been made to please Empedoclean poets. This being so, Arnold must reconsider the aesthetics of detachment that pervaded the 1849 volume; and in the very same letter where he laments how much there is to be done and how little time remains in which to do it, Arnold reverses his earlier condemnation of poets who fancy themselves reformers, and of poetry that puts moral and religious considerations above aesthetic ones by trying to guide life instead of merely accompanying it: "Modern poetry can only subsist by its *contents*: by becoming a complete *magister vitae* as the poetry of the ancients did:

by including, as theirs did, religion with poetry, instead of existing as poetry only, and leaving religious wants to be supplied by the Christian religion, as a power existing independent of the poetical power."[58] Poetry, if it is to survive at all, will have to look outside of itself and forge an alliance with religion and morality in the effort to direct modern life.

Arnold wrote this letter in the same month (October 1852) that *Empedocles on Etna* appeared; and Arnold found himself in the awkward position of having before the public a volume of poems to which he himself had the strongest principled objections. By 1853 he was casting about for new directions to follow in his life and in his poetry. In March he found inspecting "peculiarly oppressive" and told Lucy how he had been daydreaming about a diplomatic appointment to Switzerland, "and how different that would be from this incessant grind in schools." In May he confessed to Clough that "I catch myself desiring now at times political life, and this and that. . . . " Coincident with his deepening dissatisfaction with his occupation and his poetry was a new kind of moralistic reaction to literature. *Villette* struck him as a disagreeable novel because it reflected a disagreeable mind that "contains nothing but hunger, rebellion, and rage, and therefore that is all she can, in fact, put into her book." The cause of Miss Brontë's failure was just the cause of the failure of Renaissance architects according to the author of *The Stones of Venice*: she had lost her religion and had not yet found a substitute for it. "No fine writing can hide this thoroughly, and it will be fatal to her in the long run." Bulwer's *My Novel* pleased Arnold somewhat better, but "Bulwer's nature is by no means a perfect one either."[59]

Arnold had begun to read literature as a reflection of the moral life of its creator. For how can literature be a religious director of life if it is not written by religious men and women? But where were such men and women to be found in the 1850s? Charlotte Brontë's case, Arnold knew, was a representative rather than an isolated one: "Religion or devotion or whatever it is to be called may be impossible for such people [as Miss Brontë] now: but they have at any rate not found

a substitute for it and it was better for the world when they comforted themselves with it." Among "such people now" was Arnold himself. In September, a few months after berating Charlotte Brontë for her irreligious rage, he admitted that artists who had discarded religious dogmas could now produce excellent work only if they could love "*passionately* enough" what was intrinsically beautiful and compelling. "As it is, we are *warm* only when dealing with these last—and what is frigid is always bad. I would have others—most others stick to the old religious dogmas because I sincerely feel that this *warmth* is the great blessing, and this frigidity the great curse—and on the old religious road they have still the best chance of getting the one and avoiding the other."[60]

Having asserted that art must be a director of life, and that artistic success depends upon the moral and religious character of the artist, Arnold was forced by his own predicament to go a step further and say that artistic success is not entirely a matter of the will and capacity of the individual artist but also a function of the culture that produces him. Throughout 1853, as Arnold felt his own creative powers more and more fettered by his circumstances—"I am nothing and very probably never shall be anything—but there are characters which are truest to themselves by never being anything, when circumstances do not suit"—he was attracted to the idea that pervades *The Stones of Venice*, of a historical and cultural determination of formal characteristics in art. Himself troubled by problems of composition in *Sohrab and Rustum*, he noticed that English painters also failed in composition though they excelled in genius, and wondered whether in poetry it is not "to be expected that in this same article of *composition* the awkward incorrect Northern nature should shew itself?" When Clough questioned Arnold's idea that the Reformation *caused* the Elizabethan literature, Arnold replied that he meant only to say that "both sprang out of the active animated condition of the human spirit in Europe at that time." He then briefly sketched a deterministic theory of European cultural history to support the conclusion that the shortcomings of art and literature are usually the shortcomings of the cultures and nations from which they spring: "I think there never yet has been a perfect literature or a perfect art because the energetic

nations spoil them by their illusions and their want of taste—and the nations who lose their illusions lose also their energy and creative power." While working on his new poems, Arnold thought of arranging them by historical periods—"Antiquity—Middle Age—and Temps Moderne"—and he concentrated on the works of the poet who for him represented a higher spiritual order than that in which he himself was obliged to function: "I read Homer and toujours Homer."[61]

All this fermentation was brought to a head, according to Dwight Culler,[62] by Arnold's visit during an inspection tour of Wales to his old friend J. A. Froude. In 1849 Froude had expressed irritation with *The Strayed Reveller* because he did not see what right Arnold had "to parade his calmness and lecture us on resignation when he has never known what a storm is, and doesn't know what he has to resign himself to—I think he only knows the shady side of nature out of books."[63] By 1853 Arnold was at least beginning to learn what he would have to resign himself to, and he was also beginning to know the difference between reading about the loss of youth and experiencing it. But now again Froude was one step ahead of Arnold. The young man who had endured so much grief and been riven by so many doubts, was now much changed:

> I should like you to see Froude—quantum mutatus! He goes to church, has family prayers—says the Nemesis ought never to have been published etc. etc.—his friends say that he is altogether changed and re-entered within the giron de l'Eglise—at any rate within the giron de la religion chrétienne: but I do not see the matter in this light and think that he conforms in the same sense in which Spinoza advised his mother to conform—and having purified his moral being, all that was mere fume and vanity and love of notoriety and opposition in his proceedings he has abandoned and regrets. This is my view. He is getting more and more literary, and vise au solide instead of beating the air. May we all follow his example![64]

One part of that example was, no doubt, Froude's hindsighted conclusion that *The Nemesis of Faith*, his sensational 1849 novel about

religious doubt, which had been publicly burned in Exeter Hall, "ought never to have been published." For Arnold now decided that precisely the same was true about his own public confession of religious doubt, "Empedocles on Etna." He returned home and wrote a Preface—his first published prose—to the new volume of *Poems* in which he explained why he had withdrawn the title poem of the 1852 volume and what his idea of the nature and function of poetry was.

Arnold's Preface to his 1853 *Poems* and Ruskin's "The Nature of Gothic" were published within months of each other and are now recognized to have been decisive turning points in the careers of their respective authors as well as landmarks in Victorian literature. Dwight Culler has said that Arnold's rejection, in the Preface, of "Empedocles" in particular and of morbid, self-conscious literature in general, was his attempt to move from subjectivity to objectivity, and that Ruskin had already made the same move "in turning from mountains and painting to architecture and society." Culler also maintains that Arnold was embarrassed by the contrast between the gloom of "Empedocles on Etna," which ends with a suicide, and the fact that the rest of England "was strolling through the Crystal Palace," "Newman was publishing his serene and balanced lectures on the *Idea of a University*, and Ruskin was bringing out his most mature and luminous work, *The Stones of Venice*."[65]

These points of contact between Arnold's Preface and Ruskin's *Stones* are truly and wittily stated, but we must also remember that Arnold and Ruskin did not merely reflect a certain atmosphere of the fifties; they helped to form it. If we want to know what that atmosphere was, we need to keep in mind the individual as well as the social circumstances that had led each man to reconsider the relations between art and morality at this time.

Thomas Carlyle, in so many ways the teacher of Arnold and Ruskin, had called the pleasure principle of the Benthamites "the pig philosophy" and declared its obsession with happiness the most disgraceful feature of the modern mind. Yet Wordsworth in his Preface to the *Lyrical Ballads* had celebrated the pleasure principle as that by which we know and live and move, and asserted that the single

obligation from which the poet could not be freed was the obligation to give pleasure.[66] Both Arnold and Ruskin, in seeking an extra-aesthetic principle by which to judge works of art, now resorted to Wordsworth's test, but applied it in different ways.

Arnold, we recall, had in 1852 quoted for Clough "an oracular quatrain . . . terribly true" which said that

> What poets feel not, when they make,
> A pleasure in creating,
> The world, in *its* turn, will not take
> Pleasure in contemplating.

He did not therefore feel obliged to wait for the world's reaction to "Empedocles"—he withdrew it from circulation before fifty copies had been sold—before he justified its suppression in the Preface on the grounds that it had failed to give pleasure. It is not enough, asserts Arnold, for a poem to be an accurate and therefore interesting imitation of life. Poetry must fulfill a moral as well as an aesthetic obligation; and for a poem to be morally and socially adequate "it is demanded, not only that it shall interest, but also that it shall inspirit and rejoice the reader."[67]

"Empedocles on Etna" fails to give joy to the reader because its subject is a situation of prolonged mental distress in which "there is everything to be endured, nothing to be done." Arnold claims that such subjects *cannot*, when represented in poetry, give enjoyment because they are painful, not tragic. By insisting that poems which represent suffering that finds no vent in action cannot be pleasurable, Arnold has caused much confusion among his readers. Since Empedocles does indeed act, but kills himself in the process, and since Arnold had in earlier and would again in later writings use "action" as a pejorative term, we must conclude that Arnold had in mind a very special kind of action that would save intellectuals from Empedocles' fate and enable them to live, as Arnold was himself now doing, in the practical world. Arnold was now deliberately confusing art with life, and applying to aesthetic problems the strategies he had already

adopted for moral problems. Earlier in the year he had accused Clough of "morbid conscientiousness—you are the most conscientious man I ever knew: but on some lines morbidly so, and it spoils your action."[68]

Ruskin, in "The Nature of Gothic," noted that "the mass of society is made up of morbid thinkers, and miserable workers." Yet, he argued, it was only by work that thought could be made healthy, and "only by thought that labour can be made happy."[69] Like Arnold, he was going beyond art for a standard by which to judge art; and like Arnold, he found that standard in the happiness that was linked with the best kind of work.

Only, whereas Arnold made the happiness of the audience (reader or spectator) the primary test of a work of art, Ruskin tested the moral adequacy of a work of art by asking whether the artist himself was happy while making it. This theme had already been sounded in *The Seven Lamps* when Ruskin said that the right question to ask, respecting all architectural ornament, was simply: "Was it done with enjoyment—was the carver happy while he was about it?" But then aesthetic criteria still dominated Ruskin's outlook. Now, in *The Stones of Venice*, he explicitly (at least in theory) subordinates aesthetic to moral criteria. In our factories, he says, we have instituted something called division of labor, but is really division of men; and he acidly comments on a famous passage in *The Wealth of Nations* that the human intelligence has now had to be fragmented into whatever crumbs of ingenuity are small enough to make the points of pins or heads of nails. This evil can be met "not by teaching or preaching" but by making all classes understand "what kinds of labour are good for men, raising them, and making them happy; by a determined sacrifice of such convenience, or beauty, or cheapness as is to be got only by the degradation of the workman. . . . "[70]

The audience, which comes first in Arnold's moral aesthetic, is not left out of Ruskin's formulation. It is just sanguinely assumed by him that the enjoyment of the worker who produced the work of art must be "the source of the spectator's pleasure. . . . " Whereas Arnold puts the weight of moral obligation on the artist, Ruskin, in the third

volume of *The Stones of Venice*, places it on the spectator, who *ought* to take pleasure in artistic imperfections because they are a sign that the work was done as a recreation rather than a business. "It is not its own merit so much as the enjoyment of him who produced it" that is supposed to give pleasure to the spectator.[71]

The moral obligations laid upon the beholder of works of art in the third volume of *The Stones of Venice* are but outgrowths of those laid down for the consumer of products in "The Nature of Gothic." The consumer is to judge products not by their convenience or beauty or cheapness but by the signs they give that their creator enjoyed making them; and he is to encourage the joy of the worker and the artist (whose kinship Ruskin assumes) by refusing to purchase, or even to take pleasure in, articles that lack invention, or that have received an exact finish for its own sake, or that are mere imitations.

The basis of the moral aesthetic that Arnold and Ruskin tried to establish in the 1853 Preface and *The Stones of Venice* is a theory of history which assumes that at some time in the past art *was* united to religion and *was* conducive to joy. The technique of contrasting past and present for propagandistic purposes was already highly developed by 1853. The use of the Middle Ages as a social example had been widespread since Cobbett employed it and had been given great currency in the late thirties and early forties by Pugin and Carlyle. Arnold could never share in the enthusiasm of the Gothic Revival, but he had been schooled by his father in admiration for another past, that of Periclean Athens, and he needed no schooling in hostility to the poetryless present.

After Arnold has completed the practical work of his 1853 Preface —explaining the suppression of "Empedocles"—he says that he has taken the trouble of offering an explanation of so trivial a matter in order to make it clear that "Empedocles" is being excluded not because it is not "modern" enough but because it is "exclusively modern." Arnold takes issue with "many critics of the present day" who object to subjects chosen from past times and countries or to any subjects but modern ones, assuming that only these are interesting and relevant. The insistence on contemporaneity is for Arnold always

the sign of self-fascination. The critic who demands it assumes that the human action he himself witnesses is inevitably grander than the human action of a thousand years before. The poet who craves it believes that the resources of his own art are capable of transforming the dross of the most trivial subject into gold.

To these critical demands for contemporaneity Arnold replies that subjects are interesting not by virtue of their modernity or of their antiquity but by virtue of their appeal to "the great primary human affections: to those elementary feelings which subsist permanently in the race, and which are independent of time." An inherently great human action a thousand years old, he maintains, is a fitter subject for poetic representation than a trivial action of one's own time. Anticipating the objection that modern readers simply *are* more interested in petty modern subjects than in grand ancient ones, Arnold treats it as Ruskin does the possibility that spectators may not derive joy from imperfect work that was joyously created, by telling them that they have no right to be so. Invoking the Platonic and Shelleyan distinction between externals and essentials, between transient and eternal feelings, Arnold says that "transient feelings and interests . . . have no right to demand of a poetical work that it shall satisfy them."[72]

But Arnold is not content to disabuse the moderns of their predilection for contemporary subject matter. The ancient Greeks represent the standard to which modern literature should aspire not only because, unlike modern poets, they subordinated expression (isolated thoughts and striking images) to the overall action, and were more concerned with the total impression made by the whole poem than with single lines and passages, but because they actively avoided subjects drawn from contemporary life. They did so because they understood the difficulty of seeing things close at hand in true perspective, of disentangling the transient and accidental from the eternal and universal; and because they appreciated the religious and therapeutic function that they were expected to perform for their audience:

> The terrible old mythic story on which the drama was founded stood, before he entered the theatre, traced in its bare outlines upon the spectator's mind; it stood in his

memory, as a group of statuary, faintly seen, at the end of a long and dark vista: then came the poet, embodying outlines, developing situations, not a word wasted, not a sentiment capriciously thrown in: stroke upon stroke, the drama proceeded: the light deepened upon the group; more and more it revealed itself to the riveted gaze of the spectator: until at last, when the final words were spoken, it stood before him in broad sunlight, a model of immortal beauty.[73]

The Greek critic demanded this and the Greek poet produced it because the first was not inflated with the arrogant belief in the supreme importance and greatness of his own time, and the second was not afflicted by subjectivism. The modern poet goes astray in choice of subject matter and in emphasis of expression at the expense of action not only because he gets bad critical advice but because he loves himself more than his art. Whereas the ancient poet tried to efface himself and his personal peculiarities from his art, the modern poet is likely to believe that his ideal subject is nothing other than the state of his own mind.

Arnold's recommendation of a particular past as a standard against which to measure the present was in 1853 a recommendation made primarily to poets rather than the general public. But it carried within it the seeds of a whole social philosophy, for it offered a means of judging society as well as style: "The present age makes great claims upon us: we owe it service, it will not be satisfied without our admiration. I know not how it is, but their commerce with the ancients appears to me to produce, in those who constantly practise it, a steadying and composing effect upon their judgment, not of literary works only, but of men and events in general." Like all eager converts to classicism, Arnold now believed that he had found an absolute and fixed position from which to view not just the aesthetic aberrations of romantic artists but the otherwise bewildering phenomena of a changing society.

We have already seen how, in the first volume of *The Stones of Venice*, Ruskin had asserted the relevance of the Venetian past to the English present. If England did not heed the warning uttered by the

stones of a once proud empire, she would be "led through prouder eminence to less pitied destruction." Ruskin intended that the second and third volumes should show how the rise and fall of the Venetian builder's art depended on the moral temper of the Venetian state and how the relation of the life of the workman to his work in medieval times established the standard that should obtain in all times.[74] Like Arnold, Ruskin dwelt in the Mediterranean and Adriatic past yet insisted on its immediacy to the English present. Now, in "The Nature of Gothic," he wanted to articulate the practical lesson that Victorian England might learn from the contemplation of Gothic, for—again like Arnold—he believed that aesthetic preferences were but the external aspect of moral choices.

The "characteristic or moral elements" of Gothic architecture, by Ruskin's definition, are Savageness, Changefulness, Naturalism, Grotesqueness, Rigidity, and Redundance. We hardly need inquire further into the meaning of these terms to know that Ruskin is deliberately trying to outrage classical and modern canons of taste by praising in "the so-called Dark Ages" precisely those rude, uncouth, barbarous characteristics that had earned the contempt of the neoclassical writers and those nourished on them. Arnold himself, we may recall, had in this very year explained poor composition in English art as the result of "the awkward incorrect Northern nature." Ruskin now argues that the "savageness" of Gothic architecture is doubly noble: as an expression of brotherhood between cathedrals and mountains, and as an index of religious principle. For he seeks to prove that it is both more natural and more Christian than all other architectural styles.

There are, he continues, only three types of architectural ornament. In Servile ornament the execution of the inferior workman is entirely subject to the intellect of the higher workman; in Constitutional ornament, the inferior worker is partially emancipated, but must still obey the higher workman; in Revolutionary ornament "no executive inferiority is admitted at all." Within the first type Ruskin distinguishes between the Greek and the Egyptian schools. The Greek master workman, greatly the superior of the Egyptian in knowedge

and power, could not endure imperfection in anything and so allowed his workmen to execute only geometrical forms, "which could be executed with absolute precision by line and rule, and were as perfect in their way, when completed, as his own figure sculpture." The Egyptian school, less concerned with accuracy, allowed its inferior workmen to sculpt figures, lowered standards for their sake, but then trained them so that they could not fall below that lowered standard. In both systems the workman was enslaved.[75]

It is only in the medieval, or Gothic, or—and this is Ruskin's point —Christian system of architectural ornament that servility is abolished and the ordinary workman allowed to express himself as he likes. Christian architecture, like Christianity itself, recognized both the value and the necessary imperfection of the individual soul: "It is, perhaps, the principal admirableness of the Gothic schools of architecture, that they . . . receive the results of the labour of inferior minds; and out of fragments full of imperfection, and betraying that imperfection in every touch, indulgently raise up a stately and unaccusable whole."[76] Paradoxically, then, the secret of artistic success is the placing of moral and religious concerns above artistic ones.

But what has all this to do with the England of 1853? One way of fathoming Ruskin's answer to this question is to view it through the eyes of Matthew Arnold. In 1883, many years after "The Nature of Gothic" had made its way into the popular consciousness, Arnold, lecturing on "Literature and Science" before a New York audience, made one of his very rare excursions into architectural criticism. The English, he said, suffered greatly from lacking the admirable symmetry of the Greeks. This absence of symmetry damaged all English art, but showed itself most glaringly in English architecture:

> Striking ideas we have, and well-executed details we have; but that high symmetry which, with satisfying and delightful effect, combines them, we seldom or never have. The glorious beauty of the Acropolis at Athens did not come from single fine things stuck about on that hill, a statue here, a gateway there;—no, it arose from all things being perfectly

combined for a supreme total effect. What must not an Englishman feel about our deficiencies in this respect, as the sense for beauty, whereof this symmetry is an essential element, awakens and strengthens within him! what will not one day be his respect and desire for Greece and its *symmetria prisca,* when the scales drop from his eyes as he walks the London streets, and he sees such a lesson in meanness as the Strand, for instance, in its true deformity! But here we are coming to our friend Mr. Ruskin's province, and I will not intrude upon it, for he is its very sufficient guardian.[77]

By briefly intruding on "Mr. Ruskin's province," Arnold was helpfully reminding his audience of the fact that both he and Ruskin had, in their different ways, developed the technique of judging societies past and present by the style of their art, and trained their readers to believe in an inevitable correspondence between the character of a society and the character of its art. But he was also being somewhat disingenuous; for to imply that Ruskin would accept the opposition between the Greek and the English character, or that he would applaud Greek symmetry, or praise the ideal of perfection at all, was grossly to misrepresent him.

In "The Nature of Gothic" Ruskin states it to be a law of art that "no good work whatever can be perfect, and *the demand for perfection is always a sign of a misunderstanding of the ends of art.*" He takes imperfection, irregularity, deficiency, to be signs of both life and beauty; and charges those who would banish imperfection from art with trying "to destroy expression, to check exertion, to paralyze vitality." For Ruskin the Greek system of architectural ornament is a warning and not a model. The Greek system enslaved the workman because it denied him the expression of his personality in his art; it confined him to the composition of geometrical forms and symmetrical foliage, that is, to a kind of activity in which Ruskin can see no human faculty expressed. The medieval or Christian system, on the other hand, recognizing man's inherent weaknesses, also recognized the value of the individual soul and encouraged its expression in art. Ruskin's quarrel with his countrymen arises from the fact that they have chosen the pagan over the Christian system:

. . . The modern English mind has this much in common with that of the Greek, that it intensely desires, in all things, the utmost completion or perfection compatible with their nature. This is a noble character in the abstract, but becomes ignoble when it causes us to forget the relative dignities of that nature itself, and to prefer the perfectness of the lower nature to the imperfection of the higher. . . . And therefore, while in all things that we see, or do, we are to desire perfection, . . . we are nevertheless not to set the meaner thing, in its narrow accomplishment, above the nobler thing, in its mighty progress; not to esteem smooth minuteness above shattered majesty; not to prefer mean victory to honourable defeat. . . . [78]

Ruskin's creed of imperfection is a naturalistic one like the creed that he had set forth in *The Seven Lamps*. But whereas in the earlier work the essence of the natural had been conceived of as obedience to order and law, it is now made equivalent to change and imperfection: "Nothing that lives is, or can be, rigidly perfect; part of it is decaying, part nascent. . . . And in all things that live there are certain irregularities and deficiencies which are not only signs of life, but sources of beauty." Wheat, because it is of a nobler nature than the wild grass which consistently grows well and strongly, is liable to a bitterer blight.[79] In "The Lamp of Obedience" he had argued that "exactly in proportion to the majesty of things in the scale of being, is the completeness of their obedience to the laws that are set over them."[80] But now he says that if judged by the standard of perfect obedience to the laws of nature, "brute animals would be preferable to man, because more perfect in their functions and kind," and consequently one must distinguish between the perfectness of lower natures and the imperfectness of the higher. Aware that he had departed from the emphasis on law that pervaded *The Seven Lamps*, Ruskin insisted, later in *The Stones of Venice*, that he still held by what he had said in 1849 but that he now saw the need to distinguish between laws that can be reduced to form and system and those that are inscribed only in the heart, and to recognize that as men rise above the state of animals and children, "they become emancipated from this

written law, and invested with the perfect freedom which consists in the fullness and joyfulness of compliance with a higher and unwritten law; a law so universal, so subtle, so glorious, that nothing but the heart can keep it."[81]

Although Ruskin labels his creed of imperfection Christian, it is also recognizable as the romanticism Arnold attacked in his 1853 Preface. If in 1853 Arnold and Ruskin used essentially the same technique for relating art to morality, and for contrasting past and present, they sought to discover very different virtues and to enforce nearly opposed values. Whereas Arnold praised in Greek art the example of subordination of the parts to the whole and of the artist to his art, Ruskin saw in the conditions of modern industrial work the very image of that servile subordination of part to whole, of inferior to superior workman, that for him characterized Greek architecture. Consequently, Ruskin's ideal past was not ancient (and pagan) Greece but medieval (and Christian) Europe.

By a strange leap of historical imagination Ruskin saw in the conditions of modern industrial production a continuation of the ethos of Greek architecture. Like Arnold in the 1853 Preface he too was seeking to apply Carlyle's social and psychological doctrine of work in the realm of aesthetics. Arnold did this by asserting that a poem could not give pleasure if it had as its subject a state of mental distress that found no vent in action; in so asserting, he was transferring Carlyle's notion of work as a psychological anodyne, a way of preventing mental paralysis, to the realm of art. Ruskin, on the other hand, used Carlyle's doctrine of work not as a way of escaping from the hesitation that came from excessive thought but as a means of judging works by the quality of labor that had produced them. Ironically, it was Ruskin, the supposed disciple of Carlyle, rather than the Arnold who had in 1849 called Carlyle a moral desperado, who came close to subverting the master's doctrine of work by insisting that the truly important question was what *kind* of work men did:

Understand this clearly: You can teach a man to draw a straight line, and to cut one; to strike a curved line, and to

carve it; and to copy and carve any number of given lines
or forms, with admirable speed and perfect precision; and
you find his work perfect of its kind: but if you ask him to
think about any of these forms, to consider if he cannot find
any better in his own head, he stops; his execution becomes
hesitating; he thinks, and ten to one he thinks wrong; ten
to one he makes a mistake in the first touch he gives to his
work as a thinking being. But you have made a man of
him for all that. He was only a machine before, an animated
tool.[82]

G. K. Chesterton, exercising his unparalleled gift for the epigram-
matic statement of falsehood, has stated that Matthew Arnold "re-
minded us that Europe was a society while Ruskin was treating it as a
picture gallery."[83] We have seen how in 1853 both men were seeking
an extra-artistic standard by which to judge works of art, and were
finding it in the question of whether the work gave pleasure to the
great masses of men. Yet Ruskin was already having difficulty in con-
ceiving of the question solely in terms of the production and recep-
tion of works of art. In "The Nature of Gothic" he leaves the frame-
work of architectural inquiry to tell his readers that the foundations
of European society are being shaken—not because men are ill fed,
but because "they have not pleasure in the work by which they make
their bread, and therefore look to wealth as the only means of plea-
sure." The solution to the modern industrial problem lies in a true
understanding of, and a return to, those conditions of free and inde-
pendent labor that built and ornamented the Gothic cathedrals.

We must not suppose that by 1853 Ruskin had transformed him-
self from an aesthetician into a social critic; "The Nature of Gothic"
is but a single chapter in a long three-volume work, and in 1854 Rus-
kin expressed some uneasiness about printing it separately lest it be
thought the work of a mere pamphleteer.[84] He had, however, shown
that the problems of modern industrial society were sufficiently com-
pelling to distract him from the work he naturally loved and to move
him deeply, even violently.

Modern problems are a major concern of Arnold's 1853 Preface,

but they are the psychological problems of doubt, discouragement, "the dialogue of the mind with itself." Social problems appear only as one of the many modern forces that threaten to distract the poet from his true calling and one obligation. That obligation is not to praise the modern age but "to afford to the men who live in it the highest pleasure which they are capable of feeling." If the artist is told that to do this great service for his contemporaries he must deal with contemporary subjects, he is obliged to ask what special fitness the present age has for supplying the great actions that are requisite to great poetry. If he is told, as Arnold is sure he will be, that "it is an era of progress, an age commissioned to carry out the great ideas of industrial development and social amelioration," he must reply that with all this he can do nothing.[85]

It is important to see that in 1853 Arnold does not merely share Ruskin's hostility to modern society; he believes that, to survive, the artist must not only not descend to praise that society, he must not descend to quarrel with it: "He will not . . . maintain a hostile attitude towards the false pretensions of his age: he will content himself with not being overwhelmed by them. He will esteem himself fortunate if he can succeed in banishing from his mind all feelings of contradiction, and irritation, and impatience; in order to delight himself with the contemplation of some noble action of a heroic time, and to enable others, through his representation of it, to delight in it also."[86] Polemic and great art do not mix.

By 1853 Arnold had come to share Ruskin's desire for a moral aesthetic derived from the art of a particular past, and to feel deeply the moral obligations of the artist. But unlike Ruskin he still firmly believed that the artist best fulfilled this obligation as an artist rather than as a reformer or social critic. Arnold was in 1853 abandoning but a single poem, and so he could still believe that the resolution of his problem might lie in a reform of current poetic methods; it was not until he was faced with the abandonment of poetry altogether that he saw the resolution of artistic problems as inseparable from the resolution of social problems.

On the whole, these are much sadder *ages than the early ones; not sadder in a noble and deep way, but in a dim, wearied way,—the way of ennui, and jaded intellect, and uncomfortableness of soul and body. The Middle Ages had their wars and agonies, but also intense delights. Their gold was dashed with blood, but ours is sprinkled with dust.*—John Ruskin, Modern Painters III (1856)

The predominance of thought, of reflection, in modern epochs is not without its penalties; in the unsound, in the over-tasked, in the over-sensitive, it has produced the most painful, the most lamentable results; it has produced a state of feeling unknown to less enlightened but perhaps healthier epochs—the feeling of depression, the feeling of ennui. Depression and ennui; *these are the characteristics stamped on how many of the representative works of modern times!*—Matthew Arnold, "On the Modern Element in Literature" (1857)

The Modern Element in Art and Literature

The fact that "The Nature of Gothic" is so often reprinted in isolation from the rest of *The Stones of Venice* may give the impression that in 1853 Ruskin's career had taken a definitive new direction and that his life had assumed its distinctive and permanent form. But Ruskin's letters in the period immediately following the publication of the work he had written in such joy show that *The Stones of Venice* was but a halfway house on his path to a new and less congenial kind of work.

Ruskin's demanding conscience, far from being satisfied with his massive three-volume effort to enlist art in the service of morality, now reproached him more than ever before for his aloofness from mundane human affairs. To observe Ruskin in these years is to be reminded of Bernard Shaw's definition of the Puritanical Englishman as someone who thinks he is being moral when he is only being uncomfortable. No more than before was Ruskin's discomfort over his ambiguous role in the world purely the result of external criticism, though such criticism certainly existed. John Millais (a prejudiced source, to be sure) described Ruskin in the very month (July) that the second and third volumes of *The Stones of Venice* were appearing as "a good fellow but not of our kind, his soul . . . always with the clouds and out of reach of ordinary mortals."[1] But Ruskin's real problem was that he was becoming too sensitive to the plight of ordinary mortals for his own comfort, and was already growing desperate to find a means of response that was commensurate with the massiveness of the problem, or at least an intellectual point of view from which to survey it in all its variety and complexity: "The whole system of modern society, politics, and religion seems to me so exquisitely absurd that I know not where to begin about it—or to end.

My father keeps me in order, or I should be continually getting into scrapes. . . . "[2]

Far from thinking that *The Stones of Venice* had fulfilled his deep moral and religious obligations, Ruskin now felt that he had never in his work been other than comfortable, or done more than please himself. Despite all his ingenious efforts to devote his books on art to the service of man and the glory of God, he felt as he approached his thirty-fifth birthday that

> my next birthday is the keystone of my arch of life . . . and up to this time I cannot say that I have in any way "taken up my cross" or "denied myself"; neither have I visited the poor nor fed them, but have spent my money and time on my own pleasure or instruction. I find I cannot be easy in doing this any more, for I feel that, if I were to die at present, God might most justly say to me, "Thou in thy lifetime receivedst thy good things, and likewise Lazarus evil things." I find myself always doing what I like, and that is certainly not the way to heaven. I feel no call to part with anything that I have, but I am going to preach some most *severe* doctrines in my next book, and I *must* act up to them in not going on spending in works of art.[3]

To cease spending enormous amounts of money on works of art may seem rather a paltry step to take in the direction of selling all one has and giving it to the poor, but for Ruskin it seemed the natural first step to take, for it was sure to cause him pain.

If doing as one liked was not the way to heaven, neither was withdrawal from the world, always a powerful temptation to Ruskin. His mother at this time was even more concerned than was her wont about his health and tried to exact from her son a promise not to lecture until he was forty-two. He responded to her pleas by invoking the great Victorian watchword, *duty*: "There is a great deal to be done in the world which is inconsistent with health—yet is duty. Perhaps for *my health*, it might be better that I should declare at once I wanted to be a Protestant monk: separate from my wife and go and live in that

hermitage above Sion which I have always rather envied. But then I don't think my works . . . would do so much good as when I bear a little with the world. . . . "⁴ In the deepest part of his soul Ruskin must have known that he could not be true to himself or even truly happy in isolation from society. "Men like Ruskin," Shaw was later to write, " . . . have enormous social appetites and very fastidious personal ones. They are not content with handsome houses: they want handsome cities. . . . They turn up their noses at their neighbor's drains, and are made ill by the architecture of their neighbors' houses. . . . The very air is not good enough for them: there is too much factory smoke in it. They even demand abstract conditions: justice, honor, a noble moral atmosphere, a mystic nexus to replace the cash nexus."⁵

But the more deeply involved Ruskin became in the effort to alleviate human suffering and to bring happiness to others, the more loudly he began to deplore his own lost happiness. It was to be one of the terrible ironies of his career that he had no sooner published a work asserting that the right question to be asked respecting any product was whether the worker was happy in producing it than he was impelled by his uneasy conscience toward a kind of work that made him miserably unhappy.

The year 1854 was for Ruskin one of violent fluctuation between effervescent enthusiasm and blank despair. It was the year of the disintegration and annulment of his marriage in July but also of a great sense of relief and freedom after the ordeal was over. He again traveled in his beloved Switzerland in preparation for continuing *Modern Painters*; and he was, as usual, filled with myriad plans and projects:

> . . . I am rolling projects over and over in my head. I want to give short lectures to about 200 at once in turn, of the sign painters, and shop decorators, and writing masters, and upholsterers, and masons, and brickmakers, and glass-blowers, and pottery people, and young artists, and young men in general, and school-masters, and young ladies in general,

and school-mistresses; and I want to teach Illumination to the sign painters and the younger ladies; and to have prayer books all *written* again (only the Liturgy altered first, as I told you), and I want to explode printing, and gunpowder —the two great curses of the age; I begin to think that abominable art of printing is the root of all the mischief— it makes people used to have everything the same shape. And I mean to lend out *Liber Studiorums* and Albert Dürers to everybody who wants them; and to make copies of all fine thirteenth-century manuscripts, and lend *them* out—all for nothing, of course; and to have a room where anybody can go in all day and always see *nothing* in it but what is *good*, with a little printed explanatory catalogue saying *why* it is good; and I want to have a black hole, where they shall see nothing but what is bad, filled with Claudes, and Sir Charles Barry's architecture, and so on; and I want to have a little Academy of my own in all the manufacturing towns, and to get the young artists—Pre-Raphaelite always—to help me; and I want to have an Academy exhibition, an opposition shop, where all the pictures shall be hung on the line— in nice little rooms decorated in a Giottesque manner—and no bad pictures let in, and none good turned out, and very few altogether—and only a certain number of people let in each day, by ticket, so as to have no elbowing. And as all this is merely by the way, while I go on with my usual work about Turner, and collect materials for a great work I mean to write on politics—founded on the thirteenth century—I shall have plenty to do when I get home.[6]

Yet this irresistible buoyancy masked a feeling of growing desperation. For the more Ruskin saw of the world, the more helpless he felt to right its disastrous course, and the more doubtful he became about the possibility of doing this "merely by the way" as he pursued his "usual work about Turner." "The more I see of the human race," he wrote to Acland in July, "the more I think they are divided into two classes—intensely fixed in their natures—creatures made to honour and to dishonour, as the Potter willed. At least I

find it a marvellous hard thing to Unbake myself—which I have been trying to do more than usual lately. . . . "[7] In August he counseled a young friend to a patience and a resignation he could not encompass himself. Long and steady effort made in a contented way, he advised J. J. Laing, does more than violent effort made for some strong motive or at the call of enthusiastic impulses. Great things come easily and naturally, for they flow from one's genius; the "innumerable vexations and irritations" of life generally result from such noble motives as the wish to "do good to your fellow creatures." "The great lesson we have to learn in this world is to *give it all up*. It is not so much resolution as renunciation, not so much courage as resignation, that we need." But it was one thing to counsel resignation, another to practice it. At the very time that Ruskin was preaching renunciation of the world, he was telling his disciple Furnivall that "I *must* speak if I see people thinking what I know is wrong. . . . Until people are ready to receive all I say about art as 'unquestionable,' just as they receive what Faraday tells them about chemistry, I don't consider myself to have any reputation at all worth caring about."[8]

Ruskin might demonstrate that good work was the product of happy workers, and might tell others that work which came easily and naturally was the key to happiness; but his own experience confirmed neither precept. In 1855 he told Rossetti that his own pleasures consisted "in seeing, thinking, reading and making people happy (if I can, consistently with my own comfort)."[9] But he was finding that he could not work toward the happiness of others except at the sacrifice of his own. "All I hope for," he wrote, "is to be able to show, and to make men understand, how they may live more comfortably —get better wages—and be happier and wiser than they are at present." But this kind of "useful" work went against his grain and made him wretched: "I find trying to be of use to people is the most wearying thing possible. The true secret of happiness would be to bolt one's gates, lie on the grass all day, take care not to eat too much dinner, and buy as many Turners as one could afford." The same man who in the winter of 1851–52 had been writing with all the joy that he could ever ascribe to a Gothic sculptor now, in 1855, found that

he was sacrificing his life to his work: "I never write with pleasure to myself—nor with purpose of getting praise to myself—I hate writing—and know that what I do does not deserve high praise, as literature; but I write to tell truths which I can't help crying out about—. . . . "[10]

William Butler Yeats, a wayward pupil of the school of Ruskin and William Morris, was later to define in starkest terms the alternatives facing the modern writer:

> The intellect of man is forced to choose
> Perfection of the life, or of the work,
> And if it take the second must refuse
> A heavenly mansion, raging in the dark.
>
> ("The Choice," 1–4)

In 1855, several years before becoming embroiled in the economic and political controversies that were to fill his life with storm and contention, Ruskin was already becoming aware of the choice that was soon to be forced upon him, and of the terrible consequences, the "raging in the dark," that choosing the perfection of the work over perfection of the life might bring. He now found that his favorite figure from the Bible was Job, and his favorite figure from romance, Don Quixote: "If Don Q. had not been mad, I should have liked *him* best—on the whole I believe I do."[11]

But in 1855 Ruskin has not yet been forced to make the hard choice, and has not yet taken to calling himself, as he later would, "the Don Quixote of Denmark Hill."[12] In the previous year John Stuart Mill had paid high tribute to Ruskin as the single English writer who was not a mere commentator on other people's ideas but seemed to draw what he said from a source within himself; and in 1856 George Eliot called him "the finest writer living."[13] As yet the world was all before him; and wherever his omnivorous appetite led him—into the realms of intellect, of politics, or of practice—he found confusion and an invitation to his eager reforming impulse. Moreover, he had sought to bring order into his own confusion of purpose and his miscella-

neous activities by entering what Matthew Arnold liked to call "that most perfidious refuge of men of letters": the profession of teaching.

Ruskin was hard at work on the third and fourth volumes of *Modern Painters* late in 1854—Rossetti had been chiding that "*Modern Painters* . . . will be old masters before the work is ended"—when the Working Men's College opened in an old house in Red Lion Square. This project to give the working classes the same kind of education that the upper classes enjoyed without making them ambitious of rising out of their class had been organized under the leadership of F. D. Maurice and the Christian Socialists, among them Dr. Arnold's pupil Thomas Hughes (who taught gymnastics). But the Platonic idea of the college was contained in the copies of "On the Nature of Gothic," which were distributed, with Ruskin's blessing now, at its opening; and Ruskin was not long in volunteering to teach art at the school.

The question of the *practicality* of his social doctrines was always to be a sore point with Ruskin. Mill himself had qualified his glowing tribute to Ruskin's unique originality in January 1854 by adding that "to the practical doctrines and tendencies" of Ruskin "there are the gravest objections." Ruskin might bridle at criticisms leveled by the practical men at social critics—"There is really nothing funnier . . . than the way the 'practical' people turn round upon Carlyle and Tennyson and Kingsley, and all Thinkers whatsoever, who find fault with said 'practical' persons, saying, 'You find fault with what is going on—why don't you tell us what would be right?' "[14] Yet his very own principles obliged him to answer them. For a critic who had written that modern thought was morbid and modern work miserable because the two had been unlawfully divorced could hardly evade the question of the practical applicability of his ideas and the practical alternatives he proposed to the existing practices he deplored. Indeed, before he retired from the public eye to Brantwood, he was to have entered the realm of practice in a variety of ways, from slum-clearance to road-mending, which were to call down upon his head the wrath of many, not least among them, as we shall see later, Matthew Arnold.

But Ruskin's first entrance into the realm of "practice," (if we are willing to forgo the popular distinction between those who do and those who teach) was a successful one, partly because it was not a striking departure from his major enterprise. Writing had by this time become for him a form of teaching (if not preaching), and so the class-room instruction was but a variant of his primary activity. He hoped, of course, that it would be a more effective *kind* of teaching: "One may do more with a man," he later wrote, "by getting ten words spoken with him face to face, than by the black lettering of a whole life's thought."

Ruskin's teaching techniques and purposes were in accordance with the principles he had laid down in his *Times* letter of 1852 on education and in "The Nature of Gothic" on the relation between the workman's life and his work. "My efforts," he told the National Gallery Site Commission in 1857, "are directed not to making a carpenter an artist, but to making him happier as a carpenter."[15] He taught drawing primarily in order to direct his pupils' attention to the beauty of God's work in the natural universe. The aim, in short, was to effect a moral improvement in working men by developing their aesthetic sense.

For four years Ruskin taught a weekly class at the Working Men's College, and the conscientiousness of his practical benevolence can be seen in the following description of his methods, one of many that have been bequeathed us by his grateful students (for Ruskin was, even according to the hostile Ford Madox Brown, "wildly popular with the men"):

> Mr. Ruskin did not confine his work with the men to mere teaching. He gave the easels for them to work at, and from time to time furnished them with examples for drawing— always trying their powers at first with a round plaster ball pendent from a string, then going on to plaster casts of natural leaves (all of which were paid for by him). Also, he frequently brought drawings by various artists, belonging to him, for the purpose of showing how certain effects were got, *e.g.*, the rounding of a pear by William Hunt. (This

drawing was eventually spoilt by being exposed to the fumes of the gas in the class-room.) Mr. Ruskin was always pleased to bring anything associated with any work of his in progress, if he thought it would interest the men. I remember, one evening, his showing proofs of "The Lombard Apennine" and "St. George of the Seaweed," then just engraved by Thomas Lupton for vol. iii. of *Modern Painters.* Another time, when he wanted the men, for a change of subject, to draw cordage, he sent me down to a shipbreaker's at Rother-hithe to buy some old ships' hempen cable.[16]

This letter serves to remind us that Ruskin taught at the college during most of the time that he was composing *Modern Painters* III and IV. It is easy to believe that he partially assuaged whatever feelings of guilt he had about returning to his labor of love begun as a boy by engaging in practical benevolence (of which teaching was but the most public form at this time). He ceased to teach regularly at the college in May of 1858, but returned in 1860 for a term. 1860, however, was the year of *Unto This Last,* and by that time Ruskin had come to believe that in his teaching as in his art criticism he had put the cart before the horse. When in 1867 he had to explain to Maurice why he had ceased attendance at the school altogether, he wrote that "it is not from any failure in my interest in this class that I have ceased from personal attendance. But I ascertained beyond all question that the faculty which my own method of teaching chiefly regarded was necessarily absent in men trained to mechanical toil, that my words and thoughts respecting beautiful things were unintelligible when the eye had been accustomed to the frightfulness of modern city life."[17] Ruskin as a schoolmaster taught his pupils much, but they were to teach him more, by enabling him to see that art by itself could not effect moral regeneration in an unregenerate and unreformed society. Arnold was destined to learn a similar lesson in the schools. Only Arnold, unlike Ruskin, would be obliged by his straitened circumstances to remain in the schools and to discover in the maladies of the school system the maladies of English society, and in the effort to reform that school system the principles of his social and political philosophy.

Perhaps it is the optimism natural to young men who have never stood in front of a classroom that leads them to believe that instruction in art and literature can transform the human condition. Arnold had not yet become a school official (though he had spent some months teaching the lower fifth at Rugby) when in 1848 or 1849 he wrote to Clough that "those who cannot read G[ree]k sh[ou]ld read nothing but Milton and Wordsworth: the state should see to it. . . . "[18] But Arnold was shortly to find that between literature in general (to say nothing of the poetic life in particular) and state education there existed a violent, though not a natural, antipathy.

It was one thing to say that students should read Milton, another to find people who could teach them how to read Milton. "You should have heard the rubbish the female Principal, a really clever young woman, talked to her class of girls of seventeen to eighteen about a lesson in Milton." To the world at large Arnold was to become known as a champion of classical education, yet it was his constant complaint about the schools that, as he wrote later, in 1868, "We have still to make the mother tongue and its literature a part of the school course. . . . "[19]

In Arnold's 1852 report to the government on the elementary schools, he let it be known that the most striking impression he had received of the failure of the elementary schools during his first year as an inspector came from the inability of the pupil-teachers to understand English literature. The pupil-teachers, who had been the prize products of the elementary schools, seemed to Arnold, when he examined them at the end of their apprenticeship, at about age eighteen, possessed of an amount of positive, factual information out of all proportion to their mental culture and intelligence: "Young men, whose knowledge of grammar, of the minutest details of geographical and historical facts, and above all of mathematics, is surprising, often cannot paraphrase a plain passage of prose or poetry without totally misapprehending it, or write half a page of composition on any subject without falling into gross blunders of taste and expression." Arnold, believing that poetry was a moral instrument, as Ruskin believed that art-teaching would make not artists but better men,

wanted, just as Ruskin did, the same *kind* of education for these young men that the upper classes received. "Too little attention has hitherto been paid to this side of education; the side through which it chiefly forms the character; the side which has perhaps been too exclusively attended to in schools for the higher classes, and to the development of which it is the boast of what is called classical education to be mainly directed."[20] To remedy the situation, Arnold proposed that the study of portions of the best English authors be given a much larger role in the regular course of instruction.

The extent to which his earliest experience of the failure of English literary education penetrated Arnold's consciousness can be seen in the way he exploited it, thirty years later, in "Literature and Science," to prove the inadequacy of a purely scientific education. Arnold never ceased to bemoan his sufferings as a school inspector, and to complain of the obstacle that school-inspection posed to his poetry: "I hope you will remember," he once scolded a correspondent, "that while Mr. Tennyson has nothing to do but to read poetry or write it, I am a school inspector with hundreds of school-children to examine and report upon every week."[21] Nevertheless, Arnold knew that even out of "business documents and school-books," as Tolstoy describes the prosaic life, one might make, if not poetry, then certainly literature. When he did turn his experience of the classroom into literature, he stressed not the incongruity of the poet mired in a particularly disordered and grimy kind of life but the power of poetry to act, in the best and most literal sense, as a criticism of that life:

> I once mentioned in a school-report, how a young man in one of our English training colleges having to paraphrase the passage in *Macbeth* beginning, "Can'st thou not minister to a mind diseased?" turned this line into, "Can you not wait upon the lunatic?" And I remarked what a curious state of things it would be, if every pupil of our national schools knew, let us say, that the moon is two thousand one hundred and sixty miles in diameter, and thought at the same time that a good paraphrase for "Can'st thou not minister to a mind diseased?" was, "Can you not wait upon the lunatic?"

> If one is driven to choose, I think I would rather have a young person ignorant about the moon's diameter, but aware that "Can you not wait upon the lunatic?" is bad, than a young person whose education had been such as to manage things the other way.[22]

But in the fifties Arnold had not yet achieved that Olympian detachment from his own miseries which would allow him to transform the life in the schools into the object of literary criticism. School-inspecting was for him still only life, and not yet literature; and an oppressive life it was. He who had recently called on poets to rejoice their audiences now felt more than ever the joylessness of his own existence. He told his wife that only her presence on some inspection tours could "make this life anything but positive purgatory." Ironically, poetic composition, which had caused him much pain when it was his main occupation, now, as a spare-time activity, provided him with his only pleasure. Of "Sohrab and Rustum," which was to replace "Empedocles on Etna" as the chief poem in the new volume, Arnold wrote to his mother in May, "I have had the greatest pleasure in composing it—a rare thing with me, and . . . a good test of the pleasure what you write is likely to afford to others. . . . " A few months later he told Clough that "a thousand things make one compose or not compose: composition seems to keep alive in me a *cheerfulness*—a sort of Tüchtigkeit, or natural soundness and valiancy, which I think the present age is fast losing—this is why I like it."

But the predominant mood of these years was grim frustration. "Sohrab and Rustum," he told Clough too, "pleases me better than anything I have yet done—but it is pain and grief composing with such interruptions as I have. . . . " Arnold's duties as an inspector were leading him to believe that life after thirty was little besides "cares." If Ruskin was during these years moved by conscience toward a kind of worldly endeavor uncongenial to his artistic and contemplative tastes, Arnold was compelled by financial necessity to pursue "an employment which I certainly do *not* like, and which leaves me little time for anything else." Ruskin, when his mother

warned of the damage that lecturing might do to his health, had replied that he must do his duty; and Arnold, who suffered not only from the bad health that sometimes beset Ruskin but from such mundane miseries as fatigue, wretched food, and even bare hunger, told his mother at the end of 1854: "I am not very well lately, have had one or two things to bother me, and more and more have the feeling that I do not do my inspecting work really well and satisfactorily; but I have also lately had a stronger wish than usual not to vacillate and be helpless, but to do my duty, whatever that may be; and out of that wish one may always hope to make something."[23]

In the idea of doing one's duty, even if it were in "purgatory," there lay hope; and that hope was by 1859–60 to bear fruit in Arnold's conversion to the cause of popular education. But as yet he not only did not see, but even resisted any suggestion of, a connection between his dreary work and the high educational mission of his father. His mother sends him a newly discovered letter of Dr. Arnold's that plots the education of his children, and he remarks that "this is just what makes him great—that he was not only a good man saving his own soul by righteousness, but that he carried so many others with him in his hand, and saved them, if they would let him, along with himself." Yet Dr. Arnold's son is irritated by having to accept invitations from managers of schools who are recalcitrant toward government regulation yet "ask me on my father's account to come and inspect them"; and he even resents the popular supposition that any son of Thomas Arnold must have a talent for education. He wrote in 1856 to his brother Willy, who had been appointed director of public instruction in the Punjab: "I too have felt the absurdity and disadvantage of our hereditary connexion in the minds of all people with education, and am always tempted to say to people, 'My good friends, this is a matter for which my father certainly had a specialité, but for which I have none whatever.' "[24]

But William Arnold was at least better off than Matthew, for he threw himself into the work and therefore ceased to feel it a burden. "I on the contrary half cannot half will not throw myself into it, and feel the weight of it doubly in consequence." The reason Arnold

could not plunge wholeheartedly into the dreary routine of inspection was that he was determined to save himself for "something worth doing in my own way," although, as he wrote less and less poetry— "Balder Dead" had been the only important new poem in the 1854 volume—he was not at all sure what his own work was. Arnold certainly felt the dullness and subjugation of school inspection to the full, and yet he had sufficient self-knowledge to recognize that "it would have been the same with any active line of life on which I had found myself engaged—even with politics." That it was his destiny to lead a divided life Arnold already knew; and there is fatalistic resignation as well as humor in the picture he gives of himself after telling his brother that he has declined the offer to become colonial secretary of Mauritius at a salary of £1,500 (six hundred more than he earned as an inspector): "The climate of the Mauritius is heavenly and we could have taken the children—I should have sate all day on a coral rock, bathing my legs in the Southern ocean."[25]

But Arnold was no more likely to go to the Indian Ocean than Ruskin to a Protestant monastery; and the flight into fantasy is abruptly followed by a descent into the great, mundane world of London: "There is nothing here in literature worth speaking of—except that the National Review is doing well—that Ruskin has published a new volume of Modern Painters even fuller than the others of true 'aperçus,' even more than the others deprived of the 'ordo concatenatioque veri' which is the one thing needful. However to have good and faithful 'aperçus' is a great thing."[26]

That the third volume of *Modern Painters*, which Ruskin had published on 15 January 1856, was much on Arnold's mind in March is at least suggested by the fact that, having enlightened his brother about Ruskin's continuing inability to marshal his excellent perceptions according to the order and concatenation of truth, Arnold at once felt obliged to put pen to paper and tell his sister *why* Ruskin was unable to find an organizing idea for his insights: "Have you seen Ruskin's new volume of *Modern Painters*? I ask you because I saw William alluded to him in his speech. Full of excellent *aperçus*, as usual, but the man and character too febrile, irritable, and weak to allow him to possess the *ordo concatenatioque veri*."[27]

Arnold had once before, in a letter to Clough of 1848–49, deplored the impatient disregard for organizing ideas in much modern English literature. He had charged that modern poets like Keats and Browning "will not be patient neither understand that they must begin with an Idea of the world in order not to be prevailed over by the world's multitudinousness: or if they cannot get that, at least with isolated ideas. . . . "[28] He now found in Ruskin's ambitious new prose work further illustration of the capacity of the troubled multifarious modern world to overwhelm a writer unarmed with coherent general ideas.

G. M. Young has said that the mind of Ruskin "was endowed with every gift except the gift to organize the others."[29] For Arnold, Ruskin's transgression was in one sense worse than that of Keats of Browning because it was polemical and intentional, and positively invited such criticisms as Arnold's. Not only did Ruskin entitle the new volume *Of Many Things*, but as he launched his discussion of the "Grand Style," he brashly announced his contempt for system-makers, his absolute indifference to assigning groups of facts to general laws, and his total freedom to wander whither he would in his inquiries:

> Much time is wasted by human beings, in general, on establishment of systems; and it often takes more labour to master the intricacies of an artificial connection, than to remember the separate facts which are so carefully connected. I suspect that system-makers, in general, are not of much more use, each in his own domain, than, in that of Pomona, the old women who tie cherries upon sticks, for the more convenient portableness of the same. . . . I purpose, therefore, henceforward to trouble myself little with sticks or twine, but to arrange my chapters with a view to convenient reference, rather than to any careful division of subjects, and to follow out, in any by-ways that may open, on right hand or left, whatever question it seems useful at any moment to settle.[30]

If we wish to discover what Arnold's principle of the *ordo concatenatioque veri* is in addition to being the reverse of what Ruskin

does, we have only to turn to the opening remarks of Arnold's inaugural lecture of the following year as Oxford Professor of Poetry. He had been elected on 5 May 1857 to the position, whose duties consisted in examining the prize compositions, delivering a Latin oration in praise of founders at alternate commemorations, and giving three Latin lectures on ancient poetry in the course of the year. But he broke with tradition and decided to lecture in English. Ruskin, starting in March of this year, had begun to show how effective the public lecture might be in conveying serious ideas on society and the arts; and in any case Arnold did not want "to entomb a lecture which, in English, might be stimulating and interesting" by speaking in Latin.[31]

Arnold delivered the first of a projected series of lectures on "The Modern Element in Literature" on 14 November 1857. Young William Wordsworth, grandson of the poet, said of it that Arnold "seems to lust after a system of his own: and systems are not made in a day. . . ."[32] Arnold would later in life be quite as harsh with system-makers as Ruskin is at the outset of the third volume of *Modern Painters*, but if "On the Modern Element in Literature" is in large part what I believe it to be, a response to Ruskin, then we need not be surprised that Arnold, in combating so brazen an antiphilosophical position as Ruskin's, should at least have seemed systematic to some of his Oxford audience.

Arnold opens his lecture by asserting that, although both are necessary, a modern nation is more in need of intellectual than of moral deliverance. He promises to show, in the course of his lecture, that the literature of ancient Greece can be a mighty instrument of intellectual deliverance for modern England. But first he must show why it is that an intellectual rather than a moral deliverance is the particular need of modern societies.

Implicitly, the elevation of intellectual above moral deliverance is a contradiction of one theme of Arnold's earlier piece of criticism, the 1853 Preface. For in rejecting "Empedocles on Etna" Arnold had explicitly said that literature must do more than add to the knowledge of men; it must also add to their happiness. *Catharsis* could be achieved only through action, not through understanding. The contradiction is

partly explainable, as are other changes in emphasis from the 1853 Preface, by Arnold's wish to be more accommodating to those who had criticized his own lack of modernity, and to ask how literature can be adequate to the modern age instead of deploring the modern age as an inadequate subject for great literature. But the new emphasis on intellectual control is also explainable as a response to Ruskin's recent work.

Arnold had in the previous year attributed Ruskin's failure in *Modern Painters* III to attain the *ordo concatenatioque veri* to the nervous irritability of Ruskin's character. He now tells his Oxford listeners that the present age demands an intellectual deliverance because it is faced by "the spectacle of a vast multitude of facts" that invite yet defy comprehension. Deliverance will come when man can comprehend his present in relation to his past; and it begins "when one mind begins to enter into possession of the general ideas which are the law of this vast multitude of facts." Intellectual deliverance will be perfect, however, only "when we have acquired that harmonious acquiescence of mind which we feel in contemplating a grand spectacle that is intelligible to us; when we have lost that impatient irritation of mind which we feel in presence of an immense, moving, confused spectacle which, while it perpetually excites our curiosity, perpetually baffles our comprehension."[33]

Could there be a more striking example of the irritation excited in an eager, curious mind by the immense, confused spectacle of modern facts than Ruskin's description of his state of mind as he was composing *Of Many Things*?

> Not that I have not been busy—and very busy, too. I have written, since May, good 600 pages, had them rewritten, cut up, corrected, and got fairly ready for press—and am going to press with the first of them on Gunpowder Plot Day; with a great hope of disturbing the Public Peace in various directions. Also, I have prepared above thirty drawings for engravers this year, retouched the engravings (generally the worst part of the business), and etched some on steel myself. In the course of the 600 pages I have had to make var-

ious remarks on German Metaphysics, on Poetry, Political Economy, Cookery, Music, Geology, Dress, Agriculture, Horticulture, and Navigation, all which subjects I have had to "read up" accordingly, and this takes time. Moreover, I have had my class of workmen out sketching every week in the fields, during the summer; and have been studying Spanish proverbs with my father's partner, who came over from Spain to see the great Exhibition. I have also designed and drawn a window for the Museum at Oxford; and have every now and then had to look over a parcel of five or six new designs for fronts and backs to the said Museum. During my above mentioned studies of Horticulture I became dissatisfied with the Linnaean, Jussieuan, and Everybody-elsian arrangement of plants, and have accordingly arranged a system of my own; and unbound my botanical book, and rebound it in brighter green, with all the pages through other, and backside foremost—so as to cut off the old paging numerals; and am now printing my new arrangement in a legible manner, on interleaved foolscap. I consider this arrangement one of my great achievements of the year. My studies of political economy have induced me to think also that nobody knows anything about that, and I am at present engaged in an investigation, on independent principles, of the Natures of Money, Rent, and Taxes, in an abstract form, which sometimes keeps me awake all night. My studies of German metaphysics have also induced me to think that the Germans don't know anything about *them*; and to engage in a serious inquiry into the meaning of Bunsen's great sentence in the beginning of the second volume of Hippolytus, about the Finite realization of the Infinity; which has given me some trouble. The course of my studies of navigation necessitated my going to Deal to look at the Deal boats; and those of Geology to rearrange all my minerals (and wash a good many, which, I am sorry to say, I found wanted it). I have also several pupils, far and near, in the art of illumination, an American young lady to direct in the study of landscape painting, and a Yorkshire young lady to direct in

the purchase of Turners—and various little bye things be-
sides.[34]

Many years after the publication of the 1856 volumes of *Modern
Painters*, Ruskin explicitly admitted, regarding his discussion of the
cause of love of mountains, that "the more I analysed, the less I could
either understand or justify." If love of mountains was, as Ruskin
claimed, an index of nobility, why was it not present in all noble
minds? "In the end, I found there was nothing for it but simply to
assure those recusant and grovelling persons that they were perfectly
wrong, and that nothing could be expected, either in art or literature,
from people who liked to live among snipes and widgeons." Even
E. T. Cook and Alexander Wedderburn, usually undeviating in their
loyalty to Ruskin, comment that "at this one point . . . at least,
Ruskin may be held to have confirmed a criticism which Matthew Ar-
nold made upon reading the book in 1856. . . ."[35]

The earlier chapters of the third volume of *Modern Painters* re-
peatedly refer to the seeming contradictions in the work—not to deny
but to flaunt them. In 1858 Ruskin expressed himself positively
pleased by the charge that he was apt to contradict himself: "I hope
I am exceedingly apt to do so. . . . I am never satisfied that I have
handled a subject properly till I have contradicted myself at least
three times." Mere intellectual disunity and a shifting point of view
could always be covered by his blanket assertion of singleness of reli-
gious purpose throughout *Modern Painters*, in which "there is no vari-
ation from its first syllable to its last. It declares the perfectness and
eternal beauty of the work of God. . . ."[36]

Arnold, after having stated the reason for, and the nature of, an
intellectual deliverance in his first Oxford lecture, proceeded to iden-
tify the facts that required comprehension. They are, according to
him, nothing less than the collective life of humanity up to the pres-
ent time; and to be understood they must be viewed not as isolated
phenomena but as coherent parts of a general pattern: "Everywhere
there is connexion, everywhere there is illustration: no single event,
no single literature, is adequately comprehended except in its relation

to other events, to other literatures. The literature of ancient Greece, the literature of the Christian Middle Age, so long as they are regarded as two isolated literatures, two isolated growths of the human spirit, are not adequately comprehended. . . . " Yet they must be comprehended if the modern age is to comprehend itself, and to be freed from what Arnold takes to be the illusion that "modern" problems are historically unprecedented. All facts do not, of course, have an equal importance; and selection is necessary not only to maintain a sense of proportion but because "no man would be adequate to the task of mastering them all."[37]

Yet one man among Arnold's contemporaries had just attempted precisely this. In the book that had captured Arnold's attention in 1856 Ruskin had undertaken the ambitious design of comprehending the art and literature of ancient Greece in relation to the art and literature of the Christian Middle Age in order to comprehend the Modern Age. The first part of Ruskin's third volume of *Modern Painters* is primarily devoted to separating those things "which we ought to paint . . . from the nothings which we ought not."[38] In it Ruskin discusses the painter's duty of recording in detail his own impressions of nature, and also the related duty of faithful imaginative vision of ideal truth. The second part of the volume is a vast historical survey of landscape art as it has manifested itself in painting and in literature. This history of human feelings toward the natural world treats, in chronological order, "Of Classical Landscape" (chapter 13), "Of Medieval Landscape" (chapters 14, 15), and "Of Modern Landscape" (chapter 16). It is to this section of Ruskin's volume that Arnold appears to address himself in "On the Modern Element in Literature"; not until his Homer lectures would he turn his critical attention to the first half of the volume and particularly to the opening chapter on the "Grand Style."

In *The Stones of Venice* Greek architecture had been the foil to Medieval or Gothic architecture. But in plotting the history of landscape Ruskin is free to use ancient Greece as the pinnacle from which the decline into modernity commenced. For he is now dealing not with Greek buildings but with Greek literature. He says at the out-

set, "I use the words 'painter' and 'poet' quite indifferently,"[39] particularly since classical landscape has been expressed mainly in literature.

Ruskin's theory of ancient Greek landscape is that, because the Greeks found divinity in nature, they were able to subordinate nature to the service of man. Homer, he says, would never have indulged in the pathetic fallacy of Keats by describing a wave as wayward or indolent because he knew that the wave was always salt water and no more. But Homer also saw something in the wave that Keats did not see; and that something was a god. In a passage that must surely have struck Arnold as one of Ruskin's "excellent aperçus," Ruskin reminds the bitter and shortsighted Puritan who assumes the classical god to be either an idol or a diabolic power that "the Greek lived in all things, a healthy, and, in a certain degree, a perfect life. He had no morbid or sickly feeling of any kind."[40]

Discarding the tendentious elevation of Christian above pagan religion that pervaded *The Stones of Venice*, Ruskin now attributes the spiritual health and the human sympathy of the Greek to his religion. Ruskin's contemporaries, imagining God upon a cloudy throne, not in flowers or water, believe that flowers and water are dead, or governed by physical laws; but when their experience suggests that the flowers and water really are alive, they are jolted into those awkward sentimentalities and pathetic fallacies that form the modern view of nature. The Greek never removed his god from nature yet had no qualms about cutting down trees, because he had put his faith in nothing but the image of his own humanity. "Content with this human sympathy, he approached the actual waves and woody fibres with no sympathy at all." The Greeks were moved not by the beauty of nature but by that of the human form and countenance, which they conceived of as "eminently orderly, symmetrical, and tender."[41]

The Greeks' reverence for order and symmetry—the effects of which on architecture Ruskin had deplored three years earlier—made them fear all that was disorderly, unbalanced, and rugged. Hence every Homeric landscape is composed of a fountain, a meadow, and a shady grove. Everything in the landscape bespeaks its subjection to the service of men and appeals to the love of utility rather than beauty.

In the Christian Middle Age—like Arnold, Ruskin seems to think that, in a survey of literature, Greek and medieval are naturally to be paired for comparison and contrast—the feeling for landscape has undergone three changes, one bad, two good. The evidence of the new spirit of landscape is drawn from more varied sources, sculptured and painted landscapes as well as written ones; yet it bears united testimony to the medieval idea of landscape. This idea resembles the ancient Greek in that it is based on the assumption that flat land, brooks, and shady groves are much preferable to rocks and mountains as places to live, but differs from it in making the flat land a garden covered with flowers rather than a ploughed field or pasture meadow. The ideal occupation of mankind in the Middle Ages has become gathering roses or eating oranges in the garden instead of cultivating the meadows.

The most prominent feature of the changed view of nature as evidenced in medieval art is for Ruskin a disastrous one, morally and socially if not artistically. The nobility has begun to disdain agricultural pursuits; lovely but useless flowers abound; and a medieval Cincinnatus (could he be conceived) once discovered at his plough could never again have shown his face in society. Flowers and fruits became for the nobility mere sources of pleasure rather than gifts from the divine hand.

But the two other changes from Greek landscape feeling were healthy. One was a more poetical enjoyment of nature, the other the feeling that there was something else to be done in the world besides hawking and apple-eating, pleasurable as they were; and that this something else was to be done in the mountains. Ruskin is pointing, of course, to the Christian association of mountain solitude with the heroes of the Bible and thus with a special sanctity and terror.

But Ruskin is disinclined to dwell on those medieval changes from the Greek temper that tend to "a passionate, affectionate, or awestruck observance of the features of natural scenery, closely resembling, in all but this superstitious dread of mountains, our feelings at the present day."[42] For he wants to keep before the eye of his reader's mind the main truth of landscape history, that, in contradistinction to mod-

ern landscape artists, medieval artists as well as Greek artists placed *human* beauty above that of nature. People of the middle ages not only had personal beauty (Ruskin assures us that both men and women were more beautiful than their Greek counterparts), but they directed much of their art genius to the adornment of this beauty in radiant costume and dazzling armor. Finally, in yet another departure from his earlier naturalism,[43] Ruskin invokes Scott's *Marmion* to remind readers that the test of a flower or leaf inlaid in armor was not its truth to nature but its visibility at a distance:

> "Amidst the scene of tumult, high,
> *They saw Lord Marmion's falcon fly,*
> *And stainless Tunstall's banner white,*
> *And Edmund Howard's lion bright."*

In conclusion, then, although there had arisen in the Middle Ages a new poetical love of nature, human figures were still the dominating center of landscape art, and the material universe was still subordinate to *human* nature.

Turning in chapter 16 to "Modern Landscape," a subject that had occupied him since his earliest vindication of Turner, Ruskin finds that its most striking physical feature is *cloudiness*. Whereas the medieval landscape celebrated what was stable, definite, and luminous, modern landscape art rejoices in darkness and mutability. The attention to clouds is partly a sign of, and an occasion for the display of, the modern scientific spirit, which likes to make the faithful representation of the appearance of objects an end in itself.

The second prominent characteristic of modern landscape is "the love of liberty." Nature has been liberated from the service of men and grows freely or even wildly throughout modern painting and literature. Connected with the new love of liberty is a love of mountains, but a love unconnected with sanctity or with terror, as may be seen from the fact that "our modern society in general goes to the mountains, not to fast, but to feast, and leaves their glaciers covered with chicken-bones and egg shells." And this profane love of moun-

tains is but a sign of a profanity of temper regarding all nature. The medieval artist painted a cloud in order to put an angel in it; and the Greek never entered a wood without expecting to meet a god within it. But Ruskin's contemporaries would dismiss the appearance of an angel in a cloud as unnatural, and would be surprised to meet a god anywhere. "Our chief ideas about the wood are connected with poaching. We have no belief that the clouds contain more than so many inches of rain or hail, and from our ponds and ditches expect nothing more divine than ducks and watercresses."[44] Finally, the last visible characteristic of modern landscape is its denial of "the sacred element of colour." With rare exception, modern color is drab, somber, subdued, "chaste." Since medieval times, the sky has changed from bright blue to gray, and the foreground from bright green to black.

The main social lesson Ruskin hopes to draw in plotting the history of landscape from ancient Greece to modern times is that modern art, like modern society, has withdrawn its admiration from men to mountains, and from human emotion to natural phenomena. But before he draws this "moral of landscape" in chapter 16, Ruskin proposes to distinguish between the good and the bad characteristics of the modern age, for he finds it harder to generalize about his contemporaries than about the men of ancient Greece or medieval Europe. We must, he says, discover which characteristics of modern art and life are founded on "the inferior and evanescent principles of modernism," and which on "its science, its new affection for nature, its love of openness and liberty."[45]

The inferior principle of modernism that is for Ruskin the most striking fault of the age is its faithlessness, which is the root of all other modern habits of mind. The history of landscape has also been a history of the national habits of mind that gave rise to landscape. In the chapter on Classical Landscape Ruskin had depicted the emotional life of the Greeks as similar to that of a healthy child:

> They had indeed their sorrows, true and deep, but still, more
> like children's sorrows than ours, whether bursting into open
> cry of pain, or hid with shuddering under the veil, still pass-

ing over the soul as clouds do over heaven, not sullying it, not mingling with it;—darkening it perhaps long or utterly, but still not becoming one with it, and for the most part passing away in dashing rain of tears, and leaving the man unchanged: in nowise affecting, as our sorrow does, the whole tone of his thought and imagination thenceforward.[46]

Melancholy and sorrow have existed in all ages, but in Greek and also in medieval times they were not only frequently relieved by action and more frequently replaced by joy: they were a divine melancholy and a divine sorrow.

In one of the most splendid passages of *Modern Painters* Ruskin sees the disappearance of the formal element of color from modern art as the sign of the profane and thought-ridden quality of its sorrow:

At first, it is evident that the title "Dark Ages," given to the mediaeval centuries, is, respecting art, wholly inapplicable. They were, on the contrary, the bright ages; ours are the dark ones. I do not mean metaphysically, but literally. They were the ages of gold; ours are the ages of umber.

This is partly mere mistake in us; we build brown brick walls, and wear brown coats, because we have been blunderingly taught to do so, and go on doing so mechanically. There is, however, also some cause for the change in our own tempers. On the whole, these are much *sadder* ages than the early ones; not sadder in a noble and deep way, but in a dim wearied way,—the way of ennui, and jaded intellect, and uncomfortableness of soul and body. The Middle Ages had their wars and agonies, but also intense delights. Their gold was dashed with blood; but ours is sprinkled with dust.

The cause of this new darkness of the heart that has in turn darkened art is the loss of religious faith; and Ruskin asserts that "nearly all our powerful men in this age of the world are unbelievers."[47]

"The nobleness of grief is gone," Arnold had written in his own lament for the dead medieval faith in "Stanzas from the Grande Chartreuse," published in the previous year, 1855. "Ah, leave us not," he

begged, "the pang alone!" In his lecture "On the Modern Element in Literature," delivered in 1857, the year after he had read Ruskin's dissertation on the moral of landscape, Arnold offered this diagnosis of "the disease of the most modern societies":

> The predominance of thought, of reflection, in modern epochs is not without its penalties; in the unsound, in the over-tasked, in the over-sensitive, it has produced the most painful, the most lamentable results; it has produced a state of feeling unknown to less enlightened but perhaps healthier epochs—the feeling of depression, the feeling of *ennui*. Depression and *ennui*; these are the characteristics stamped on how many of the representative works of modern times![48]

Unlike Ruskin, Arnold does not speak explicitly in his lecture of the loss of religious faith as the cause of the jaded intellect, the depression, and the ennui they both see as the most prominent spiritual characteristic of modern art. But that he assigned it as the cause both his many poems of melancholy and his previously published prose work leave no doubt. When Empedocles loses his faith, he is transformed from a man into "a devouring flame of thought," "a naked, eternally restless mind" (Act Two, lines 329–30); and in the 1853 Preface the feelings of Empedocles in the period of decline of Greek religion are described as "exclusively modern" because they flow into "the dialogue of the mind with itself."[49] In "The Scholar-Gipsy" Arnold describes himself and his contemporaries as "Light half-believers of our casual creeds, / Who never deeply felt, nor clearly willed, / Whose insight never has borne fruit in deeds . . . " (172–74).

For Ruskin the melancholy and doubt and jaded intellect of modern literature were its most prominent features, distressing accompaniments of more hopeful features of the new sensibility, and perhaps necessary to be borne for their sake; and for Arnold excessive intellectualism, the peculiar disease of modern life, seemed the nearly inevitable price that had to be paid for seeking "an intellectual deliverance." "I feel immensely," he had written to Clough in 1853, "—more and more clearly—what I *want*—what I have (I believe) lost and

choked by my treatment of myself and the studies to which I have addicted myself. But what ought I to have done in preference to what I have done? there is the question."[50]

By 1857 Arnold, like Ruskin, took it for granted that explorations of the past had to serve the needs of the present. He therefore tells his audience in the Sheldonian[51] that those past ages will be of most interest that were themselves "highly developed" and in search of an intellectual deliverance. The past literatures most deserving of present attention will be those that solved for their own age the modern problem of discovering a point of view from which a complicated multitude of phenomena can be seen steadily and coherently, those that "saw life steadily and saw it whole."

But great epochs, Arnold is quick to point out, do not always get the literatures they deserve. It is here that Arnold's deterministic theory becomes more complicated than Ruskin's. In his inquiries into Greek and medieval art Ruskin was always able "to describe, in general terms, what all men did or felt."[52] He might allow for changes within medieval art—for example, from Symbolic to Imitative—but he had always to insist that all artists changed at once, in about 1399. Arnold says that a nation may well achieve a full social and political development without having that development adequately comprehended or represented in its literature. Conversely, great authors may exist in ages less great than themselves and so lack a subject worthy of their powers.[53] What will most enlighten the modern age as to the means of intellectual deliverance is "the simultaneous appearance, of a great epoch and a great literature."[54]

Like Ruskin, Arnold begins his historical survey with ancient Greece; but whereas Ruskin chose most of his illustrations of classical landscape from Homer's poetry, Arnold finds that the life of Athens in the fifth century of the old era was the great culminating age of ancient times that had a literature adequate to represent its greatness. More than that, it was a "modern" age. Arnold refuses to be bound, as Ruskin was, by chronology in defining modernity because Arnold is resistant to the notion that certain experiences and phenomena are exclusively modern. Nevertheless, the positive characteristics he as-

signs to "modernity" in this earliest of his many circular definitions are somewhat similar to those Ruskin claims to have discerned in the ubiquitous clouds of modern landscape. Of supreme importance is the spirit of science, or "the tendency to observe facts with a critical spirit; to search for their law, not to wander among them at random. . . . "[55] But modernity is also characterized by liberty, in the form of religious and intellectual toleration, and by civil peace and security. Thucydides is then called upon by Arnold to give evidence of the modern characteristics of Periclean Athens.

To show what a modern age is *not* (and as if to flaunt his indifference to chronological definitions), Arnold moves hundreds of years ahead in time to Elizabethan England. Why Arnold chooses to compare ancient Greece with Elizabethan England when earlier in his lecture he has spoken of the importance of studying the literature of ancient Greece in conjunction with that of the Christian Middle Age, it is difficult to say with certainty. But he had long maintained that the effort of nineteenth-century poets like Keats to imitate the exuberant expression of the Elizabethan poets had done great harm in English poetry because the complexity of the modern world required the use of plain rather than extravagant speech.[56] Critics could not learn this because the Elizabethan poets were undoubtedly England's greatest. If, therefore, Arnold could show that Elizabethan England was not a modern age and that, as he wrote to his brother Tom in December 1857, "Shakespeare . . . is the infinitely *more than adequate* expression of a *second class* epoch,"[57] he might do some practical good to working poets.

Arnold's own critical and scientific spirit may seem somewhat lacking when he uses Walter Scott's *Kenilworth* for testimony on the "barbarous magnificence" and "fierce vanities" of the Elizabethans; but since Ruskin had used *Marmion* for testimony on the Middle Ages, the sin may have been general and in this study at least is forgivable. What we learn from *Kenilworth* is that the pleasures and recreations of the Athenians were spiritually more edifying than those of the Elizabethans. More important, in place of the intellectual tolerance prevalent in Periclean Athens the Elizabethans had Puritanism.[58]

Most important of all, the Athenians possessed a critical spirit, and the Elizabethans did not. The eminent historian of the earlier, but more modern, time was Thucydides. His is the work of a scientific historian who sifts current stories, separates fact from rumor, and orders facts in a rational and coherent way. The great historian of the Elizabethan age, by contrast, is Sir Walter Ralegh, who equals Ruskin and Sterne in his love of digression, who is mired in superstition, who makes no distinction between fact and fiction, history and romance, and wanders among the facts he does have "helplessly and without a clue."[59]

Having, as he thinks, definitely established the modernity of Periclean Athens, Arnold asks whether this modern civilization had a literature adequate to interpret it, and finds that it did: "The peculiar characteristic of the poetry of Sophocles is its consummate, its unrivalled *adequacy.* . . . " It is not only that Sophocles accurately reflects the energy, maturity, freedom, and intelligent observation characteristic of his age—in other words, that he does what he can hardly help doing—but that he idealizes and glorifies these attributes by "the noblest poetical feeling."[60]

Yet no sooner has Arnold emerged from the illogic of a purely deterministic theory of art that underestimates the aesthetic impulse than he invokes the deterministic theory to explain why Menander, despite all his gifts, perished but Aristophanes, despite his grossness, survived. The explanation is very like the one that Ruskin had used to interpret the decline of Venetian art, for it is that "between the times of Sophocles and Menander a great check had befallen the development of Greece;—the failure of the Athenian expedition to Syracuse. . . . "[61] That disaster checked Athenian growth and dried up Athenian political activity; inevitably the art that reflected Athens after this "check" had to be inferior to the art of Athens in its period of glory.

Having used ancient Greece to establish the standard, by which all modern literature must measure itself, of the fruitful union of a great age with an adequate literature, Arnold passes on to consideration of the Roman world. His main aim here is to demonstrate that a great

age does not necessarily get the literature it deserves; having admitted that the achievement of great poetry is not entirely within the power of the individual poet, he now returns to the definition of the weighty responsibilities of the individual poet to be adequate to his age.

Not all modern qualities are blessings, and the quality of morbidity, which Arnold, no less than Ruskin, finds the dominant quality of contemporary literature, renders literature inadequate to interpret its age. Lucretius and Virgil, for all their greatness, fell short of adequacy to the interpretation of the Roman world of their time. Lucretius was afflicted by excessive reflection, by depression, ennui, and gloom; and over the whole of Virgil's greatest work "there rests an ineffable melancholy," not the rigid and moody gloom of Lucretius, but gloom nevertheless.[62]

Ruskin in his discussion of "Modern Landscape" had said that the literal darkness of modern art was the inevitable reflection of the faithlessness, sadness, and ennui of the modern age. Therefore, the greatest artists of the modern age, he believed, must themselves be faithless, sad, and bored. Walter Scott was for Ruskin the great representative of the modern mind in literature as Turner was its great representative in painting; and therefore, despite all his admiration for Scott, Ruskin had to visit all the afflictions of modernity on his hero's head. "Thus, the most startling fault of the age being its faithlessness, it is necessary that its greatest man should be faithless. Nothing is more notable or sorrowful in Scott's mind than its incapacity of steady belief in anything." Again—since sorrow is eminently characteristic of the modern age, Ruskin finds that "of all poetry that I know, none is so sorrowful as Scott's." The rigidity of Ruskin's determinism may have had its philosophical limitations, but at least it enabled him to be, for a Victorian critic, extraordinarily tolerant of modern writers and painters.[63]

Arnold, on the other hand, though he agreed with Ruskin's estimate of the pervasive melancholy of the modern age, was certain that "he who is morbid is no adequate interpreter of his age." That is why Arnold had so little good to say about his literary contempo-

raries. After all, the two most publicly melancholy writers of the mid-Victorian period were Alfred Tennyson and Matthew Arnold himself. Arnold had described the poet laureate as one who "takes dejectedly / His seat upon the intellectual throne; / And all his store of sad experience . . . / Lays bare of wretched days. . . . " "The Scholar-Gipsy" itself, which contains this description of the king of melancholy and of poetry, and which so eloquently deplores "the sick fatigue, the languid doubt" of modern life, was for Arnold a prime example of poetry rendered inadequate to the modern age by its morbidity. He wrote to Clough in November 1853: "I am glad you like the Gipsy Scholar—but what does it *do* for you? Homer *animates*— Shakespeare *animates*—in its poor way I think Sohrab and Rustum *animates*—the Gipsy Scholar at best awakens a pleasing melancholy."[64]

Arnold's rejection of Lucretius and Virgil in his Oxford lecture, and his abandonment, at about the same time, of work on a tragedy about Lucretius, were but indirect ways of saying about most modern poetry, including his own, what he had said directly four years earlier about "Empedocles"—that literature which accurately reflects its age but fails to give joy to its readers is not adequate literature. Only now, instead of recommending that poets attend exclusively to elementary subjects independent of time and place, he implies that every age, even the Victorian age, is entitled to be interpreted adequately in literature.

Like Ruskin in *Modern Painters* III Arnold was to some extent making a theory of art out of his dissatisfaction with his own past achievements. When in the mid-fifties Ruskin's feeling for the wonders of nature began to slacken and his interest in society to increase, he laboriously discovered that the moral of landscape was that, in the "starry crowd of benefactors of the human race," the "dreamy love of natural beauty . . . has been . . . subordinated either to hard work or watching of *human* nature."[65] When Arnold came to believe that it was literature's function to make men happy, and that his own poetry (so far as he could tell) failed to do so, he drew from the history of literature the lesson that for the production of great literature

there must be a happy union of a healthy society and a healthy individual sensibility.

The secret of adequacy, Arnold still believed, lay somewhere in Greek literature, above all in Greek poetry. In 1853 he had written that the Greeks were in poetic expression "unapproached masters of the *grand style*." Surrounded as the expression is by injunctions to seek the classical grandeur of generality, Arnold did not feel obliged to define it. It had, after all, been defined already with unexampled articulateness by Joshua Reynolds in the discourses he delivered before the Royal Academy between 1769 and 1790.

Nature, Reynolds argued, should not be copied too closely because all the arts receive their perfection from an ideal beauty, superior to what can be found in individual nature. Yet ideal perfection and beauty must be sought on earth, not in the heavens. Greatness of style comes from attention in observing nature's works, and from skill in selecting, digesting, and methodizing one's observations. The true artist acquires by experience the power of discovering the deformed, the particular, and the uncommon in nature; perfection in his art comes when he is able to go beyond all single forms, local customs, particularities, and details in order to reach a central form from which every deviation will be recognizable as a deformity. The practical method for discovering the ideal to be imitated is to observe what any set of objects of the same kind have in common, to eliminate accidental deficiencies, excrescences, and deformities from their *general* figures, and finally to make an abstract idea of their forms more perfect than any original.

There was only one substitute for close observation of Nature, and that was a study of the works of ancient sculptors, who according to Reynolds had left to posterity models of the perfect forms of nature. Reynolds was in this respect merely echoing the sentiments of Pope, who in his *Essay on Criticism* had proposed the reading of Homer as an adequate substitute for the actual observation of nature:

> When first young *Maro* in his boundless Mind
> A Work t'outlast Immortal *Rome* design'd,

Perhaps he seem'd *above* the Critick's Law
And but from *Nature's Fountains* scorn'd to draw:
But when t'examine ev'ry Part he came,
Nature and *Homer* were, he found, the *same*:
(130–35)

Michelangelo, whom Reynolds called "the Homer of painting," performed for artists the function that Homer performed for poets; and both these exemplars of the grand style performed for men in general the function of lifting them above their ordinary selves. "The effect of the capital works of Michael Angelo," said Reynolds, "perfectly corresponds to what Bouchardon said he felt from reading Homer; his whole frame appeared to himself to be enlarged, and all nature which surrounded him diminished to atoms."[66]

Reynolds held that after reducing the variety of nature to an abstract idea, the artist's next task was to become acquainted with the genuine habits of nature as distinct from those of fashion. The artist—and here the indebtedness of Arnold's 1853 Preface to Reynolds is clear—must divest himself of all prejudices in favor of his age or country, must disregard local and temporary ornaments to fix his attention exclusively on those general habits that are everywhere and always the same. If he will succeed in thus detaching himself from the particular, the local, and the contemporary, he need add only that nobleness of conception which adds dignity to its subject, to achieve the Grand Style; and—Reynolds concludes his Third Discourse (which I have been summarizing)—there is only one Grand Style of painting.

"As for Sir Joshua," Arnold wrote to J. D. Coleridge in 1868, "your mention of his lectures recalls to my mind the admiration with which I read them and the debt I owe them."[67] Arnold's 1853 Preface was a Victorian repetition of Reynolds's injunctions to timelessness, to wholeness, to general truth, and to ideal subjects of heroic action, especially if they were of Greek or Roman origin. One way of describing the opposition between Arnold and Ruskin in the fifties and the sixties is to say that whereas Arnold was, as a critic of the romantic

sensibility in Keats and Shelley and himself, a great continuator of the classical tradition, Ruskin was a great Victorian romantic, a writer who developed the aesthetic principles of romanticism into social and ethical imperatives.[68]

Although Arnold mentioned the "grand style" in his 1853 Preface, he was not to discuss it at length until his 1860 lectures on Homer. In the interim Reynolds's classical doctrine of the Grand Style was subjected to the most searching criticism it had received since the on-slaughts of Blake and Hazlitt during the Romantic period, in the opening chapter of Ruskin's *Modern Painters* III, which is entitled "Of the Received Opinions Touching the 'Grand Style.' "

Ruskin does not pretend to be the original iconoclast in a realm formerly dominated by Reynolds and his disciples. Although it is true that for one hundred and fifty years all writers on art aspiring to eminence have insisted on distinguishing between Great and Low Schools, "lately this established teaching, never very intelligible, has been gravely called in question."[69] Ruskin delights to see the emergence in his time of art forms (probably he alludes to Pre-Raphaelitism) that seek to be strong, healthy, and humble rather than high.

The "received opinion" touching the Grand Style had, in Ruskin's view, been most clearly formulated by Joshua Reynolds in two papers in the *Idler*. Ruskin stresses the fact that they were written "under the immediate sanction of Johnson," as if to signal his readers that he intends here to do for painting what Wordsworth had done for literature in combating the Johnsonian principles of generalization in his Preface to the *Lyrical Ballads*. Ruskin approaches Reynolds in no spirit of hostility, for he admired both his character and his painting, and in chapter 3 of this volume of *Modern Painters* says that Reynolds was fortunate in not having practiced what he preached: "He enforced with his lips generalization and idealism, while with his pencil he was tracing the patterns of the dresses of the belles of his day. . . . "[70] But it was Reynolds's precept rather than his practice that was still influencing modern art and criticism, and Ruskin hoped to stem that baleful influence by invalidating the precepts.

The first idea of Reynolds that Ruskin questions is the assertion

that the Grand Style is incompatible with minute attention to particular details. Reynolds had said that the injunction to imitate nature must not be taken literally, else "Painting must lose its rank, and be no longer considered as a liberal art, and sister to Poetry."[71] Reynolds believed that painters of genius addressed the mind rather than the eye, and that only drudges stooped to mechanical imitation in which understanding played no part. He therefore said that Dutch painting, which excelled in literal truth and minute imitation of detail, was merely historical, whereas Italian painting, which attended only to the invariable, great, and general ideas inherent in nature, was poetical.

Ruskin, who elsewhere in this volume of *Modern Painters* says that the highest human activity is to *see* something, and report it clearly, and that "thousands can think for one who can see," is sure that Reynolds has misconceived the nature of poetry. Since Ruskin is writing his critique from a window looking out on the lake of Geneva, and the mountains above Chillon, the first example of verse that comes into his mind is naturally a descriptive passage from Byron's "The Prisoner of Chillon," which he quotes (inaccurately):

> A thousand feet in depth below
> The massy waters meet and flow;
> So far the fathom line was sent
> From Chillon's snow-white battlement.
> (162–65)

Ruskin now launches into a detailed reading of the lines—he was nearly unique among Victorians in his habit of "close" reading of poetry—which shows that the poetry, far from being distinguished from history by the omission of details, consists "entirely in the *addition* of details"; and instead of being characterized by exclusive attention to the universal and invariable, gains its power precisely from the "clear expression of what is singular and particular!" It is, in fact, not the exception but the rule that poetical statements are more specific, not more vague, than historical ones.[72]

The insistence on fidelity to particular details in art was a natural outgrowth of Ruskin's scientific reverence for natural forms. We have seen before how his discovery that the secret of capturing nature's beauty in art was truth rather than generalization impelled him to become an art critic. It was a revelation that enabled him to recognize the truth to nature of the paintings of Turner, which combined the scientific passion for minute and particularized description of nature with the poet's grasp of her spirit. Turner, like Ruskin, had grasped the truth of clouds, of rocks, of trees, by means of "the balanced union of artistic sensibility with scientific faculty." It became Ruskin's mission to demonstrate that Turner's drawings of mountains and clouds, which the public had called absurd, were the only true drawings of mountains and clouds ever made, "and I proved this to be so, as only it could be proved, by steady test of physical science."[73]

Like his romantic predecessors, then, Ruskin argues that good poetry and painting are more specific and detailed, not more general, than history. But he brings to his support the new ideal of scientific objectivity, which holds qualities to be inherent in objects rather than dependent on observers. This new scientific ideal obliges a writer who seeks to be truthful—and "throughout our past reasonings about art, we have always found that nothing could be good or useful, or ultimately pleasurable, which was untrue"—to keep his eyes fixed firmly on the *pure fact*, out of which if any feeling comes to him or his reader, he knows it must be a true one."[74]

So long as Ruskin uses science as a repository of objective facts about the natural world by which the accuracy of neoclassical painting or metaphorical poetry can be measured, his argument is simple enough. But, as Rosenberg, Hough, and Bradley have shown, Ruskin is as much opposed to the photographic realism of the Dutch or Venetian schools of painting as to the generalizing, idealizing school of Reynolds. Therefore, he moves to cover an exposed flank and to keep readers from supposing that he endorses the Dutch school by saying that addition of details cannot by itself turn history into poetry. The question then arises, as it was perpetually doing for Arnold in this

decade (although Ruskin says he hardly ever hears it), "What is poetry?"

Ruskin's answer, for all his objection to the Grand Style, is couched in the language of "nobility" that Reynolds's discourses on the Grand Style habitually employ. He comes, in fact, "after some embarrassment"—very brief embarrassment, to be sure—to the conclusion that poetry "is the suggestion, by the imagination, of noble grounds for the noble emotions." In case the reader is ignorant of what are the noble emotions, Ruskin identifies them as Love, Veneration, Admiration, and Joy, and their opposites, Hatred, Scorn, Horror, and Grief. Noble emotion, he continues, can no more than details alone make poetry; the poetic power is that of assembling, by the help of imagination, the images that will excite noble emotions in the reader. Having harnessed poetry to the horses of nobility, Ruskin returns to his criticism of Reynolds's *Idler* essays.

Reynolds has said that great art, or art in the Grand Style, is like the writing of Homer in that it achieves nobility of style by having as little as possible of "common nature" in it. But Ruskin, knowledgeable and dedicated Homerian that he was, is quick to point out that Homer describes a great deal that is common: "cookery, for instance, very carefully, in all its processes." In fact, the most admired passage in the *Iliad* describes such instances of common nature as a wife's sorrow at parting from her husband, or a child's fright at its father's helmet. Moreover, says Ruskin, Homer describes these common and unheroic matters, as he describes the heroic and uncommon ones, with the greatest attention to detail.

The second chapter of *Modern Painters* III is a brief discussion of "realization" in painting; but in the third chapter Ruskin, having dismissed "received opinions" touching the Grand Style, attempts a definition "Of the Real Nature of Greatness of Style." The definition, like that of poetry, hinges on nobility, for the primary characteristic of genuine greatness of style is "CHOICE OF NOBLE SUBJECT." One cannot help being reminded of Arnold's 1853 Preface; for according to Arnold's distillation of Aristotle's poetics, "all depends upon the subject; choose a fitting action, penetrate yourself with the feeling of

its situations; this done, everything else will follow."[75] Now, Ruskin insists that the first condition of greatness of style is the choice of subjects that involve wide interests and profound passions. The style will be "greater or less in exact proportion to the nobleness of the interests and passions involved in the subject." What Ruskin has done is to transfer his definition of poetry as the suggestion by the imagination of noble grounds for noble emotions to the realm of painting.[76]

The remainder of chapter 3 adds Love of Beauty, Sincerity, and Invention to the list of prerequisites to the Grand Style. But the most important qualification of the injunction to nobility of feeling and subject is Ruskin's warning that expressional, or moral, purpose is useless in painting if it is not joined to technical power. Ruskin finds his ideal of union between mechanical competence and nobility of feeling realized in Holman Hunt's Pre-Raphaelite painting "The Light of the World," which is "the most perfect instance of expressional purpose with technical power, which the world has yet produced."[77] Arnold, at the conclusion of his 1853 Preface, had employed Goethe's distinction between two kinds of poetical *dilettanti*, those who neglected "the indispensable mechanical part" while priding themselves on their "spirituality," and those who sacrificed "soul and matter" to mechanism; and he had chosen, because an age unpropitious to poetry forced him to do so, mechanical perfection over spirituality.[78] Ruskin, whose moral and humanitarian impulses were actively competing with his aesthetic ones when he wrote *Modern Painters* III, nevertheless refused to admit the necessity, or even the possibility, of subordinating one to the other. It was at about this time he composed, as an appendix to *Modern Painters* II, a piece of advice to painters that is, rather astonishingly, simultaneously an injunction to involvement with human suffering and an exhortation to aesthetic detachment from it:

> Your ordinarily good man absolutely avoids, either for fear
> of getting harm, or because he has no pleasure in such places
> or people, all scenes that foster vice, and all companies that

delight in it. He spends his summer evenings on his own quiet lawn, listening to the blackbirds or singing hymns with his children. But you can't learn to paint of blackbirds, nor by singing hymns. You must be in the wildness of the midnight masque—in the misery of the dark street at dawn —in the crowd when it rages fiercest against law—in the council-chamber when it devises worst against the people— on the moor with the wanderer, or the robber—in the boudoir with the delicate recklessness of female guilt—and all this, without being angry at any of these things—without ever losing your temper so much as to make your hand shake, or getting so much of the mist of sorrow in your eyes, as will at all interfere with your matching of colours; never even allowing yourself to disapprove of anything that anybody enjoys, so far as not to enter into their enjoyment. Does a man get drunk, you must be ready to pledge him. Is he preparing to cut purses—you must go to Gadshill with him— nothing doubting—no wise thinking yourself bound to play the Justice, yet always cool yourself as you either look on, or take any necessary part in the play. Cool, and strong-willed —moveless in observant soul. Does a man die at your feet —your business is not to help him, but to note the colour of his lips; does a woman embrace her destruction before you, your business is not to save her, but to watch how she bends her arms.

Ruskin, like Arnold, finds that there are two kinds of *dilettanti* in art. The first kind, who subordinates moral concerns to technical excellence, is merely "sacrificing his subject to his own vanity or pleasure, and losing truth, nobleness, and impressiveness for the sake of delightful lines or creditable pedantries." Of the second group, whose members subordinate technical excellence to "tender emotions and lofty aspirations," Ruskin says scathingly: "Some of them might have made efficient sculptors, but the greater number had their mission in some other sphere than that of art, and would have found, in works of practical charity, better employment for their gentleness and sentimentalism, than in denying to human beauty its colour, and to natural

scenery its light; in depriving heaven of its blue, and earth of its bloom, valour of its glow, and modesty of its blush."[79]

Although wrong-headed views of Homer originally provoked Ruskin to inquire into the nature of nobility in art and literature, Homer is barely mentioned between the first chapter of *Modern Painters* III, on the "Grand Style," and chapter 12, the famous discussion "Of the Pathetic Fallacy," where his poetry again becomes central to Ruskin's argument. Homer is reintroduced in chapter 12 in order to illustrate the force of the expression of pure fact in literature, and to expose the nature of that lower order of poetic sensibility which causes Pope to mistranslate him.

Ruskin's discussion of the pathetic fallacy and of the four different classes of perceivers who comprise the human race is really an attempt to justify poetic departures from scientific truth; and M. H. Abrams has pointed out[80] how Ruskin anticipates Arnold's attempts of the sixties to validate the natural object seen by the poet, as against the object analyzed by the natural scientist. Ruskin claims that, at the lowest level, the level where poetry cannot be said to exist, we have the man who perceives rightly only because he does not feel; at the second level, the man whose feeling makes his perception inaccurate; at the third level—which Ruskin momentarily calls the highest—we have "the man who perceives rightly in spite of his feelings"; but above even this level, which is that of the first order of poets, we find "the men who, strong as human creatures can be, are yet submitted to influences stronger than they, and see in a sort untruly, because what they see is inconceivably above them."[81]

The discussion of the pathetic fallacy, then, carries us beyond the simple notion that poets and painters prove their integrity by fixing their eyes upon pure fact. Ruskin is already moving toward the position of Wordsworth, who is omnipresent in *Modern Painters*, or of certain schools of twentieth-century scientific thought, that perception is itself a creative act in which we half-perceive and half-create, and that it is wrong to locate "science" in the object of perception and "art" in the perceiver.[82] If we fail to perceive this, it is only because in *Modern Painters* Ruskin clings to a terminology based on the idea of

unending opposition between the fact and the artist who perceives it, at the same time that he is trying to steer a middle course between neoclassicism and photographic realism in painting, and between Coleridgian subjectivism and lifeless reportage in poetry.

There are, then, good as well as bad fallacies in poetry. When Coleridge speaks of "the one red leaf, the last of its clan, / That dances as often as dance it can," he is perpetrating a falsehood by ascribing to the leaf a will and life it does not have; but he achieves some beauty partly because a real emotion has vanquished his intellect. But when Pope translates the "simple, startled words" with which Ulysses addresses the shade of his daughter—"Elpenor! How camest thou under the shadowy darkness? Hast thou come faster on foot than I in my black ship?"—into

> "O, say, what angry power Elpenor led
> To glide in shades, and wander with the dead?
> How could thy soul, by realms and seas disjoined,
> Outfly the nimble sail, and leave the lagging wind?"

we have falsehood without emotion. The conceits have been put into the mouth of a passion that could never have uttered them, the passion of agonized curiosity.

It was precisely Homer's strict fidelity to fact that made modern translators stumble in rendering him into English. In order to emphasize how little Homer ever allows his own emotions to divert him from the expression of pure fact, Ruskin refers his readers to the famous moment in the *Iliad* when Helen wonders why her brothers Castor and Pollux are not visible among the Grecian host who have come from Lacedaemon, and Homer comments on the tragic irony of the situation: "So she spoke. But them, already, the life-giving earth possessed, there in Lacedaemon, in the dear fatherland." Having thus translated Homer's comment on the disparity between Helen's surmise that her brothers have absented themselves for fear of her scorn and the actual fact of their death, Ruskin urges his readers to "note, here, the high poetical truth carried to the extreme. The poet

has to speak of the earth in sadness, but he will not let that sadness affect or change his thoughts of it. No; though Castor and Pollux be dead, yet the earth is our mother still, fruitful, life-giving. These are the facts of the thing. I see nothing else than these. Make what you will of them."[83]

What Matthew Arnold made of these "facts" was, ironically, material for an indictment of Ruskin himself as a sentimental purveyor of pathetic fallacies. The indictment came in November of 1860 in the very first of Arnold's series of Oxford lectures *On Translating Homer*. The stated purpose of the lectures was to offer practical help to a translator of Homer by defining the peculiarly Homeric qualities—rapidity; plainness and directness in syntax and diction; plainness and directness of thought; nobility above all—and by exposing the want of one or more of these qualities in existing English translation. But Arnold also had other targets, social as well as poetic, in mind when he began the lectures. In December 1860 he wrote to his sister Fan that though his poetic interest in the Middle Age was again vibrant and refreshing, he had "a strong sense of the irrationality of that period, and of the utter folly of those who take it seriously, and play at restoring it." Tennyson had failed in *Idylls of the King* to convey the genuine flavor of the Middle Ages because he was deficient in intellectual power. "However," Arnold confesses, "it would not do for me to say this about Tennyson, though gradually I mean to say boldly the truth about a great many English celebrities, and begin with Ruskin in these lectures on Homer."[84]

At the outset of his lectures Arnold announces his refusal to enter the current controversy about the identity of Homer, the authorship of the Homeric poems, and related questions. These might be questions of scholarship, but since there exist no data for answering them, they are more likely to issue in pedantry, "and pedantry is of all things in the world the most un-Homeric." Certainly, they are not questions for the translator, whose work is likely to suffer—as Francis Newman's translation has suffered—from the attempt to make a translation of Homer illustrative of a particular theory of authorship and composition.

But pedantry is not the only danger that faces the modern translator of Homer; there is also the danger of "modernity." In an admonition that must surely have struck those who had heard his lecture "On the Modern Element in Literature" as an instance of the pot calling the kettle black, Arnold warns that "modern sentiment tries to make the ancient not less than the modern world its own; but against modern sentiment in its applications to Homer the translator . . . cannot be too much on his guard."

Ruskin serves as Arnold's example of the imposition of modern sentiment on Homer. Arnold has been disturbed by an article on English translators of Homer in the *National Review* that praised Ruskin for his interpretation of Homer's comment on Helen's mention of her brothers as alive when in fact they were dead. He quotes Ruskin's commendation of Homer for not letting the sadness of the event change his view of the earth as a fruitful, life-giving mother, and then launches into the most extended tirade against Ruskin's work he was ever to publish:

> "The poet," says Mr. Ruskin, "has to speak of the earth in sadness; but he will not let that sadness affect or change his thought of it. No; though Castor and Pollux be dead, yet the earth is our mother still,—fruitful, life-giving." This is a just specimen of that sort of application of modern sentiment to the ancients, against which a student, who wishes to feel the ancients truly, cannot too resolutely defend himself. It reminds one, as, alas! so much of Mr. Ruskin's writing reminds one, of those words of the most delicate of living critics: "Comme tout genre de composition a son écueil particulier, *celui du genre romanesque, c'est le faux.*" The reader may feel moved as he reads it; but it is not the less an example of "le faux" in criticism; it is false. It is not true, as to that particular passage, that Homer called the earth φυσίξοος because, "though he had to speak of the earth in sadness, he would not let that sadness change or affect his thought of it," but consoled himself by considering that "the earth is our mother still,—fruitful, life-giving." It is not true,

as a matter of general criticism, that this kind of sentimental-
ity, eminently modern, inspires Homer at all. "From Homer
and Polygnotus I every day learn more clearly," says Goethe,
"that in our life here above ground we have, properly speak-
ing, to enact Hell:"—if the student must absolutely have a
keynote to the *Iliad*, let him take this of Goethe, and see what
he can do with it; it will not, at any rate, like the tender
pantheism of Mr. Ruskin, falsify for him the whole strain
of Homer.[85]

In accusing Ruskin of romantic falsehood[86] and of modern senti-
mentality, Arnold very likely has in mind not just the passage on
Homer, or even the chapter on the pathetic fallacy in which it ap-
peared, but the entire theory of the history of landscape in *Modern
Painters* III. Ruskin had said in his discussion of classical landscape
that it was precisely the pantheism of Homer that kept him from the
sentimentality of Keats; and he had instituted a very Arnoldian con-
trast between the sorrow of the Greeks, which might darken the soul
yet not become one with it, and the sorrow of the modern age, which
permanently affected the whole tone of thought and imagination.
Arnold is therefore using some of Ruskin's own criteria in finding
Ruskin's criticism of Homer fallacious and sentimental, and in charg-
ing him with failure to live up to the ideal of unemotional depic-
tion of pure fact.

But how can a modern critic or translator ever escape entirely from
his modernity? Ruskin had actually said that "modern" writers had
inevitably to participate in the vices as well as the virtues of moder-
nity; and his manuscript notes on the passage in question amply con-
firm Arnold's accusations. After commenting on "the unsurpassably
tender irony in the epithet—'life-giving earth'—of the grave," he
compares the passage to one in *Vanity Fair*:

Compare the hammer-stroke at the close of the [32d] chap-
ter of *Vanity Fair*—"The darkness came down on the field
and city, and Amelia was praying for George, who was lying
on his face, dead, with a bullet through his heart." A

great deal might have been said about it. The writer is very sorry for Amelia, neither does he want faith in prayer. He knows as well as any of us that prayer must be answered in some sort; but those are the facts. The man and woman sixteen miles apart—one on her knees on the floor, the other on his face in the clay. So much love in her heart, so much lead in his. Make what you can of it.[87]

But Arnold was not less guilty than Ruskin of applying modern sentiment to Homer when he recommended Goethe's dictum that our life on earth is really an enactment of Hell as a truer keynote to the *Iliad* than Ruskin's tender pantheism. Arnold's keynote was as personal and therefore as modern as any could be, for in May of 1857, some months before he was to name depression and ennui among the characteristic elements of modern literature, he wrote thus to his sister Jane about his prospects for getting to the Alps and composing again: "I shall be baffled, I daresay, as one continually is in so much, but I remember Goethe, 'Homer and Polygnotus daily teach me more and more that our life is a Hell, through which one must struggle as best one can.' "[88]

Having found Ruskin guilty of something very like the sin Ruskin had himself defined as the pathetic fallacy, Arnold says that he has done with negative counsel and will commence with positive. He also appears to have done with Ruskin, who is mentioned but one other time in the lectures, and then in connection with the very same sin of Homeric interpretation. But I believe that Ruskin, whom Arnold had identified as his initial target in these lectures, was present to his mind throughout them.

Ruskin, in the section of his discussion of the pathetic fallacy from which Arnold was to wrench the remarks on Homer, had been insisting on the dignity Homer gains from his fidelity to fact; and he had since at least 1851 praised the Pre-Raphaelite Brotherhood painters for their stern fidelity to "the actual facts of the scene they desire to represent," and for their insistence upon "working everything, down to the most minute detail, from nature, and from nature only."

In the volume of *Modern Painters* that would command so much of Arnold's attention, he not only gave the highest possible praise to Holman Hunt's "Light of the World" but praised Pre-Raphaelitism generally for "the wholesome, happy, and noble—though not noblest—art of simple transcript from nature. . . . "[89]

Arnold, shortly after he has finished with Ruskin and begun to test English translations of Homer for possession of Homer's four characteristic qualities, blames Cowper for failing in rapidity and links Cowper's failure with that of the Pre-Raphaelite Brotherhood. Cowper, Arnold points out, excused his deficiencies in other respects as a translator by boasting of his close fidelity to the original. But this will never do, for "to suppose that it is *fidelity* to an original to give its matter, unless you at the same time give its manner, is just the mistake of our pre-Raphaelite school of painters, who do not understand that the peculiar effect of nature resides in the whole and not in the parts."[90]

Arnold saw in the Pre-Raphaelite creed, as he saw in Ruskin's inability to find or even to seek the *ordo concatenatioque veri*, a revival of the romantic aesthetic he had begun to attack in the 1853 Preface. His remarks about the Pre-Raphaelite aesthetic of naturalism and particularity really bring us nearer to the heart of his quarrel with Ruskin than does the somewhat petulant questioning of the purity of Ruskin's anti-modernism, although the petulance may in itself be a good sign of Arnold's feeling that whereas he and Ruskin tended to start out on the same track, Ruskin always deviated perversely from the appointed destination.

Jacques Barzun has said that "cultural periods are united by their questions, not their answers."[91] Ruskin, in *Modern Painters* III, and Arnold, in his lectures at Oxford, were asking many of the same questions. What is the role of the artist in modern society? What is the peculiarly modern element in art and literature, and what relation does it bear to the art and literature of the past? What kind of art will help us to master our own experience and to view it in relation to the collective experience of the human race? Can art and literature convey to us a nobility that modern society fails to provide?

Arnold's growing awareness of the Ruskinian enterprise of searching in art for answers to social questions was a sign that by the time he delivered his Oxford lectures on Homer the social question had become of great importance to him. He was seeking in Homer qualities that were disappearing from an increasingly democratic society, and so tended to stress the aristocratic qualities and connections of Homer. In order to make a point about Pope's weakness in rendering Homer's plainness and directness of style and diction, Arnold recounts the story of an English aristocrat, Lord Granville, who on his deathbed declined the opportunity to postpone his duty of considering the details of the Treaty of Paris to end the Seven Years' War. He was fulfilling his task, he said, because he would not prolong his life by neglecting his duty; and he then quoted from Book XII of the *Iliad* the speech of Sarpedon:

> Man, supposing you and I, escaping this battle, would be able to live on forever, ageless, immortal, so neither would I myself go on fighting in the foremost nor would I urge you into the fighting where men win glory. But now, seeing that the spirits of death stand close about us in their thousands, no man can turn aside nor escape them, let us go on and win glory for ourselves, or yield it to others.
>
> (322–28)[92]

Arnold says that he quotes this story from Robert Wood's *Essay on the Genius of Homer* primarily because "it is interesting as exhibiting the English aristocracy at its very height of culture, lofty spirit, and greatness." Ruskin, in the volume of *Modern Painters* that elicited both praise and blame from Arnold, had defined poetry as "the suggestion, by the imagination, of noble grounds for noble emotions," and made "noble subject" the chief prerequisite of that Grand Style which Reynolds had made synonymous with the poetry of Homer. Arnold now chose to link Homer with nobility more than with any other single quality because nobility was the preeminent quality of the English aristocracy, and because English aristocracy would soon be supplanted by English democracy. In his political pamphlet of the

previous year Arnold had praised the good qualities of this class, whose virtues were as undeniable as its demise was inevitable. Now he asserted that although arguments about Homer's identity were sterile, the best argument for the existence of a single poet of the *Iliad*, of a real Homer, was "precisely this nobleness of the poet, this grand manner. . . . " The *Iliad* carried the unique stamp of the great masters, "and that stamp is *the grand style*." In 1861 Arnold made explicit the implied link of the Homer lectures between the Grand Style of Homer and the English aristocracy by saying: "I have had occasion, in speaking of Homer, to say very often, and with much emphasis, that he is *in the grand style*. It is the chief virtue of a healthy and uncorrupted aristocracy, that it is, in general, in this grand style."[93]

Arnold was by no means the only Victorian to recognize and assert the link between the principle of aristocracy and the nobility of Homer. "I am, and my father was before me," wrote Ruskin in *Fors Clavigera*, "a violent Tory of the old school (Walter Scott's school, that is to say, and Homer's). I name these two out of the numberless great Tory writers, because they were my own two masters. I had Walter Scott's novels, and the *Iliad* (Pope's translation), for my only reading when I was a child, on weekdays. . . . " Ruskin always maintained that in youth he had learned from Scott and Homer the whole philosophy of Toryism, which all his later experience only served to confirm; and in a letter to J. S. Blackie he once claimed to have acquired from Homer his ideas on kingship, on womanhood, on household order, on good workmanship, on political economy, and on rural labor.[94]

The link that always existed in Ruskin's memory between Homer and Walter Scott as the two great teachers of Tory ideals led him to make them the chief representatives of their respective ages in his history of landscape in *Modern Painters*: "I believe the true mind of a nation, at any period, is always best ascertainable by examining that of its greatest men; and that simpler and truer results will be attainable for us by simply comparing Homer, Dante, and Walter Scott, than by attempting . . . an analysis of the landscape in the range of contemporary literature." Yet for all his devotion to Scott, Ruskin

was forced to admit that the identity that obtains between Homer and Scott in the realm of doctrine fails in the realm of art. Scott is the greatest representative of the modern mind in literature because he is a great man but also because he suffers from all the characteristic faults of modernity. Like all great men he is humble and unaffected, and he creates with ease; but, like all modern artists, he is faithless, sentimental about the past yet contemptuous of it, ignorant of art, and eminently sorrowful. "Life begins to pass from him very early; and while Homer sings cheerfully in his blindness . . . Scott, yet hardly past his youth, lies pensive in the sweet sunshine and among the harvest of his native hills."[95]

For Arnold, in his lectures on Homer, it was also a matter of the first importance to separate Scott from Homer—not only because Francis Newman, the most ignoble and therefore the worst of Homer's translators, had linked them, but because Homer belonged "to an incomparably more developed spiritual and intellectual order than . . . Scott and Macaulay." Francis Newman had asserted that Walter Scott was "by far the most Homeric of our poets" and had expressed the hope that some genius might arise who would translate Homer into the melodies of *Marmion*." William Maginn, who produced *Homeric Ballads* on the assumption that Homer was most like the English balladists, had argued that "the *truly* classical and the *truly* romantic are one," and had gone so far as to label a descriptive passage by Scott "graphic, and therefore Homeric."[96]

Arnold, who could hardly have forgotten Ruskin's recent use of Homer and Scott to contrast classical and modern landscape, absolutely rejects the possibility that Scott could ever be Homeric. What Dr. Maginn has failed to remember is that Homer is not merely graphic; "he is also noble, and has the grand style." More important, says Arnold, although human nature may be the same in all ages, we only know the human nature of other ages through the artistic representations that have come down to us, "and the classical and the romantic modes of representation are so far from being 'one,' that they remain eternally distinct, and have created for us a separation between the two worlds which they respectively represent."[97]

Arnold's contrast between classical and romantic, Homer and

Scott, is similar to Ruskin's but far more absolute. Arnold had rejected much of his own poetry because it was romantic—that is, as he saw it, mired in private melancholy and therefore incapable of giving joy to others. But Ruskin, though he could see the weaknesses of modern, romantic art, could not see what choice the modern artist had but to participate in the weaknesses of his age. He might trace the decline of landscape in several respects from classical to modern times, and might deplore the change from classical health to modern, romantic sorrow, yet for him it remained an open question "how far our melancholy may be deeper and wider than theirs in its roots and view, and therefore nobler."[98]

For Arnold the nobility of art lay exclusively in the past. Scott, he admitted, was a true genius, and a man of the highest powers; yet even Scott's poetry at its best "is not in the grand manner, and therefore it is not like Homer's poetry." Scott in the best lines of *Marmion* may be touching and stirring; "but the grand style, which is Homer's, is something more than touching and stirring; it can form the character, it is edifying."[99]

There seems little doubt that Ruskin in 1856 ascribed to Scott preeminence among modern landscape artists partly because of his attachment to Scott's social and political principles. Scott's shortcomings linked him to modern art, but his greatness as an ethical and political teacher linked him to Homer. For both Ruskin and Arnold, Homer and the Grand Style represented the principle of aristocracy. But whereas Ruskin derived, or claimed to derive, from Homer specific political doctrines that committed him to the defense of a hierarchical system of class based on the theory of *noblesse oblige*, and that disposed him to admire modern writers like Scott, who exalted these Tory virtues, Arnold was loyal only to the general spirit of nobility that was embodied in Homer and that was lacking in modern poetic style and in modern society. But if Ruskin was rigid in his political application of the Homeric heritage, Arnold could be equally rigid in deriving his aesthetic from Homer and the classical tradition. Arnold's loyalty was to the spirit rather than the letter of Homer's nobility, yet it was a fierce and exclusive loyalty. It obliged Arnold

to sacrifice almost completely the aesthetic flexibility that enabled Ruskin to find much that was admirable and even noble in Scott and in a host of modern writers and painters.[100]

Walter Pater was later to point out that ever since the time of Goethe the overwhelming question for the modern artist had been: "Can the blitheness and universality of the antique ideal be communicated to artistic productions, which shall contain the fulness of the experience of the modern world?"[101] Arnold responded to this question negatively, and by the end of the fifties was on his way, as an artist, to opting for the blitheness of the antique ideal rather than for the fullness—and frightfulness—of the experience of the modern world. But even as his aesthetic creed and his own art became paralyzed, his social and political imagination became more flexible and inventive; the energy that was stopped in one direction found expression elsewhere. His fidelity, to use the terms of his own criticism of the Pre-Raphaelites, to Homer's noble manner rather than to the details of Homer's "Tory" creed liberated Arnold from the obligation to seek nobility only where it had existed in the past and enabled him to propose new social and political means for the perpetuation of ancient virtues. For the Arnold of the sixties there was no longer much possibility of linking writers across the centuries or of separating artistic virtues and faults from social virtues and faults; but there was every hope that new institutions might have an ennobling influence on the large numbers of people who could not even read Homer.

By the time Arnold delivered his last lecture on Homer, in November 1861, he had published his first major political essay and had devoted it not to Homeric Toryism or to aristocracy but to democracy, the new force that everyone talked of and everyone lamented, but for the reception of which no one prepared. Some, Arnold charged, think that "all democracy wants is vigorous putting-down; and that . . . it is perfectly possible to retain or restore the whole system of the Middle Ages." But now Arnold recalls once again the anecdote he had related in the first Homer lecture about Lord Granville and asks whether anyone can believe that the aristocratic culture indicated by that tale is still the culture of a whole class. Since it is not, the preg-

nant question for English society, according to Arnold, is: "On what action may we rely to replace, for some time at any rate, that action of the aristocracy upon the people of the country, which we have seen exercise an influence in many respects elevating and beneficial, but which is rapidly, and from inevitable causes, ceasing?"[102]

When Arnold took up his professorial duties in 1857, he still conceived of deliverance as a task for intellect and for literature; by the time he completed his Homer lectures in 1861, the professor of poetry was more concerned with social action than with poetic style, though he saw them as inextricably bound up with each other. From one point of view, 1861 was an odd year in which to desert the criticism of art for the criticism of society, for the *Times* was expressing general sentiment when in December it described the state of England enjoying "a degree of general contentment to which neither we nor any other nation we know of ever attained before." Yet in 1860 Arnold's sometime adversary John Ruskin had made just the same move from art to society by publishing in the *Cornhill Magazine* a series of essays on political economy so violent in their denunciations of the existing social system—Ruskin called them his incendiary production—that George Smith, the publisher, was obliged to order his editor Thackeray to discontinue their publication. At least one person seems to have noticed the striking parallels between Ruskin's changing career and Arnold's, for in 1861 Arnold's sister Jane warned him that he was becoming as dogmatic as Ruskin. He replied:

> So you find my tone in the Lectures too dogmatic? I shall be curious to see if the reviewers find the same thing. No one else has yet made this complaint, and you must remember that the tone of a lecturing professor to an audience supposed to be there to learn of him, cannot be quite that of a man submitting his views to the great world. The expression to speak ex cathedra in itself implies what is expected in one who speaks from a Professor's chair. Also it is not positive forms in themselves that are offensive to people—it is posi-

tive forms in defense of paradox; such as Ruskin's, that
Claude is a bad colorist, or Murillo a second-rate painter.[103]

In the early years of the new decade Arnold was to grow more and
more conscious of Ruskin, as a predecessor more than a rival, and
as one whose removal from art to society had been accompanied by
errors that Arnold hoped to avoid.

"Whenever wise men," said Herbert, *"have taken to thinking about their own times, it is quite true that they have always thought ill of them. But that is because the times must have gone wrong before the wise men take to the business of thinking about them at all. We are never conscious of our constitutions till they are out of order." "Ah; yes,"* said Mr. Luke; *"how* true that is, Herbert! Philosophy may be a golden thing. But it is the gold of the autumn woods, that soon falls, and leaves the boughs of the nation naked."*—W. H. Mallock, *The New Republic* (1877)

Government and co-operation are in all things and eternally the laws of life. Anarchy and competition, eternally, and in all things, the laws of death.—John Ruskin, *Modern Painters* V (1860)

A very strong, self-reliant people neither easily learns to act in concert, nor easily brings itself to regard any middling good, any good short of the best, as an object ardently to be coveted and striven for. It keeps its eye on the grand prizes, and these are to be won only by distancing competitors, by getting before one's comrades, by succeeding all by one's self; and so long as a people works thus individually, it does not work democratically.—Matthew Arnold, "Democracy" (1861)

The Threat of Anarchy

Through the decade of the fifties Ruskin was becoming more deeply involved in the myriad distresses of the vast world existing outside of art. Up until 1858 his personal religion served to keep him from what he looked upon as the precarious and unenviable position of those secular reformers who in despair of an afterlife had submerged all their own hopes for happiness in the effort to increase the happiness of mankind.[1] But in this year Ruskin underwent a "conversion" that removed the last props of his childhood Protestantism and forced him to seek consolation in the Religion of Humanity.

In May of 1858 Ruskin, exhausted by his work arranging Turner's drawings for the National Gallery, by his teaching at the Working Men's College, and by his lecturing, set out for a holiday in Switzerland and Italy (for a change, without his parents). The tour lasted four months, and comprised experiences that moved Ruskin to modify his outlook on art and his role in the world.

One of these came near Bellinzona, and gave a permanent impress to Ruskin's political sensibility. He saw the weak misery of the people in this area of Switzerland as a small-scale illustration of the disastrous effects of the ethos of competition: "No pity nor respect can be felt for these people, who have sunk and remain sunk, merely by idleness and wantonness in the midst of all blessings and advantages: who cannot so much as bank out—or in—a mountain stream, because . . . every man always acts for himself: they will never act together and do anything at common expense for the common good. . . . " Ruskin was to use this account of the consequences of the creed of "every man for himself" in *Unto This Last* and elsewhere; and the effect of this Swiss impression on his political creed is felt in the fifth volume of *Modern Painters*, where he proclaims that "the highest and

first law of the universe—and the other name of life is . . . 'help.' The other name of death is 'separation.' Government and co-operation are in all things and eternally the laws of life. Anarchy and competition, eternally, and in all things, the laws of death."² But *Unto This Last* and the final volume of *Modern Painters* were not to appear until 1860, and before Ruskin could write those works, with their secular and humanistic bias, he had to pass through a spiritual crisis of the first order of magnitude.

From Baveno and the Isola Bella, Ruskin traveled to Turin, where he set himself to observing and writing about the paintings by Veronese in the Gallery. In the process both his aesthetics and his religion were transformed. In later years he would maintain that all his early books, up to the end of *The Stones of Venice*, had been written under the aegis of his simple childhood religious belief; and that *Modern Painters* II in particular had placed the religious painter Fra Angelico above all others. He had, however, during his work at Venice, experienced the enormous yet irreligious power of Tintoret and Titian, and ever since *The Stones of Venice* had in his art teaching used Titian as the standard of perfection. But in his inner mind he suffered under the weight of the problem of "how the most perfect work I knew, in my special business, could be done 'wholly without religion'!"³

The problem was to be dramatically resolved in Turin by the accidental collision of two sides of Ruskin's experience. He was pondering an "Annunciation" by Orazio Gentileschi when the question of nobility in art, which he had discussed in *Modern Painters* III, burst upon him once again in the form of a paradox:

> Besides being well studied in arrangement, the features of both figures are finely drawn in the Roman style—the "high" or Raphaelesque manner—and very exquisitely finished; and yet they are essentially ignoble; while, without the least effort, merely treating their figures as pieces of decoration, Titian and Veronese are always noble; and the curious point is that both of *these* are sensual painters, working apparently with no high motive, and Titian perpetually with definitely sensual aim, and yet invariably noble; while this Gentileschi is perfectly modest and pious, and yet base. And

Michael Angelo goes even greater lengths, or to lower depths, than Titian; and the lower he stoops, the more his inalienable nobleness shows itself. Certainly it seems intended that strong and frank animality, rejecting all tendency to asceticism, monachism, pietism, and so on, should be connected with the strongest intellects. Dante, indeed, is severe, at least, of all nameable great men; he is the severest I know. But Homer, Shakespeare, Tintoret, Veronese, Titian, Michael Angelo, Sir Joshua, Rubens, Velasquez, Correggio, Turner, are all of them boldly Animal. Francia and Angelico, and all the purists, however beautiful, are poor weak creatures in comparison. I don't understand it; one would have thought purity gave strength, but it doesn't. A good, stout, self-commanding, magnificent Animality is the make for poets and artists, it seems to me.[4]

The prescription Ruskin had issued in 1856 for uniting expression with technical excellence failed to take into account the force of opposition between religious purity and naturalism that he now discerned in art and experienced in life.

The crisis of the new turning of his thought came one Sunday morning when "from before Paul Veronese's Queen of Sheba, and under quite overwhelmed sense of his God-given power, I went away to a Waldensian chapel, where a little squeaking idiot was preaching to an audience of seventeen old women and three louts, that they were the only children of God in Turin. . . . " Like other Victorians, Ruskin was discovering that, as Walter Bagehot liked to say, nothing is more unpleasant than a virtuous person with a mean mind; and he was anticipating Arnold's contrast between the unlovely Puritan religion of those who called themselves "the children of God" and the beauty and sweetness of the pagan or Hellenic ideal. Ruskin could no longer abide by a conception of human nature that either left many of the best human powers out of account or condemned them to perdition:

Has God made faces beautiful and limbs strong, and created these strange, fiery, fantastic energies, and created the splen-

dour of substance and the love of it; created gold, and pearls, and crystal, and the sun that makes them gorgeous; and filled human fancy with all splendid thoughts; and given to the human touch its power of placing and brightening and perfecting, only that all these things may lead His creatures away from Him? And is this mighty Paul Veronese, in whose soul there is a strength as of the snowy mountains, and within whose brain all the pomp and majesty of humanity floats in a marshalled glory, capacious and serene like clouds at sunset—this man whose finger is as fire, and whose eye is like the morning—is he a servant of the devil; and is the poor little wretch in a tidy black tie, to whom I have been listening this Sunday morning expounding Nothing with a twang—is he a servant of God?[5]

Ruskin, for whom religion had always been Evangelical Protestantism or nothing, came out of the Waldensian chapel "a conclusively *un*converted man."[6] He had lost his Protestantism and found instead the Religion of Humanity.[7] In trying to understand why Titian, despite his want of religion, had been able to do the most perfect work in painting, Ruskin was forced to the conclusion, "which did indeed alter, from that time forward, the tone and method of my teaching,—that human work must be done honourably and thoroughly, because we are now Men;—whether we ever expect to be angels, or ever were slugs, being practically no matter." In 1877 Ruskin told the workmen and laborers of Great Britain that they would find examples of the work that might be done, in the absence of religious belief, on behalf of humanity, in all the works he himself had written since 1858: "It is all sound and good, as far as it goes: whereas all that went before was so mixed with Protestant egotism and insolence, that, as you have probably heard, I won't republish, in their first form, any of those former books."[8]

In reaction against his old religious loyalties, Ruskin now spitefully claimed to have learned from his experience in Turin that "positively, to be a first-rate painter—you *mustn't* be pious; but rather a little wicked, and entirely a man of the world." His ideal of world-

liness, however, was the very opposite of a bohemian aestheticism or a studied indifference to human suffering; for he was trying to replace what he now thought of as narrow Protestant piety with a broadly humanistic view of the miseries of the world and of their relation to his own happiness. He was much struck at about this time by the tendency of many religious people, in subtle collusion with apostles of the laissez faire ethic, to invoke the principle of "Mind your own business" as the one to be followed in dealing with foreign affairs. Yet, according to Ruskin, the Bible makes "our own" precisely the last business we should mind. "It tells us often to mind God's business, often to mind other people's business; our own, in any eager, or earnest way, not at all."[9] Moral awareness now seemed to Ruskin to have been artificially confined within very narrow boundaries by his contemporaries.

Yet even now Ruskin was incapable of subordinating his various aesthetic pursuits to his social goals or of channeling his energies into a single direction. At the end of 1858 he makes his customary statement of goals for the following year, and it is as rich and as diverse and as impossible of realization as ever it had been before his unconversion:

Indeed, I rather want good wishes just now, for I am tormented by what I cannot get said, nor done. I want to get all the Titians, Tintorets, Paul Veroneses, Turners, and Sir Joshuas in the world into one great fireproof Gothic gallery of marble and serpentine. I want to get them all perfectly engraved. I want to go and draw all the subjects of Turner's 19,000 sketches in Switzerland and Italy, elaborated by myself. I want to get everybody a dinner who hasn't got one. I want to macadamize some new roads to Heaven with broken fools'-heads. I want to hang up some knaves out of the way, not that I've any dislike to them, but I think it would be wholesome for them, and for other people, and that they would make good crows' meat. I want to play all day long and arrange my cabinet of minerals with new white wool. I want somebody to amuse me when I'm tired. I want Turn-

er's pictures not to fade. I want to be able to draw clouds, and to understand how they go, and I can't make them stand still, nor understand them. . . . Farther, I want to make the Italians industrious, the Americans quiet, the Swiss romantic, the Roman Catholics rational, and the English Parliament honest—and I can't do anything and don't understand what I was born for.

Ruskin's confusion of purpose came mainly from his recognition that, with the consolation of an afterlife gone, he had to justify his existence by worldly work; that collecting Turners and Titians into fireproof Gothic galleries was not likely to be viewed by future generations as an adequate apologia for a life; and that the noble and justifiable work, toward which he now felt himself irresistibly impelled, of getting everybody a dinner, was conducive neither to his health nor to his happiness. His postscript to this letter to Charles Eliot Norton indicates his own awareness of the incompatibility of his hopes: "I want also to give lectures in all the manufacturing towns, and to write an essay on poetry, and to teach some masters of schools to draw; and I want to be perfectly quiet and undisturbed and not to think. . . . "[10]

Humanitarianism was always for Ruskin an enterprise both unnatural and unpleasant. Despite his oft-expressed hostility to John Stuart Mill, he should have sympathized deeply with a young man who had been courageous enough to ask himself, at an early stage in his career of political reform, whether the realization of all the changes in institutions and opinions toward which he had been working would bring great joy and happiness to *him*; and who had been honest enough to answer "No!" Ruskin was fond of referring to himself, after 1858, as "miserably benevolent." He admitted to the Brownings that he was never happy as he wrote, whereas they, for all their pretenses to benevolence, enjoyed their singing as much as nightingales did. Ruskin could never sing, only howl:

For my own pleasure I should be collecting stones and mosses, drying and ticketing them—reading scientific books

—walking all day long in the summer—going to plays, and what not, in winter—never writing nor saying a word—rejoicing tranquilly or intensely in pictures, in music, in pleasant faces, in kind friends. But now—about me there is this terrific absurdity and wrong going on. . . . I live the life of an old lady in a houseful of wicked children—can do nothing but cry out—they won't leave me to my knitting needles a moment. And this working in a way contrary to one's whole nature tells upon one at last—people never were meant to do it.[11]

Nevertheless, within a few months of writing this letter, Ruskin was to announce that he would no longer write or do anything else that did not bear directly on getting people their dinners—"to fill starved people's bellies is the only thing a man can do in this generation, I begin to perceive." What had driven him to this decision, he told Norton on 31 July 1859, was "the dastardly conduct of England in this Italian war." Ruskin espoused the cause of Italian freedom from Austria, not because he disliked the Austrians—who (Prince Radetzky especially) had greatly impressed him in Venice in the winter of 1849–50—but because, having saved Italy from "the rottenness of revolution," they felt nothing but scorn for Italians and were stifling the development of the country.[12] In June he had published two letters in the *Scotsman* on "The Italian Question" in which he had defended the attempt of Louis Napoleon to expel Austria from Italy and had sharply criticized England's espousal of the principle of nonintervention. Now, in July, he was embittered by the news that Napoleon, beset by a number of political and military obstacles, had failed to keep his promise to free Italy as far as her eastern coasts, and had been forced to settle, in the Peace Treaty of Villafranca, merely for the freedom of Milan while the rest of Italy remained under Austrian control.

Ruskin, though he did not have the highest expectation of France's intervention in Italian affairs—"No French Emperor, however mighty his arm or sound his faith, can give Italy freedom," for she would have to earn it herself—was angered at what he believed to

be England's contribution to Napoleon's failure. England had in-invoked the principle of nonintervention, of "Mind your own busi-ness," when the freedom of Italians was being suffocated by a foreign power, and Napoleon attempted to expel that power, Austria. Yet the English government seemed to forget the theory of noninterven-tion in all its dealings with the free, independent country of France:

> The French are at present happy and prosperous; content with their ruler and themselves; their trade increasing, and their science and art advancing; their feelings towards other nations becoming every day more just. Under which circum-stances we English non-interventionalists consider it our duty to use every means in our power of making the ruler sus-pected by the nation, and the nation unmanageable by the ruler. We call both all manner of names; exhaust every term of impertinence and every method of disturbance; and do our best, in indirect and underhand ways, to bring about revolution, assassination, or any other close of the existing system likely to be satisfactory to rogues in general. This is your non-intervention when a nation is prosperous.[13]

If Ruskin's anger at England seems understandable, his interpreta-tion of England's political duplicity as the sign that he must hencefor-ward devote himself exclusively to dealing with economic questions is at first sight surprising. That he did react to the Peace of Villa-franca by turning to the problem of filling starved bellies is clear from his letters in the days and weeks following the 31 July outburst of disillusionment to Norton. On 15 August he tells Norton that he is undecided "whether Art is a Crime or only an Absurdity," and on 18 August he tells E. S. Dallas that he is ready to do battle with the po-litical economists and with the soulless precepts of laissez faire, "were it not still in question with me how far certain truths connected with them *can* be spoken in the present state of the public mind."[14]

Ruskin's articles on "The Italian Question" led him to his attack on political economy for two reasons. First, England's pious invoca-tion of the principle of nonintervention in foreign affairs struck him

as an extension of the principle of laissez faire that obtained in the realm of industrial relations at home: " 'Let who will prosper or perish, die or live—let what will be declared or believed—let whatsoever iniquity be done, whatsoever tyranny be triumphant, how many soever of faithful or fiery soldiery be laid in new embankments of dead bodies along those old embankments of Mincio and Brenta; yet will we English drive our looms, cast up our accounts, and bet on the Derby, in peace and gladness; our business is only therewith; for us there is no book of fate, only ledgers and betting-books. . . . ' "15 Secondly, England's selective use of the principle—the unprosperous Italians could be left to themselves, but the contented French with their humane social system, must be rescued from their follies—suggested to Ruskin that English jealousy of France arose from mingled fear and suspicion of a society that had so often seen the red flag of revolution raised on behalf of the working class and that had done more than England to civilize that class.

Ruskin's sense of the superiority of France's social system to England's was publicly expressed in his testimony of March 1860 before the Public Institutions Committee. The committee had been appointed to consider the desirability and the means of opening such public institutions as museums on weekday hours when the working classes would be able to visit them. Ruskin recommended that the institutions be opened in the evenings and made several concrete recommendations about the kinds of pictures, prints, and collections of shells, birds, and plants that might be made available to the working classes. But he also took the opportunity, when questioned by Sir Robert Peel, to point out that far greater interest was taken in such matters by France than by England:

Sir Robert Peel. You stated that you thought there was far more interest taken in foreign countries in the intellectual development of the working classes than in England?

Ruskin. I answered that question rather rashly. I hardly ever see anything of society in foreign countries, and I was thinking, at the time, of the great efforts now being made

in France, and of the general comfort of the institutions
that are open.

In France, Ruskin told the Committee, the working man was gener-
ally happier than his English counterpart because "there is less de-
sire to get as much out of him for the money as they can; less of that
desire to oppress him and to use him as a machine than there is in
England." When Sir Robert expressed doubt that more interest was
taken in the workers at Swiss factories than at English, Ruskin re-
plied that "I was not thinking of Switzerland or of Zurich. I was
thinking of France, and I was thinking of the working classes gen-
erally, not specially the manufacturing classes."[16]

What led Ruskin to champion France's social system at this time
was not its democracy but its humanity; not its equality but, on the
contrary, what he saw as its sharp definition of classes. Why was it
that, in the Louvre, a workingman looked at the pictures with a
greater degree of self-respect than a workingman evinced in Lon-
don's National Gallery? In France, Ruskin claimed, workingmen
were far more happily combined in public with the upper classes of
society than they were in England exactly because they were more
distinctly separated: "The temper abroad seems to be, while there is
a sterner separation and a more aristocratic feeling between the up-
per and the lower classes, yet just on that account the workman
confesses himself for a workman, and is treated with affection. I
do not say workmen merely, but the lower classes generally, are
treated with affection, and familiarity, and sympathy by the master
or employer. . . ."[17]

In the course of his testimony Ruskin stubbornly resisted the sug-
gestion that the French people's greater knowledge of art, greater love
of color, and greater happiness resulted simply from a more artistic,
colorful, and happy nature than it was the Englishman's lot to pos-
sess. No, says Ruskin, the difference lies not in our genes or in our
stars, but in our social institutions:

> *Mr. Slaney.* Do not you think that the light-hearted tem-
> perament of our southern neighbours, and the fineness of

the climate, which permits them to enjoy themselves more in the open air, has something to do with it?

Ruskin. I hope that the old name of Merry England may be recovered one of these days. I do not think that it is in the disposition of the inhabitants to be in the least duller than other people.

Sir Robert Peel. When was that designation lost?

Ruskin. I am afraid ever since our manufactures have prospered.[18]

In the previous year, 1859, Matthew Arnold had written of France that "it is the bright feature in her civilisation that her common people can understand and appreciate language which elsewhere meets with a response only from the educated and refined classes." The language to which Arnold referred was the language of ideas, especially political ideas. The common people of France, and of no other European country, were sufficiently accessible to elevated ideas to be able to say of Louis Napoleon's "generous and disinterested" attempt to liberate Italy: "*Après tout, c'est une belle guerre, c'est une belle guerre.*"[19]

The occasion of Arnold's high tribute to the lower classes of France was "England and the Italian Question," his first political pamphlet, published on 1 August 1859, about six weeks after Ruskin's letters on "The Italian Question" appeared in the *Scotsman*. Arnold had found himself on the Continent throughout the Italian crisis as the result of a new assignment he had accepted as a foreign assistant commissioner to the Newcastle Commission on Elementary Education. He had been offered the position on 24 January 1859 by Fitzjames Stephen, then secretary to the Education Commission (and shortly, in fact as early as August, to become one of Arnold's severest political critics), and was delighted at the prospect of breathing the liberating air of foreign soil, and of France in particular. His original task was to report on the systems of elementary education in France and the French-speaking countries (Belgium, Switzerland, and Pied-

mont), but was later altered to include France, the French cantons of Switzerland, and Holland. Even after he accepted the assignment, he admitted to Jane: "You know that I have no special interest in the subject of public education, but a mission like this appeals even to the general interest which every man cannot help feeling in such a subject."[20]

In January of 1859, four days before he was offered this new opportunity by Stephen, Arnold had been more than usually overwhelmed by grammar papers to read. Nevertheless, he vowed to his sister, he was determined not to give up his "own work" entirely for any routine business. By his "own work" in 1859 he probably meant literary criticism more than poetry; certainly he did not mean his educational reports. But his experience of France later in the year was to awaken his interest in public education and to suggest the possibility of a fruitful marriage between his true vocation of literature and the routine business of school inspection. The nature of the experience in France that would make him into an advocate of popular education is best described by an account of Herder's experience that Arnold copied into his notebook in 1864: "Herder awoke, in France—to the sentiment of human sympathy. The social spirit of France revealed to him the mission he can fulfill in the world. . . . Herder, without renouncing the superior ideas that were fermenting in his soul, conceived an ardent desire to imitate the *effective character* of French literature."[21]

The first public sign of Arnold's awakening to his new mission came in "England and the Italian Question," which he composed in June and July, after he had spent several months inspecting schools and interviewing school administrators, statesmen, and men of letters. It is noteworthy that his political impulses, which had been relatively dormant since the Continental upheavals of 1848, should again be stirred into activity by foreign turmoil, and that he should now find himself defending the authoritarian emperor who had been the beneficiary of the miserable demise of the Second Republic, and whose accession to power had so deeply disturbed Arnold ten years earlier.

Arnold's main purpose in the pamphlet was identical to Ruskin's

purpose in his *Scotsman* articles and in his testimony before the Committee on Public Institutions. Arnold wanted his aristocratic countrymen to learn a lesson about their own masses by contemplating the different aspect and behavior of the masses of France. Like Ruskin, Arnold made the mistake of believing that Napoleon's intentions in intervening in Italy were entirely beneficent and that he had no wish to substitute the domination of France for that of Austria in Italy. Like Ruskin, he believed that the English aristocracy and the ministry of Lord Derby were responsible for foiling Napoleon's scheme of liberation. Like Ruskin, he also believed that Italian liberty could not really be given as a boon by the French emperor, and that "the future of a liberty so bestowed would have been at least ambiguous." But unlike Ruskin, Arnold believed that the English government, in its hostile indifference to Napoleon's effort, had made the right decision for the wrong reasons. Arnold was saddened by the "bitter disappointment of the Italians," yet did not regret the failure of Louis Napoleon's grand design. It would, after all, be distressing for an Englishman to witness a French emperor gaining material and moral predominance over the European Continent. "England may not concern herself with material predominance in Europe; but a share in moral predominance may and must be dear to her."[22]

What really provoked Arnold to write his pamphlet was not the English government's opposition to Napoleon but its inability to understand the nobility of his motives in trying to liberate Italy. Napoleon, whatever his faults, was in sympathy with the masses; and since—Arnold here generalizes (not very carefully) from his four months' experience in France—"not one Frenchman in a thousand wishes to enlarge the territory of France," it is certain that Napoleon's intervention was not a war of conquest but one of liberation. The English aristocracy cannot fathom this because it does not understand how the man it views as a despot is the elected and trusted ruler of the great majority of "the industrious classes" of France. Accustomed as it is to a working class that talks of selfish interests rather than of disinterested ideas, the English aristocracy also cannot understand how accessible are French common people "to the gratification of

playing before the world the brilliant part of generous and disinterested liberators of such a country as Italy."[23]

Aristocracies in general, Arnold continues, and the English aristocracy in particular, are indifferent to the power that ideas can have over the populace because they form a caste of their own, have little personal experience of the masses, and are indifferent to ideas themselves. The greatest political mistake of the English aristocracy had been its supposition that in conquering France in 1815 it had conquered the ideas of the French Revolution, which must therefore be hollow. But, Arnold warns—somewhat paradoxically, in a pamphlet that champions Napoleon III—that the English aristocracy "did not conquer the ideas of the French revolution, and these ideas were, in the main, true."[24]

Ruskin, who thought liberty and equality incompatible with true fraternity, told Sir Robert Peel that the French working classes were superior to their English counterparts because they were treated more humanely, not more equally, by their masters or employers. He hoped for the alleviation of the plight of the English working class through aristocracy's recovery of its old sense of obligation to those of a lower social station, and its recognition of the modern application of the old paternalistic ideal. "I believe that the way of ascertaining what ought to be done for the workman in any position," he concluded his testimony before the Public Institutions Committee, "is for any one of us to suppose that he was our own son, and that he was left without any parents, and without any help; that there was no chance of his ever emerging out of the state in which he was, and then, that what we should each of us like to be done for our son, so left, we should strive to do for the workman."[25]

But Arnold, who was later to describe the belief that a governing class can serve the interests of classes without power or representation as "the last left of our illusions," learned a different practical lesson from the contrast between the English and the French masses. Alleging that the French masses were, politically, "as far superior to the insensible masses of England as to the Russian serfs," Arnold tells the English aristocracy that "the present Europe is no longer the

Europe of Mr. Pitt" and that it must prepare itself for a future in which force, the special instrument of aristocracies, will give way before ideas, the special instrument of the masses. The compelling problem of the present is not how to reconstruct the paternalistic and aristocratic system that once supported Merry England, but how to prepare the lower classes for their inevitable role as the new rulers of a democratic England. Though Arnold and Ruskin both speak of the "masses" (a term that was later to make Arnold uneasy) Arnold calls them pointedly the *democratic* masses. As for the paternalistic ideal, Arnold has no patience whatever with it. "Is a citizen's relation to the State that of a dependent to a parental benefactor?" he asks in *A French Eton*. "By no means; it is that of a member in a partnership to the whole firm."[26]

The composition and publication of his political pamphlet had a remarkable effect in reviving Arnold's spirits and giving to his letters a buoyancy very rare in these years of what in the previous summer he had called his subjugated existence. "I have not been in such spirits for a long time," he wrote on 17 July as he was completing the pamphlet, which he wrote "with great zest and pleasure." So pleased was he with his new political self and its first production that he sent copies to a number of political figures, especially his great Whig friends. "I wrote in the earnest desire to influence them, and to approach them on an accessible side—but they are *very* hard to get at." One of his most cogent critics was Fitzjames Stephen, the very man who had sent him on his foreign educational mission; but a confident Arnold seemed more pleased by all the attention than disturbed by the criticism. He was eager to know whether Bright and Cobden liked his pamphlet, and was positively elated by Gladstone's compliment.[27]

Arnold's extraordinary exuberance during these summer months of 1859 must have come not only from the discovery of a new vocation as a social and political critic but from the consciousness that, after so much resistance, he had at last begun to follow in his father's footsteps. "I have often thought," he wrote to his sister on 29 August, "since I published this on the Italian question, about dear papa's pamphlets. Whatever talent I have in this direction I certainly

inherit from him, for his pamphleteering talent was one of his very strongest and most pronounced literary sides. . . . It is the one literary side on which I feel myself in close contact with him, and that is a great pleasure."[28]

Arnold's experience in France brought home to him with renewed force the truth of the casual observation he had made in his very first week of school inspection in October 1851, to the effect that he must eventually become interested in the schools because they were the instruments of civilizing "the next generation of the lower classes, who, as things are going, will have most of the political power of the country in their hands." Education was to be the means of preparing the idea-moved masses for their role as governors of a new, democratic England. Not surprisingly, therefore, the report Arnold wrote between January and March 1860 on the popular education of France, Switzerland, and Holland was, when printed separately in 1861, prefaced by an introductory essay eventually entitled "Democracy."[29]

The gist of the detailed survey of Continental popular education that Arnold wrote for the government in 1860 and published on his own account in 1861 was that in France the state carried out the function of educating its citizens whereas in England the state was paralyzed in this vital function by the spirit of religious sectarianism and the doctrine of laissez faire.

France, like England, was beset by religious divisions; but the French state was of the religion of all of its people without the fanaticism of any of them. France recognized three "necessary, irreconcilable religious divisions," Protestantism, Roman Catholicism, and Judaism, and no others in an empire of thirty-six millions. England, on the other hand, in a population of only twenty-one millions, recognized no fewer than seven divisions, six of them Protestant, one of them Roman Catholic, and none of them Jewish. Worse yet, where the French state encouraged denominations to make themselves national, the English state made itself denominational. Hence French state inspectors of schools represented the unity of the civil power, not the divisions of rival sects. In England, with its state religion, the state failed to offer the various denominations an example of non-

sectarian civil unity. The system in which Arnold had now worked for ten years, despite its recognition of so many sects, was constantly exacerbating sectarian susceptibilities. Anglican ecclesiastics held more than three-quarters of the inspectorships and were constantly guilty of sectarian bullying in schools that were supported by public grants.

The great obstacle to nonsectarian state education in England was the creed of liberty of instruction, or voluntaryism. The English state, unlike the French, had been content to confer grants-in-aid on the existing educational agencies for popular education despite the fact that they were church-directed. In 1851, the first year of Arnold's inspectorship, the *Westminster Review* summed up the charges against the church-run voluntary schools: they were inadequate to the demand (under their tutelage half the female adult population, and one third the adult male population of England and Wales could not sign their names); their efforts were capricious and fitful; last, and most important, they were not responsible to any public agency for the efficient discharge of their duties.[30]

"Democracy," as Arnold would later call his introduction to *The Popular Education of France*, crystallizes the political position to which Arnold's observation of English and Continental schools had led him. Written in 1861, it contains all the ideas of *Culture and Anarchy*, minus the rhetorical elaboration and the "personality" of the later work. Arnold was not exaggerating when, in 1869, he told his mother that his long experience of visiting the nonconformist schools had been the source of "all I have written on religious political and social subjects."[31]

The fact that Arnold was composing his lectures on Homeric nobility and his reports on popular education at the same time has often been noted as a sign of the complex unity of his thought. That he too looked upon them as related activities in a new critical enterprise is suggested by the fact that in July 1861 he sent to his mentor Sainte-Beuve copies of *On Translating Homer* and of *The Popular Education of France* accompanied by the advice to "jetez-y les yeux quelque jour, lorsque vous en aurez de loisir, et voyez si, en abandonnant la

trace d'Obermann, je réussis à ne pas tomber, sans remède, dans la routine de l'esprit, dans la platitude absolue!"[32] Arnold could believe that his educational enterprise was no longer merely routine business because he had connected it with his literary and critical enterprise.

Arnold had established in the Homer lectures, the last of which was given in January 1861, that nobility resided in Homer as well as in aristocracy; and he therefore recommended the Homeric poems as a source of nobility for the nourishment of an otherwise ignoble democratic culture. But it was one thing to recommend Homeric nobility to Oxford and another to recommend it to the East End of London. Arnold had by 1861 become sensitive to the fact that literature, however grand its style, could not exercise a civilizing function on those who could not read English, much less Greek. Therefore, in the following month of February, Arnold applied himself to answering the question of what social agency could replace the once ennobling, but now dying, influence of the English aristocracy upon the people of England. "In other words, and to use a short and significant modern expression which every one understands, what influence may help us to prevent the English people from becoming, with the growth of democracy, *Americanised?* I confess I am disposed to answer: On the action of the State."[33]

Aristocracy, when it was healthy and uncorrupted, had made of the English a people "*in the grand style*"; but now "it is becoming impossible for the aristocracy of England to conduct and wield the English nation any longer" and "that lofty maxim, *noblesse oblige,*" is but an anachronism. In France, which had destroyed its aristocracy in a series of revolutions, and which had instituted the social equality that so terrified Englishmen, Arnold had found a system of education and a people that were in the grand style. "The common people, in France, seems to me the soundest part of the French nation. They seem to me . . . to have a more developed human life, more of what distinguishes elsewhere the cultured classes from the vulgar, than the common people in any other country with which I am acquainted."[34]

There were two reasons for the superiority of the French common people to their English counterparts. One was France's social equality

(a phenomenon whose existence had not been visible to Ruskin). Arnold argues that a community which desires to expand and develop instinctively chooses equality; for communities that resist equality sacrifice the contribution to the community that their common people might otherwise make. Great inequalities depress rather than excite the energies of the common people; for in the presence of vast inequalities they forsake even the modest amount of improvement available to them and feel only the absolute futility of trying to raise themselves to the level, so far above their own, of the highest class. In France, where social equality prevails, the common people have a self-respect and "a consciousness of counting for something in their country's action" unknown elsewhere.[35]

The other reason for the quality of working-class life in France and indeed for France's power in Europe was that France alone had organized democracy in the institutions of the state. Other countries had also felt the great ideas of 1789, but only France had made them the basis of her state and its organizations. France had had the rare courage to remodel her institutions "with an eye to reason rather than custom, and to right rather than fact."[36]

Whereas Ruskin attributed the superior civilization of the French workingman to French inequality and to a less throughgoing commercialism than prevailed in England, Arnold attributed it to French equality and to the organization of French democracy. We need not doubt that Arnold and Ruskin were talking about the same country. Political theorists using foreign countries as foils to their own have a talent for finding what they look for; and whereas Ruskin saw democracy as only the latest extension of the spirit of laissez faire, Arnold looked upon democracy as both desirable and inevitable. The real question for him was whether England would follow the French or the American model. America, in Arnold's view (a distant one, since he was not to visit the country until 1883) lacked respect for individual distinction and was entirely dominated by her middle class. Her middle-class character and her religion of the "average man" were attributable to the fact that she had never had a priesthood or an aristocracy. Of course, America was not to blame for lacking what

she could never possibly have had; but she was to blame for not having substituted for aristocratic institutions "the dignity and authority of the State." Democracy, Arnold argued, need not be interpreted as the Americans had interpreted it. The real question for Englishmen was this: "When the inevitable course of events has made our self-government something really like that of America, when it has removed or weakened that security for national dignity, which we possessed in *aristocracy*, will the substitute of the *State* be equally wanting to us?"[37]

Lionel Trilling has remarked that "in Arnold's time he might as well have told the English middle class that only Popery or Mohammedanism could save the national life from meanness as that in the State lay spiritual salvation."[38] Arnold, aware of the strength of opposition to the idea of the state—"With many Englishmen, perhaps with the majority, it is a maxim that the State . . . ought to be entrusted with no more means of action than those which it is impossible to withhold from it. . . . "[39]—sought to mitigate hostility to the state by tracing its historical causes and by showing that the reasons that once justified it no longer existed.

Aristocracies are naturally jealous of a strong state power, but it is not with the aristocratic class that Arnold is concerned. The suspicion of the state had also found extraordinary favor in the English middle class and especially in the Protestant Dissenters for the very good reason that during the early burgeoning of this class the state had been made the instrument of high church and prelatic persecution of the Puritan party and the middle class.[40] The middle-class abhorrence of state action that had discriminated against its religious convictions and social interests had, illogically and unfortunately, been exaggerated into abhorrence of state action in general. "*Leave us to ourselves!* magnates and middle classes alike cried to the state. Not only from those who were full and abounded went up this prayer, but also from those whose condition admitted of great amelioration. Not only did the whole repudiate the physician, but also those who were sick."[41]

But the mid-Victorian middle classes believed that they owed their

freedom and their prosperity, not their sickness (could they even be brought to admit it), to the doctrine of laissez faire. Cobden, the great advocate of free trade, had warned in 1853, "Depend upon it, there is a spice of despotism at the bottom of all this intervention by combined bodies in the concerns of individuals. . . . I think we shall not get right till there is a revolt against all such organizations . . . in the interests of *Liberty*—PERSONAL LIBERTY."[42] The typical member of the Victorian middle classes resented government interference in his business affairs, in his religious worship, and in his education of his children. Government inspectors like Arnold might submit Blue-Book reports documenting the harm caused by laissez faire in the schools, in the factories, in the mines, and in nearly every corner of English life. But their advice was often futile to overcome the kind of high-principled inertia that Samuel Smiles described:

> When typhus or cholera breaks out, they tell us that Nobody is to blame. That terrible Nobody! How much he has to answer for. More mischief is done by Nobody than by all the world besides. Nobody adulterates our food. Nobody poisons us with bad drink. . . . Nobody leaves towns undrained. Nobody fills jails, penitentiaries and convict stations. Nobody makes poachers, thieves and drunkards. Nobody has a theory too—a dreadful theory. It is embodied in two words: *laissez-faire*—let alone. When people are poisoned with plaster of Paris mixed with flour, "let alone" is the remedy. . . . Let those who can, find out when they are cheated: *caveat emptor*. When people live in foul dwellings, let them alone, let wretchedness do its work; do not interfere with death.[43]

Such grim accounts of the evils wrought by the system of laissez faire may cause us to forget that the resistance to state action came not exclusively from benighted or self-seeking men, but also from such intelligent, humane, and disinterested thinkers as John Stuart Mill. In June 1859, while he was on his inspection tour of French schools, Arnold read Mill's new book *On Liberty*, and commended it to his

sister as "worth reading attentively, being one of the few books that
inculcate tolerance in an unalarming and inoffensive way." Still, he
could hardly have been pleased by all he read in the book. Here he
was formulating his idea of the supreme importance of state educa-
tion, and he read in *On Liberty* that "a general State education is a
mere contrivance for molding people to be exactly like one an-
other: . . . in proportion as it is efficient and successful, it estab-
tablishes a despotism over the mind, leading by natural tendency to
one over the body."[44] In 1861, when Arnold was publishing *The Pop-
ular Education of France* and urging his countrymen to emulate
French rather than American democracy, Mill, who had already writ-
ten that "society in America requires little but to be let alone," was
in *Considerations on Representative Government* asserting that there
was "a superiority of mental development" in even the lowest class
of Americans not to be found in any other country, and that if forced
to choose between France's "mania for uniformity" and England's
"unbounded toleration for every description of anomaly," he would
unhesitatingly choose the latter.[45] Not surprisingly, by the end of the
decade Arnold had taken to linking Mill with Edward Miall, one of
the leaders of the voluntaryist opposition to state "interference" in
education, and warning his countrymen of the related dangers of
"Millism" and "Miallism."[46]

In espousing democracy in conjunction with a strong state, and in
dispensing with the principle of laissez faire, Arnold saw himself as
a liberal of the future, searching for "some better liberalism than the
sterile liberalism of the past, with its pedantic application of certain
maxims of political economy in the wrong place." He was separating
himself from the shibboleths of Mill and his school but not from
their central allegiance to democracy and equality. After all his ob-
jections to Mill, Arnold was able to recognize him in 1863 as "a writer
of distinguished mark and influence, a writer deserving all attention
and respect," and to say after Mill's death that if he was not quite
the great spirit that his admirers supposed, he was nevertheless "a
singularly acute, ardent, and interesting man . . . capable of follow-
ing lights that led him away from the regular doctrine of philosoph-
ical radicalism. . . . "[47]

But there was another kind of reaction to Millite liberalism seething in mid-Victorian England, one that had no more fondness for democracy and equality than it did for laissez faire, and that looked upon liberalism not as a true faith needing reform and revitalization but as the very instrument of the devil. Of this reaction John Ruskin was to become the most formidable spokesman. "When I accuse Mill of being the root of nearly all immediate evil among us in England, I am in earnest—the man being looked up to as 'the greatest thinker' when he is in truth an utterly shallow and wretched segment of a human creature, incapable of understanding *Anything* in the ultimate conditions of it, and countenancing with an unhappy fortune whatever is fatallest in the popular error of English mind."[48]

But it must be remembered that this outrageous letter to Charles Norton was not written until 1869; and that the violent condemnation of liberty that is often paired with it[49]—"my own teaching has been, and is, that Liberty, whether in the body, soul, or political estate of men, is only another word for Death, and the final issue of Death, putrefaction"—was not written until 1875 and was downright inaccurate as a description of Ruskin's past teaching. Not only had Ruskin, as we have already seen, spoken favorably of liberty in his earlier works on painting and architecture; he had written in the last volume of *Modern Painters*, published in 1860, that the highest service of art was the exposition of true authority and of freedom, and that all he should care to say on the subject of individual freedom "has been already said admirably by Mr. J. S. Mill in his essay on *Liberty*." Even as late as 1865 he could bring himself to say that "there is much that is true in the part of Mr. Mill's essay on Liberty which treats of freedom of thought; some important truths are there beautifully expressed, but many, quite vital, are omitted. . . . "[50]

The significance of Ruskin's change from a balanced and relative assessment of Mill to an extreme and absolute one is that during the ten-year period of controversy that intervened the question of political economy had become for Ruskin the one great question, outweighing and then consuming all others. He was to allow his conviction of the wrongness of laissez faire to master all other social and political considerations, and to serve as a touchstone for measuring the qual-

ity of thinkers and even the devotion of friends. He went so far as to inform Charles Eliot Norton in 1869 that until Norton declared publicly, in *Atlantic Monthly* or elsewhere, whether he espoused Ruskin's political economy or Mill's, there could be no true friendship between them. Ruskin insisted that Norton acquiesce in his own absolute conviction that Mill and those of his school "are *not* wise men —nor scientific men (nor—I say *here good* men). . . . "[51]

Yet the original basis of Ruskin's quarrel with Mill was "science" and not ethics, the nature of economy, not of goodness. Whatever modifications Mill might have introduced into the laissez faire creed that he articulated in *Principles of Political Economy* (1848), he continued to believe firmly in competition; for "wherever competition is not, monopoly is; and . . . monopoly, in all its forms, is the taxation of the industrious for the support of indolence, if not of plunder."[52] But for Ruskin competition was a synonym for anarchy. Of all the shocking and contentious things he said before the Public Institutions Committee in March 1860, none was more shocking or contentious than his assertion that the deterioration in the condition of the English working class was due to the increase of competitive trade and manufactures. When the chairman of the committee suggested that Ruskin might have been victim of a slip of the tongue, the witness repeated his heresy: "I intended not only to cast a slur, but to express my excessive horror of the principle of competition, in every way. . . . "[53]

In August of the previous year, as we have already noted, Ruskin had expressed doubt about whether the time had yet come for speaking the truth to the public concerning political economy, since "it is often impossible, often dangerous, to inform people of great truths before their own time has come for approaching them. . . . " Now, in the course of his testimony before the committee, he said that the relation between the upper class and the working class in England was "a subject which cannot at present be discussed. . . . "[54] But, quite aside from the fact that Ruskin's contentiousness tended always to overpower his prudence, he was being sucked irresistibly into the whirlpool of political and economic controversy over practical affairs.

By late 1859 Ruskin found himself more than usually dissatisfied with his own and everybody else's work in art. He told Tennyson, à propos of *Idylls of the King*, that it was a pity to see so great a poetic power squandered on "visions of things past" instead of exerted on "the living present." As he drew toward the conclusion of seventeen years' labor on *Modern Painters*, Ruskin expressed a sense of futility in producing his work, "not merely because of the time's sorrow or injustices . . . but because even its mechanism is becoming too strong for any hope of resistance"; and he told the Brownings he would try to devote himself to quiet copying of nature and Turner: "It seems to me the most useful thing I can do. I am tired of talking."[55]

But even as Newman was drawn almost against his will and despite all adverse circumstance, into the Roman Catholic Church, which is depicted in the *Apologia* as his appointed destiny, so was Ruskin drawn against his will and his predilection, and at the cost of his happiness, into what he later called "a new epoch of life and death." For he had come at last to recognize that the true cause of his lassitude and of his sense of the uselessness of his previous work was his discovery of "the great fact that great Art is of no real use to anybody but the next great Artist; that it is wholly invisible to people in general—for the present—and that to get anybody to see it, one must begin at the other end, with moral education of the people, and physical, and so I've to turn myself quite upside down. . . . " His new revelation, as E. D. H. Johnson has noted, was similar to Arnold's discovery at about the same time that the grand style in literature was not of much use to those who could not read; and as Arnold in 1860 moved from questions of Homeric translation to the problem of popular education, Ruskin moved from paintings and from nature into economics and society: "I got the bound volume of *Modern Painters* in the valley of St. Martin's in that summer of 1860, and in the valley of Chamouni I gave up my art-work and wrote this little book —the beginning of the days of reprobation."[56]

The "little book" was *Unto This Last*, "the only book," Ruskin said in *Sesame and Lilies*, "properly to be called a book, that I have yet

written, the one that will stand (if anything stand) surest and long-est of all work of mine."[57] Ruskin, like Arnold, had for a long time insisted on art's obligation to give joy; but by 1860 both men had come to believe that joy and perfection could not be conceived of as individual gifts or attainments, and that individual perfection was neither desirable nor possible in the midst of suffering and imperfect men. To be real, Arnold was shortly to argue, perfection had to be general; and Ruskin too now espoused the view that, as he wrote some years later, "the beauty which is indeed to be a joy for ever, must be a joy for *all*." He saw his movement from art to society as one from il-lusion to reality: "It is the vainest of affectations to try and put beauty into shadows, while all real things that cast them are in deformity and pain."[58]

Ruskin composed *Unto This Last*, the culmination of years of thought about society and politics, with the utmost care, writing every word of the book twice and much of it three times. By the end of June 1860 he had submitted the first essay to the *Cornhill Maga-zine*, which had been founded at the end of the preceding year by George Smith under the editorship of Thackeray.

According to Ruskin, the objects of his *Cornhill* essays were simple enough. He aimed to give an accurate and stable definition of wealth and to show that wealth could only be acquired under certain moral conditions of society, primary among them the belief in the existence and attainment of honesty. His title, *Unto This Last*, was derived from the parable in Matthew 20 : 14 of the master of the vineyard who insists on paying all his workers the same wage, even including those hired at the eleventh hour. To the workers who protest against the equal reward meted out to industry and to idleness, the master replies: "Friend, I do thee no wrong. Didst not thou agree with me for a penny? Take that thine is, and go thy way. I will give unto this last even as unto thee."

Ruskin used the parable from Matthew not only to support his be-lief that the state is obliged to feed those who (for whatever reason) do not work as well as those who do, but to connect the "science" of political economy with an entirely new order of value. The "laws" of

political economy were built on an analogy with the laws of physics; the theory of the natural identity of interests was thought of by its propounders as comparable to one of Newton's laws. Philosophical Radicals held that all social phenomena are reducible to laws, and that the laws of the social world depend upon the laws of human nature.[59] As late as 1877, *Hard Times*, whose criticism of industrial society is warmly recommended in the first chapter of *Unto This Last*, could be condemned in the *Atlantic Monthly* as a quixotic assault on the laws of nature: "The time will come," wrote E. P. Whipple of Dickens's fictional critique of laissez faire economics and ethics, "when it will be as intellectually discreditable for an educated person to engage in a crusade against the established laws of political economy as in a crusade against the established laws of the physical universe; but the fact that men like Carlyle, Ruskin, and Dickens can write economic nonsense without losing intellectual caste shows that the science of political economy, before its beneficent truths come to be generally admitted, must go through a long struggle with benevolent sophisms and benevolent passions."[60]

That such a time of intellectual sophistication in economic matters never did arrive was partly due to the fact that, as G. M. Young has pointed out, Ruskin "evolved, and forced his world to accept, a new set of axioms as the basis of all future political science in England."[61] He sought to show that the laws of economy were not physical but moral, and that the constant in human behavior was not greed but "social affection." The "*soi-disant* science of political economy" had, in his view, been constructed on a false thought model. It had been willing to recognize the social affections, but only as accidental elements in human nature that might occasionally require modifications in the laws deduced from the great central axiom that man is basically "a covetous machine" dedicated to buying what he needs in the cheapest market and selling what he does not in the dearest.[62] Mill might admit that the conclusions of political economy "even in its own peculiar province [that of Wealth], are only true conditionally, subject to interference and counteraction from causes not directly within its scope";[63] but for Ruskin the concession was meaningless

since the social affections are not of the same nature as the economic drives: "They alter the essence of the creature under examination the moment they are added; they operate, not mathematically, but chemically, introducing conditions which render all our previous knowledge unavailable."[64]

Political economy was a pseudo-science because its starting point was a mythical being rather than a man; all its conclusions might be true if it were the case that men had no souls. But since they do have them, the attempt to erect a science upon the fiction of a soulless automaton whose efficiency is only occasionally marred by the interference of soulful, noneconomic considerations, is futile. That is one reason why the political economists are helpless to settle the strife between employers and employed in the strikes that beset English society.

But even if political economy were a true rather than a false science, it would be useless for practical application, "it being not by 'science' of any kind that men were ever intended to be set at one." Ruskin sensed the absurdity of the political economists' exhorting people to act in obedience to laws which were supposed to be inevitable in any case; and he recognized that the morality of the utilitarian economists was nothing more than their psychology put in the form of an imperative. The advocates of the enlightened pursuit of self-interest may argue that the interests of the masters are not antagonistic to those of the men; but such argument is vain labor because, as everyone knows who has observed the life of his own family, it does not follow that persons must be antagonistic because their interests are. It is characteristic of Ruskin that he employs the model of family relationships to prove the uselessness of the speculations of political science. "If there is only a crust of bread in the house, and mother and children are starving, their interests are not the same. If the mother eats it, the children want it; if the children eat it, the mother must go hungry to her work. Yet it does not necessarily follow that there will be 'antagonism' between them, that they will fight for the crust, and that the mother, being strongest, will get it, and eat it."[65]

Ruskin was attempting to moralize the sphere of industrial rela-

tions, which lay under the aegis of laissez faire utilitarianism. Bentham and his innumerable followers had maintained that actions were to be judged not by conformity to an arbitrary moral standard but by their utility, in the sense of their capacity to produce pleasure or to deflect pain. But Ruskin holds that morality cannot, and should not, be based on the notion of usefulness: "For no human actions were ever intended by the Maker of men to be guided by balances of expediency, but by balances of justice. He has therefore rendered all endeavours to determine expediency futile for evermore. No man ever knew, or can know, what will be the ultimate result to himself, or to others, of any given line of conduct. But every man may know, and most of us do know, what is a just and unjust act."[66]

To illustrate the primacy of justice over expediency in the relations between men, Ruskin uses the example of the relations that prevail between masters and domestic servants; and it is noteworthy that Ruskin's prescriptions for the moralization of industrial relations are nearly always based on relations between parents and children or between master and servant. According to the political economist, the master will only get the greatest possible average of work from his servant if he feeds and lodges him as poorly, and drives him as hard, as the servant will endure without leaving for a better place. But according to Ruskin, the largest quantity of work will be done by this man only if his will or spirit "is brought to its greatest strength by its own proper fuel: namely, by the affections. . . . " If the servant were a soulless machine, with entirely calculable energies and predictable responses, the political scientists would be right; but he is a human being whose motive power is "an unknown quantity," a soul. It is not, therefore, antagonism but affection between man and master that produces the "greatest material result."[67]

Ruskin's stress on material results is important. Although his own ultimate end is moral reform, his arguments to that end are eminently pragmatic, indeed, utilitarian. Bentham used to say that all objectors to the principle of utility eventually end up justifying their anti-utilitarian dogmas in utilitarian terms; and in this instance Ruskin seems to bear him out. "In any case, and with any person, this unselfish treat-

ment will produce the most effective return. Observe, I am here considering the affections wholly as a motive power; not at all as things in themselves desirable or noble, or in any other way abstractedly good." Of course, Ruskin hastily adds, the master who consciously extends affection to his servant in order to turn the servant's gratitude to account will find none of his economical purposes answered, for "in this, as in all other matters, whosoever will save his life shall lose it, whoso loses it shall find it."[68]

Ruskin had constant recourse to the Scriptures because he knew that they would recall to the minds of his readers a world of associations and values that the political economists had intentionally left out of account. He recognized the tendency of modern industrial society to subsume all values under the values of the marketplace, to transform men into "labor," nature into "property,"[69] and the social bond into the "cash nexus"; and he saw that the laissez faire philosophy had in fact become a religious creed, with its shibboleths of free enterprise, supply and demand, exchange theory of value, and competition. To struggle against the new creed and the new values he needed to revitalize moral and religious values that were still professed, but no longer—at least in the economic sphere—practiced; for it was one of the paradoxes of the Victorian era that, to cite G. M. Young once more, "its practical ideals were at odds with its religious professions."[70] It was Ruskin's ability to bring religious awareness back into economic thought that caused Bernard Shaw to assert in his Fabian pamphlet on Ruskin that "the most thoroughgoing opponents of our existing state of society" declared themselves followers not of Marx but of Ruskin.[71] It is a striking paradox that Ruskin had no sooner undergone his conversion from Evangelical Anglicanism to the Religion of Humanity than he most strenuously asserted, in his quarrels with the political economists that, as Plato said, "Not man, but a god, must be the measure of all things."

The iconoclasm implicit in Ruskin's title is made explicit in the two concrete proposals of the first chapter of *Unto This Last*, "The Roots of Honour." The first of these is for a fixed rate of wages, irrespective of the demand for labor. For all of the important, and much of the unimportant, labor done, Ruskin argues, wages are already so

regulated. ". . . Sick, we do not inquire for a physician who takes less than a guinea; litigious, we never think of reducing six-and-eight-pence to four-and-sixpence; caught in a shower, we do not canvass the cabmen, to find one who values his driving at less than sixpence a mile."[72] The only way to protect the good workman from being replaced by the bad one or from being forced by competition to work for an inadequate wage is to pay all labor at a fixed rate, but to employ only the good workmen. Ruskin's second practical proposal is that, to diminish the suffering caused by the violent fluctuations of demand in modern industrial society, a constant number of workmen be maintained in employment. In addition to creating security for the men, this measure would give them a permanent interest in the establishment with which they are connected, like domestic servants in an old family or soldiers in a crack regiment.

Ruskin does admit that there will be difficulty, loss, and inconvenience occasioned by the radical changes he proposes. But things that can be done with convenience and without loss are not always the things that most urgently require doing. Merchants would understand this better if they adopted what Ruskin now proposes to them, a code of heroism for trade. Admitting yet deploring the fact that the merchant, unlike the soldier or even the lawyer and physician, has always been presumed to act selfishly, Ruskin declares that henceforward "sixpences have to be lost, as well as lives, under a sense of duty; that the market may have its martyrdoms as well as the pulpit; and trade its heroisms as well as war." Where Arnold in 1860 was seeking to resurrect the grand style of Homer in the democratic state, Ruskin was seeking to instill heroism in the very class that most blatantly lacked it. Commerce was a selfish pursuit because "men of heroic temper have always been misguided in their youth into other fields; not recognizing what is in our days, perhaps, the most important of all fields." There are in every civilized nation, says Ruskin, five great intellectual professions, relating to the necessities of daily life. Each has its special function in a nation:

The Soldier's profession is to *defend* it.
The Pastor's to *teach* it.

> The Physician's to *keep it in health*.
> The Lawyer's to *enforce justice* in it.
> The Merchant's to *provide* for it.
> And the duty of all these men is, on due occasion, to *die* for it.
> "On due occasion," namely:—
> The Soldier, rather than leave his post in battle.
> The Physician, rather than leave his post in plague.
> The Pastor, rather than teach Falsehood.
> The Lawyer, rather than countenance Injustice.
> The Merchant—what is *his* "due occasion" of death?[73]

Never one to be backward in assigning the duty of others, Ruskin asserts that the duty of the merchant, which he has to perform even at the cost of his life, is to provide for the nation, and to guarantee that the work done to produce what he sells is work beneficial to the men he employs. He may be sure that the work will benefit his employees if he treats them in all things as he would treat his own son. In place of the laissez faire ideal of competition, which is for him the negation of the social bond itself, Ruskin puts the paternalistic ideal of the family in which children surrender their freedom to do as they like in return for the sustenance and direction provided by loving parents.

What Ruskin sought to destroy was the prevalent belief that the value of men, called "labor," could and should be determined in the market by supply and demand, just as the price of land was determined. "Oversupply" of labor, he knew, meant starvation; and leaving the fate of men to the vicissitudes of the market was equivalent to denying their value as human beings. Did some value attach to the human status as such, or was value merely a function of the market place? If value was not determined in the market place, where and how was it determined?

Four years earlier, in his discussion of the pathetic fallacy, Ruskin had voiced his contempt for German and English metaphysicians who purported to distinguish between subjective and objective qualities of things, applying the former label to those qualities of things that depend upon our perception of them, the latter label to those

qualities of things that they always have. The disjunction between "objective" and "subjective" was in Ruskin's view a specially corrosive falsehood because it encouraged the artist and thinker to believe that "it does not much matter what things are in themselves, but only what they are to us," so that nothing really exists in its own right, but everything depends upon how we see it or think of it. In fact, Ruskin urges, the metaphysicians have deceived themselves in supposing that the word "Blue" means the *sensation* caused by a gentian on the human eye. On the contrary, "it means the *power* of producing that sensation: and this power is always there, in the thing, whether we are there to experience it or not, and would remain there though there were not left a man on the face of the earth."[74]

Qualities of things and values of things are not identical, but when Ruskin comes to define value in the fourth and last essay of *Unto This Last*, "Ad Valorem," he is trying to assert for value the kind of independence from human whim that he had in *Modern Painters* III ascribed to the qualities of things. His adversary Mill had equated value with "value in exchange," so that usefulness was defined as "capacity to satisfy a desire, or serve a purpose"; but Ruskin says that a useful object is one that supports life, and this idea is the key to his conception of value. Ruskin, indulging in one of those etymological excursions that so irritated Arnold, mockingly suggests that a sounder Latin instruction than is fashionable among middle-class merchants might have taught them that the nominative of *valorem* is *valor*; that *valor* comes from *valere*, meaning "to be well or strong," *in* life (if a man), *for* life (if a thing); and that, as a result, to be "valuable" means to "avail towards life."[75]

Value, for Ruskin, is primarily *intrinsic*, independent both of opinion and quantity: "Think what you will of it, gain how much you may of it, the value of the thing itself is neither greater nor less. For ever it avails, or avails not; no estimate can raise, no disdain repress, the power which it holds from the Maker of things and of men." If value is intrinsic, so too is wealth; neither, as Ruskin was to point out two years later in *Munera Pulveris*, is constituted by the judgment of men. The task of political economy is not merely to assign to "de-

mand" or any subjective desire the authority of objectivity, but to teach men and nations to "demand" what leads to life and to scorn what leads to destruction and death. If political economy is truly a science of wealth, it must respect human capacities and dispositions, and recognize that they are moral considerations. To admit, what Ruskin contends, that values have an absolute and autonomous existence is but the first step toward reform; for the values may exist indeed, but be ineffectual if human beings fail to recognize them: " . . . Economists have never perceived that disposition to buy is a wholly *moral* element in demand: that is to say, when you give a man half a crown, it depends on his disposition whether he is rich or poor with it— whether he will buy disease, ruin, and hatred, or buy health, advancement, and domestic love. And thus the agreeableness or exchange value of every offered commodity depends on production, not merely of the commodity, but of buyers of it; therefore on the education of buyers, and on all the moral elements by which their disposition to buy this, or that, is formed."[76]

But it was precisely with education that Ruskin's well-to-do readers were most stingy. "Charitable persons suppose the worst fault of the rich is to refuse the people meat. . . . Alas! it is not meat of which the refusal is cruelest, or to which the claim is validest. The life is more than the meat. The rich not only refuse food to the poor; they refuse wisdom; they refuse virtue; they refuse salvation." And having refused all these, they exclaim that the poor "cannot receive education!"[77]

This condemnation of the rich for withholding knowledge from the poor calls to mind a famous passage of *Culture and Anarchy* written eight years later, and also published in the *Cornhill Magazine*:

> I remember, only the other day, a good man looking with me upon a multitude of children who were gathered before us in one of the most miserable regions of London,—children eaten up with disease, half-sized, half-fed, half-clothed, neglected by their parents, without health, without home, without hope,—said to me: "The one thing really needful

is to teach these little ones to succour one another, if only with a cup of cold water; but now, from one end of the country to the other, one hears nothing but the cry for knowledge, knowledge, knowledge!" And yet surely, so long as these children are there in these festering masses, without health, without home, without hope, and so long as their multitude is perpetually swelling, charged with misery they must still be for themselves, charged with misery they must still be for us, whether they help one another with a cup of cold water or no; and the knowledge how to prevent their accumulating is necessary, even to give their moral life and growth a fair chance![78]

Arnold's culture seeks to fulfill itself in marriage to conduct, and conduct seems to cry out for guidance by culture. Arnold's advocacy of birth control, striking as is its appearance in a work generally supposed to rest on pious platitudes, is but a part of his affirmation of man's responsibility, in this world, for creating his own good.

Arnold was moved to describe what he had seen on his inspection tours in the East End of London by the laissez faire necessitarianism of the *Times*, which had doggedly maintained that increases in trade and in population were always desirable, and that the human misery that might be caused by "ebbs and flows in the tide of trade and business" was inevitable and therefore not to be quarreled with. Arnold, whenever he visited the East End, armed his spirit against its depressing sights by carrying with him that "finest economical doctrine" of the *Times* which explained: "There is no one to blame for this; it is the result of Nature's simplest laws!"[79]

But Arnold heard the spirit of Pangloss speak through religion as well as through economic liberalism. As laissez faire economics looked upon increases in trade and manufacture as goods in themselves, so did Scottish poets like Robert Buchanan and English Hebraists in general celebrate increases in population as unmitigated benefits. If the economists cloaked their doctrines in the inviolability of "natural law," the Hebraists cloaked theirs in the sanctity of "God's law." "God's law" enjoins, or is held by the Hebraists to enjoin,

people to "be fruitful and multiply," while it simultaneously proclaims that "the poor shall never cease out of the land." Yet a devotee of culture, which decrees that "individual perfection is impossible so long as the rest of mankind are not perfected along with us," cannot reconcile himself, by means of such comforting doctrines, to the existence of great masses of "half-sized, half-fed, half-clothed" people in the East End of London.[80]

Arnold's collision in *Culture and Anarchy* with those advocates of free trade and "philoprogenitiveness" who denied that knowledge could help the poor was the culmination of a quarrel with the laissez faire conception of value that Arnold had carried on since the beginning of the decade. We have already seen how, in 1861, he blamed the creed of voluntaryism and of "Leave us to ourselves!" for the shabby mediocrity of English education. But in 1862 there occurred an event that was to give him, for much of the rest of his life, an intensely personal as well as broadly intellectual reason for hostility to the philosophy of laissez faire and the market conception of value.

In May of 1862 a "Revised Code of Minutes and Regulations of the Committee of the Privy Council on Education," somewhat modified from the Revised Code presented in July 1861, was approved by Parliament. Although its chief framers, Robert Lowe, vice-president of the council, and Ralph Lingen, permanent secretary of the Education Department (and the friend who had originally secured Arnold his appointment), claimed that the Revised Code was intended to remove the educational evils identified by the Newcastle Commission, the chief motive for its promulgation appears to have been the desire to reduce spending. Indeed, defenders of the Revised Code were habitually saying that if it was not efficient, it would be cheap, and that if not cheap, it would be efficient. The main feature of the new scheme, called "payment by results," was the stipulation that payment of grants to schools be contingent upon a combination of inspection and individual examination of pupils in reading, writing, and arithmetic, instead of, as had been the case previously, upon the inspector's general evaluation of the entire operation of the school.

Arnold at once recognized the Revised Code as a means not merely

of reducing state grants for support of the schools of the poor but of transforming the school from "a living whole with complex functions, religious, moral and intellectual" into "a mere machine" for teaching the three r's. In March of 1862, while the controversy (unique among English educational controversies in that it did not arise from sectarian religious strife) was at its height, Arnold published a forceful attack on "The Twice-Revised Code" in *Fraser's Magazine*. Since, as an inspector, he was in the position of attacking his own superior in the Committee of the Privy Council on Education, Robert Lowe, he published the essay anonymously. But he was widely known as its author and risked his job by printing it. To his timid wife he wrote: "If thrown on the world I daresay we should be on our legs again before very long. Anyway, I think I owed as much as this to a cause in which I have now a deep interest, and always shall have, even if I cease to serve it officially."[81]

Arnold's vitality as a writer on educational subjects came from his vision of education as an agent of civilization itself rather than of mere instruction. He had the foresight to recognize the futility of trying to instill in the poor the ability to read merely by forcing schools for the poor to concentrate exclusively upon reading; and he reminded the reformers that what mainly hindered poor children in reading was the disdain for books and for knowledge in the homes from which these children came and to which they returned. In other words, what the poor wanted even more than reading ability was civilization. "It is the advance of them and their class in civilization which will bring them nearer to this power, not the confining them to reading-lessons, not the striking out lessons on geography or history. . . . "[82] To attain good reading, cultivation in other subjects was necessary; but the Revised Code would cut off all grants for those subjects in the hope of getting better reading.

The immedacy of Arnold's regret over the introduction of the new system is apparent in the intensity of the language he uses to describe the diminution of his inspectorial role. The new system, he alleges,

turns the inspectors into a set of registering clerks, with a mass of minute details to tabulate, such a mass as must, in

Sir James Shuttleworth's words, "necessarily withdraw their attention from the religious and general instruction, and from the moral features of the school." In fact the inspector will just hastily glance round the school, and then he must fall to work at the "log-books." And this to ascertain the precise state of each individual scholar's reading, writing, and arithmetic. As if there might not be in a school most grave matters needing inspection and correction; as if the whole school might not be going wrong, at the same time that a number of individual scholars might carry off prizes for reading, writing, and arithmetic! It is as if the generals of an army,—for the inspectors have been the veritable generals of the educational army,—were to have their duties limited to inspecting the men's cartouch-boxes. The organization of the army is faulty:—inspect the cartouch-boxes! The camp is ill-drained, the men are ill-hutted, there is danger of fever and sickness. Never mind; inspect the cartouch-boxes! But the whole discipline is out of order, and needs instant reformation:—no matter; inspect the cartouch-boxes! But the army is beginning a general movement, and that movement is a false one; it is moving to the left when it should be moving to the right: it is going to a disaster! That is not your business; inspect, inspect the cartouch-boxes![83]

Arnold affixed blame for the new system of "payment by results" to two causes. One was laissez faire, the other was "that tide of reactionary sentiment against everything supposed to be in the least akin to democracy which . . . is now sweeping over Europe."[84] Conveniently for Arnold, both the laissez faire philosophy and the terror of democracy were summed up in the figure of Robert Lowe, chief perpetrator of the Revised Code.

Robert Lowe, whom Disraeli called an "inspired schoolboy" (as well as the only M.P. whose hand he would not shake), and to whom Gladstone, his chief opponent, attributed "genuine power of mind," had achieved brilliant successes at Winchester and at Oxford, where he had examined Ruskin for "Smalls." Yet he came to disapprove of the public schools and of classical education as well, because the form-

er, as endowed schools, contravened the natural interplay of supply and demand, and the latter was less important than modern languages and the scientific habit of mind, "the one invaluable thing in life." Lowe was one of the few men of his time hated (in roughly equal measure) by classical scholars and by trade-union leaders, and there is a curious sense in which Arnold's unusual combination of sympathies—for classical education, for democracy, for a strong and responsible State—found its mirror image in the strange mixture of loyalties—to science, to aristocracy, and to laissez faire—in the man who headed the Committee of the Privy Council on Education from 1859 to 1864.

We can better understand Arnold's educational effort if we remember that his adversary until 1864 was both an educational aristocrat and a doctrinaire exponent of laissez faire. Lowe believed that "any attempt to keep children of the labouring classes under intellectual culture after the very earliest age at which they could earn their living, would be as arbitrary and improper as it would be to keep the boys at Eton and Harrow at spade labour." He also believed that education was a commodity, like bread; if there was free trade in corn, there should be free trade in schools.[85]

Arnold was therefore hardly exaggerating Robert Lowe's religious devotion to the laissez faire creed when, at the conclusion of "The Twice-Revised Code," he described his antagonist as "a political economist of such force, that had he been by when the Lord of the harvest was besought 'to send labourers into his harvest,' he would certainly have remarked of that petition that it was 'a defiance of the laws of supply and demand,' and that the labourers should be left to come of themselves."[86] As Ruskin had resorted to Matthew, so Arnold resorts to Luke, to remind readers that the "laws" of supply and demand are distinctly secular. The image of Robert Lowe forcefully calling Jesus' attention to the science of political economy was intended to remind Arnold's readers of what Ruskin had been urging in *Unto This Last*, that the ebb and flow of supply and demand are not the ultimate determinants of value.

Later in 1862, writing about "Ordnance Maps" in the *London Re-*

view, Arnold pointed out that free enterprise provided no guarantee of demand for quality. Nowhere did public demand "ensure" a supply of maps of first-rate excellence; but on the Continent excellent maps existed because governments demanded them. In England, on the other hand, reliance had to be placed on private enterprise, and private enterprise always failed, because "a tradesman's business is simply to make money."[87] In its maps as in its educational system, the English government preferred cheapness to excellence.

Arnold was unwilling to entrust the definition of standards and value to the marketplace, because (as he wrote in the following year in *A French Eton*) "the mass of mankind know good butter from bad, and tainted meat from fresh, and the principle of supply and demand may, perhaps, be relied on to give us sound meat and butter. But the mass of mankind do not so well know what distinguishes good teaching and training from bad; they do not here know what they ought to demand, and, therefore, the demand cannot be relied on to give us the right supply." It was in *A French Eton* that Arnold moved from the subject of elementary to that of secondary education, but he was still fighting the same obstacle to the improvement of education through state organization and supervision, and public guarantees of the quality of instruction: the obstacle of laissez faire. Arnold believed that every Englishman should have been able to see, with his own eyes if not those of Dickens, that the system of free enterprise in secondary education had produced endless variations of Salem House operating under the aegis of countless Mr. Creakles. "By this time we know pretty well that to trust to the principle of supply and demand to do for us all that we want in providing education is to lean upon a broken reed."[88]

Arnold's criticism, begun in 1861, of the evil effects of the principles and practice of laissez faire, was to continue for the rest of his career. We have already seen how in *Culture and Anarchy* he charged that the untaxing of the poor man's bread had "been used not so much to make the existing poor man's bread cheaper or more abundant, but rather to create more poor men to eat it," and how he blamed the dogged adherence to laissez faire axioms for the fact that "about one

in nineteen of our population is a pauper," and that the children of the East End dragged out their existences "without health, without home, without hope."[89] Much later, in 1880, he was to endorse the position espoused by unionist workmen that "free political institutions do not guarantee the well-being of the toiling class." In "The Future of Liberalism" he would beg Lord Derby, when next he was about to launch into one of his customary paeans to the free institutions, free trade, and free manufacture of Liberal England, first to look about him at such flourishing centers of manufacturing industry as Bolton, Wigan, and St. Helens, and then to ask himself whether they are gardens in which the human spirit can flourish. Arnold's description of industry's development and effects in such "hell-holes" as these is, for reasons that will shortly become apparent, worth quoting its entirety:

> St. Helens is eminently what Cobbett meant by a *Hell-hole*, but it is only a type . . . of a whole series of places so designated by him . . . places developing abundantly their manufacturing industries, but in which man's instinct for beauty, and man's instinct for fit and pleasing forms of social life and manners . . . find little or no satisfaction. . . . And not only have the inhabitants of what Cobbett called a Hell-hole, and what Lord Derby and Mr. Bright would call a centre of manufacturing industry, no satisfaction of man's instinct for beauty to make them happy, but even their manufacturing industries they develop in such a manner, that from the exercise of this their instinct for expansion they do not procure the result which they expected, but they find uneasiness and stoppage. For in general they develop their industries in this wise: they produce, not something which it is very difficult to make, and of which people can never have enough, and which they themselves can make far better than anybody else; but they produce that which is not hard to make, and of which there may easily be produced more than is wanted, and which more and more people, in different quarters, fall to making, as times goes on, for themselves, and which they soon make quite as well as the others do. But

at a given moment, when there is a demand, or a chance of demand, for their manufacture, the capitalists in the *Hell-holes*, as Cobbett would say, or the leaders of industrial enterprise, as Lord Derby and Mr. Bright would call them, set themselves to produce as much as ever they can, without asking themselves how long the demand may last, so that it do but last long enough for them to make their own fortunes by it, or without thinking, in any way beyond this, about what they are doing, or troubling themselves any further with the future. And clusters and fresh clusters of men and women they collect at places like St. Helens and Bolton to manufacture for them, and call them into being there just as much as if they had begotten them. Then the demand ceases or slackens, because more has been produced than was wanted, or because people who used to come to us for the thing we produced take to producing it for themselves, and think that they can make it (and we have premised that it is a thing not difficult to make) quite as well as we can; or even, since some of our heroes of industrial enterprise have been in too great haste to make their fortunes, and unscrupulous in their processes, better. And perhaps these capitalists have had time to make their fortunes; but meanwhile they have not made the fortunes of the clusters of men and women whom they have called into being to produce for them, and whom they have, as I said, as good as begotten. But these they leave to the chances of the future, and of the further development, as Lord Derby says, of great manufacturing industries. And so there arise periods of depression of trade, there arise complaints of over-production, uneasiness and distress at our centres of manufacturing industry. People then begin, even although their instinct for expansion, so far as liberty is concerned, may have received every satisfaction, they begin to discover, like those unionist workmen whose words Mr. John Morley quotes, that "free political institutions do not guarantee the well-being of the toiling class."[90]

In view of all this, it is hard to understand what is meant by the persistent charge that Arnold was indifferent to social and economic

questions. Ladd, in his book on Ruskin's moral aesthetic, describes Arnold as "retreating from the roar of machines and the spectacle of industrial poverty" into the "leisurely culture" of "sweetness" and "light." Lippincott, in his study of Victorian critics of democracy, holds that Arnold "underestimated the materialism engendered by the profit-system, and . . . did not probe the problem of inequality in relation to industrial property. . . . "[91] Raymond Williams has argued that "both Arnold and Ruskin are, in the end, victims of abstraction in their social criticism: Arnold, because he shirked extending his criticism of ideas to criticism of the social and economic system from which they proceeded; Ruskin . . . because he was committed to an idea of 'inherent design' as a model for society."[92] This charge, as it regards Arnold, is plainly untrue—unless we suppose that the only way of relating ideas to the social and economic system is by means of the Marxist version of the genetic fallacy: namely, that all ideas and all motives are derived from class and material motives.[93] But perhaps the cloud of confusion raised by this charge can be dispersed, and its true meaning discovered, if we ponder yet another remark on Arnold and Ruskin by Williams. "It is now orthodox," he says, "to suppose that democracy is the root of our cultural problems, and from this supposition Arnold is a major figure. . . . On the other hand, if we see the cultural argument as essentially a critique of a commercial society, other figures take the foreground: Carlyle, Dickens, Ruskin, Morris; and then Arnold is an important but minor contributor. . . . "[94]

When Arnold is charged with shirking his duty—if that is the right word—of criticizing the Victorian social and economic system, what is really meant is that he did not make the economic question the one great, all-consuming issue of his social philosophy, did not choose to explain human action in economic terms, and did not conclude, from the fact that "free political institutions do not guarantee the well-being of the toiling class," that free institutions were not worth preserving. Arnold paid sufficient attention to the question of social justice to exercise a powerful influence over thinkers with such impeccable socialist credentials as R. H. Tawney, who took the title and theme of the second chapter of his book *Equality*—"The Religion of

Inequality"—from Arnold; but he steadfastly resisted the temptation, which has been so powerful in the last hundred years, to allow the economic and social question to obliterate all considerations of what is needful to a free and humane life. By espousing democracy and liberalism Arnold had, in effect, from the point of view of observers like Williams, cut himself off from that true faith which unites nineteenth-century "conservatives" like Ruskin with twentieth-century Marxists.[95]

T. S. Eliot has said that *"Culture and Anarchy* is on the same side as *Unto This Last,"* and he is right in the sense that both excoriate the principle of laissez faire and preach the superiority of government and cooperation to anarchy and competition. But whereas for Ruskin anarchy was coextensive with the realm of industrial relations and production, Arnold looked upon the anarchy of the laissez faire industrial system as but one manifestation of a deeper moral and spiritual anarchy.[96] He agreed with Ruskin that the collision of opposed forces or interests in the economic realm was not guided by an invisible hand that made private vices into public benefits and the pursuit of selfish interests into a social obligation; but he went beyond Ruskin in recognizing that, as Irving Howe has astutely observed, there is no more reason to suppose that this mythical invisible hand by means of which innumerable conflicting units are supposed to be wrought into a resultant of cooperation will prove any more satisfactory "in the economy of moral conduct than it has in the morality of economic relations."[97]

This is why Arnold sought a solution to "anarchy" not merely in new economic arrangements but in a wider conception that he called "culture." His criticism of laissez faire economics is couched in the terminology of culture rather than in the terminology of Christian socialism or of Marxism; but it is no less sincere or accurate for this deviation from progressive orthodoxy. We have seen how for Ruskin all social and political questions, all considerations of liberty and equality, were subsumed by the single issue of political economy, correct views about which even became a prerequisite for continued friendship with him. Arnold, on the other hand, with his deep, abid-

ing suspicion of a "one thing needful," whether in politics, economics, aesthetics, or religion, felt the importance of, and maintained his allegiance to, democracy and liberalism even as he recognized that neither was a guarantee of economic salvation for the working class. It was no accident that in 1879 when he chose to republish the essay that contains his first public onslaught on the principle of laissez faire, his introduction to *The Popular Education of France,* he entitled it "Democracy"; and he surely did not consider it accidental that Robert Lowe, who in the first part of the decade of the sixties had invoked the laissez faire doctrines to defend "payment by results" in education should in the second half of the decade emerge as the most thunderous and articulate parliamentary opponent of working class suffrage and of democracy.[98]

There is hardly a book on Ruskin that does not celebrate his prescience in advocating social and welfare schemes put into practice in the twentieth century, or remind us that the members of the first Parliamentary Labor Party claimed to have been more deeply influenced by *Unto This Last* than by any other book. Arnold, though he gave far more attention to the conditions created by the Industrial Revolution than has generally been recognized, and was even, according to Lionel Trilling, among "those writers who made the old conditions of the Industrial Revolution ever less possible,"[99] declined to make economics and sociology the basis of his political inquiries. The dismal industrial slums that arose from the practice of laissez faire had to be viewed as a symptom, along with religious sectarianism, worship of machinery, and love of "collision" for its own sake, of spiritual anarchy; and Arnold would not fix his attention exclusively on what he took to be one symptom among many of a pervasive infection.

Ultimately, Arnold and Ruskin agreed on the cause of modern anarchy. It was a new state of things in which, to quote Hannah Arendt, "a conception of law which identifies what is right with the notion of what is good for—for the individual, or the family, or the people, or the largest number" replaces "the absolute and transcendent measurements of religion." They disagreed over where this anarchy mani-

fested itself most menacingly, and how it might be combated, but their views need not therefore be thought mutually exclusive. John Stuart Mill, in writing of Bentham and Coleridge, once formulated a distinction between "complete thinkers" and "one-eyed men" that may be of use in comparing the modes of thought of Arnold and Ruskin, especially since it does not force us to choose between the two men. Bentham, says Mill, was a revolutionary thinker and a narrow one; in fact, he was revolutionary because he was narrow. Bentham's indifference to questions that did not suit his philosophy is certainly deplorable, yet perhaps, concedes Mill, "man has but the choice to go a little way in many paths, or a great way in only one." Desirous as Mill was of a social philosophy that synthesized partial truths, he seemed compelled to admit the necessity of "a large tolerance for one-eyed men, provided their one eye is a penetrating one: if they saw more, they probably would not see so keenly, nor so eagerly pursue one course of inquiry. Almost all rich veins of original and striking speculation have been opened by systematic half-thinkers: though whether these new thoughts drive out others as good, or are peacefully superadded to them, depends on whether these half-thinkers are or are not followed in the same track by complete thinkers."[100]

The social philosophies of Ruskin and Arnold may be seen as complementary if, applying Mill's suggestion, we view Arnold as the "complete" thinker of more inclusive yet less intense perception who follows in the track of Ruskin, the man of genius whose perception, as Hazlitt once said the perception of all genius must be,[101] is partial and exclusive. The difference between Ruskin's stress on one particular question at the expense of all others, and Arnold's search for a "complete" philosophy, is but the reappearance in the political realm of the difference between their romantic and classical ideas of art. Ruskin had always stressed the importance of strict fidelity to separate facts and details, in disregard of all requirements of "system," of wholeness, and of the generality of truth; and he had determined, in all his inquiries, "to follow out, in any by-ways that may open, on right hand or left, whatever question it seems useful at any moment to settle." Arnold, by contrast, though he found Ruskin's work full of

excellent, penetrating insights, thought it lacking in the order and concatenation of things that was the preliminary to truth; and he urged the necessity, in art and in thought, of seeing life steadily and seeing it whole, and warned of the dangers of supposing that the present concerns of men, however compelling, were their only or their most important concerns. Our present life must always be viewed, he believed, in relation to the collective experience of the past, and our latest impulses and experiences wrought into consistency with future exigencies as well as inherited truths. The attempt to grapple with present problems and needs, pressing as they might be, in disregard of the necessary continuities of human society, threatened to bring on yet worse problems. In society as in poetry, Arnold believed, one was morally obliged to respect traditional boundaries even as one tried to alter what happened within them. In 1853 he had issued a plea to poets to transmit intact to future generations the traditional framework of poetry. Fifteen years later, in *Culture and Anarchy*, he proclaimed: "For us the framework of society, that theatre on which this august drama has to unroll itself, is sacred; and whoever administers it, and however we may seek to remove them from their tenure of administration, yet, while they administer, we steadily and with undivided heart support them in repressing anarchy and disorder; because without order there can be no society, and without society there can be no human perfection."[102]

Arnold's and Ruskin's theories of art became theories of society because, as we have seen in previous chapters, they were originally framed as conceptions not only of the good work of art but of the good life. The difference between Arnold's classicism and Ruskin's romanticism was the difference between two orders of intelligence and two kinds of temperament. In 1873 Ruskin told an Oxford audience that "the writers and painters of the Classic school set down nothing but what is known to be true, and set it down in the perfectest manner possible in their way. . . . Romantic writers and painters, on the contrary, express themselves under the impulse of passions which may indeed lead to the discovery of new truths, . . . but their work, however brilliant or lovely, remains imperfect.

. . . "[103] Arnold would have agreed with this formulation, except that he saw the personal consequences of the romantic artist's passionate desire to be truthful to a uniquely modern experience in graver terms than Ruskin did—at least until Ruskin began to suffer those consequences himself.

In one of his 1866 Oxford lectures, "On the Study of Celtic Literature," Arnold tried to show the difference between Celtic and Germanic "races" by pointing to the different qualities of their plastic art. The Celts seemed, with their insatiable sentiment and yearning toward the impalpable, "almost impotent" in sculpture and painting. The Germanic "races," on the other hand, with their appreciation of *architectonicé*, of composition and of wholeness, excelled in painting. England, being primarily a mixture of the Celtic and Germanic elements, was better off than the all-Celtic Irish, but still far inferior to "the more unmixed German races." The best example, in Arnold's view, of the Celtic inaptitude for composition in painting was Ruskin's idol, Turner; for the characteristic Celtic "impulse to express the inexpressible carries Turner so far, that at last it carries him away, and even long before he is quite carried away, even in works that are justly extolled, one can see the stampmark, as the French say, of insanity."[104]

From the very outset of his career as an artist, Arnold had sought to take precautions against immersion in the kinds of experience, external and internal, that courted insanity; and in March 1865 he told his mother:

> No one has a stronger and more abiding sense than I have of the "daemonic" element—as Goethe called it—which underlies and encompasses our life; but I think, as Goethe thought, that the right thing is, while conscious of this element, and of all that there is inexplicable round one, to keep pushing on one's posts into the darkness, and to establish no post that is not perfectly in light and firm. One gains nothing on the darkness by being, like Shelley, as incoherent as the darkness itself.[105]

Ruskin, on the other hand, conceived of the relation between the light and the darkness of human life in a far different and less cautious way. He had, in *Modern Painters*, written the history of the disappearance of light and color from art and from the world; and when madness beset him, it took the form of a black storm cloud that darkened the heavens and cast moral and physical gloom over the earth. But in 1860, when he was writing *Unto This Last* and allowing himself to be "blackened" (to use the word Arnold will later apply) by political conflict, he could only see that to turn his back on the darkness was to turn his back on life. In the last volume of *Modern Painters*, after noting the shadows and coloring of some Highland and English hill scenery, he wrote:

> Now, as far as I have watched the main powers of human mind, they have risen first from the resolution to see fearlessly, pitifully, and to its very worst, what these deep colours mean, wheresoever they fall; not by any means to pass on the other side, looking pleasantly up to the sky, but to stoop to the horror, and let the sky, for the present, take care of its own clouds. However this may be in moral matters, with which I have nothing here to do, in my own field of inquiry it is so; and all great and beautiful work has come of first gazing without shrinking into the darkness. If, having done so, the human spirit can, by its courage and faith, conquer the evil, it rises into conceptions of victorious and consummated beauty.[106]

In my concluding chapter I hope to show the different kinds of critical stances adopted by Arnold and Ruskin to meet the encroaching darkness of the modern world, and the kinds of choices that had to be made by a Victorian critic who wanted to penetrate the darkness of his world without being submerged by it.

The loneliness is very great, in the peace in which I am at present, and the peace is only as if I had buried myself in a tuft of grass on a battlefield wet with blood, for the cry of the earth about me is in my ears continually if I do not lay my head to the very ground.—John Ruskin, letter of 10 March 1863

It irked him to be here, he could not rest.
He loved each simple joy the country yields,
He loved his mates; but yet he could not keep,
For that a shadow loured on the fields,
Here with the shepherds and the silly sheep.
Some life of men unblest
He knew, which made him droop, and filled his head.
He went; his piping took a troubled sound
Of storms that rage outside our happy ground;
He could not wait their passing, he is dead.

Matthew Arnold, "Thyrsis" (1864–65),
lines 41–50

If we had a keen vision and feeling of all ordinary human life, it would be like hearing the grass grow and the squirrel's heart beat, and we should die of that roar which lies on the other side of silence. As it is, the quickest of us walk about well wadded with stupidity.—George Eliot, *Middlemarch*, chap. 20 (1871–72)

Darkness and Dawn

When he embarked on his career as a political writer, Ruskin believed that one of his chief qualifications for the struggle that lay ahead was his independence and detachment. "I have perfect leisure," he told Henry Acland, "for inquiry into whatever I want to know. I am untroubled by any sort of care or anxiety, unconnected with any particular interest or group of persons, unaffected by feelings of Party, of Race, of social partialities, or of early prejudice. . . . " His one seeming disqualification for writing about the affairs of the world was that he himself lived outside of it and could therefore know nothing about it. But anyone who alleged that Ruskin's detachment from society invalidated his speculations about it showed himself a poor epistemologist. The truth was, Ruskin maintained, that just because he lived out of the world, he knew more about it: "Who do you suppose know most about the lake of Geneva—I, or the Fish in it?"[1]

Subsequent events were to prove that wealth, leisure, and physical detachment were for Ruskin no more guarantees of spiritual detachment than they were obstacles to knowledge. Even as he was composing *Unto This Last*, in self-imposed exile in Chamouni, Ruskin felt that his independence of spirit and his happiness were about to be sacrificed irrevocably: "It may be much *nobler* to hope for the advance of the human race only, than for one's own and their immortality; much less selfish to look upon one's self merely as a leaf on a tree than as an independent spirit, but it is much less pleasant. I don't say I have come to this—but all my work bears in that direction."[2]

The publication of his papers on political economy in the *Cornhill Magazine* brought down a torrent of abuse on Ruskin's head. The *Literary Gazette* found them "one of the most melancholy spectacles" it had ever witnessed. The *Saturday Review* described Ruskin's on-

slaught on the prevailing political economy as "eruptions of windy hysterics," "absolute nonsense," and defiantly announced that the world was not ready to be "preached to death by a mad governess." The *Manchester Examiner and Times*, fearful that "his wild words will touch the spring of action in some hearts . . . and a moral floodgate may open and drown us all," held Thackeray, the editor, morally culpable for printing *Unto This Last*. Finally, as Ruskin himself wrote later, "the outcry against them became then too strong for any editor to endure," and George Smith, the publisher, succumbed to the pressure and told Ruskin, after the third paper ("Qui Judicatis Terram") that he could admit only one more essay. Warming to the challenge, Ruskin made his last paper his longest, and, in his words, most "incendiary production," "a smasher."[3]

Ruskin, for all his spirit of contentiousness, was thrown into a state of severe depression and barely suppressed fury by the hostility visited upon him and upon the work that he considered his best to date. On the fourth day of November, the month of publication of the final essay, he told Norton: "I am resting now, and find myself in a general state of collapse. I hate the sight of pen and paper, and can't write so much as a note without an effort. . . . When I begin to think at all, I get into states of disgust and fury at the way the mob is going on . . . that I choke; and have to go to the British Museum and look at Penguins till I get cool." His fury resulted partly from the hostile reaction to what he had said, but even more from his feeling that he had forsaken his true work and turned himself upside down to no purpose. Leslie Stephen once described Ruskin as "a man of genius, placed in a pillory to be pelted by a thick-skinned mob, and urged by a sense of his helplessness to utter the bitterest taunts that he can invent." His fury in print was partly righteous indignation against callousness and stupidity, but partly too a way of striking back at "the world," which had lured him away from the work that suited and gratified him. At long last, he had turned away from pleasure toward duty and had spoken out clearly and forcefully on what most deeply troubled him; but his words were derided or ignored, and he seemed to have sacrificed his happiness for nothing: "The things I most re-

gret in all my past life are great pieces of virtuous and quite heroi-
cal self-denial; which have issued in all kinds of catastrophe and dis-
appointment, instead of victory. Everything that has turned out well
I've done merely to please myself, and it upsets all one's moral prin-
ciples so."[4]

Like Tennyson's Lady of Shalott, Ruskin had grown sick of shad-
ows and virtuously involved himself with the world that had cast the
shadows—only to discover that by doing so he had sacrificed life as
well as art, and was misunderstood by the world that had spurred
him to betray his calling in the first place. Ruskin was discovering,
to his despair, that for him there was no middle ground between
Olympian detachment from the world's sufferings and total immer-
sion in them. He was unable to make the descent into darkness as
a dispassionate observer; he moved with his sensibility wholly ex-
posed, and every increase in his knowledge exacerbated his grief and
fed his anger. By the end of 1860 he was telling his old tutor, the
Reverend W. L. Brown, that when he thought about wealth and eco-
nomics he became "so wild with contempt and anger . . . that I can't
write."[5]

The shock that Ruskin's moral principles received from the rebuff
to *Unto This Last* was so great that the leisure and independence he
had boasted of before he set himself to compose it began to weigh
upon him as burdens: "I find it wonderfully difficult to know what
to do with myself. If only a little round-headed cherub would tumble
down through the clouds and tree-branches every morning to every-
body with an express order to do so and so tied under his wing, one
would be more comfortable." That Ruskin in 1861 should still find
himself at loose ends, undecided about his future, praying for deliv-
erance from an unchartered freedom, seems, from one point of view,
incredible. With the wisdom of hindsight we can see him moving ir-
resistibly, over a very long period, almost under the guidance of
Fate, toward the great culminations of *Unto This Last* and *Munera
Pulveris*. But what looks to us like destiny looked to Ruskin like sui-
cide—and in one sense was; and no man approaches that destiny with-
out a great deal of reluctance. Ruskin himself admitted in the 1871

Preface to *Munera Pulveris* that after the violent reprobation of the *Cornhill* essays by the public, he turned the matter "hither and thither" in his mind for two years before resolving "to make it the central work of my life to write an exhaustive treatise on Political Economy."[6]

In February of 1861 Ruskin, who had for so long maintained that work was to be judged by the pleasure with which it was done, said he took about as much pleasure in the writing of political economy as he would in the breaking of stones. So eager had he been during the previous winter to escape from the intellectual troubles surrounding him that "it seemed . . . no life would do for me but one as like Veronese's as might be, and I was seriously, and despairingly, thinking of going to Paris or Venice and breaking away from all modern society and opinion, and doing I don't know what." But Bohemia was no more possible a refuge for Ruskin than a monastery; and he had already discovered that physical detachment was no guarantee of spiritual detachment. Through 1861 and 1862 he struggled with illness, isolation, indolence, purposelessness, and paranoia. But, worst of all, he was plagued by his consciousness of the glaring contradiction that his present life offered to his philosophical principles. The relation between his work and his misery seems never to have been far from his mind at this period. In a letter of October 1861 to his father he squeezed what consolation he could out of the fact that "of the two Athenians, Pericles and Phocion, who had most universal and benevolent influence on their nation, it is recorded that neither were ever seen to smile from their youth up." In November he told Robert Browning, "I am . . . in a state of sick apathy, or dull resolution— plodding on with work which will probably be as fruitless as it is pleasureless." He had always maintained that all good and useful work *was* done with pleasure. Now he found that as soon as he attended to the suffering and pain of human creatures and sought means of alleviating it, he became miserable himself. "My only way of being cheerful is . . . to shut myself up and look at weeds and stones. . . ."[7]

His conscience would not allow him to return to his artistic work —"of my intended work," he said in August 1862, "I have done noth-

ing"—and his realism would not allow him to take pleasure or satis-
faction in his humanitarian work. Recounting for Norton some of his
physical and emotional suffering in 1862, Ruskin wrote: "You say 'does
it give you no pleasure to have done people good?' No—for all seems
just as little to me as if I were dying (it is by no means certain I'm
not) and the vastness of the horror of this world's blindness and mis-
ery opens upon me—as unto dying eyes the glimmering square (and
I don't hear the birds). . . . " Ruskin's tears, as well as his labors,
seemed to him idle.[8]

Despite his doubts and his gloom, the disappointed philanthropist
resumed his vendetta against political economists in the winter of
1862–63 in the pages of *Fraser's Magazine*. The fourth paper of what
was intended as a long preface to *Munera Pulveris* appeared in March
1863; but Ruskin never got beyond his preface, for a storm of criticism
like that which had prematurely terminated *Unto This Last* forced J.
A. Froude (*Fraser's* editor)—or rather, his publisher—to discontinue
publication. Now, after three years of living in a state of constant in-
dignation and personal suffering, Ruskin retreated from "English bru-
tal avarice and stupidity" to the little village of Mornex in High
Savoy; but once again he found no real retreat, no real peace: " . . .
The loneliness is very great, in the peace in which I am at present, and
the peace is only as if I had buried myself in a tuft of grass on a bat-
tlefield wet with blood, for the cry of the earth about me is in my ears
continually if I do not lay my head to the very ground."[9]

The battlefield of which Ruskin spoke was more than a metaphor.
Wars were raging in America and Austria, and Ruskin could hardly
help hearing the cries and visualizing the blood of the combatants
in those struggles. England, in his view, was in the throes of an indus-
trial civil war, in which "that red ink" was recklessly shed over ac-
count books, and from whence came the noise and smoke that
assaulted Ruskin's eyes and ears every day.

Through the first half of the decade of the sixties Ruskin tried re-
peatedly to lay his head to the ground, to shut his eyes and ears, to es-
chew benevolence and eloquence, and to cultivate his interests and
himself. Between total immersion of his soul in the darkness of the

world about him, and entire withdrawal into solitude he saw no half-way house. Whereas in 1860 he had personally assumed the obligation not only to descend into darkness, to "stoop to the horror," but also to arise from it into conceptions of triumph and beauty, he now believed that although the human spirit might ultimately regain the light, the lonely explorer of the underworld would die in bondage to the god of darkness. With this fate before him, he could conceive of no compromise between detachment and involvement; and even if he could have conceived of one, his hypersensitivity to human suffering would not have allowed him to execute it. "The least mortification or anxiety," he confessed to the Carlyles, "makes me ill so quickly that I shall have, I believe, to live the life of a monster for some years and care for nothing but grammar. If I could make a toad of myself and get into a hole in a stone, and be quiet, I think it would do me good. My eyes . . . and ears are too much for me."[10]

Some years later, in *Middlemarch*, George Eliot, whose own moral sensibility was hardly what one would call underdeveloped, wrote, "If we had a keen vision and feeling of all ordinary human life, it would be like hearing the grass grow and the squirrel's heart beat, and we should die of that roar which lies on the other side of silence. As it is, the quickest of us walk about well wadded with stupidity."[11] But Ruskin was an exception; he most definitely lacked the protective wadding of stupidity (or of stoical armor) that George Eliot assumed to be a universal endowment. Perhaps Ruskin's parents, albeit in their old-fashioned way, understood their son's peculiar nakedness when they told him he was torturing himself in vain. His mother suggested that her son's gloom was leading him into misanthropy, and his father suggested that Ruskin's liver might be at the base of his problems. But Ruskin retorted that his grief was "no more biliousness than the Lamentations of Jeremiah was biliousness," and that "there is no more chaos in my mind than there was in Hesiod's or Virgil's, but you will find neither of them were happy men." The Ruskins were, of course, more concerned with their son's physical and emotional well-being than with transforming English society. But Ruskin, with a kind of spiritual pride that must have reminded his father more of Byron

than of the Jesus with whom his son now claimed fraternity, insisted upon the need for the prophet or seer to sacrifice his happiness and even his life:

> It is just because I am so clear-sighted, so just, and in many respects so unselfish, that I suffer in this way. There are not two men in the Parliament of England who would not be more angry if the Emperor of Russia stopped their partridge-shooting than if he murdered every soul in his dominions. These men are far happier than I. But they are neither better nor wiser. Depend upon it, though crime and folly bring grief, Wisdom and Knowledge bring it also. In much wisdom is much grief, and he that increaseth knowledge increaseth sorrow. There has been one man upon the earth of whom we believe, or profess to believe, that he knew all things, and did no sin. Of him it is recorded that he sorrowed constantly, fasted often, wept, and agonised. But it is only *once* said that he rejoiced. . . . [12]

By a strange irony, the man who had once maintained that the sign of all good work was that it was done in joy, now asserted that the necessary sign of work done to alleviate human misery was the absence of joy in the worker. But Ruskin was no longer talking of workmen or of artists or even of social critics; for he had come to think of himself as a prophet martyring himself for the benefit of the human race. If his vision became fitful and his expression at times incoherent, that was to be expected. When in 1856 he had classified the four types of human perceivers, he had rated above all the rest "the men who, strong as human creatures can be, are yet submitted to influences stronger than they, and see in a sort untruly, because what they see is inconceivably above them." "This last," Ruskin added, was "the usual condition of prophetic inspiration."[13] Toward this condition Ruskin now believed himself to be moving.

To his dismay, Ruskin was discovering that one might live out of the world and yet be only too much a part of it; nor did there seem for him to be any means of becoming involved in the affairs of the

world without surrendering to it the possession of his soul. In July 1863 he wrote to Charles Norton that he was "tormented between the longing for rest and for lovely life, and the sense of the terrific call of human crime for resistance and of human misery for help—though it seems to me as the voice of a river of blood which can but sweep me down in the midst of its black clots, helpless."[14]

It was at about this time that Ruskin and Matthew Arnold met for the first time. Arnold described the occasion, in June of 1863, in a letter to his mother:

> On Sunday night I dined with Monckton Milnes, and met all the advanced liberals in religion and politics, and a Cingalese in full costume; so that, having lunched with the Roths-childs, I seemed to be passing my day among Jews, Turks, in-fidels, and heretics. But the philosophers were fearful! G. Lewes, Herbert Spencer, a sort of pseudo-Shelley called Swinburne, and so on. Froude, however, was there, and Browning, and Ruskin; the latter and I had some talk, but I should never like him.[15]

We do not know whether the subject of the conversation that occasioned Arnold's (temporary) dislike of Ruskin was the nature of the critical character and the relation of the critic to his subject. But we do know that, since 1856, Arnold had seen in Ruskin's career an object lesson for critics, not as a model but as a warning. He undoubtedly knew of the storm of abuse that had befallen Ruskin with the publication of *Unto This Last* and *Munera Pulveris,* and it would be surprising if Ruskin's plight had not set him thinking about the manner of his own criticism and the relation between the critic's life and his work.

Ruskin's fate as a critic and a man may well have reassured Arnold of the rightness of a decision he had taken long before about the way he should see, and relate himself to, the world. In the title poem of his first volume, "The Strayed Reveller," he had, through the mouth of the young reveller, contrasted two ways of perceiving the world. The first way was that of the gods, who "turn on all sides / Their shining eyes, / And see below them / The earth and men." What they see

from Mt. Olympus includes the prophet Tiresias, the Centaurs, the Indian reaping his harvest of melons and cucumbers, the Scythian tethering his beast and making his meal, the ferry carrying merchants across the Oxus, and the Argonauts approaching the Happy Isles. These gods observe the world from the height and serenity of their detachment, and (like many other gods) pronounce it good. But when the poet looks at the very same world, he sees that it desperately needs to be improved; and unlike the gods he cannot see it at all without great pain:

> These things, Ulysses,
> The wise bards also
> Behold and sing.
> But oh, what labour!
> O prince, what pain!
> They too can see
> Tiresias; but the Gods,
> Who give them vision,
> Added this law:
> That they should bear too
> His groping blindness,
> His dark foreboding,
> His scorned white hairs. . . .
>
> (207–19)

Whereas the gods see all in peace and tranquility, the poet, looking deeper, sees the Centaurs speared by the Lapithae, the Indian's melons gnawed by worms, the Oxus merchants overtaxed and robbed; and not only sees, but feels: ". . . such a price / The Gods exact for song: / To become what we sing." (232–34) Dwight Culler has suggested that Arnold is here contrasting classical poetry, "objective, serene, and rather shallow," with romantic poetry, "profound, inward, and tortured."[16] At least, he is contrasting two ways of looking at the world, one of which causes the truth to suffer, the other of which causes the seeker of truth to suffer. Neither alternative was entirely attractive to the young Arnold, and he was determined to avoid both.

Arnold, like his own Empedocles, felt the need men have for joy,

but it had to be "joy whose grounds are true." In modern life the perspective of Olympian detachment was for gods and not for men; modern man was even too sorely tried, "too harassed, to attain / Wordsworth's sweet calm, or Goethe's wide and luminous view."[17] As long as he was mainly engaged in writing poetry, Arnold could still express the romanticist suspicion that classical serenity, simplicity, and stability come from closing one's eyes to painful difficulties and evil circumstances and all the complexities of life; yet he was even more terrified of romantic instability and turbulence, and of the price exacted, in unsteadiness of eye and mind, in incoherence of thought and expression, and in personal suffering, for the concrete, immediate romantic vision. We have already seen how, in such poems as "Resignation" and "To a Friend," Arnold had formulated a poetic creed according to which the poet might steer a middle course between classical detachment and romantic involvement. To put Arnold's aim positively, he hoped to combine the romantic allegiance to concrete, felt experience with the classical love of form and universality; to see all of life but to see it steadily; to incorporate the experience of human suffering in his poetic vision and yet to keep himself at a distance from it.

Arnold's most ambitious attempt to resolve the dilemma posed in "The Strayed Reveller" was "Empedocles on Etna." Frank Kermode has argued that in this poem Arnold has dissociated the figure of the romantic poet into Callicles, who has the calm that comes from shutting one's eyes to evil, and Empedocles, who experiences suffering with an immediacy that deprives him of all hope of joy and makes him stop writing poetry.[18] But it would be equally true to say that Callicles is precisely the image of classical art. As Warren Anderson has asserted, and very ably demonstrated, Callicles is none other than the "symbol of the classical ideal expressed through its most perfect medium."[19] It is Empedocles who flings himself into Mt. Etna and leaves the field to Callicles, who says that the formal perfection and classical universality of poetry cannot afford to stoop to such subjects as Empedocles: "Not here, O Apollo! / Are haunts meet for thee." (What Apollo's view of the matter is, we do not know.)

Though many of his readers, then and since, might suppose that Arnold had temporarily resolved his dilemma by giving an ordered, objective form to his turbulent, subjective feelings, Arnold himself looked upon "Empedocles" as a failure. For it seemed to have proved to him the impossibility of uniting the romantic and classical modes of perceiving and organizing experience. The creed that Callicles celebrates at the end of the poem—poetry should deal exclusively with "What will be for ever; / What was from of old"—is the truncated classicism that Arnold will henceforward espouse. The very action of his own poem seems to have forced him, in the 1853 Preface, to choose between Empedocles and Callicles, between romantic immediacy at the expense of survival and survival at the expense of awareness of evil; and his choice was clear:

> If we must be *dilettanti*: if it is impossible for us, under the circumstances amidst which we live, to think clearly, to feel nobly, and to delineate firmly: if we cannot attain to the mastery of the great artists;—let us, at least, have so much respect for our art as to prefer it to ourselves. Let us not bewilder our successors; let us transmit to them the practice of poetry, with its boundaries and wholesome regulative laws, under which excellent works may again, perhaps, at some future time, be produced, not yet fallen into oblivion through our neglect, not yet condemned and cancelled by the influence of their eternal enemy, caprice.[20]

Arnold talks of sacrificing himself to his art, but actually he was sacrificing his art to himself. This is made abundantly clear by his correspondence of the next few years, and receives its most forceful expression in a letter of August 1858 to his sister Jane. In it he is attempting to justify his play *Merope*, that tepid experiment with a great classical form that had been published late in 1857. He had, of course, already offered a public apologia for his work in the form of a Preface. There he said that despite his "supposed addiction to the classical school in poetry" he had published almost nothing deserving of that honorific label. Still, he was sure that "even in England, even in this

stronghold of the romantic school," there was a curiosity about the classical school, even among those "who have been taught to consider classicalism as inseparable from coldness, and the antique as another phrase for the unreal," which deserved to be satisfied. For this purpose, and also to satisfy his own desire for "the power of true beauty, of consummate form" Arnold had written his "Greek" drama. This, at any rate, was his public justification; his private one was very different:

> People do not understand what a temptation there is, if you cannot bear anything not *very good*, to transfer your operations to a region where form is everything. Perfection of a certain kind may there be attained, or at least approached, without knocking yourself to pieces, but to attain or approach perfection in the region of thought and feeling, and to unite this with perfection of form, demands not merely an effort and a labour, but an actual tearing of oneself to pieces, which one does not readily consent to . . . unless one can devote one's whole life to poetry.[21]

Arnold chose to retreat from art into life, and to pursue perfection of the life rather than perfection of the work.[22] But "life" too required a choice between, or at least a reconciliation of, the way of detachment and that of involvement. We have already seen how, in 1849, Arnold felt himself being driven by "Fate" to forsake youth, romance, and poetry; to leave Obermann's mountains and enter the world. "A Summer Night," composed sometime between 1849 and 1852, finds Arnold contemplating the alternatives open to him. The speaker of the poem, who is no longer among lakes and mountains but in a "moon-blanch'd" city street, deplores his inability to achieve either romantic ecstasy or a restful acquiescence in the ways of the world; he is "*Never by passion quite possessed / And never quite benumbed by the world's sway*" (32–33). The majority, he knows, succumb to the temptations of restful ease and routine:

> For most men in a brazen prison live,
> Where, in the sun's hot eye,

With heads bent o'er their toil, they languidly
Their lives to some unmeaning taskwork give,
Dreaming of nought beyond their prison-wall.
 (37–41)

A minority, however, reject the prison and take the more daring alternative of steering their own course on the "ocean of life." For them the speaker shows a guilty admiration; and yet he knows there is a preordained moral law that contradicts the untutored impulses of the heart and destines the individual adventurer to destruction:

And the pale master on his spar-strewn deck
With anguished face and flying hair
Grasping the rudder hard,
Still bent to make some port he knows not where,
Still standing for some false, impossible shore.
And sterner comes the roar
Of sea and wind, and through the deepening gloom
Fainter and fainter wreck and helmsman loom,
And he too disappears, and comes no more.
 (65–73)

Having beheld the sorry fates that befall both the spiritually indolent and the rashly courageous, the speaker asks, in desperation:

Is there no life, but these alone?
Madman or slave, must man be one?
 (74–75)

The answer to this question is found in the "pure dark regions" of the night sky. They follow, as do the stars of "Quiet Work" and of "Self-Dependence," an ordered course, and remain "untroubled and unpassionate." They represent the condition of serene labor toward which the man who wants to be neither slave nor madman must aspire. In the poem of farewell to Obermann, Arnold had imagined a select group of figures called "The Children of the Second Birth, / Whom the world could not tame," (143–44) and whose one bond was that they had been "Unspotted by the world" (156). Some of them

had been anchorites "who pined unseen" (153), some soldiers and men of action. Arnold knew he was destined neither for ascetic withdrawal nor for heroic action; and so he set himself to find a way to "share in the world's toil," and yet "keep free from dust and soil!"[23]

Arnold's strategy for remaining unspotted by the world in general, and by the little world of business documents and school books in which he moved, was to "hide" his life. In a letter of December 1856 he told his sister Jane that he had been escaping from the bustle of Eaton Place (his father-in-law's residence) to the "profoundest secrecy" of a friend's vacant apartment. At first this sounds like a lower-middle-class version of Ruskin's retreats to Chamouni; but for Arnold it was something more, a principle rather than a mere habit: "'Hide thy life,' said Epicurus, and the exquisite zest there is in doing so can only be appreciated by those who, desiring to introduce some method into their lives, have suffered from the malicious pleasure the world takes in trying to distract them till they are as shatter-brained and empty-hearted as the world itself."[24]

We know from Arnold's poetry that he conceived of man's true life as "buried" out of reach of his consciousness and of his tampering. This buried life was for Arnold essentially a mystery that beat wild and deep in the "soul's subterranean depth,"[25] far beneath the level of consciousness. It rose to the surface only rarely, in love, and also—though Arnold does not say so explicitly—in poetry. Empedocles, the former poet who is about to fling himself into Etna, hearkens back to the time when he *was* a poet, and wonders whether, in the reincarnated state, "we will . . . at last be true / To our own only true, deep-buried selves" or "will once more fall away / Into some bondage of the flesh or mind . . . " (Act II, lines 370–71, 373–74). Paradoxically, however, Arnold's dissatisfaction with his own poetry arose in part from the fact that it brought his buried life to the surface too often, even when he least intended to bring it there. The buried life is, almost by definition, subjective, irrational, or "wild," to use Arnold's term; that is why it is inadmissible in poetry that claims to appeal only to "those elementary feelings which subsist permanently in the race, and which are independent of time."[26]

Self-effacement became Arnold's code of conduct in life and in prose partly because he had so much difficulty adhering to it in poetry. Wordsworth's grandson acutely observed in 1858 that the discrepancy between Arnold's poems and his public personality was precisely the discrepancy between the poems and the 1853 Preface: "The preface to his earlier volume was curiously inconsistent with his practice: for I suppose few writers are so intensely introspective as he is: I do not know whether it is the result of a general law or not, but it seems to me that these young gentlemen who are as melancholy as night, and kick under the burden of life—seem sufficiently resigned and prosperous when one meets them."[27]

In any case, the notion of a hidden life seems to have been much in Arnold's mind in the early sixties. In 1862 and again in 1863 he copied into his notebooks Lacordaire's saying: "Se retirer en soi et en Dieu est la plus grande force qui soit au monde!" In the 1862 notebook we also find quoted Maurice de Guérin's praise of "une vie studieuse et cachée" as a continual celebration. In 1863 Arnold quotes Lacordaire on the way to achieve Christian detachment. His final Oxford lecture of this year was on Joseph Joubert, "A French Coleridge." In giving, as was his custom, a thumbnail biography of his subject, Arnold noted that Joubert cared more to perfect himself than to acquire a reputation, and stopped to explain the paucity of striking incident in his subject's life: "He has chosen, Chateaubriand (adopting Epicurus's famous words) said of him, *to hide his life*. Of a life which its owner was bent on hiding there can be but little to tell." The same might, of course, be said of Arnold—or so, at least, he hoped. It was, according to his friend G. W. E. Russell, "Arnold's express wish that he might not be made the subject of a Biography."[28] Putting himself in Joubert's place, he thought that he had kept his own life hidden, and that therefore a biographer could have but little to tell of it.

The decision to hide his life was for Arnold originally a method of self-preservation. In April of 1863, several months before delivering the "Joubert" lecture, he completed an article on Spinoza which asserted one of the two greatest doctrines of that thinker, who had lived

even more obscurely than Joubert, to be his doctrine of self-preserva-
tion: "Man's very essence is the effort wherewith each man strives to
maintain his own being. . . . Man's virtue is this very essence, so
far as it is defined by this single effort to maintain his own being. . . .
Happiness consists in a man's being able to maintain his own being.
. . . " Arnold clung to this decision to live obscurely, reminding him-
self of Epicurus's dictum throughout his life. The perfect life, he
would write to his mother, is probably beyond the reach of most men,
even such men as Plato, yet surely Plato would have been less perfect
had he been a man of action. When he was in America, Arnold wrote
home to comment on the American obsession with movement and
publicity that "I thank God it only confirms me in the desire to 'hide
my life,' as the Greek philosopher recommended, as much as possible."
Gladstone found Arnold the most inaccessible man he knew, and ac-
quaintances complained that his later elegies on persons who had been
very close to him (like Clough and Stanley) were oddly lacking in
"direct personal effusion." When in 1872 Henry Coleridge saw Ar-
nold for the first time in years and expressed astonishment at not see-
ing a white-headed old man, Arnold said his white hairs "were all in-
ternal."[29]

Arnold had been thinking and writing about the "hidden life" as
a means of protecting and ordering his existence for some years, then,
when in October 1863 something came to his attention suggesting
that the spiritual discipline of detachment and self-effacement that he
had long cultivated for its own sake might prove valuable as a means
of persuasion.

The October 1863 number of the *Westminster Review* carried an
article entitled "The Critical Character," which purported to review
the critical works of John Ruskin and Matthew Arnold and to define
the role of the ideal Victorian critic by comparing the relative effec-
tiveness of the two men as critics. The reviewer, a clergyman-journal-
ist named Samuel Reynolds, begins by subscribing to Renan's asser-
tion that criticism has been an outgrowth of the nineteenth century.
It exists by virtue of a new temper, characterized by freedom of
thought, sympathy with both past and present, "foresight of the fu-

ture," ability to distinguish the abiding from the transitory, and in-
tellectual integrity. Having thus defined the critical character in the
abstract, Reynolds chooses Arnold and Ruskin to illustrate his mean-
ing, for Arnold, "in spite of some faults, . . . is the very best critic
we possess" and Ruskin, "in spite of many great and noble qualities,
. . . is one of the most deficient in the true critical temper."

Reynolds is far from hostile to Ruskin and anything but contemp-
tuous of his intellectual power. On the contrary, he praises Ruskin for
recalling the attention of his contemporaries to the civilization of the
Middle Ages, which he refers to, in typical Victorian fashion, as if it
were yesterday. What he takes to be Ruskin's entire distaste for the
present is, to be sure, objectionable; but who—especially when he is
under the spell of Ruskin's vivid contrast between a peaceful, con-
tented past and a fevered, unsettled present—does not find it under-
standable and forgivable? Reynolds's deeper uneasiness is caused by
the temper of mind revealed in Ruskin's writings. He is a reckless
writer, whose ignorance of a subject never keeps him from formulat-
ing its theory and proclaiming the laws by which its study must ab-
solutely be regulated. Furthermore, the disorderliness of his thought
is perpetually at war with his stated intentions. "His sympathies and
antipathies are often in ludicrous extremes; his whims and fancies
are more than feminine in their number and absurdity. . . . " Where-
as Arnold contents himself with judging the "adequacy" of the lit-
erature of each age, Ruskin must assume the role of the prophet and
combine the function of the moralist and religious teacher with that of
the critic. But his prophetic ardor moves Ruskin away from persua-
sion into a denunciation of sin that is so much the self-indulgence of
the author that it can hardly be called criticism. Reynolds concludes
that Ruskin's works are fatally flawed as criticism because they reflect
too immediately and probably too accurately the personality of their
author: "They have too deep an impress throughout of his self-will
and eccentricity for us ever to accept his judgment without a degree
of hesitation and mistrust. He is a thorough partisan; and appears
to see no merit in what he dislikes, no faults in what he is pleased to
admire."

Arnold, on the other hand, is the model of the critical temper. He is quite as bold and confident in his criticisms as Ruskin, "but he is confident without being self-willed, and bold without being paradoxical." Arnold always follows the rule of moderation and does justice to those whose wide differences from himself test his powers of sympathy. Having thus suggested the secret of Arnold's persuasiveness, Reynolds unwittingly attests to it by cheerfully accepting Arnold's classification of modern English literature in the third rank when two pages earlier he had chafed at Ruskin's undervaluing of modern English culture and civilization.[30]

The *Westminister Review* essay was called to Arnold's attention by Lady Rothschild. He was so pleased that he wrote to her to disclaim authorship: "It contains so much praise that you must have thought I wrote it myself, except that I should hardly have called myself by the hideous title of 'Professor'." "I must send it to you," he wrote to his mother later the same day:

> It is a contrast (all in my favour) of me with Ruskin. It is the strongest pronunciamento on my side there has yet been; almost too strong for my liking, as it may provoke a feeling against me. The reviewer says, "Though confident, Mr. Arnold is never self-willed; though bold, he is never paradoxical." Tell Fan to remember this in future when she plays croquêt with me. I also keep it as a weapon against K., who said to me that I was becoming as dogmatic as Ruskin. I told her the difference was that Ruskin was "dogmatic and *wrong*," and here is this charming reviewer who comes to confirm me.[31]

Arnold did not, of course, so badly misconstrue the review as to suppose that it had complimented him for being dogmatic but right. Rather it confirmed and sharpened his conviction of the need to subordinate personality and indignation to the task of persuasion. He seemed suddenly to have recognized that the stoical detachment that purged the fire and life from his poetry might be the secret of success in criticism. Two weeks after reading the comparison between Ruskin

and himself, he told his mother: "I was in poor force and low spirits for the first ten days after I returned from [Fox How]; now I am all right again, and hope to have a busy year. It is very animating to think that one at last has a chance of *getting at* the English public." Reynolds's contrast between his own critical stance and Ruskin's appears to have awakened Arnold to "the precious truth that everything turns upon one's exercising the power of *persuasion, of charm*; that without this all fury, energy, reasoning power, acquirement, are thrown away and only render their owner more miserable."[32] Great energies thrown away and rendering their owner miserable—it is precisely the image of himself and of his powers that tortured Ruskin's spirit at this time; and it is easy to believe that Arnold sought consciously to preserve his happiness as well as his effectiveness by eschewing Ruskin's critical approach.

In prose as in poetry Arnold aspired toward a point of view from which he might contemplate the miseries of his world without being made miserable by them. He wanted, like Ruskin, to effect a great transformation of the English spirit and of English society; but in this effort he would not jeopardize his soul. He must maintain his own being, and recognize the primacy of the law of self-preservation. In November 1863 he told Jane that whereas her husband, the politician W. E. Forster, was destined to work for the "evolution" of English society in Parliament, "I shall do what I can for this movement in literature; freer perhaps in that sphere than I could be in any other, but with the risk always before me, if I cannot charm the wild beast of Philistinism while I am trying to convert him, of being torn in pieces by him. . . . "[33]

Arnold was too good a psychologist not to know that the energies he had determined to suppress, first as a poet and then as a critic, were not obliterated but diverted. Yet he chose to keep this spring of vitality and of trouble buried, hidden from consciousness. In December of this year, the simultaneous arrival of his forty-first birthday and of the news of Thackeray's sudden death moved him to reflect upon this life he had buried; but he was determined not to reflect too deeply or too long: ". . . I can feel, I rejoice to say, an inward spring which seems

more and more to gain strength, and to promise to resist outward
shocks, if they must come, however rough. But of this inward spring
one must not talk, for it does not like being talked about, and threat-
ens to depart if one will not leave it in mystery."[34]

The compartmentalized relation between the soul that abides in
mystery and the conscious mind now seemed to Arnold a necessary
condition not only of reaching toward the light but of diffusing it
among others. In the first month of the new year he wrote to his mother
to express his satisfaction with the way in which his lecture of the
previous November had called attention to its subject rather than to
the brilliance of the essayist. With the praise accorded him by the
Westminster obviously still in mind, Arnold reveals his new aware-
ness that the strategy of hiding one's life, valuable as it is in itself, is
also a most effective device of persuasion: "I was sure you would be
pleased with Joubert, and you say just what I like when you speak of
'handing on the lamp of life' for him. That is just what I wish to do.
. . . In the long-run one makes enemies by having one's brilliancy
and ability praised; one can only get oneself really accepted by men
by making oneself forgotten in the people and doctrines one recom-
mends. I have had this much before my mind in doing the second part
of my *French Eton*. I really want to *persuade* on this subject, and I
have felt how necessary it was to keep down many and many sharp
and telling things that rise to one's lips, and which one would gladly
utter if one's object was to show one's own abilities."[35] The people
who needed to be persuaded by *A French Eton*, it should be noted,
were the very people whom Ruskin had attacked in *Unto This Last*:
the opponents of state action.

At the time he wrote this letter Arnold had in mind, and may have
already begun to work on, the Oxford lecture called "The Influence
of Academies on National Spirit and Literature." Between the time of
its delivery on 4 June 1864 and its publication in the *Cornhill Maga-
zine*, Arnold deleted from the lecture "two or three pages . . . about
the limits of criticism."[36] He also agreed, partly in deference to his new
principle of self-effacement, but mainly in deference to his publisher,
to delete or to temper some of his criticism of Ruskin. George Smith,

passages from such earlier writers as Jeremy Taylor, Joseph Addison, and Edmund Burke; his chief example from among his contemporaries is John Ruskin. Nor is this at all surprising. For whereas Ruskin had taken for granted that the basic human dualism is a simultaneous consciousness of power and weakness—"Do what you can, and confess frankly what you are unable to do"[40]—Arnold assumed that reason and emotion were in natural opposition unless some external power reconciled them. He therefore urges his Oxford audience to

> think of the difference between Mr. Ruskin exercising his genius, and Mr. Ruskin exercising his intelligence; consider the truth and beauty of this:—
> "Go out, in the spring-time, among the meadows that slope from the shores of the Swiss lakes to the roots of their lower mountains. There, mingled with the taller gentians and the white narcissus, the grass grows deep and free; and as you follow the winding mountain paths, beneath arching boughs all veiled and dim with blossom,—paths that for ever droop and rise over the green banks and mounds sweeping down in scented undulation, steep to the blue water, studded here and there with new-mown heaps, filling all the air with fainter sweetness,—look up towards the higher hills, where the waves of everlasting green roll silently into their long inlets among the shadows of the pines. . . . "[41]

In such a passage, Arnold remarks, one sees the genius, the feeling, and the temperament of John Ruskin at work; these are the qualities that originate and culminate in Ruskin the individual artist and that could neither be communicated by others to him, nor to others by him. What flows from Ruskin's genius is exquisite, and the only possible objection that a critic might make to such a passage is that in it Ruskin is trying to make prose "do more than it can perfectly do," that he is reaching out beyond what he can grasp, reaching out, in effect, toward poetry.

But now, says Arnold, let us look at another passage by Ruskin, a

passage about Shakespeare's names, in which not Ruskin's individual genius but his intelligence and judgment, "the acquired, trained, communicable part in him," are operative:

> "Of Shakespeare's names I will afterwards speak at more length; they are curiously—often barbarously—mixed out of various traditions and languages. Three of the clearest in meaning have been already noticed. Desdemona—'δυσ-δαιμονία,' *miserable fortune*—is also plain enough. Othello is, I believe, 'the careful;' all the calamity of the tragedy arising from the single flaw and error in his magnificently collected strength. Ophelia, 'serviceableness,' the true, lost wife of Hamlet, is marked as having a Greek name by that of her brother, Laertes; and its signification is once exquisitely alluded to in that brother's last word of her, where her gentle preciousness is opposed to the uselessness of the churlish clergy:—'A *ministering* angel shall my sister be, when thou liest howling.' Hamlet is, I believe, connected in some way with 'homely,' the entire event of the tragedy turning on betrayal of home duty. Hermione (ἕρμα), 'pillar-like' (ἡ εἶδος ἔχε χρυσέης 'Αφροδίτης); Titania (τιτήνη), 'the queen;' Benedick and Beatrice, 'blessed and blessing;' Valentine and Proteus, 'enduring or strong' (*valens*), and 'changeful.' Iago and Iachimo have evidently the same root—probably the Spanish Iago, Jacob, 'the supplanter.' "[42]

The passage Arnold quotes comes from the "Government" chapter in Ruskin's then recently published attack on political economy; since it is a mere note to a passage in defense of slavery, one is tempted to guess that it is at this point that Arnold truncated his criticism of Ruskin in deference to George Smith. At any rate, Arnold proceeds to quarrel not with Ruskin's ideal polity, but with his eccentric, nonsensical etymology. For Arnold, this passage, which Northrop Frye and other twentieth-century critics have applauded as a rare example of "genuine" criticism in the Victorian age,[43] is an impertinent extravagance because it assigns to the meaning of Shakespeare's names an im-

possibly exaggerated importance. To indulge, as Ruskin does, in these etymological eccentricities is "to throw the reins to one's whim, to forget all moderation and proportion, to lose the balance of one's mind altogether. It is to show in one's criticism, to the highest excess, the note of provinciality."[44]

The source of Arnold's distinction between urbane and provincial criticism appears to have been a review essay on the French Academy published in 1858 by Sainte-Beuve. In it the French critic celebrated "urbanité" at the expense of "provincialisme" or "quelques habitudes de province, au moins dans le goût."[45] He seemed always to provide Arnold with a potent club for chastising Ruskin's romanticist deviations from the classical norm of criticism, whether (as in 1860) toward "tender pantheism" or as now, in 1864, toward "provinciality." This is hardly surprising in view of the fact that Sainte-Beuve, who was himself a convert from romantic poetry to classical criticism, virtually presided over Arnold's own translation from romanticism to classicism. As he wrote to Mme de Solms in 1860: "Je connais Arnold; il nous aimait beaucoup dans sa jeunesse; il est allé voir George Sand à Nohant; c'était un Français et un peu romantique égaré là-bas. C'était piquant chez le fils du respectable Arnold, le grand réformateur de l'instruction publique en Angleterre. Depuis, il s'est marié, s'est réglé, et, dans ses poésies, il reste fidèle au culte des anciens et de l'art. . . . "[46]

We tend to find Sainte-Beuve an acute and reliable observer of Arnold's career partly because his own career was in some sense the paradigm for Arnold's. As early as January 1854 Arnold had expressed to the French critic his belief that, since the death of Goethe, "vous êtes . . . le seul guide et la seule espérance de ceux qui aiment surtout la vérité dans les arts et dans la littérature."[47] Sainte-Beuve was for Arnold the perfect critic because he thought of himself as a humble workman rather than a fierce gladiator. He was measured, not exuberant; urbane, not provincial; amiable, not pugnacious. But "the root of everything in his criticism is his single-hearted devotion to truth." Whereas Ruskin was the purveyor of "le faux" in criticism, Sainte-Beuve was the avowed enemy of "fictions," whether in litera-

ture, politics, or religion; and the basis of his devotion to truth was his scientific spirit.[48] A born naturalist, he carried into letters "the ideas and methods of scientific natural inquiry." His exclusive study was "to find the real data with which, in dealing with man and his affairs, we have to do. Beyond this study he did not go. . . . "[49]

Sainte-Beuve's dispassionate scientific curiosity was kept pure by his refusal to enter the realm of action, particularly political action. "In that sphere," wrote Arnold in 1869, only months after the publication of *Culture and Anarchy*, "it is not easily permitted a man to be a *naturalist*. . . . " English writers, says Arnold, tend to assume that they already possess the data required for dealing with men, and "have only to proceed to deal with human affairs in the light of them." Because they have the courage of their ignorance, the English are keen for political action and strife. Sainte-Beuve, by contrast, "stopped short at curiosity, at the desire to know things as they really are, and did not press on with faith and ardour to the various and immense applications of this knowledge which suggest themselves, and of which the accomplishment is reserved for the future. . . . "[50]

Once Arnold had assimilated the critical naturalism of Sainte-Beuve, "the father and master of us all," it remained for him to unite this code of disinterestedness with a personal strategy of stoical detachment that would enable him to avert the calamities that had befallen Ruskin. It is important to remember that between 1856, when Arnold first criticized Ruskin for lacking orderliness and coherence, and 1864, when he came to formulate his critical creed in the Oxford lecture "The Functions of Criticism at the Present Time," Arnold had discovered in Ruskin nearly every shortcoming of temper and intellect that he pronounced baneful to criticism. Ruskin was febrile and irritable; he was subjective and sentimental; he was dogmatic and paradoxical; he was eccentric and extravagant; he tended to become obsessed with particulars at the expense of coherence and wholeness. Now, Arnold was to discover in Ruskin the most fatal flaw of all in the critic, the absence of the "Indian virtue of detachment."[51]

Arnold delivered his lecture "The Functions of Criticism at the Present Time" within two months of the publication of his lecture

on academies. It is as paradoxical a production as Arnold ever was to bring forth. On the one hand, it urged and exemplified the obliteration of all distinction between literary and social criticism; on the other, it insisted that the true critic must remain detached from practical affairs. On the surface, Arnold was continuing his search for the means to strengthen and purify English intellectual life; but simultaneously he was composing his apologia, justifying his own desertion of poetry for criticism and distinguishing his role as a critic from that of his predecessors.

The beginning of the essay—which in *Essays in Criticism* bears the slightly altered title "The Function of Criticism at the Present Time" —implies, though it does not state, a comparison between Arnold and those writers of the past whose careers prompt us to ask whether creative activity is in all circumstances preferable to critical activity. Granted that the inventive faculty is in an absolute sense higher than the critical faculty, "Is it true that Johnson had better have gone on producing more *Irenes* instead of writing his *Lives of the Poets* . . . is it certain that Wordsworth . . . was better employed in making his Ecclesiastical Sonnets than when he made his celebrated Preface . . . ?"[52] Is it true, we are invited and tempted to ask, that Arnold had better have gone on producing more *Meropes* instead of writing his *Essays in Criticism*? But then we recall that the real question for Arnold was a much harder one: not whether to produce more *Meropes* but whether to produce more poems like "Empedocles on Etna." Yeats was later to assert that "we make out of the quarrel with others, rhetoric, but of the quarrel with ourselves, poetry."[53] But for Arnold the dialogue of the mind with itself was not adequate poetry; criticism, the quarrel with others, would have to do its work before the poet could once again do something better than quarrel with himself.

Criticism, however, if it is to establish the order of ideas and of society in which poetry can again flourish, must be "disinterested." Arnold's disinterestedness is the public, external side of his stoical detachment; it is his old strategy for self-preservation transformed into an instrument of science—and of persuasion. We recall how, as long

ago as 1848, while reading the *Bhagavad Gita*, Arnold had told
Clough, "The Indians distinguish between . . . abandoning practice,
and abandoning the fruits of action and all respect thereto. This last
is a supreme step. . . . " By 1864, when he came to write "The Func-
tion of Criticism," Arnold had himself entered the realm of action,
but was trying to keep his soul "unspotted" by it, trying to learn how
to "share in the world's toil" and yet "keep free from dust and soil";
and so he thought he saw in the Indian secret of self-preservation
the secret of persuasion as well: "It will be said that it is a very subtle
and indirect action which I am thus prescribing for criticism, and that,
by embracing in this manner the Indian virtue of detachment and
abandoning the sphere of practical life, it condemns itself to a slow
and obscure work. Slow and obscure it may be, but it is the only proper
work of criticism."[54]

What had once been recommended to Clough as a means of saving
the soul was now recommended to all would-be critics as a prereq-
uisite of disinterestedness. Disinterestedness meant the ability to re-
main aloof from the "practical" view of things and to heed the sci-
entific commandment "to see the object as in itself it really is." The
duty of the critic is to engage in a free play of the mind on all the sub-
jects he touches and never to subordinate this activity of mind to ul-
terior, political, or practical considerations, however high-minded
these may be. Arnold saw, perhaps more clearly than any social critic
ever has, that the commitment to truth cannot for very long survive
the commitment to active citizenship and philanthropy. Even though
he knows that works of literature and philosophy have no defense
against the uses to which they may be put, he makes it the duty of the
critic "to leave alone all questions of practical consequences and ap-
plications."[55]

But disinterestedness was not just a means of protecting truth from
partisan commitments; it was also—somewhat paradoxically—a
means of persuading the practical man. If the man of action were not
convinced of the critic's integrity and disinterestedness, if he believed
that the critic was merely invoking the protective authority of "sci-
ence" in order to forward his own practical, party schemes, he would
pay no attention to the critic:

Where shall we find language innocent enough, how shall we make the spotless purity of our intentions evident enough, to enable us to say to the political Englishman that the British Constitution itself, which, seen from the practical side, looks such a magnificent organ of progress and virtue, seen from the speculative side,—with its compromises, its love of facts, its horror of theory, its studied avoidance of clear thoughts,—that, seen from this side, our august Constitution sometimes looks . . . a colossal machine for the manufacture of Philistines?

Other men whose philanthropic instincts had led them from letters into social criticism had, Arnold believed, vitiated their criticism by scorning the Indian virtue of detachment, by taking sides and letting themselves be sucked into the "vortex" of practical affairs. None of *them* could now persuade the political Englishman that the British Constitution is a machine for manufacturing Philistines: "How is Cobbett to say this and not be misunderstood, blackened as he is with the smoke of a lifelong conflict in the field of political practice? how is Mr. Carlyle to say it and not be misunderstood, after his furious raid into this field with his *Latter-day Pamphlets*? how is Mr. Ruskin, after his pugnacious political economy?"[56] The example of Ruskin was the most relevant to Arnold and certainly the one of greatest immediacy to his audience. Cobbett had been dead since 1835, and Carlyle's *Latter-day Pamphlets* had been published in 1850, whereas Ruskin's *Unto This Last* and *Munera Pulveris* (as the *Fraser's* essays of 1862–63 would later be called) were still new in the world and still the subject of intense controversy.

Thus, for the second time within a period of less than five months, Arnold had used John Ruskin, a son of Oxford, as an object lesson for an Oxford audience in what a critic should not be. Spurred on by the *Westminster Review*'s October 1863 comparison between them, he had, in fact, begun to use Ruskin as a kind of foil in whom he could identify and stifle the very temptations he felt to be latent in himself, just as he had once used Arthur Hugh Clough. Or rather, as he was still using Clough. Arnold's old Oxford friend had died late in 1861, and Arnold had promised early in 1862 to work on an elegy. Yet he

was unable to begin composition of the poem until late November or early December of 1863 and unable to bring himself to work continuously on the poem that became "Thyrsis" until 1864, or roughly the period when he was writing and delivering his lectures on academies and on the functions of criticism.[57]

The fact is more than coincidental; for Arnold was now in the process of transforming the personal and poetic advice he had given in the forties to Clough into critical doctrine; the "Indian doctrine," which he had once recommended to Clough as a means of saving the soul, he was now recommending to all would-be critics as a prerequisite of disinterestedness. Much of the immediacy of "Thyrsis" comes from the fact that it is not merely an expression of Arnold's satisfaction that he had avoided, fifteen years earlier, the suicidal idealism of Clough, but a forceful depiction of the self-destructive path of the prophet that such contemporaries as Ruskin were taking and that Arnold was doing his best to avoid.

Why was it, Arnold asked in "Thyrsis," that he had survived and Clough had died? Superficially, their fates seemed to have been identical; for both left Oxford and the Scholar-Gipsy and poetry for life in the world (and in fact for equally boring jobs in the Education Office):

> Ah me! this many a year
> My pipe is lost, my shepherd's holiday!
> Needs must I lose them, needs with heavy heart
> Into the world and wave of men depart;
> But Thyrsis of his own will went away.
>
> (36–40)

What Arnold means by saying that whereas he was forced to enter the world of men, Clough went willingly, may be understood by hearkening back, momentarily, to the year 1848. We have already seen how Arnold and Clough differed in their reactions to the political upheavals of that year. Arnold tried to balance involvement with skeptical detachment; but Clough, heedless of Arnold's prescriptions of the *Bhagavad Gita*, resigned his Oriel fellowship partly out of his

"morbid conscientiousness" over subscribing the Thirty-Nine Articles,
but partly too out of concern over the suffering and oppression of
"men unblest," as Arnold labels the objects of Clough's sympathy in
"Thyrsis." He traveled to Paris in the spring of 1848 to witness the
Revolution and went to Rome in April of the following year—armed
with a cigar-case sent by Carlyle for Mazzini—for Garibaldi's strug-
gle against the French. He identified himself with the Republicans
to the extent that he could write to Tom Arnold in May, "You will
have heard of our driving back the French." By November, Arnold
knew that he must eventually separate himself from Clough's inten-
sity of idealism and social conscience, for he would rather part from
such friends as Clough altogether than "be sucked for an hour even
into the Time Stream in which they . . . plunge and bellow."[58]

By immersing himself in the world when he could have remained
detached from it, Clough had in 1848 "of his own will" gone away.
Arnold, writing fifteen years later, still cannot resist the impulse to
blame his friend in the capsule biography he provides in the fifth stanza
of his elegy:

> It irked him to be here, he could not rest.
> He loved each simple joy the country yields,
> He loved his mates; but yet he could not keep,
> For that a shadow loured on the fields,
> Here with the shepherds and the silly sheep.
> Some life of men unblest
> He knew, which made him droop, and filled his head.
> He went; his piping took a troubled sound
> Of storms that rage outside our happy ground;
> He could not wait their passing, he is dead.
>
> (41–50)

It seems at first astonishing, for more reasons than one, that Arnold
should berate the dead Clough for transgressions (if that is what they
were) committed so many years earlier; especially when we recognize
that Clough's transgressions consisted of a tendency to be moved by
social problems, to become miserable over other people's miseries and

allow them to disturb the calm of his poetry, and to be incapable of patiently waiting out transient political storms. Arnold, we should remember, was hardly a recluse in 1864–65 when he composed "Thyrsis"; he was certainly not indifferent to the "life of men unblest," and he surely did not believe that the political storms of 1848 were going to turn out the only bad weather of the nineteenth century. Rather, it seems likely that he was using the figure of the dead Clough just as he had once been accused of using the living one, "as food for speculation."[59] The temptations to which Clough had supposedly succumbed were still very real to Arnold, and that is why he is so severe in condemning them. If we keep in mind the fact that "The Function of Criticism" and "Thyrsis" were being written concurrently, we can see this more clearly. It was not only Clough whose "rustic flute" lost its "happy" tone because its owner insisted on playing the "stormy note / Of men contention-tossed, of men who groan." Arnold tells his Oxford audience that the lack of the Indian virtue of detachment has cost Cobbett, Carlyle, and Ruskin their effectiveness as social critics; but he says in "Thyrsis" that Clough's inability to grasp the Oriental wisdom had cost him his life.

Whether or not Arnold knew it, his verse biography of "Thyrsis" was a more accurate description of Ruskin than of Clough. Ruskin had truly left the "simple joy" of natural beauty in obedience to an irresistible urge to help those "men unblest" whose plight cast a lowering shadow before his eyes. His "piping" had indeed, in the sixties, taken the troubled sound and his eyes the horrific vision of what he was later to call the storm cloud of the nineteenth century. His lack of the patience and detachment that Arnold had prescribed to Clough "made him droop," cost him his happiness, and may have contributed to the loss of his sanity.

Yet Ruskin and Arnold faced similar problems in the sixties. The movement from creative, artistic work to social and moral criticism was not made without deep misgivings. For both men it seemed to involve the sacrifice not only of true vocation but of youth and joy. Arnold, even when he had become deeply embroiled in social and political controversies, felt himself recoiling and "disposed to touch

them only as far as they can be touched through poetry." Yet even as he pledged himself in 1861 to finish with his critical writings and devote the next decade to poetry—"It is my last chance"—he would recognize the futility of his wish and the impossibility of ever following his natural bent: "At forty, how undecided and unfinished and immature everything seems still, and will seem so, I suppose, to the end."[60] Ruskin in 1862 admitted that he was "in a curiously *unnatural* state of mind in this way—that at forty-three, instead of being able to settle to my middle-aged life like a middle-aged creature, I have more instincts of youth about me than when I was young. . . . " He felt himself torn between following his natural bent toward the study of beauty, and using his social influence to curb misery, knowing that if the latter gave him no pleasure, it also caused him no guilt, whereas the former brought joy, but joy followed by remorse: " . . . I neither like to give up my twenty years' cherished plans about Turner on the one side, nor to shrink behind the hedges from the battle of life on the other. The strange thing of all is that whenever I work selfishly—buy pictures that I like, stay in places that I like, study what I like, and so on—I am happy and well; but when I deny myself, and give all my money away, and work at what seems useful, I get miserable and unwell. The things I most regret in all my past life are great pieces of virtuous and quite heroical self-denial; which have issued in all kinds of catastrophe and disappointment, instead of victory."[61]

Thus both men in the 1860s recognized what they had lost in forsaking their artistic vocations in order to redirect the energies of a society that made the production of great art impossible. But Arnold, recognizing that he had alienated himself from his own soul—"Too rare, too rare, grow now my visits here"—was determined to make the best of a diminished personal life and to find happiness in self-denial: " . . . The gray hairs on my head are becoming more and more numerous, and I sometimes grow impatient of getting old amidst a press of occupations and labour for which, after all, I was not born. Even my lectures are not work that I thoroughly like, and the work I do like is not very compatible with any other. But we are not here to have facilities found us for doing the work we like. . . . "[62]

Ruskin, on the contrary, felt that stoical reconciliation to one's plight was the privilege of a spectator of, not a participant in, life:

> It is not that we have not the will to work, but that the work exhausts us after the distress. I stopped at this Bishop's Castle to draw, and if I could have drawn well, should have been amused, but the vital energy fails (after an hour or two) which used to last one all day, and then for the rest of the day one is apt to think of dying, and of the "days that are no more." It is vain to fight against this—a man may as well fight with a prison wall. The remedy is only in time, and gradual work with proper rest. Life properly understood and regulated would never be subject to trials of the kind. Men ought to be severely disciplined and exercised in the sternest way in daily life—they should learn to lie on stone beds and eat black soup, but they should never have their hearts broken—a noble heart, once broken, never mends—the best you can do is to rivet it with iron and plaster the cracks over— the blood never flows rightly again.[63]

Earlier in life, Ruskin had always been able to dispel regret and melancholy by work, but now, it seemed, the old expedients were no longer effective.

As for expedients of the kind adopted by Arnold in order to remain detached from the world, Ruskin found them either irrelevant or contemptible. Long before Arnold thought of using the dispassionate observation of science as a thought model upon which to base criticism, Ruskin had been a highly knowledgeable devotee of science, yet in the sixties the sciences afforded no balm for his perturbed spirit. "I have fallen back into the physical sciences," he wrote to Elizabeth Browning in 1861, "but they are hard and cold, and I don't care about them." In addition to being useless as an emotional balm, science had begun to subserve the malignant social forces that Ruskin was contending against. As late as 1859, he could praise science as "the source of utmost human practical power, and the means by which the far-distant races of the world . . . are to be reached and regenerated." But the American Civil War and his observation of industrial squalor

crushed his hopes and led him to predict that future ages would hate his own age for nothing so much as for its scientific and technical achievements: "Perhaps no progress more triumphant has been made in any science than that of chemistry; but the practical fact which will remain for the contemplation of the future, is that we have lost the art of painting on glass, and invented gun-cotton and nitro-glycerine."[64] Science pursued for its own sake, rather than for use or beauty, and in isolation from moral considerations, seemed to Ruskin one of the most insolent and dangerous enterprises of the modern spirit.

Not surprisingly, therefore, Arnold's exemplars of value-free, scientific detachment, like Sainte-Beuve, were Ruskin's abhorrence (just as Arnold's villainously unscholarly critics like Colenso were Ruskin's heroes of sincerity and forthrightness).[65] What seemed to Arnold, when he studied Sainte-Beuve, the salutary caution of a scientific investigator who would not go beyond the study of data, seemed to Ruskin the cowardice of one who dared not look beneath the surface, who never allowed his reach to exceed his grasp, and who preferred smooth minuteness to noble imperfection. Writing in August 1869 to Charles Norton, a great admirer of Sainte-Beuve's criticism (and of Matthew Arnold's), Ruskin expressed his contempt for Sainte-Beuve:

> I came yesterday on a sentence of Ste.-Beuve's, which put me upon writing this letter (it is he who is your favourite critic, is it not?): "Phidias et Raphael faisaient admirablement les divinités, et n'y croyaient plus." Now, this is a sentence of a quite incurably and irrevocably *shallow* person—of one who knows everything—who is exquisitely keen and right within his limits, sure to be fatally wrong beyond them. And I think your work and life force you to read too much of, and companion too much with, this kind of polished contemplation of superficies, so that I find I have influence over you, and hurt you by external ruggednesses. . . .

Subsequent discussion between Ruskin and his American friend, and the coincidence of their reading Sainte-Beuve's *Virgil* at the same time, seem to have brought Ruskin a year later to change his outright

condemnation of Sainte-Beuve to damning with faint praise: "I like Ste.-Beuve much, and see why you spoke of his style as admirable; but he is altogether shallow and therefore may easily keep his agitation at ripple-level."[66]

The success that came from the ability to keep one's agitation "at ripple-level" was for Ruskin the ultimate failure, in life as in art; and his criticism of Sainte-Beuve to Norton was but an indirect way of chastising Norton himself. During the years when Ruskin was being entrapped into an unnatural occupation and spiritually enveloped by the misery of the world, his friend Norton was witnessing the bloody Civil War raging on the other side of the ocean. Yet Norton, to Ruskin's way of thinking, had succeeded in keeping himself aloof from the struggle that was tearing his community apart, and by so doing had isolated himself from Ruskin. In August 1864 Ruskin told Norton that whereas he was engrossed in "all sorts of problems in life and death," he envisioned his American friend "washing your hands in blood, and whistling—and sentimentalizing to me. I know you don't know what you are about, and are just as good and dear as ever you were, but I simply can't write to you while you are living peaceably in Bedlam."[67]

Men living peaceably in the midst of a lunatic asylum—this is the image by which Ruskin had come to conceive of those who sought to live by reason in the midst of madness, to balance themselves in a world of agitation, to detach themselves spiritually from the chaos in which they were obliged to live and move. Ruskin had begun to judge the detachment of others by the standard of his own passionate involvement and righteous indignation, just as Arnold had begun to judge the practical involvement of others by the standard of his own detachment. Ruskin had come to feel that the world was too horrible to permit him to find pleasure or happiness in even the best thing that happened in it. "That a child is born—even to my friend— is to me no consolation for the noble grown souls of men slaughtered daily through his follies, and mine." Pope, he thought, had given the most lofty expression and accurate description of moral temper in English literature: "Never elated, while one man's oppress'd; / Never

dejected, while another's bless'd." Yet the fury with which Ruskin
now drove himself into a dark world of sorrows from which he could
not, he knew, emerge into the light, arose not only from a moral
compulsion but from a belief that true sympathy and understanding
were denied to those who did not become a part of the suffering they
contemplated. "I daresay if ever I get any strength again," he wrote
to Norton in 1866, "I shall find I've learned something through all
this darkness. Howbeit, I fancy Emerson's essay on Compensation must
have been written when he was very comfortable."[68]

Arnold, though he often stated that the individual could not per-
fect himself in the midst of an imperfect society, was nevertheless
determined to salvage his happiness while he worked in the midst of
men who suffered. He had, long before his involvement in social crit-
icism, pondered the fate of those poets eulogized by Wordsworth,
who began their youth in gladness, only to end in despondency and
madness; and he had always sought to learn some lesson of endur-
ance from contemplating the fate of Obermann or Heine or Clough
—or, for that matter, Cobbett, Carlyle, and Ruskin. He had sought
this help in comprehending, and accommodating himself to, a world
whose secret was not joy but peace. Even in Bedlam, Arnold believed,
one might seek, and could find, peace. One had to be conscious of
the demonic element that surrounded one, without being engulfed by
it. "One gains nothing on the darkness by being . . . as incoherent
as the darkness itself."[69] Arnold was determined, in his criticism, to
avoid irritation, envy, and contentiousness; by doing so he would
not only charm the wild beast of Philistinism but keep his soul hidden
and remote from the tumult in which he was forced to participate.

On a practical level, Arnold's means for achieving order in the
midst of disturbance was work. "Nothing," he repeats tirelessly
through the sixties, "saves one in this life but occupation and work."
If the work of school inspection was "a *little* too much as the business
half of one's life in contradistinction to the inward and spiritual half
of it," it brought unexpected rewards in the form of knowledge of
society and of oneself. When Arnold claimed that his experience as
a school inspector was the source of all he had written on religious,

political, and social subjects, he meant that this routine work had not only provided him with information but taught him a lesson in self-denial. On the one hand, school inspection enabled him to see and know places and people he would not otherwise have seen and known, gave him an immediate practical motive for advocating culture and deploring anarchy, and endowed him with a knowledge of practical affairs that made for the patience and detachment of his critical temper; on the other hand, it firmly disciplined his ego by forcing him into prosaic, businesslike relations with indifferent persons through many hours of the week. From observing them, Arnold learned that his own sacrifice of poetry was but a paradigm of the sacrifice that the majority of men are called on to make: "I met daily in the schools with men and women discharging duties akin to mine, duties as irksome as mine, duties less well-paid than mine, and I asked myself, Are they on roses? Would not they by nature prefer . . . to go where they liked and do what they liked, instead of being shut up in school?"[70]

Arnold learned, from watching his fellow workers, that renunciation is the lot of all men, not just of poets. "To no people, probably, does it so often happen to have to break in great measure with their vocation and with the Muses, as to the men of letters. . . . But perhaps there is no man . . . however positive and prosaic, who has not at some time or other of his life, and in some form or other, felt something of that desire for the truth and beauty of things which makes the Greek, the artist."[71] Like Ruskin, Arnold felt that he had forsaken his vocation and wandered from the inward life of imagination into a storm of contention and strife. But where Ruskin, fluctuating between the artistic work he guiltily loved and the political controversy he hated but virtuously embraced, longed for a cherub to emerge from the clouds "with an express order to do so and so tied under his wing,"[72] Arnold's circumstances obliged him to live and work in the world and to learn there the conditions in which man must shape his own fate and make his own good. George Eliot, in *Silas Marner* (1861), had written of Nancy Cass's addiction to self-punishment that "this excessive rumination and self-questioning is perhaps a mor-

bid habit inevitable to a mind of much moral sensibility when shut out
from its due share of outward activity and of practical claims on its
affections . . . [and when] there are . . . no peremptory demands
to divert energy from vain regret or superfluous scruple" (chap. 17).
Ruskin, lacking such diversions from suffering, vented his rage in his
criticism against those whose follies had drawn him away from art;
Arnold decided that he, like other men who had never been artists
at all, would have to find his happiness in self-denial. He observed
his fellow workers "making the best of it," wondered at "the cheer-
fulness and efficiency with which they did their work," and posed for
himself the question, "How do they do it?"[73]

In his idea of the relation between a workman's happiness and his
product Arnold was a more devout Ruskinian than Ruskin. In "The
Function of Criticism at the Present Time" he says that the exercise
of creative power is proved to be the highest function of man by his
finding in it his true happiness. Yet, he maintains, men may have the
feeling of free creative activity in other ways than by producing great
art and literature. By 1864 he knows that were this not so, "all but a
very few men would be shut out from the true happiness of all men."
Arnold had learned from grim experience that all work is not, in-
deed, cannot be, creative. Men may and must have happiness apart
from the inward, imaginative, creative life. "They may have it in well-
doing, they may have it in learning, they may have it even in criticiz-
ing." That, at least, is where Arnold was now determined to have it.
Nevertheless, he is obliged to admit, at the conclusion of "The Func-
tion of Criticism," that the fullest measure of creative activity be-
longs to literature and not to criticism; and therefore his own readi-
ness to forego the great happiness that comes only with creation, in
order to bring about a better social order through criticism, may be
viewed as a sacrifice on the altar of the future: "The epochs of
Aeschylus and Shakespeare make us feel their preeminence. In an
epoch like those is, no doubt, the true life of literature; there is the
promised land, towards which criticism can only beckon. That prom-
ised land it will not be ours to enter, and we shall die in the wil-
derness. . . . "[74]

We do not, unfortunately, possess any evidence of Ruskin's reaction to Arnold's critical formulations of this period. Yet it seems the duty of the critic to try to imagine what this might have been. Inevitably, a comparison between Arnold's and Ruskin's conceptions of criticism proceeds from Arnold's point of view. This is true for the same reason that comparisons between Arnold's and Clough's conceptions of poetry generally proceed from Arnold's point of view (and produce the kinds of distortions regarding Clough that Walter Houghton has enumerated): Arnold developed his conception of the critic partly in reaction to what he considered the errors of Ruskin, and having defined his own role as critic in contradistinction to that of his erring predecessors, hypostatized that role as the standard to which all criticism should adhere.

If, then, we try to lend Ruskin a voice in this dispute, it does not seem to me farfetched to suppose that a man who had all his life been obsessed by the implications of the gospel dictum that whosoever will save his life shall lose it, and whosoever loses it shall find it, must have found Arnold's representation of his desertion of poetry for criticism as a kind of exemplary, stylized martyrdom almost blasphemous. Ruskin too recognized that society would not be transformed in his lifetime, but unlike Arnold he could squeeze no consolation from a belief that his own jeremiads would show others the way to the promised land: "I have no hope for any of us but in a change in the discipline and framework of all society, which may not come to pass yet, nor perhaps at all in our own days; and therefore it is that I do not care to write more, or to complete what I have done, feeling it all useless." As for the future resurrection of art, it was folly even to think of it at present. "I utterly disdain to speak a word about art in the hearing of any English creature—at present," he wrote in 1867. "Let us make our Religion true, and our Trade honest. *Then* and not till then will there be even so much as *ground* for casting seed of the Arts."[75]

Ruskin's frustrations in his battles with political economy led him to view the world as a place of deepening gloom; in a gigantic pathetic fallacy he projected the darkness of his mind on the external world

(which greeted it, to be sure, with plenty of its own darkness). Para-
doxically, the more he saw, the darker his vision became. The Death
in Life of Tennyson's "Tears, Idle Tears" appears again and again in
his letters in the years 1862–63, when, as he tells his friend John
Brown, "All good and knowledge seems to come to me now 'As unto
dying eyes / The casement slowly grows a glimmering square.' "[76] The
"death" that seemed to descend on Ruskin in the form of literal and
metaphorical darkness in the wake of storms raised by *Unto This Last*
and *Munera Pulveris* was a far cry from the "death" envisioned by
Arnold at the conclusion of "The Function of Criticism." Yet it bears
a certain resemblance to a mood indulged by Arnold in his other ma-
jor composition of 1864–65, the imaginative complement to "The
Function of Criticism," "Thyrsis."

At the nadir of the poet's imaginative quest in "Thyrsis," he loses
his grasp of the Cumnor country around Oxford, and in being forced
to acknowledge the death of the past and of his friend, begins to an-
ticipate his own decline into old age and death:

> Yes, thou art gone! and round me too the night
> In ever-nearing circle weaves her shade.
> I see her veil draw soft across the day,
> I feel her slowly chilling breath invade
> The cheek grown thin, the brown hair sprent with grey;
> I feel her finger light
> Laid pausefully upon life's headlong train;
> The foot less prompt to meet the morning dew,
> The heart less bounding at emotion new,
> And hope, once crushed, less quick to spring again.
>
> And long the way appears, which seemed so short
> To the less practised eye of sanguine youth;
> And high the mountain-tops, in cloudy air,
> The mountain-tops where is the throne of Truth,
> Tops in life's morning-sun so bright and bare!
> Unbreachable the fort
> Of the long-battered world uplifts its wall;
> And strange and vain the earthly turmoil grows,

And near and real the charm of thy repose,
And night as welcome as a friend would fall.

(131–50)

This is the dark side of Arnold's affirmative commitment to prose and criticism in 1864; if "The Function of Criticism at the Present Time" expresses his acceptance of the duties of criticism, these stanzas of "Thyrsis" express his resistance to them. If in "The Function of Criticism" the barriers that sectarianism and selfish interest and practicality erect to the discovery of truth are held to be surmountable by disinterestedness and stoical detachment from practical life, here the aspirant to truth finds himself engulfed in "earthly turmoil," quite incapable of ascending the mountains or scaling the walls that obstruct the road to truth. This is as close as Arnold will come in the 1860s to the Tennysonian and Ruskinian equation between "the days that are no more" and a Death in Life.

Yet even here the speaker does not, after all, succumb to the temptation to escape from hard struggle into the dark night of easeful death. He suddenly hears a troop of Oxford hunters, whose presence suggests to him that the past may, after all, be recoverable; and so he crosses "into yon farther field," (157) from whence he is able once more to see, upon its lonely ridge, "the single elm-tree bright" (26) that had been for him and Thyrsis the symbol of the Scholar-Gipsy and the light of imagination. But although he is now able to see the tree, he cannot reach it; "I cannot reach the signal-tree to-night, / Yet, happy omen, hail!" (165–66) In the Preface to *Essays in Criticism,* written at the same time as "Thyrsis," Arnold affirmed that "we are all seekers still!"[77] So, too, the affirmation of the poem lies in the speaker's ability to continue striving toward the light even as he feels himself surrounded by the darkness. Clough, by giving himself wholeheartedly to the storms that raged outside the happy ground of art, had lost sight of the Scholar-Gipsy and become a part of that darkness. That is why it is so hard for a latter-day shepherd, especially a part-time one like Arnold, to "flute his friend, like Orpheus, from the dead" (90). Tempted though he has been by the darkness, the poet will not follow his friend into it:

There thou art gone, and me thou leavest here
Sole in these fields! yet will I not despair.
Despair I will not, while I yet descry
'Neath the mild canopy of English air
That lonely tree against the western sky.
Still, still these slopes, 'tis clear,
Our Gipsy-Scholar haunts, outliving thee!
Fields where soft sheep from cages pull the hay,
Woods with anemones in flower till May,
Know him a wanderer still; then why not me?
A fugitive and gracious light he seeks,
Shy to illumine; and I seek it too.

<div align="right">(191–202)</div>

"Thyrsis" plumbs depths not exposed in "The Function of Criticism at the Present Time," which Arnold was composing simultaneously with it. In the prose essay it is not Arnold, who aligns himself with "spotless purity," but Cobbett, Carlyle, and Ruskin, who are encircled by darkness and who do indeed become "blackened . . . with the smoke of . . . conflict in the field of political practice." Yet both poem and essay finally celebrate what is only a partial victory over circumstances, not a discovery of truth but a recovery of the ability to work toward it in despite of doubts and uncertainties. The tree of "Thyrsis" is a part of the "promised land" envisioned at the conclusion of "The Function of Criticism at the Present Time"; as the poet must rest content with the ability to "hail" the tree, so the critic, toiling in the wilderness, must be content "to have saluted [the promised land] from afar."[78]

Truth was not, Arnold now believed, to be found by penetrating ever deeper into the darkness and the storm in the expectation that at the heart of the darkness was the light, and at the eye of the storm peace; he was willing to explore the darkness only with an abiding awareness that the source of light lay outside and above it. In 1863, while inspecting schools in the East End of London, where "the fierce sun overhead / Smote on the squalid streets of Bethnal Green," Arnold met a sick and overworked preacher whose ability to sustain his cheerfulness in the midst of the squalor by his religious faith re-

inforced Arnold's conviction that spiritual detachment was the key to vision as well as to peace:

> O human soul! as long as thou canst so
> Set up a mark of everlasting light,
> Above the howling senses' ebb and flow,
> To cheer thee, and to right thee if thou roam—
> Not with lost toil thou labourest through the night!
>
> ("East London," 1–2, 9–13)

The letters on education and the state that Arnold sent to the *Pall Mall Gazette* at the end of 1865 were signed only by "A Lover of Light."

When Arnold published "The Function of Criticism at the Present Time" in 1865, Ruskin's involvement in practical affairs was still, with the exception of his agreement in 1864 to subsidize Octavia Hill's slum reclamation project, largely confined to the expression of opinion about practical questions. In the following year, however, he declined to allow his name to be brought forward as Arnold's successor for the Oxford Professorship of Poetry because "it was not the purpose of fate that I should lose any more days in such manner. . . . " Besides, he was by that time plunged deep in the defense of Governor Eyre, who had in 1865 presided over the brutal and murderous suppression of an uprising in Jamaica. To the defense of Governor Eyre, as Leon has remarked, Ruskin lavishly contributed time, money, and eloquence. "The Eyre Committee," Carlyle wrote on September 15, 1866, "is going on better, indeed is now setting fairly on its feet. Ruskin's speech . . . is a right gallant thrust, I can assure you." In a revealing metaphor Carlyle went on to describe how, "while all the world stands tremulous, shilly-shallying from the gutter, impetuous Ruskin plunges his rapier up to the very hilt in the abominable belly of the vast block-headism."[79]

In 1868, two years after Arnold, in his elegy to Clough and to his own poetic powers, had publicly and formally rededicated himself to the pursuit of an elusive light, Ruskin delivered what Rosenberg has called an "elegy to his abandoned hopes"[80] in the lecture "The Mys-

tery of Life and Its Arts." In it he admits that whereas earlier in life his influence was due to his ability to reveal to others the beauty of the physical cloud and of its colors in the sky, in future his influence must depend upon his ability to discover to others the terrifying knowledge that comes from the perception that this cloud is truly "a pillar of darkness," that human life partakes in large measure of "the mystery of the cloud," and that "its avenues are wreathed in darkness, and its forms and courses no less fantastic, than spectral and obscure."[81] Ruskin, who from his earliest works had attached high metaphysical significance to degrees of light and dark in works of art, now believed that genuine insight was denied to him who did not descend into the darkness of the modern world and suffer its disappointments as his own.

Later in the lecture, Ruskin asserts that a great lesson may be received from the hewers of wood, and drawers of water, those dumb Carlylean figures who speak only through their deeds; but "I grieve to say, or rather—for that is the deeper truth of the matter—I rejoice to say—this message of theirs can only be received by joining them—not by thinking about them!" Nor did Ruskin lose any time in attempting to practice what he preached, but began to enter the realm of practical life in a variety of ways. Having given up his belief in art, having concluded that *"You cannot have a landscape by Turner, without a country for him to paint; you cannot have a portrait by Titian, without a man to be portrayed,"* he determined that "the beginning of art *is in getting our country clean, and our people beautiful."* In 1871 he decided to clean the streets of St. Giles and hired three sweepers for the task. Never afraid to touch dirt, literal or metaphorical, himself, he personally demonstrated to the three how to use the broom to sweep refuse neatly into the gutters. But his chief sweeper disappeared, and the project foundered. It was followed by the famous road-mending scheme in Oxford. Struck by a feature of the Scholar-Gipsy's Hincksey countryside that appears to have evaded Arnold's eye, Ruskin decided that a country lane that had deteriorated into a morass of dried mud might be made over by Ruskinian undergraduates into a decent country road. Despite, or perhaps because of, the participation

of such notable young men as Oscar Wilde and Arnold Toynbee, Ruskin's noble attempt to show that, as *Punch* said, "The truth he has writ in the Stones of Venice / May be taught by the Stones of Hincksey too," resulted in a road that Ruskin himself admitted to be the worst in the three kingdoms.[82]

Many more such experiments, many more such failures, followed, the culminating disaster being the Guild of St. George. Acting on his belief that ideas need to be validated by practical application, Ruskin in 1871 conceived the idea of a guild that would be composed of men of good will who would follow his example by giving a tithe of their income, and more of their energy, to develop "some small piece of English ground" in accordance with Ruskinian ideals. But it was not until April 1872 that Ruskin received his first gift for St. George's— £30—and not until early in 1878 that the Guild was formally established. The increase of members was as small as that of funds, and by 1884, the membership still numbered just fifty-six. Of all the practical undertakings of the society—which ranged from communal farms to a traditionally organized linen industry—none flourished except, ironically, the museum at Sheffield. He who had deserted the muses to build a new Jerusalem could finally build only a temple in which to worship—the muses.[83]

The repeated failures of Ruskin's practical schemes aggravated the distress he had felt over the hostile reception accorded to *Unto This Last* and *Munera Pulveris* because they could so easily, and so cynically, be used as "proofs" of the impracticality of the general ideas upon which the schemes purported to be based. It was with great bitterness that he wrote to Octavia Hill in 1878, "Of all injuries you could have done—not me—but the cause I have in hand, the giving the slightest countenance to the vulgar mob's cry of 'impractical' was the fatallest."[84]

"I went mad," Ruskin wrote later in life, "because nothing came of my work." Like Arnold, Ruskin found himself in the wilderness, but unlike Arnold he felt himself to be wandering through it aimlessly. In one of the letters of *Fors Clavigera*, written in October 1875, Ruskin felt obliged to explain why he should be the single master at the apex of the hierarchy of the Guild of St. George:

And what am I, myself then, infirm and old, who take, or claim, leadership even of these lords? God forbid that I should claim it; it is thrust and compelled on me—utterly against my will, utterly to my distress, utterly, in many things, to my shame. But I have found no other man in England, none in Europe, ready to receive it,—or even desiring to make himself capable of receiving it. Such as I am, to my own amazement, I stand—so far as I can discern—alone in conviction, in hope, and in resolution, in the wilderness of this modern world. Bred in luxury, which I perceive to have been unjust to others, and destructive to myself; vacillating, foolish, and miserably failing in all my own conduct in life— and blown about hopelessly by storms of passion—I, a man clothed in soft raiment,—I, a reed shaken with the wind, have yet this Message to all men again entrusted to me: "Behold, the axe is laid to the root of the trees. Whatsoever tree therefore bringeth not forth good fruit, shall be hewn down and cast into the fire."[85]

In attempting to reap the fruits of his own disappointments, Ruskin found that a mind that immersed itself in darkness and storm became itself dark and stormy; but this, he believed, was the price that had to be paid for the gift of prophecy.

In one sense, then, Arnold was certainly right to have used Ruskin as a foil in defining his own role as a social critic. Even as early as 1849, when the storms that beset Arnold were purely romantic and therefore held a kind of attraction for him, he would not brave them at the risk of his lucidity:

> I struggle towards the light; and ye,
> Once-longed-for storms of love!
> If with the light ye cannot be,
> I bear that ye remove.
>
> I struggle towards the light. . . .
>
> ("Absence," 13–17)

Much more was this the case when the storms were intellectual and social, and had nothing intrinsically desirable about them. The picture

Arnold drew in "A Summer Night" of the "madman" who is struck by the tempest as he desperately tries to guide his wrecked ship toward "some false, impossible shore" is lent an almost prophetic power by being juxtaposed with Ruskin's picture of himself in 1875 as the beleaguered master of St. George's Guild, "blown about hopelessly by storms of passion," or (in a letter of the same year) as "a wrecked sailor, picking up pieces of his ship on the beach." But if we are reluctant to believe that life imitates art, we should at least take note of the fact that Arnold had already come close to predicting madness as Ruskin's particular fate.

In his 1864 lecture "The Influence of Academies on National Spirit and Literature" Arnold had, as we have already noted, accused Ruskin of losing the balance of his mind altogether in some of his critical speculations. But no one seems to have noticed that Arnold went even further than this in the lecture: he explicitly linked Ruskin with a lunatic asylum, and only when George Smith objected to the linkage did Arnold agree to expunge it from the printed version of his lecture:

> As to the bit about Hanwell, it is not the very least too hard upon Ruskin; but it shall come out, or be softened down, if your personal friendship with him makes you unwilling it should appear in a magazine which you edit.[86]

Hanwell was a lunatic asylum, and one whose physical layout had made a special impression on Ruskin because it suggested to him the near alliance between madness and genius. In 1872 he wrote a letter to the *Pall Mall Gazette* on the subject of "Madness and Crime," in which he said: "I assure you, sir, insanity is a tender point with me. One of my best friends has just gone mad, and all the rest say I am mad myself." In 1874 he described the letter as one referring to "the increase of commercial, religious, and egotistic insanity, in modern society, and delicacy of the distinction implied by that long wall at Hanwell, between the persons inside it, and out." Ruskin, unlike his friend Charles Eliot Norton, wanted no part of peace in Bedlam, and yet could not conceive of his existence in perfect separation from it.

"Indeed," he wrote, "it has been the result of very steady effort on my own part to keep myself, if it might be, out of Hanwell, or that other Hospital which makes the name of Christ's native village dreadful in the ear of London . . . having long observed that the most perilous beginning of trustworthy qualification for either of those establishments consisted in an exaggerated sense of self-importance; and being daily compelled, of late, to value my own person and opinions at a higher and higher rate, in proportion to my extending experience of the rarity of any similar creatures or ideas among mankind. . . . "[87]

Ironically, however, as Ruskin's descent (or what at times we are compelled to call ascent) into madness seemed to confirm the prudential wisdom of Arnold's strategy of detachment and self-effacement, Arnold seemed to relax much of his old severity toward his critical rival. In February of 1865, not long after Arnold had attacked Ruskin for his provinciality, dogmatism, and pugnacity, and had by study of his criticism diagnosed an imbalance of mind that seemed to forebode residence at Hanwell, he told Robert Browning that he would review a book on Ruskin that Browning's friend Joseph Milsand had published in 1864.[88] His notebook for 1865 also lists the book as one he may review for the *Pall Mall Gazette*. Yet, as far as we know, Arnold never carried out his intention. It was as if, having used Ruskin for the purpose of defining himself and his critical role, he no longer felt challenged by him and could be more charitable in dealing with a man whose example no longer tempted him. Late in 1869 he wrote in the *Cornhill Magazine*, whose readers had reacted, as he had designed, far more tolerantly to his *Culture and Anarchy* than to Ruskin's *Unto This Last*, "If I were not afraid of intruding upon Mr. Ruskin's province, I might point out the witness which etymology itself bears to this law of righteousness as a prime element and *clue* in man's constitution."[89] This "compliment" is, of course, tinged with irony; but it was sufficiently ambiguous for one of Arnold's readers, his friend the philologist Max Müller, to miss the point and require to be set straight. "What I said about etymology," Arnold patiently explained to Müller in 1871, "contained some intention not of chaffing etymology, but of chaffing *Ruskin* and the incredible nonsense he has

permitted himself to talk about it. . . . "[90] This is obviously true, and yet the tone of the comment on Ruskin is strikingly different from five years earlier, when Ruskin's penchant for etymology had been used as evidence of mental imbalance. Moreover, the form of this ambiguous compliment—with its expression of apprehension about "intruding on Mr. Ruskin's province"—is exactly that of the better known and more effusive compliment in "Literature and Science."

In 1872, the year Ruskin took up residence at Brantwood, only about ten miles from Arnold in Ambleside, Arnold wrote what was probably his first letter to Ruskin, but unfortunately the letter has not survived.[91] Still, the fact of its being written may itself suggest Arnold's desire to lessen any impression of animosity that his Oxford lectures might have conveyed. Even in his Preface to *God and the Bible* in 1875, where he rather sharply rebukes Ruskin for the dogmatism of a passage Ruskin had written years earlier in *Modern Painters* II, Arnold softens his criticism by adding: "However, Mr. Ruskin is talking only about the beauties of nature; and here, perhaps, it is an excuse for inventing certainties that what one invents is so beautiful."[92] In September of 1877 Arnold received Ruskin as a visitor at Ambleside, and in December of the same year decided that he was actually growing fond of the man whom in 1863 he had decided he should never like. After a London dinner party, Arnold wrote his sister: "Ruskin was there, looking very slight and spiritual. I am getting to like him. He gains much by evening dress, plain black and white, and by his fancy's being forbidden to range through the world of coloured cravats."[93]

In the next decade Arnold and Ruskin were to engage in a debate that had little rancor and great significance. This friendly debate was but the latest installment of a feud that had raged in English literary circles for forty years, over the relative merits of Byron and Wordsworth. What makes the debate particularly revealing is the fact that Ruskin to a considerable degree identified Arnold with Wordsworth and himself with Byron. Athough he had "used Wordsworth as a daily text-book from youth to age" and had even "lived . . . according to the tenor of his teaching," Ruskin was growing more and more

impatient with "the amiable persons who call themselves 'Words-worthians'." There were two reasons for his impatience with the Wordsworthians. First, they did not practice the Wordsworthian doctrines they preached. None of *them* would do practical spadework at Ferry Hincksey, and "not all the influence of Mr. Matthew Arnold and the Wordsworth Society together obtained, throughout the whole concourse of the Royal or plebeian salons of the town, the painting of so much as one primrose nested in its rock, or one branch of wind-tossed eglantine." Arnold boasted in 1879 that as a Words-worthian he could read "with pleasure and edification" not only *Peter Bell* and the *Ecclesiastical Sonnets*, but even "the address to Mr. Wil-kinson's spade. . . . " But Ruskin in 1880 claimed that "it was mat-ter of some mortification to me, when, at Oxford, I tried to get the memory of Mr. Wilkinson's spade honoured by some practical spade-work at Ferry Hincksey, to find that no other tutor in Oxford could see the slightest good or meaning in what I was about. . . . " But even worse, in Ruskin's view, than the Wordsworthians' failure to practice what they preached was their refusal to recognize that their "excellent master often wrote verses that were not musical, and some-times expressed opinions that were not profound."[94]

Ruskin's irritation with the Wordsworthians reached its height when he read, shortly after its appearance in 1879, *Poems of Words-worth Chosen and Edited* (with a Preface) *by Matthew Arnold*. In this Preface, Arnold maintains that only Shakespeare and Milton de-serve a higher place among English poets than Wordsworth, and that Wordsworth's recognition has been hindered or delayed by special obstacles that Arnold hopes to remove. His first aim is to select, from among Wordsworth's voluminous output, his best poems and to ar-range them more logically than their author did; additionally, he hopes to indicate the true nature of Wordsworth's power and value. These lie, Arnold stresses, not in Wordsworth's "philosophy," so dear to the Wordsworthians—although "I am a Wordsworthian myself" —but in his ability to feel and to convey "the joy offered to us in na-ture, the joy offered to us in the simple primary affections and duties. . . . " The realization of this joy in Wordsworth's poetry is especially

valuable because the joy comes from a universally accessible source; it is capable of being a joy for all, a "joy in widest commonalty spread."[95]

Ruskin expressed his reaction to Arnold's edition of Wordsworth in the second installment of "Fiction, Fair and Foul," appearing in the August 1880 number of the *Nineteenth Century*:

> I have lately seen, and with extreme pleasure, Mr. Matthew Arnold's arrangement of Wordsworth's poems; and read with sincere interest his high estimate of them. But a great poet's work never needs arrangement by other hands; and though it is very proper that Silver How should clearly understand and brightly praise its fraternal Rydal Mount, we must not forget that, over yonder, are the Andes, all the while.

In Ruskin's view, Arnold estimated Wordsworth's poems so highly precisely because he could not see over them; one lowly peak paid tribute to another, less lowly. In fact, it was Wordsworth himself who most accurately determined his rank and scale among English poets when he exclaimed: "What was the great Parnassus' self to thee, / Mount Skiddaw?" "Answer his question faithfully," snaps Ruskin, "and you have the relation between the great masters of the Muse's teaching and the pleasant fingerer of his pastoral flute among the reeds of Rydal." Despite his long allegiance to Wordsworth, Ruskin's personal and social suffering had removed him beyond the compass of Wordsworth and of the Lake Country. From the height of his new but sad eminence, Ruskin views Wordsworth as "simply a Westmoreland peasant, with considerably less shrewdness than most border Englishmen or Scotsmen inherit."[96]

Long before this, in his "Memorial Verses" of 1850, composed upon the occasion of Wordsworth's death, Arnold had celebrated the "healing power" of this poet of the iron age:

> Wordsworth has gone from us—and ye,
> Ah, may ye feel his voice as we!

He too upon a wintry clime
Had fallen—on this iron time
Of doubts, disputes, distractions, fears.
He found us when the age had bound
Our souls in its benumbing round;
He spoke, and loosed our heart in tears.
He laid us as we lay at birth
On the cool flowery lap of earth,
Smiles broke from us and we had ease;
The hills were round us, and the breeze
Went o'er the sun-lit fields again;
Our foreheads felt the wind and rain.
Our youth returned; for there was shed
On spirits that had long been dead,
Spirits dried up and closely furled,
The freshness of the early world.

(40–57)

Europe, Arnold wrote, might again be supplied with examples of
Goethe's "sage mind" and "Byron's force," with those who would
teach men daring and courage; but never again with a Wordsworth
who would teach men how to avoid the tragic fate:

The cloud of mortal destiny,
Others will front it fearlessly—
But who, like him, will put it by?

(68–70)

Ruskin too was appreciative of Wordsworth's healing power (and
may even have learned from Arnold how to define it), but finally it
was not enough—men needed something more. Wordsworth had in-
deed a vivid sense of natural beauty, and "a pretty turn for reflections,
not always acute, but, as far as they reach, medicinal to the fever of the
restless and corrupted life around him. Water to parched lips may be
better than Samian wine, but do not let us therefore confuse the qual-
ities of wine and water."[97]
Not only was Wordsworth remiss in providing a well rather than

a vineyard; the well he provided was but a shallow one. The poets of the English Lakes, says Ruskin, were innocent, domestic, refined —and isolated from the turmoil of the real world. They observed "the errors of the world outside of the Lakes with a pitying and tender indignation, and [arrived] in lacustrine seclusion at many valuable principles of philosophy, as pure as the tarns of their mountains, and of corresponding depth." And just in case his readers are unacquainted with the Lake District, Ruskin tells them in a note that he has been "greatly disappointed, in taking soundings of our most majestic mountain pools, to find them, in no case, verge on the unfathomable."[98]

Wordsworth, like nearly every subject that Ruskin approached after 1870, had to be studied in the terms of light and dark imagery. By the standards of Ruskin's majestic darkness, Wordsworth had to be judged wanting. His poetry, far from conveying (as Arnold held) "joy in widest commonalty spread," is "lowly in its privacy of light," that is, the light remains a low one because it does not penetrate or surmount those dark obstacles that only the attempt to extend one's private light to others will reveal. Wordsworth's was "a gracious and constant mind; as the herbage of its native hills, fragrant and pure; —yet, to the sweep and the shadow, the stress and distress, of the greater souls of men, as the tufted thyme to the laurel wilderness of Tempe,—as the gleaming euphrasy to the dark branches of Dodona."[99]

To epitomize the placid and unruffled shallowness of Wordsworth's vision, Ruskin, in the third installment of "Fiction, Fair and Foul," quotes the following lines from Wordsworth's poem "Near the Spring of the Hermitage," from the series called *Inscriptions*:

> Parching summer hath no warrant
> To consume this crystal well;
> Rains, that make each brook a torrent,
> Neither sully it, nor swell.

"So it was," notes Ruskin contemptuously, "year by year, among the unthought-of hills. Little Duddon and child Rotha ran clear and glad;

and laughed from ledge to pool, and opened from pool to mere, translucent, through endless days of peace. But eastward, between her orchard plains, Loire locked her embracing dead in silent sands; dark with blood rolled Isar; glacial-pale, Beresina-Lethe, by whose shore the weary heart forgot their people, and their father's house." While Wordsworth cultivated his wise passiveness amidst the rills and streams of Westmorland, innocent men and women were being murdered in revolutionary carnage in Nantes, the French were massacring Austrians in Bavaria, and, in 1812, the grand army of Napoleon was being overwhelmed on its retreat from Moscow.[100]

Lest he be thought to judge Wordsworth by an arbitrary standard, Ruskin now commences his comparison between Wordsworth and Byron. Byron, "the first great Englishman who felt the cruelty of war," asks, "Who thinks of self, when gazing on the sky?" and Ruskin finds himself compelled to answer that "Mr. Wordsworth certainly did." It infuriates Ruskin, as his own vision of the heavens darkens, to think that Wordsworth characteristically saw the clouds "brightened by Man's *Im*mortality instead of dulled by his death." Byron, on the contrary, darkened the clouds with his own melancholy; and of him it might be said, as he had said of Lucifer in "The Vision of Judgment," "Where *he* gazed, a gloom pervaded space." Wordsworth, happily crossing Westminster Bridge at so early an hour of the morning that the sleeping city might be seen as if it were country, could remark how the city wore like a garment the beauty of the morning; "Byron, rising somewhat later, contemplated only the garment which the beauty of the morning had by that time received for wear from the city." The contrast that Ruskin sees between Wordsworth's vision and Byron's is very like that which Arnold had instituted over thirty years earlier between the classical and the romantic poet in "The Strayed Reveller." Whereas Wordsworth, from his aloof detachment, "calls God to witness that the houses seem asleep, Byron, lame demon as he was, flying smoke-drifted, unroofs the houses at a glance, and sees what the mighty cockney heart of them contains in the still lying of it, and will stir up to purpose in the waking business of it, 'The sordor of civilization, mixed / With all the passions which

Man's fall hath fixed.' " Naturally, says Ruskin, the piously sentimental public shrinks with alarm from the poet who refuses to provide it with "the pure oblation of divine tranquillity."[101]

If, in Ruskin's eyes, Arnold in Fox How was the spiritual brother of Wordsworth of Rydal Mount, neither of them having known the depth or the trouble of human compassion, then he himself was the spiritual descendant of the sorrowful and righteously indignant Byron. Those who disapprove of Byron say that he does not suffer fools or enemies gladly or with repose; and an amused Ruskin cannot help remarking ironically: "*This* defect in his Lordship's style, being myself scrupulously and even painfully reserved in the use of vituperative language, I need not say how deeply I deplore." Still less did Ruskin deplore another "fault" of Byron's, his combination of steady, "bitter melancholy" with a sense of the material beauty that lurks in iridescence, color-depth, and morbid mystery, a combination that is found to the full "only in five men that I know of in modern times; namely, Rousseau, Shelley, Byron, Turner, and myself." This peculiar sense of the link between melancholy and beauty set Ruskin and Turner and the three great romantics cited apart from all artists who delighted in clear-struck beauty and also from the "cheerful joys of Chaucer, Shakespeare, and Scott, by its unaccountable affection for 'Rokkes blak' and other forms of terror and power. . . . " This group in which Ruskin proudly places himself is united not just by its melancholy, its attraction to darkness, and its love of mountains, thunderclouds and dangerous seas; it shares also a "volcanic instinct" of justice, "which will not at all suffer us to rest any more in Pope's serene 'whatever is, is right'; but holds, on the contrary, profound conviction that about ninety-nine hundredths of whatever at present is, is wrong: conviction making four of us, according to our several manners, leaders of revolution for the poor, and declarers of political doctrine monstrous to the ears of mercenary mankind. . . . " Ruskin concludes this segment of his comparison of Wordsworth and Byron by saying that the elements of Byron's nature, "as of mine also in its feebler terms," made him an object of loathing to the "selfishly comfortable public."[102]

Arnold was quick to notice, in the August and September numbers of *Nineteenth Century*, this passionate outburst of Byronic allegiance that his own edition and discussion of Wordsworth had provoked. Into his notebook for 1880 he copied, from the page of "Fiction, Fair and Foul" that contained the remarks critical of his Wordsworth edition, Ruskin's condescending description of Wordsworth as "simply a Westmorland peasant" who had a gift for natural beauty and for reflections "medicinal to the fever of the restless and corrupted life around him"; he also quoted two of the lines Ruskin had cited as evidence of Wordsworth's shallow placidity ("Parching summer hath no warrant / To consume this crystal well") and set beside them his own pet example of bad Wordsworth, "Sol hath dropt into his harbour—."[103]

Arnold was probably appalled by the intensity of Ruskin's attack on Wordsworth. In the course of his correspondence with Macmillan concerning the book of selections from Byron to be published in 1881, Arnold went so far as to call the long-dead Wordsworth "the old man whom Ruskin despises." Yet in one sense Arnold replied to Ruskin's essays, in his introduction to the Byron volume, by granting the justice of their criticism of Wordsworth. True, he quotes many horrendous passages from Byron in order to demonstrate that this poet of the aristocratic, or barbarian class, had indeed "the insensibility of the barbarian" in his poetic style; yet he frankly admits that although he had in his previous essay ranked Wordsworth just after Shakespeare and Milton, their verse was of a higher order altogether not only than Byron, but than Wordsworth, "the author of such verse as 'Sol hath dropt into his harbour'—or (if Mr. Ruskin pleases) as 'Parching summer hath no warrant'—."[104] Leon Gottfried rightly points out that Arnold thus "appears to be softening the tone of controversy implied by his quotation of the gallery of horrors from Byron."[105] But Arnold's concession does not go beyond appearances. Ruskin's objection to Wordsworth had been a moral, not an aesthetic, objection; although Arnold admits the stylistic badness of "such lumbering verse as Mr. Ruskin's enemy, 'Parching summer hath no warrant,'" he reiterates the assertion of his earlier essay, denied by

Ruskin, that Wordsworth's great power lay in his sense "Of joy in widest commonalty spread."[106]

Yet the impulse that moved Ruskin to express so forcefully his moral and political preference for Byron over Wordsworth was one by no means foreign to Arnold. Even now, in 1881, when Arnold is certain that "Wordsworth has an insight into permanent sources of joy and consolation for mankind which Byron has not," he must candidly admit, "I . . . can even remember the latter years of Byron's vogue, and have myself felt the expiring wave of that mighty influence." In "Memorial Verses," written thirty years earlier, Arnold had confessed to a guilty admiration of Byron's power:

> When Byron's eyes were shut in death,
> We bowed our head and held our breath.
> He taught us little; but our soul
> Had *felt* him like the thunder's roll.
> With shivering heart the strife we saw
> Of passion with eternal law;
> And yet with reverential awe
> We watched the fount of fiery life
> Which served for that Titanic strife.
>
> (6–14)

Then, in a slightly later poem, "Stanzas from the Grande Chartreuse," he unwittingly revealed a certain sympathy with Byron's romantic melancholy even as he determined to separate himself from it. If Arnold never went so far in his mild apostasy from Wordsworth as Ruskin was to do in 1880, he had in 1849, as we have already seen, admitted that "Wordsworth's eyes avert their ken / From half of human fate" and in 1865 acknowledged that among the English romantics only Byron and Shelley had possessed the courage to make the bold attempt to apply the skeptical and subversive modern spirit in English literature. Attempting more, they achieved less than some of their contemporaries; and the greatest *literary* success of the romantic period was achieved by Wordsworth, a man who, according to Arnold, "retired (in Middle-Age phrase) into a monastery. I mean, he plunged

himself in the inward life, he voluntarily cut himself off from the modern spirit." Byron and Shelley, Arnold predicted, would be remembered, and well remembered, not for their successful works but for their passionate and futile efforts, their Titanic struggles and grandiose failures.[107]

Even now, in 1881, Arnold makes no attempt to conceal his admiration for the power of Byron's personality, which was best evinced in his fierce struggle against both the old order and middle-class philistinism. The sincerity and strength with which Byron opposed, in his poetry and in his life, the old order, "with its ignorance and misery below, its cant, selfishness, and cynicism above," count for a great deal both in life and in literature.[108] The energy and the agony of Byron's personality still serve to remind men of "the struggle that keeps alive, if it does not save, the soul."[109] Eventually, Byron destroyed himself by his immoderate passion for justice. Upon the impregnable philistinism of the middle class, "he shattered himself to pieces"; and he is now remembered by contemporary warriors against the philistines as "the passionate and dauntless soldier of a forlorn hope, who, ignorant of the future and unconsoled by its promises, nevertheless waged against the conservation of the old impossible world so fiery battle; waged it till he fell. . . . "[110]

Byron, like Clough, is dead because he could not await the passing of the social and political storms of his day. Yet we do not sense, when we read this essay of 1881, any hostility toward Byron of the kind that was directed toward Clough in the earlier "Thyrsis." Arnold's admiration for Byron is, in fact, no longer tinged with the guilt and uneasiness that were apparent in "Memorial Verses." For Arnold has by this time in his life chosen the other, the Wordsworthian, path; the temptation has passed, the decision has long since been made. Arnold can now offer to Byron the least qualified praise of his "straining after the unlimited" that is to be found anywhere in his work just because he has so entirely separated himself from the Byronic impulse in art, in politics, and in life. Whereas Ruskin in the previous year had gone out of his way to affirm his fellowship in suffering, sadness, and indignation with Byron, their shared love for "Rokkes blak," Arnold

now makes it perfectly clear that, although he had once felt Byron's influence, he now regards him, and has long regarded him, "without illusion." Goethe, who had taught Arnold that to act is easy, to think hard, also helped him to see that the cause of all defects in Byron, the true source of his weakness both as a man and as a poet, was his inability to think: " 'The moment he reflects, he is a child,' says Goethe;—'*sobald er reflectirt ist er ein Kind.*' " Dedicated to dwelling in the light, Arnold was bound to divorce himself from Byron, for Byron "has no light, cannot lead us from the past to the future; 'the moment he reflects, he is a child.' The way out of the false state of things which enraged him he did not see,—the slow and laborious way upward; he had not the patience, knowledge, self-discipline, virtue, requisite for seeing it."[111]

Patience, knowledge, self-discipline, virtue—they were all endowments that Arnold had at one time or another found wanting in the man whose criticism of him had partly determined his strategy in the "Byron" essay; and by 1881 Ruskin was well on his way toward meeting that doom which, just because he lacked these endowments, Arnold had foretold for him. In 1878 he had suffered his first attack of madness, and was thereafter never very far from the darkness that was to engulf him by 1889. His vision of the world as a place of literal and metaphysical darkness was set forth in two lectures that he delivered at the London Institution in 1884, and that bore the magnificent title, at once literal and metaphorical, "The Storm-Cloud of the Nineteenth Century." Storm clouds had already preoccupied him when he was writing *Modern Painters*; and for fifty years he had recorded in his journals, in the most precise and scientific way, the weather, and various effects of cloud. He now claimed that since 1871 there had been a prevalence of a new kind of cold north wind—"plague wind"—blowing from no particular point of the compass but bringing always a new kind of dirty cloud: "not rain-cloud, but a dry black veil, which no ray of sunshine can pierce; partly diffused in mist, feeble mist, enough to make distant objects unintelligible, yet without substance, or wreathing, or colour of its own."

What was the source of this plague-cloud and what was its mean-

ing? It was in part, Ruskin knew and said, the product of science and technology: "It looks partly as if it were made of poisonous smoke: very possibly it may be: there are at least two hundred furnace chimneys in a square of two miles on every side of me." But Ruskin saw in the cloud not only the product of perverted science but the physical manifestation of divine judgment upon that perversion. Mere smoke, he conjectures, would not blow about so wildly. "It looks more to me as if it were made of dead men's souls. . . . "[112] But the overriding fact for him was that the new phenomenon had "blanched sun,—blighted grass—blinded man," and that "the Empire of England, on which formerly the sun never set, has become one on which he never rises."

The prophetic vision of a storm cloud enveloping Europe as the nineteenth century neared its end embodied Ruskin's condemnation of the whole direction of modern thought and society. He who had once hoped that the dispassionate scientific mind would unite poetry, prophecy, and religion in its clarity of vision, was now moved to assign blame for the impending uncreation of the world to those seekers after light who had plunged the world into a new darkness:

> If, in conclusion, you ask me for any conceivable cause or meaning of these things—I can tell you none, according to your modern beliefs; but I can tell you what meaning it would have borne to the men of old time. Remember, for the last twenty years, England, and all foreign nations, either tempting her, or following her, have blasphemed the name of God deliberately and openly; and have done iniquity by proclamation, every man doing as much injustice to his brother as it is in his power to do. Of states in such moral gloom every seer of old predicted the physical gloom, saying, "The light shall be darkened in the heavens thereof, and the stars shall withdraw their shining."[113]

Ruskin was led to his apocalyptic vision of the great Anarch dropping the curtain of universal darkness by his genius, but also by his madness. Lamb says that "the true poet dreams being awake. He is

not possessed by his subject, but has dominion over it."[114] Of Ruskin it is difficult to say this, for the storm cloud, though it is partly the projection of his own mental state upon the external world, is an effect that becomes in turn a cause, and further darkens the state of his mind, does indeed take possession of him. Ruskin had himself become a part of that darkness which, in the view of Arnold, the writer who lacked compass and guide entered at his own peril. Yet just when Ruskin's fate seemed to bear witness to Arnold's predictive powers, Arnold seemed to lose all desire for combat with his critical adversary. The "Byron" essay, in which Arnold sought to placate Ruskin while disagreeing with him, is more notable for its spirit of conciliation than for any impulse to deal another blow to Byron and Byronism. Ruskin's vigorous and emotional linkage of himself with Byron was still fresh in Arnold's mind when, writing as a Wordsworthian, he tried at the conclusion of his essay to suggest that both men and both traditions had a place in the English poetic heaven and were perhaps even a complementary pair:

> Wordsworth has an insight into permanent sources of joy and consolation for mankind which Byron has not; his poetry gives us more which we can rest upon now, and which men may rest upon always. I place Wordsworth's poetry, therefore, above Byron's on the whole, although in some points he was greatly Byron's inferior, and although Byron's poetry will always, probably, find more readers than Wordsworth's, and will give pleasure more easily. But these two, Wordsworth and Byron, stand, it seems to me, first and preeminent in actual performance, a glorious pair, among the English poets of this century.[115]

Though Arnold never went so far as to suggest that he and Ruskin, who for a couple of decades had been the most widely read of English social critics, might be, in a spiritual or a literary sense, a complementary pair, his subsequent allusions to Ruskin touched this gentle note of reconciliation. In 1882 he graciously told a Cambridge audience, after venturing a remark or two on the meanness of London

streets, that "here I have entered Mr. Ruskin's province, and I am well content to leave not only our street architecture, but also letters and Greek, under the care of so distinguished a guardian."[116] Although Arnold felt even less at home with painting than with architecture, on 5 June 1883 he attended a drawing-room lecture given by Ruskin in a private home in Kensington for "some of his friends" on the merits of Kate Greenaway and the drawings of Francesca Alexander.[117] Four years later, in response to a request for an article from the editor of the *Hobby-Horse*, Arthur Galton, who mentioned that Ruskin had already contributed an article, Arnold wrote, "I shall be curious to see what Ruskin has done for you. His is indeed a popular influence; I will not say that a contribution from me would do you no service; but it is not to be compared, as a help with the great public, to one from J. Ruskin."[118] Just how much Arnold knew of the nature and history of Ruskin's personal travail it is difficult to say; but from his friendship in the 1880s with J. E. Millais, the husband of Ruskin's former wife and at one time the intimate of Ruskin himself, he is likely to have gained some information. In any case, we know that in February 1888, just two months before Arnold's death, a growing curiosity about the man whose approach to art and to life he had so decisively rejected led him to ask Sir Robert Collins, a friend of Ruskin's who had been tutor to Prince Leopold and afterward comptroller of the prince's household, to let him see a letter Ruskin had written to Collins:

> My dear Sir Robert:
> I was afraid you had forgotten to send Ruskin's letter; many thanks to you for letting me see it. It is a beautiful letter, though a very sad one. I cannot think that either at the National Gallery or at the British Museum he would not meet the great consideration due to him; if he does not, it is too bad.[119]

Beautiful but sad—it is perhaps the fitting final tribute of a man who believed that beauty and truth might be known without personal suffering to one who had become convinced that if in modern life there

existed a way through to beauty, it lay through participation in sadness and in suffering. Arnold's willingness to reinclude Ruskin within the outer confines of the spiritually blessed has about it something of the empty ring of the final reinclusion of Clough at the end of "Thyrsis" within the ideal of the Scholar-Gipsy. It is the sportsmanlike gesture of the victor toward the vanquished, a gesture that can be made only after the combat is over, because good sportsmanship, like disinterestedness, is the virtue of a spectator but not of a participant. From Ruskin's point of view, however, Arnold's life must have seemed a rejection of honorable defeat for mean victory, of Empedocles for Merope, of imperfect expression in the highest form for perfect expression in a lower; and the critical doctrine that grew out of this life an attempt to cut Shakespeare down to a Greek drama, to fit Gothic cathedrals to the proportions of Greek temples, and to order life without having fully experienced it. It is hardly surprising that Ruskin, when he went over to Ambleside in 1877 to visit Arnold, was "much disappointed in him."[120]

The questions that arise from a comparison of Arnold and Ruskin are questions of epistemology, of politics, and of morality. They are not simple questions, nor are they exclusively Victorian questions. What I have called the conflict between the classical temper of Arnold and the romantic temper of Ruskin is but a special Victorian version of a perpetually recurring conflict in human experience, a conflict that goes on not only between individuals and groups but within every man and woman. If one part of George Eliot could warn of the madness that will be visited upon a mind oversensitive to "all ordinary human life," another part could, with equal sincerity and fervor, proclaim that "Half man's truth must hidden lie / If unlit by sorrow's eye."[121]

Perhaps most of us, as we try to weigh the relative merits of Arnold's classicist detachment and Ruskin's romanticist involvement, will be influenced by our evaluation of the dilemmas of our own age and society. Have the cataclysms of our century been due primarily to the anarchic industrial system that preoccupied Ruskin, or to the in-

tellectual and spiritual anarchy that Arnold deplored? Has the disinterested spirit of science and scholarship been a blessing or a curse? Are we passing through a dark night of the soul in transit to a new dawn, or are we finally awakening from a dream that dawned in 1789 to discover that it has been a nightmare? Does the solution to our problems rest in intellectual lucidity or in moral indignation? Do we require more light or more heat?

From one modern point of view nothing is more discreditable to Arnold than his insistence upon looking beyond the storms of his own day to what he called "the first faint promise and dawn of that new world which our own time is but now more fully bringing to light,"[122] and nothing more creditable to Ruskin than the fact that he went mad in the vain attempt to persuade the world that all of Europe was entering upon an age of madness. Those who espouse this point of view will point out that the new evils that had darkened the Victorian world made Ruskin's single-minded, passionate, all-consuming crusade against laissez faire industrialism the only morally acceptable reaction, and that he alone saw in the terrible new system a darkness that was to engulf the world. "Auschwitz," Lionel Trilling has said, "may be thought of as the development of the conditions of the factories and mines of the earlier Industrial Revolution."[123] From this point of view Arnold's detachment, his unwillingness to risk his coherence and his sanity by fully meeting the darkness that surrounded him, crippled him intellectually and made him a morally culpable prototype of those who, in this century, have remained mere "onlookers," coolly pursuing truth while the whole creation groaned; but Ruskin, in spite of being, as Proust wrote, "often stupid, fanatical, exasperating, false and irritating," stands forth before us as "always praiseworthy and always great."[124] Who but Ruskin, in his "madness," foresaw with literal accuracy the end of European civilization in factory smoke "made of dead men's souls"?

From another modern point of view, however, Ruskin's obsession with darkness and his unwillingness to look beyond it are equivalent to the irrational misery of the child, unable to conceive that night will eventually give way to morning, and his madness only the out-

ward sign that he was the first in a long line of sick people who in modern society have, by a strange paradox, assumed the mask of physicians.[125] Those who espouse this point of view will tend to see in Ruskin a prototype of all those righteously indignant social reformers, terribly certain of the generosity of their own motives, who in this century have become so obsessed with social welfare and the urgency of filling men's bellies that they have been blinded to all other concerns, and particularly those safeguards of individual liberty that have been so painstakingly developed in democratic societies. "An army of unemployed led by millionaires quoting the Sermon on the Mount—that is our danger," prophesied George Orwell.[126] From this point of view, the lesson of Auschwitz is not that laissez faire capitalism is the source of all our woes but that any piece of what Arnold called "machinery" can be made to serve the purposes of barbarism if it is employed by barbarians, and that the road that led to Auschwitz was to a considerable extent paved by those who, like Ruskin himself, were passionate for the destruction of laissez faire capitalism and saw nothing worth conserving in a liberal democracy that was willing to coexist with it. Arnold, on the other hand, recognized the danger both to oneself and to one's social vision in the "tyrannous single thought" or passion that subdues the soul, and saw that the true alternative to anarchy lay in culture, which opposed itself not to any particular form of "machinery" but to the barbarism that might employ machinery for inhuman ends.

Which of these positions is the true, or the truer, one, each reader must finally decide for himself. My comparison of Arnold and Ruskin has been intended to make clearer to the reader what were, in a particular time and place, the consequences and implications of holding these positions, and to suggest that neither position has a monopoly on wisdom or on virtue.

Notes

INTRODUCTION

1. Northrop Frye, *Anatomy of Criticism: Four Essays*, p. 346.
2. Lionel Trilling, *The Liberal Imagination: Essays on Literature and Society*, p. 191.
3. See G. M. Young, *Victorian England: Portrait of an Age*, p. 162.
4. "The Scholar-Gipsy," lines 187–90. (All quotations from Arnold's poems are from *The Poems of Matthew Arnold*, ed. Kenneth Allott.)
5. Letter no. 3 of *The Tamworth Reading Room* (London, 1841); Josef Altholz, "Newman and History," p. 293.
6. MS letter of 14 June 1871 to Stanhope Sprigg, Berg Collection, New York Public Library.
7. *Letters of Matthew Arnold: 1848-88*, ed. G. W. E. Russell, 1:193 (hereafter cited as *Letters of Arnold*). The pamphlet was "The Twice-Revised Code," *Fraser's Magazine* (March 1862).
8. *The Works of John Ruskin*, ed. E. T. Cook and Alexander Wedderburn, 36:417 (hereafter cited as *Works of Ruskin*).
9. Ibid., p. 450.
10. Raymond Williams, *The Long Revolution*, p. 47.
11. *Culture and Anarchy*, ed. R. H. Super, p. 113.
12. Ralph Cohen, *The Art of Discrimination: Thomson's "The Seasons" and the Language of Criticism*, pp. 9–10.

CHAPTER ONE

1. *Sartor Resartus*, conclusion of chapter 9 of Book Two.
2. Arthur P. Stanley, *Life of Thomas Arnold, D.D.*, p. 37.
3. George Eliot, *Middlemarch*, ed. G. S. Haight (Boston: Houghton Mifflin, 1956), chap. 56, pp. 409–10. The best general discussion of this topic is to be found in the section on "Work" in Walter E. Houghton, *The Victorian Frame of Mind: 1830-1870*, pp. 242–62.
4. Derrick Leon, *Ruskin: The Great Victorian*, p. 524.

5. See Helen Gill Viljoen, *Ruskin's Scottish Heritage: A Prelude.*

6. Norman Wymer, *Dr. Arnold of Rugby*, p. 186.

7. Thomas Arnold, *Passages in a Wandering Life*, p. 63.

8. Wymer, *Dr. Arnold of Rugby*, p. 109.

9. Stanley, *Life of Thomas Arnold*, p. 406.

10. *Works of Ruskin*, 35:185.

11. Leon, *Ruskin*, p. 42.

12. *Works of Ruskin*, 35:202.

13. It is indicative of Ruskin's dissatisfaction with contemporary religious leaders that he comments about the heads of this Society: "They were all reverends and wanted somebody to rouse them" (W. G. Collingwood, *The Life of John Ruskin*, p. 69).

14. Ibid., p. 67.

15. *Works of Ruskin*, 1:395–98.

16. Ibid., 36:25–26, 30.

17. Ibid., 35:312.

18. Ibid., pp. 314–15.

19. Collingwood, *The Life of John Ruskin*, p. 84.

20. *Works of Ruskin*, 3:665–66.

21. *Ruskin's Letters from Venice, 1851-1852*, ed. John L. Bradley, p. 109.

22. Leon, *Ruskin*, p. 189.

23. Thomas Arnold, *Passages in a Wandering Life*, p. 55.

24. Thomas Arnold, D.D., *Introductory Lectures on Modern History* (Oxford, 1842), pp. 36, 39.

25. Wymer, *Dr. Arnold of Rugby*, p. 186.

26. Max Müller, *My Autobiography: A Fragment*, p. 283.

27. *Letters and Verses of Arthur Penrhyn Stanley*, ed. R. E. Prothero, p. 74.

28. *The Correspondence of Arthur Hugh Clough*, ed. F. L. Mulhauser, 1:134, 178–79.

29. C. K. Shorter, *Charlotte Brontë and Her Circle*, p. 459.

30. Ibid.

31. *Discourses in America*, p. 140.

32. *Passages in a Wandering Life*, p. 57.

33. See Kenneth Allott, "An Allusion to Pope in an Early Unpublished Arnold Letter."

34. Arnold Whitridge, *Dr. Arnold of Rugby*, p. 15.

35. Mrs. Humphry Ward, *A Writer's Recollections*, 1:72.

36. Max Müller, *Auld Lang Syne*, p. 128.

37. Thomas Arnold, *Passages in a Wandering Life*, p. 63.

38. *Letters of Matthew Arnold to Arthur Hugh Clough*, ed. H. F. Lowry, pp. 59, 66.

39. Ibid., p. 66.

CHAPTER TWO

1. J. P. T. Bury, *France: 1814-1940*, pp. 64–68.

2. E. L. Woodward, *The Age of Reform: 1815-1870*, pp. 127–28, 138.

3. Elie Halévy, *Victorian Years: 1841-1895*, trans. E. I. Watkin, p. 237.

4. Ibid.; and Robert K. Webb, *Modern England: From the Eighteenth Century to the Present*, pp. 275–76.

5. *Letters of Arnold*, 1:7–8.

6. *Letters to Clough*, p. 79.

7. Halévy, *Victorian Years*, p. 251.

8. *Don Juan*, Canto Eighth, stanza 51.

9. Cecil Woodham-Smith, *The Great Hunger: Ireland 1845-49* (New York: Harper & Row, 1962), pp. 375–76.

10. *Letters to Clough*, p. 78.

11. *The Diaries of John Ruskin*, ed. Joan Evans and John Howard Whitehouse, 3 vols., 1:104. See also 1:117, 118.

12. *Works of Ruskin*, 4:xxxiv.

13. Ibid., p. 26.

14. Ibid., pp. 28–29, 31 n.

15. Sir William James, *John Ruskin and Effie Gray*, p. 93.

16. *Diaries of Ruskin*, 1:352 (entry for 30 July 1847).

17. *Works of Ruskin*, 36:86–87.

18. Ibid., p. 88.

19. Ibid., p. 104.

20. Ibid., p. 90.

21. Ibid., 8:xxxii–xxxiii.

22. Ibid., pp. 3, 225, 242.

23. Ibid., pp. 245–46.

24. Ibid., pp. 19–20.

25. Ibid., p. 20.

26. Ibid., p. 21.

27. Ibid., p. 25.

28. *The Economist*, 26 May 1849, p. 585. Many years later, when he was teaching art at Oxford, Ruskin warned students: "I wish it at once to be known that I will entertain no question of the saleability of this or that manner of art; and that I shall

steadily discourage the attendance of students who propose to make their skill a source of income" (*Works of Ruskin*, 33:391).

29. *Works of Ruskin*, 8:39–40.

30. Ibid., pp. 42–43.

31. Ibid., p. 175.

32. Ibid., pp. 59, 138, 218.

33. Ibid., pp. 191–92.

34. Ibid., p. 219.

35. Ibid., p. 260.

36. Ibid., p. 261.

37. Ibid., pp. 265–66.

38. *A Writer's Recollections*, 1:66, 68–69.

39. *Letters to Clough*, p. 66. "Edward" refers to Matthew's younger brother, then at Balliol.

40. *Times*, 1 March 1848, p. 5.

41. *Letters to Clough*, pp. 68–69, 74.

42. According to J. P. T. Bury, "On the 25th February only the eloquence of Lamartine saved the tricolour from being displaced by the Socialist red flag . . . " (*France: 1814-1940*, p. 74).

43. *Letters to Clough*, pp. 72–73, 69; *Letters of Arnold*, 1:5.

44. *Letters to Clough*, p. 74.

45. Ibid., p. 75.

46. Ibid., pp. 69, 71.

47. *Letters of Arnold*, 1:4.

48. *Works of Ruskin*, 8:136.

49. "A Summer Night," lines 40–41.

50. *Letters to Clough*, pp. 59, 68.

51. *Letters of Arnold*, 1:5–6.

52. Ibid., p. 7.

53. *The Poems and Prose Remains of Arthur Hugh Clough*, ed. his wife, 2 vols. (London, 1869), 1:119.

54. Louis Bonnerot, *Matthew Arnold, Poète: Essai de Biographie Psychologique*, pp. 139–40.

55. Edmund Burke, *Reflections on the Revolution in France* (New York: Dutton, 1910), p. 59.

56. Lionel Trilling, *Matthew Arnold*, p. 30.

57. *Letters to Clough*, pp. 84, 90.

58. G. Robert Stange, *Matthew Arnold: The Poet as Humanist*, p. 26.

59. Alan Harris, "Matthew Arnold: The 'Unknown Years,'" p. 500.

60. *Letters to Clough*, pp. 88–89.

61. Stanley, *Life of Thomas Arnold*, p. 424.

62. Christopher Wordsworth, *Memoirs of William Wordsworth*, 2 vols. (London, 1851), 1:173.

63. *Works of Ruskin*, 8:249–50.

64. *Letters to Clough*, p. 146. This particular quotation, however, is from 1853.

65. *The Poems of Matthew Arnold*, p. 91 n.

66. "Wordsworth and the Rabbis," in *The Opposing Self*, p. 130.

67. "A Slumber Did My Spirit Seal," lines 6–8.

68. "How Soon Hath Time . . . ," lines 3–4, 11–14.

69. *Works of Ruskin*, 8:250–51. But see the important modification of this assertion in *The Stones of Venice, Works of Ruskin*, 11:115–16.

CHAPTER THREE

1. Asa Briggs, *Victorian People: A Reassessment of Persons and Themes, 1851-67*, p. 2; W. L. Burn, *The Age of Equipoise: A Study of the Mid-Victorian Generation* (New York: W. W. Norton, 1965), pp. 36, 58.

2. *Letters to Clough*, p. 95.

3. *Works of Ruskin*, 36:105.

4. *Letters of Arnold*, 1:18.

5. *Works of Ruskin*, 12:lxxix.

6. *Unpublished Letters of Matthew Arnold*, ed. Arnold Whitridge, p. 14.

7. *Letters to Clough*, p. 111.

8. Ibid., pp. 99, 149, 111, 113–14; *A Writer's Recollections*, 1:57; *Unpublished Letters of Arnold*, pp. 16–17; *Lectures and Essays in Criticism*, ed. R. H. Super, p. 261.

9. *Letters to Clough*, p. 88.

10. Ibid., p. 126. See also Arnold's letter of 12 November 1867 to Dunn in C. B. Tinker and H. F. Lowry, *The Poetry of Matthew Arnold: A Commentary*, pp. 271–72, 287–88.

11. *Letters to Clough*, p. 71.

12. *Unpublished Letters of Arnold*, p. 18. This letter dates from July 1849, not 1853, to which Whitridge tentatively assigned it.

13. *Sartor Resartus*, Book Second, chap. 7.

14. *Letters of Arnold*, 1:16.

15. Ibid., pp. 16–17.

16. In this connection it is ironic that in 1893 Mrs. Arnold replied to a query from Mrs. Clough about the date of composition of "Thyrsis" that it must have been published "as soon as it was written" because "Matt . . . never wrote until the last moment . . . " (MS letter of 16 December 1893 in Yale University Library).

17. *Correspondence of Arthur Hugh Clough,* 1:290; *A Writer's Recollections,* 1:70.

18. But not consistently; see, for example, "In Harmony with Nature."

19. George Ford suggests this allusion in *The Norton Anthology of English Literature,* ed. M. H. Abrams et al., 2 vols. (New York: W. W. Norton, 1968), 2:1040.

20. A. Dwight Culler, *Imaginative Reason: The Poetry of Matthew Arnold,* p. 41.

21. *Works of Ruskin,* 36:115.

22. Ibid., p. 127.

23. Ibid., p. 138.

24. Ibid., 9:57–58, 17.

25. Ibid., 18:443.

26. Ibid., 9:14.

27. Ibid., p. 38.

28. Ibid., pp. 31–32.

29. Ibid., p. 44.

30. For an excellent discussion of the relation between art and the moral life in Ruskin's work, see Graham Hough's essay on Ruskin in *The Last Romantics,* especially p. 18.

31. John D. Rosenberg, *The Darkening Glass: A Portrait of Ruskin's Genius,* p. 87.

32. Collingwood, *The Life of John Ruskin,* p. 128.

33. *Works of Ruskin,* 9:xlv.

34. *Diaries of Ruskin,* 2:468.

35. Briggs, *Victorian People,* pp. 38–39, 16.

36. *Works of Ruskin,* 3:361; 12:420–21.

37. "All that I did at Venice was by-work, because her history had been falsely written before. . . . Something also was due to my love of gliding about in gondolas" (*Works of Ruskin,* 10:xlvii).

38. Ibid., pp. xxvi–xxviii.

39. Ibid., 36:125–26.

40. Ibid., pp. 134, 132.

41. Ibid., 10:xl.

42. Ibid., 12:lxxxiv.

43. Ibid., p. 593.

44. *Ruskin's Letters from Venice, 1851-1852,* p. 262.

45. *Works of Ruskin,* 11:258–60.

46. Ibid., p. 261.

47. Ibid., p. 263.

48. See James H. Broderick, "Two Notes on Arnold's 'Grande Chartreuse,' " p. 161.

49. *Letters of Arnold,* 1:20.

50. W. F. Connell, *The Educational Thought and Influence of Matthew Arnold,* p. 285; *Letters of Arnold,* 1:21; *Letters to Clough,* p. 118.

51. G. M. Young, *Victorian Essays*, ed. W. D. Handcock, p. 134.

52. *Letters to Clough*, pp. 125, 120.

53. Ibid., p. 118; *Letters of Arnold*, 1:26; *Letters to Clough*, p. 126.

54. *Letters to Clough*, p. 126.

55. *The Poems of Matthew Arnold*, p. 148; *Letters to Clough*, pp. 130, 128.

56. See Act II, lines 90–94.

57. *Letters to Clough*, pp. 122–23.

58. Ibid., p. 124.

59. *Letters of Arnold*, 1:30–31, 34; *Letters to Clough*, pp. 135, 132.

60. *Letters to Clough*, pp. 132, 143.

61. Ibid., pp. 135, 139, 142–43, 133.

62. *Imaginative Reason*, p. 196.

63. Waldo H. Dunn, *James Anthony Froude: A Biography, 1818-1856* (Oxford: Clarendon Press, 1961), p. 134.

64. *Letters to Clough*, p. 140.

65. *Imaginative Reason*, pp. 204-5.

66. Lionel Trilling has explored the implications of Wordsworth's idea of pleasure in his essay "The Fate of Pleasure," in *Beyond Culture: Essays on Literature and Learning*, pp. 57–87.

67. *On the Classical Tradition*, p. 2.

68. *Letters to Clough*, p. 130.

69. *Works of Ruskin*, 10:201.

70. Ibid., p. 196. See Book I, chap. 1, *The Wealth of Nations.*

71. Ibid., 11:158.

72. *On the Classical Tradition*, pp. 3–4.

73. Ibid., p. 6.

74. *Works of Ruskin*, 9:17, 14.

75. Ibid., 10:184–89.

76. Ibid., p. 190.

77. *Discourses in America*, pp. 133–34.

78. *Works of Ruskin*, 10:202–4, 190–91.

79. Ibid., pp. 203, 190.

80. Ibid., 8:250.

81. Ibid., 10:190; 11:116.

82. Ibid., 10:191–92.

83. G. K. Chesterton, *The Victorian Age in Literature*, p. 48.

84. *Works of Ruskin*, 36:178.

85. *On the Classical Tradition*, pp. 1, 13.

86. Ibid., p. 14.

CHAPTER FOUR

1. Mary Lutyens, *Millais and the Ruskins* (London: John Murray, 1967), p. 69.

2. *Works of Ruskin*, 36:155 (letter of 8 November 1853).

3. Ibid., 12:lxix.

4. *Millais and the Ruskins*, pp. 109–10.

5. Preface to *Major Barbara* (New York: Dodd, Mead & Co., 1907), p. 17.

6. *Works of Ruskin*, 36:175–76.

7. *Millais and the Ruskins*, p. 231. See, in the same vein, his letter of November 1853 on "the utter *unchangeableness* of people" (ibid., p. 107).

8. *Works of Ruskin*, 36:169–73.

9. W. M. Rossetti, *Ruskin: Rossetti: Preraphaelitism*, p. 72.

10. *Works of Ruskin*, 36:185, 217, 223. There is irony in the fact that in this year Ruskin wrote, and then canceled, the following conclusion to the second chapter of *Modern Painters* III, to be published in 1856: "Let either the artist base his efforts, or the critic his opinion, on a *desire to be great*, and they are as sure to fall into a spurious art, and a false judgment, as if they had deliberately chosen the paths of Darkness. Both of them must love what is beautiful and right for its own sake, and must follow it, and judge of it, by instinct. . . . They may rest assured that they are never right but when they were working for enjoyment, or judging by enjoyment; if they enjoy what is wrong, they may discipline themselves, so as to enjoy something else, but if they once pretend that they enjoy what they do not, it is all over with them. One honest question, therefore, will always keep both artists and critics right: 'Do I heartily love this? Am I doing it for love of it? If not, I will not do it, I will not praise it'" (ibid., 5:43 n).

11. Ibid., 36:193.

12. Ibid., 30:110.

13. *Letters of John Stuart Mill*, ed. H. S. R. Elliot, 2 vols. (London: Longmans, 1910), 2:361; *The George Eliot Letters*, ed. G. S. Haight, 7 vols. (New Haven, Conn.: Yale University Press, 1954-55), 2:255.

14. *Works of Ruskin*, 36:157.

15. Ibid., 5:xxxvi, xli. It is instructive to set alongside this disavowal Ruskin's later statement (November 1871) in *Fors Clavigera* that "a true artist is only a beautiful development of tailor or carpenter" (27:186).

16. Ibid., 5:xxxix.

17. Leon, *Ruskin*, pp. 230–31.

18. *Letters to Clough*, p. 97.

19. *Letters of Arnold* 1:54; *Schools and Universities on the Continent*, ed. R. H. Super, p. 299.

20. *Matthew Arnold and the Education of the New Order*, ed. Peter Smith and Geoffrey Summerfield (Cambridge: At the University Press, 1969), pp. 233–34.

21. MS letter of 15 May 1869 in University of Texas Library; *Discourses in*

America, pp. 126–27. The report to which Arnold refers was made in 1876: "Even second year students still show . . . an astonishing crudeness. 'Doctor, can you fulfil the duties of your profession in curing a woman who is distracted?' or again 'Can you not wait upon the lunatic?'—these are paraphrases of Shakespeare's *Canst thou not minister to a mind diseased*, from which I am even now fresh" (*Matthew Arnold and the Education of the New Order*, p. 221).

22. *Discourses in America*, pp. 126–27.

23. *Letters of Arnold*, 1:32, 34–35, 43, 47; *Letters to Clough*, pp. 146, 136; *Unpublished Letters of Arnold*, p. 20.

24. *Letters of Arnold*, 1:48, 28; *Unpublished Letters of Arnold*, p. 31.

25. *Unpublished Letters of Arnold*, pp. 31–33.

26. Ibid., p. 33.

27. *Letters of Arnold*, 1:58. Although this letter and the one to William Arnold are both dated 31 March, Arnold says that the date on the letter to William is "a false date."

28. *Letters to Clough*, p. 97.

29. *Victorian England: Portrait of an Age*, p. 112.

30. *Works of Ruskin*, 5:18.

31. *A Writer's Recollections*, 1:73.

32. *Correspondence of Henry Crabb Robinson with the Wordsworth Circle*, ed. Edith J. Morley, 2:825–26.

33. *On the Classical Tradition*, p. 20.

34. *Works of Ruskin*, 5:xlix–l.

35. Ibid., p. lvi.

36. Ibid., p. liv. See Millais's comment of 29 August 1853 on Ruskin: "I never heard a man contradict himself like he does. I have given up reminding him of his own remarks for he always forgets" (Lutyens, *Millais and the Ruskins*, p. 89).

37. *On the Classical Tradition*, p. 21.

38. *Works of Ruskin*, 5:lv.

39. Ibid., p. 221.

40. Ibid., p. 230.

41. Ibid., pp. 232–33.

42. Ibid., p. 255.

43. As if to accentuate the departure from Gothicist orthodoxy, Ruskin goes on to revel in the subordination of *curved* lines, "which are chiefly the confusing lines," to straight ones in medieval painting (ibid., p. 258).

44. Ibid., p. 320.

45. Ibid., p. 327.

46. Ibid., p. 233.

47. Ibid., pp. 321–22.

48. *On the Classical Tradition*, p. 32.

49. Ibid., p. 1.

50. *Letters to Clough*, p. 136.

51. I stress this because Arnold did not publish the lecture until 1869.

52. *Works of Ruskin*, 5:327.

53. For a detailed application of the doctrine of "the man and the moment" to a particular author, see Arnold's much later (1880) essay on Thomas Gray.

54. *On the Classical Tradition*, p. 23.

55. Ibid., p. 24.

56. *Letters to Clough*, p. 124.

57. R. L. Lowe, "Two Arnold Letters," *Modern Philology* 52 (May 1955) : 263.

58. "Yes, in Greece, in the Athens of Pericles, there is toleration; but in England, in the England of the sixteenth century?—the Puritans are then in full growth" (*On the Classical Tradition*, p. 24). Arnold's cryptic reluctance to develop this point is suggestive of his later hostility to nonconformists. There must have been some people in the Sheldonian who asked themselves: "Were the Puritans always the instruments of intolerance, and never its victims?"

59. *On the Classical Tradition*, p. 28.

60. Ibid.

61. Ibid., p. 30.

62. Ibid., p. 35.

63. *Works of Ruskin*, 5:336, 338. One reason for Ruskin's tolerance was that he had learned for himself that, as he wrote in April 1857, "no wreck is so frequent, no waste so wild, as the wreck and waste of the minds of men devoted to the arts . . . " (ibid., 36:259).

64. *Letters to Clough*, p. 146.

65. *Works of Ruskin*, 5:359.

66. Joshua Reynolds, *Fifteen Discourses Delivered in the Royal Academy*, p. 66.

67. *Life and Correspondence of John Duke Lord Coleridge*, ed. E. H. Coleridge, 2:160.

68. See Hough, *The Last Romantics*, and Harold Bloom's remarks on Ruskin as the "most original critic that Romanticism has produced, as well as one of its most celebrated avatars" (Introduction, *The Literary Criticism of John Ruskin* [New York: Doubleday, 1965], p. xxvii).

69. *Works of Ruskin*, 5:19.

70. Ibid., p. 46.

71. Ibid., p. 21.

72. Ibid., pp. 333, 26–27.

73. Ibid., 28:647; 22:211.

74. Ibid., 5:202, 204, 211.

75. *On the Classical Tradition*, p. 7.

76. *Works of Ruskin*, 5:49. In chapter 1 Ruskin explicitly denies any opposition between poetry and painting. "Both painting and speaking are methods of expression. Poetry is the employment of either for the noblest purposes" (p. 31).

77. Ibid., p. 52.

78. *On the Classical Tradition*, p. 15.

79. *Works of Ruskin*, 4:388–89; 5:53–55.

80. M. H. Abrams, *The Mirror and the Lamp*, p. 312.

81. *Works of Ruskin*, 5:209.

82. I am here indebted to the discussion of this problem in Raymond Williams, *The Long Revolution*, pp. 19–23.

83. *Works of Ruskin*, 5:206–7, 212–13.

84. *Letters of Arnold*, 1:147.

85. *On the Classical Tradition*, pp. 101–2.

86. In his eagerness to tarnish Ruskin with the accusation of romanticist falsehood, Arnold has probably misunderstood Sainte-Beuve's phrase *genre romanesque* as "the romantic genre." According to Professor Samuel N. Rosenberg, the distinguished philologist of Romance languages, Sainte-Beuve's adjective can have as its primary value only the technical sense: "novelistic," and since "novelistic genre" is awkward, the phrase is best translated simply as "the novel." That Arnold did not so translate it is indicated by a letter of 1882, in which he wrote of a play advertisement that irritated him that it had "an unpleasant touch of *le faux*—that danger, as the critic tells us, of the romantic artist:—*Comme chaque genre de composition a son écueil particulier, celui du genre romanesque, c'est le faux*" (*Letters of an Old Playgoer*, ed. Brander Matthews [New York: Publications of the Dramatic Museum of Columbia University, 1919], p. 24).

87. *Works of Ruskin*, 5:213 n.

88. *Letters of Arnold*, 1:63–64. Ruskin, for his part, once said: "Take Homer first, and think if there is any sadder image of human fate than the great Homeric story" (*Works of Ruskin*, 18:160).

89. *Works of Ruskin*, 12:322, 157; 5:188. Here and elsewhere Ruskin says that the Pre-Raphaelite Brotherhood must add to its faithfulness in transcription the "great imaginative element" if it is to attain the level of the noblest art (see 12:161–62).

90. *On the Classical Tradition*, p. 105. R. H. Super has suggested the possibility of Arnold's awareness of Ruskin at this point (ibid., p. 243 n).

91. *Classic, Romantic, and Modern*, p. xx.

92. I have used Richmond Lattimore's translation, *The Iliad of Homer* (Chicago: University of Chicago Press, 1951), partly because in his introduction, p. 55, Lattimore says that he has tried to reproduce three of the four qualities that Arnold ascribes to Homer: rapidity, plainness, and directness. Lattimore does not think nobility a quality to be striven for directly.

93. *On the Classical Tradition*, pp. 108, 127–28; *Democratic Education*, ed. R. H. Super, pp. 5–6.

94. *Works of Ruskin*, 27:167–68; 37:550.

95. Ibid., 5:244, 339.

96. *On the Classical Tradition*, pp. 211, 134–35.

97. Ibid., p. 135.

98. *Works of Ruskin*, 5:233.

99. *On the Classical Tradition*, pp. 136, 94.

100. Ruskin shed tears over Elizabeth Browning's poetry, was enthralled (and enraged) by Dickens, responded eagerly to *In Memoriam* and many of Tennyson's "contemporary" poems, and was an enthusiastic admirer of Longfellow.

101. Walter Pater, *The Renaissance* (London: Macmillan, 1919), p. 230.

102. *Democratic Education*, pp. 19, 15–16.

103. *Unpublished Letters of Arnold*, pp. 51–52.

CHAPTER FIVE

1. John Stuart Mill described in his *Autobiography* how Bentham's principle of utility became for him "a creed, a doctrine, a philosophy . . . a religion . . . " and how "all those to whom I looked up, were of opinion that the pleasure of sympathy with human beings, and the feelings which made the good of others, and especially of mankind on a large scale, the object of existence, were the greatest and surest sources of happiness" (*Autobiography of John Stuart Mill* [New York: Columbia University Press, 1924], pp. 47, 97).

2. *Works of Ruskin*, 7:xxxvi, 207.

3. Ibid., 29:88.

4. Ibid., 7:xl.

5. Ibid., 29:89; 7:xli. See George P. Landow, *The Aesthetic and Critical Theories of John Ruskin*, pp. 281–85, for an instructive discussion of the different accounts Ruskin gave of his "un-conversion."

6. *Works of Ruskin*, 29:89.

7. See Hough, *The Last Romantics*, p. 28.

8. *Works of Ruskin*, 29:90.

9. Ibid., 36:293; 18:540.

10. Ibid., 36:296–97.

11. Ibid., pp. 302–3.

12. Ibid., p. 311; 18:539.

13. Ibid., 18:539, 541.

14. Ibid., 36:313, 316.

15. Ibid., 18:542.

16. Ibid., 16:481–82.

17. Ibid., p. 484.

18. Ibid., p. 485.

19. *On the Classical Tradition*, pp. 78–79.

20. *Letters of Arnold*, 1:90–91.

21. *The Note-Books of Matthew Arnold*, ed. Howard F. Lowry, Karl Young, and W. H. Dunn, pp. 26–27. The translation of this passage, which Arnold quotes from an article by Saint-René Taillandier in *Nouvelle biographie générale*, is my own.

22. *On the Classical Tradition*, p. 92.

23. Ibid., p. 78.

24. Ibid., p. 84.

25. *Works of Ruskin*, 16:487.

26. "The Future of Liberalism," in *Irish Essays*, p. 141; *Letters of Arnold*, 1:6; *On the Classical Tradition*, p. 96; *Democratic Education*, p. 300.

27. *Letters of Arnold*, 1:115; *Letters to Clough*, p. 150. To Gladstone, Arnold wrote on 5 August: "It is an honour to be read by you—a still greater honour to be read by you with sympathy—the greatest honour of all to be read by you with sympathy when one writes of Italy, for which you yourself . . . have done so much" (MS letter in British Museum, Add. MSS. 44392, f. 109).

28. *Letters of Arnold*, 1:125.

29. The introduction to *The Popular Education of France* was not given the title "Democracy" until its separate publication in 1879.

30. Connell, *The Educational Thought and Influence of Matthew Arnold*, pp. 52–53.

31. MS letter owned by Arnold Whitridge.

32. Bonnerot, *Matthew Arnold, Poète*, p. 528.

33. *Democratic Education*, p. 16.

34. Ibid., pp. 6, 9–10.

35. Ibid., pp. 8–9.

36. Ibid., p. 11.

37. Ibid., p. 18. Arnold refers to the American "religion" of the *"average man"* in "Milton," *Essays in Criticism: Second Series*, p. 57.

38. *Matthew Arnold*, p. 179.

39. *Democratic Education*, p. 3.

40. Trilling charges Arnold with a lack of realism in citing only the religious repression by the earlier state and not its economic discrimination in favor of landed interests and against free enterprise and large-scale manufactures (*Matthew Arnold*, p. 187).

41. *Democratic Education*, p. 21.

42. Briggs, *Victorian People*, p. 124.

43. Ibid., p. 126.

44. *On Liberty*, p. 161. Mill was not, however, unmindful of the problems created by the application of laissez faire to education. In 1869 he maintained that education was emphatically not "one of those marketable commodities which the interest of rival dealers can be depended on for providing, in the quantity, and of the quality required" (*Dissertations and Discussions*, 4:12).

45. *Dissertations and Discussions*, 2:35; *Considerations on Representative Government*, pp. 278, 375.

46. *Dissent and Dogma*, ed. R. H. Super, p. 126.

47. *Lectures and Essays in Criticism*, p. 136; preface to 1874 edition of *Higher Schools and Universities in Germany*, in *God and the Bible*, ed. R. H. Super, p. 100.

48. *Works of Ruskin*, 36:590.

49. See, e.g., in the excellent essay on Ruskin by Gaylord C. LeRoy, *Perplexed Prophets: Six Nineteenth-Century British Authors*, pp. 98–100.

50. *Works of Ruskin*, 28:402; 7:229 n; 19:127. John Morley recalled how, on the occasion when they met, Ruskin, even as he "filled the festive hour with unbridled railing at Mill, felt drawn to some of the truths in *Liberty*, which he found both important and beautifully expressed . . . " (*Recollections*, 1:64).

51. *Works of Ruskin*, 36:586–87, 583.

52. *Principles of Political Economy*, ed. John M. Robson, 2:794.

53. *Works of Ruskin*, 16:486–87.

54. Ibid., 36:316; 16:482.

55. Ibid., 36:320–21, 330–31.

56. Ibid., p. 348; 17:xxi. See E. D. H. Johnson, *The World of the Victorians* (New York: Charles Scribner's Sons, 1964), pp. 257–58.

57. *Works of Ruskin*, 17:xxv. Rosenberg has pointed out that Ruskin was, in choosing his words here, consciously rebutting the metaphor his father had in 1852 applied to his politics as "Slum Buildings liable to be knocked down" (*The Darkening Glass*, p. 117).

58. *Works of Ruskin*, 20:212; 17:xxiv.

59. See Elie Halévy, *The Growth of Philosophic Radicalism*, trans. Mary Morris, p. 433.

60. "Dickens's Hard Times," p. 353.

61. *Victorian Essays*, p. 125.

62. *Works of Ruskin*, 17:25.

63. *Autobiography*, pp. 165–66.

64. *Works of Ruskin*, 17:26.

65. Ibid., p. 27.

66. Ibid., p. 28.

67. Ibid., pp. 29–30.

68. Ibid., pp. 30–31.

69. See Karl Polanyi, *The Great Transformation*, pp. 130–31.

70. *Victorian England: Portrait of an Age*, p. 16.

71. George Bernard Shaw, *Ruskin's Politics*, pp. 8–9.

72. *Works of Ruskin*, 17:33.

73. Ibid., pp. 39–40.

74. Ibid., 5:202.

75. Ibid., 17:84.

76. Ibid., pp. 85, 164, 81.

77. Ibid., pp. 106–7.

78. *Culture and Anarchy*, p. 217.

79. Ibid., pp. 216–17.

80. Ibid., pp. 215, 217.

81. *Democratic Education*, pp. 213, 224; *Letters of Arnold*, 1:195. For Ruskin's expression of distaste for the teaching of the three r's, see *Works of Ruskin*, 27:296; 29:479.

82. *Democratic Education*, p. 226.

83. Ibid., p. 235. Not just this passage but the whole essay is written with a zestful ferocity unknown in Arnold's earlier work. "I am surprised myself," he told his mother on 5 March 1862, "at the length of many of the sentences in my article, but I find that for everything new I write there comes a style which I find natural for that particular thing, and this tendency I never resist" (*Letters of Arnold*, 1:188).

84. *Democratic Education*, p. 226.

85. *Victorian England: Portrait of an Age*, p. 81; Briggs, *Victorian People*, pp. 255–57.

86. *Democratic Education*, p. 243.

87. Ibid., p. 254.

88. Ibid., p. 282. I am guilty of some anachronism here, since Arnold does not use *David Copperfield* to illuminate the state of the English schools until his June 1881 essay in *The Nineteenth Century*, "The Incompatibles. II."

89. *Culture and Anarchy*, pp. 210, 213, 217.

90. *Irish Essays*, pp. 148–51.

91. Henry Ladd, *The Victorian Morality of Art: An Analysis of Ruskin's Esthetic*, p. 319; Benjamin Lippincott, *Victorian Critics of Democracy* (Minneapolis: University of Minnesota Press, 1938), p. 132.

92. Raymond Williams, *Culture and Society: 1780-1950*, p. 146.

93. "One need not ask how [Marx], living on Engels and Engels on Manchester cotton, could escape the universal taint. A prophet's garments are pure from the very fact that he is a prophet and cries out" (Jacques Barzun, *Darwin, Marx, Wagner*, p. 183).

94. "Mill, Arnold, and the Zeitgeist," p. 32.

95. *Culture and Society*, p. 140. Williams himself, it should be noted, has recognized and studied Arnold's influence on Tawney in *Culture and Society*, pp. 216–26.

96. J. Dover Wilson has made this point well in the introduction to his edition of *Culture and Anarchy* (Cambridge: At the University Press, 1932), p. xxxiii.

97. Irving Howe, "The New York Intellectuals," p. 47.

98. In a memorable speech in the House of Commons, Lowe told his colleagues: "You have had the opportunity of knowing some of the constituencies of this country; and I ask, if you want venality, if you want ignorance, if you want drunkenness and facility for being intimidated; or if, on the other hand, you want impulsive, unreflecting, and violent people, where do you look for them in the constituencies? Do you go to the top or to the bottom?"

99. *Beyond Culture*, p. 159.

100. Hannah Arendt, *Imperialism*, Part Two of *The Origins of Totalitarianism* (New York: Harcourt, Brace, 1967), p. 179. *Mill on Bentham and Coleridge*, ed. F. R. Leavis (London: Chatto & Windus, 1950), p. 65.

101. In "On Genius and Common Sense" Hazlitt writes: "A view of a subject, to be connected and regular, cannot be all new. A writer will always be liable to be charged either with paradox or common-place, either with dulness or affectation. But we have no right to demand from any one more than he pretends to. There is indeed a medium in all things, but to unite opposite excellencies, is a task ordinarily too hard for mortality" (*The Complete Works of William Hazlitt*, ed. P. P. Howe, 21 vols. [London and Toronto: J. M. Dent & Sons, 1930-34], 8:48).

102. *Culture and Anarchy*, pp. 222–23.

103. *Works of Ruskin*, 23:121–22.

104. *Lectures and Essays in Criticism*, pp. 354–55.

105. *Letters of Arnold*, 1:289–90.

106. *Works of Ruskin*, 7:271.

CHAPTER SIX

1. *Works of Ruskin*, 36:239.

2. Ibid., p. 339.

3. Ibid., 17:xxviii–xxix, 143; 36:344; Leon, *Ruskin*, p. 296.

4. *Works of Ruskin*, 36:346, 350–51; Leslie Stephen, "Mr. Ruskin's Recent Writings," p. 689.

5. *Works of Ruskin*, 17:xxxv.

6. Ibid., p. xxxix; p. 143.

7. Ibid., 36:356, 392, 417.

8. Ibid., pp. 417, 423.

9. Ibid., pp. 412, 436–37.

10. Ibid., pp. 403, 400.

11. *Middlemarch,* chap. 20, p. 144.

12. *Works of Ruskin,* 17:xlii.

13. Ibid., 5:209.

14. Ibid., 36:450.

15. *Letters of Arnold,* 1:227–28.

16. *Imaginative Reason,* p. 71.

17. "Stanzas in Memory of the Author of 'Obermann,' " lines 78–80.

18. Frank Kermode, *Romantic Image,* p. 14.

19. Warren D. Anderson, *Matthew Arnold and the Classical Tradition,* p. 38.

20. *On the Classical Tradition,* p. 15.

21. *Letters of Arnold,* 1:72.

22. See Kermode, *Romantic Image,* p. 19; and Lionel Trilling's description of Yeats as the embodiment of the Scholar-Gipsy in *The Opposing Self,* pp. xiii–xiv.

23. "A Summer Night," lines 81–82.

24. *Letters of Arnold,* 1:62–63.

25. "The Buried Life," lines 53, 73.

26. *On the Classical Tradition,* p. 4.

27. Morley, *Correspondence of H. C. Robinson with the Wordsworth Circle,* 2:826.

28. *Note-Books,* pp. 16, 18, 17, 22; *Lectures and Essays in Criticism.* p. 185; *Letters of Arnold,* 1:vii.

29. *Lectures and Essays in Criticism,* p. 177; *Letters of Arnold,* 1:456; 2:267, 153, 229, 104.

30. "The Critical Character." I am indebted to Professor Walter E. Houghton, editor of *The Wellesley Index to Victorian Periodicals,* for identifying the author of this article as Samuel Reynolds (1831-97). A note rather similar to Reynolds's is sounded by the writer of Arnold's obituary in the *Pall Mall Budget,* 19 April 1888, p. 13: "Mr. Ruskin is a greater prophet of culture, but RUSKIN'S work has not always had that stamp of moderation which comes to Mr. ARNOLD from his criticism."

31. *Letters of Arnold,* 1:231–33.

32. Ibid., pp. 233–34.

33. Ibid., p. 240.

34. Ibid., pp. 247–48.

35. Ibid., p. 255.

36. William E. Buckler, *Matthew Arnold's Books: Toward a Publishing Diary,* p. 65.

37. *Lectures and Essays in Criticism,* p. 236.

38. Ibid., pp. 237–38.

39. Ibid., p. 245.

40. *Works of Ruskin,* 10:190.

41. *Lectures and Essays in Criticism,* p. 251.

42. Ibid., pp. 251–52.

43. Frye remarks: "Now whether Ruskin is right or wrong, he is attempting genuine criticism. He is trying to interpret Shakespeare in terms of a conceptual framework which belongs to the critic alone, and yet relates itself to the plays alone. Arnold is perfectly right in feeling that this is not the sort of material that the public critic can directly use. But he does not seem even to suspect the existence of a systematic criticism as distinct from the history of taste. Here it is Arnold who is the provincial" (*Anatomy of Criticism,* pp. 9–10). See also the remarks by Geoffrey Tillotson and John Rosenberg in *The Art of Victorian Prose,* ed. George Levine and William Madden (New York, London, and Toronto: Oxford University Press, 1968), pp. 79–81, 183–84.

44. *Lectures and Essays in Criticism,* p. 252.

45. See Super's notes, ibid., pp. 462–64.

46. Bonnerot, *Matthew Arnold, Poète,* p. 57.

47. Ibid., p. 519.

48. "Sainte-Beuve," in *Five Uncollected Essays,* ed. Kenneth Allott, p. 74.

49. "Sainte-Beuve," in *Essays, Letters, and Reviews,* ed. Fraser Neiman, p. 166.

50. Ibid., pp. 166–68.

51. *Letters from Matthew Arnold to John Churton Collins,* p. ii; *Lectures and Essays in Criticism,* p. 274.

52. *Lectures and Essays in Criticism,* p. 259.

53. "Anima Hominis," *Per Amica Silentia Lunae, Essays* (London: Macmillan, 1924), p. 492.

54. *Letters to Clough,* p. 71; *Lectures and Essays in Criticism,* p. 274.

55. *Lectures and Essays in Criticism,* p. 270.

56. Ibid., p. 275.

57. For information about Arnold's composition of "Thyrsis" I am indebted to Kenneth Allott's detailed notes to the poem in *The Poems of Matthew Arnold.*

58. Katharine Chorley, *Arthur Hugh Clough: The Uncommitted Mind,* p. 190; *Letters to Clough,* p. 95.

59. *Letters to Clough,* p. 136.

60. *Letters of Arnold,* 1:270–71, 162.

61. *Works of Ruskin,* 36:404, 550–51, 350–51.

62. *Letters of Arnold,* 1:193.

63. *Works of Ruskin,* 36:460–61.

64. Ibid., p. 364; 16:220; 22:147.

65. Ruskin was delighted by the appearance of Colenso's book (*The Pentateuch and Book of Joshua Critically Examined,* 1862) both because he agreed with it and because it rescued him from the loneliness of solitary heresy. See *Works of Ruskin,*

36:424–25, 429–30, 460; and also Landow, *The Aesthetic and Critical Theories of John Ruskin*, pp. 266–71.

66. *Works of Ruskin*, 36:586–87; 37:14. Ruskin went on to point out the superiority of his own translation of Homer's Aeolus (in *Queen of the Air*) to Sainte-Beuve's, a fact that may indicate Arnold's use of Sainte-Beuve, in 1860, to condemn Ruskin's Homeric criticism still rankled.

67. *Works of Ruskin*, 36:474.

68. Ibid., 20:77; 36:511.

69. *Letters of Arnold*, 1:289–90.

70. Ibid., pp. 260, 223; *Essays, Letters, and Reviews*, pp. 308–9.

71. *Essays, Letters, and Reviews*, p. 200.

72. *Works of Ruskin*, 17:xxxix. Ruskin's father remarked, in August 1861, "It seems to me to be as much a want of purpose as a want of Health" (ibid., 36:380).

73. *Essays, Letters, and Reviews*, p. 309.

74. *Lectures and Essays in Criticism*, pp. 260, 285. The change from February 1858, when Arnold pronounced himself "dead sick of criticism" and declared he had "no intention to keep preaching in the wilderness," is noteworthy.

75. *Works of Ruskin*, 36:523, 543.

76. Ibid., p. 404. See also 19:101; 36:461.

77. *Lectures and Essays in Criticism*, p. 289. See, in a similar vein, the letter of 31 December 1869 to Henry Dunn: "We belong to a time when every one is in movement and no one has arrived" (MS letter held by Professor F. L. Mulhauser).

78. *Lectures and Essays in Criticism*, pp. 275, 285.

79. *Works of Ruskin*, 36:524; Leon, *Ruskin*, p. 381.

80. *The Genius of John Ruskin*, ed. John D. Rosenberg, p. 316.

81. *Works of Ruskin*, 18:146–47, 151.

82. Ibid., 20:107; Leon, *Ruskin*, pp. 432–36.

83. *Works of Ruskin*, 27:96; Leon, *Ruskin*, pp. 458, 465.

84. Leon, *Ruskin*, p. 513.

85. *Works of Ruskin*, 28:425.

86. Buckler, *Matthew Arnold's Books*, p. 66.

87. *Works of Ruskin*, 28:220, 206, 203. Ruskin's reference to "that other Hospital" is to the Hospital of St. Mary of Bethlehem, known as Bedlam (from Middle English *Bedlem-Bethlem*).

88. John Drinkwater, "Some Letters from Matthew Arnold to Robert Browning," p. 658.

89. *Dissent and Dogma*, p. 30.

90. MS letter of 20 January 1871, Bodleian Library, Oxford.

91. See Arthur K. Davis, Jr., *Matthew Arnold's Letters: A Descriptive Checklist*, p. 235.

92. *God and the Bible,* p. 560.

93. *Letters of Arnold,* 2:163.

94. *Works of Ruskin,* 34:349–50; 33:406; Arnold, *Essays in Criticism: Second Series,* pp. 161–62.

95. *Essays in Criticism: Second Series,* pp. 153–54, 161.

96. *Works of Ruskin,* 34:318. Ruskin apparently confuses Silver How with Fox How, the Arnold family home about half a mile from Rydal Mount. But Professor Helen Gill Viljoen has informed me that there *is* a hillock called Silver How behind Goody Bridge, Grasmere.

97. *Works of Ruskin,* 34:318–19.

98. Ibid., p. 318.

99. Ibid., p. 320.

100. Ibid., p. 322.

101. Ibid., pp. 328, 326, 342, 344.

102. Ibid., pp. 323, 341–44.

103. *Note-Books,* pp. 347, 343.

104. MS letter of 5 December 1880 in Macmillan Papers, British Museum 54978 (811D); *Essays in Criticism: Second Series,* p. 177.

105. Leon Gottfried, *Matthew Arnold and the Romantics,* p. 101.

106. *Essays in Criticism: Second Series,* p. 190.

107. Ibid., pp. 203, 172; "Stanzas from the Grande Chartreuse," lines 121–44; "Stanzas in Memory of the Author of 'Obermann,'" lines 53–54; *Lectures and Essays in Criticism,* pp. 121–22.

108. *Essays in Criticism: Second Series,* p. 195.

109. Ibid., p. 197. Arnold here is quoting Professor John Nichol.

110. Ibid., p. 202.

111. Ibid., pp. 184, 172, 185, 198.

112. *Works of Ruskin,* 34:32–33. Ruskin wrote these passages in July 1871 and first published them in *Fors Clavigera* for August of that year.

113. Ibid., pp. 40–41.

114. Charles Lamb, "Sanity of True Genius," *The Works of Charles and Mary Lamb,* ed. E. V. Lucas, 7 vols. (London: Methuen, 1903-5), 2:187.

115. *Essays in Criticism: Second Series,* p. 203.

116. "Literature and Science," p. 230.

117. *Works of Ruskin,* 32:xxiii. The wild extravagance of Ruskin's praise for Francesca Alexander in this lecture, which was reported by the *Spectator,* seems of a piece with the eccentricity and intemperance that characterized his Slade lectures at Oxford during this year; and the lecture may have confirmed Arnold's suspicions about Ruskin's mental state. Yet it did not impede the development of his sympathy for Ruskin at this time.

118. Arthur Galton, *Two Essays upon Matthew Arnold with Some of His Letters to the Author*, p. 110.

119. MS letter of 17 February 1888 in Osborn Collection, Yale University Library.

120. E. T. Cook, *The Life of John Ruskin*, 2:395; *Brantwood Diary*, ed. Helen Gill Viljoen, p. 48. Professor Viljoen suggests that one cause of Ruskin's displeasure was that he "had probably tried to enlist Arnold's opposition to using the Lake of Thirlmere as a source of water for Manchester" (ibid., p. 48 n).

121. *Works of George Eliot*, Cabinet Edition, 24 vols. (Edinburgh and London: Blackwood, 1878-85), 10:274.

122. Arnold's note of 1869 to "Stanzas in Memory of the Author of 'Obermann,'" *The Poems of Matthew Arnold*, p. 129.

123. *Beyond Culture*, p. 158.

124. *A un ami* (Paris: Amiot-Dumont, 1948), p. 149.

125. See Robert B. Heilman, *Tragedy and Melodrama: Versions of Experience* (Seattle: University of Washington Press, 1968), pp. 88–162.

126. George Orwell, *The Lion and the Unicorn: Socialism and the English Genius* (London: Secker & Warburg, 1941), p. 83.

Bibliography

WORKS AND LETTERS BY ARNOLD

Culture and Anarchy. Edited by R. H. Super. Ann Arbor: University of Michigan Press, 1965.

Democratic Education. Edited by R. H. Super. Ann Arbor: University of Michigan Press, 1962.

"Diaries, the Unpublished Items: A Transcription and Commentary." Edited by William B. Guthrie. Ph.D. dissertation, University of Virginia. Ann Arbor: University Microfilms, 1959.

Discourses in America. London and New York: Macmillan, 1896.

Dissent and Dogma. Edited by R. H. Super. Ann Arbor: University of Michigan Press, 1968.

Essays in Criticism: Second Series. London and New York: Macmillan, 1896.

Essays, Letters, and Reviews. Edited by Fraser Neiman. Cambridge: Harvard University Press, 1960.

Five Uncollected Essays. Edited by Kenneth Allott. Liverpool: University of Liverpool Press, 1953.

God and the Bible. Edited by R. H. Super. Ann Arbor: University of Michigan Press, 1970.

Irish Essays. London: Macmillan, 1904.

Lectures and Essays in Criticism. Edited by R. H. Super. Ann Arbor: University of Michigan Press, 1962.

Letters from Matthew Arnold to John Churton Collins. London: Printed for Private Circulation, 1910.

Letters of Matthew Arnold: 1848-1888. Edited by G. W. E. Russell. 2 vols. in 1. New York and London: Macmillan, 1900.

Letters of Matthew Arnold to Arthur Hugh Clough. Edited by Howard F. Lowry. London and New York: Oxford University Press, 1932.

"Literature and Science." *Nineteenth Century* 12 (August 1882): 216–30.

Matthew Arnold and the Education of the New Order. Edited by Peter Smith and Geoffrey Summerfield. Cambridge: Cambridge University Press, 1969.

The Note-Books of Matthew Arnold. Edited by Howard F. Lowry, Karl Young, and W. H. Dunn. London, New York and Toronto: Oxford University Press, 1952.

On the Classical Tradition. Edited by R. H. Super. Ann Arbor: University of Michigan Press, 1960.

The Poems of Matthew Arnold. Edited by Kenneth Allott. London: Longmans, 1965.

Schools and Universities on the Continent. Edited by R. H. Super. Ann Arbor: University of Michigan Press, 1964.

Unpublished Letters of Matthew Arnold. Edited by Arnold Whitridge. New Haven, Conn.: Yale University Press, 1923.

WORKS AND LETTERS BY RUSKIN

Brantwood Diary: Together with Selected Related Letters and Sketches of Persons Mentioned. Edited by Helen Gill Viljoen. New Haven, Conn., and London: Yale University Press, 1971.

The Diaries of John Ruskin. Edited by Joan Evans and John Howard Whitehouse. 3 vols. Oxford: Clarendon Press, 1956.

The Gulf of Years; Letters from John Ruskin to Kathleen Olander. Edited by Rayner Unwin. London: George Allen & Unwin, 1953.

Letters of John Ruskin to Charles Eliot Norton. 2 vols. Boston and New York: Houghton Mifflin, 1905.

Letters of John Ruskin to Lord and Lady Mount-Temple. Edited by John L. Bradley. Columbus: Ohio State University Press, 1964.

Ruskin's Letters from Venice: 1851-1852. Edited by John L. Bradley. New Haven, Conn.: Yale University Press, 1955.

The Winnington Letters: John Ruskin's Correspondence with Margaret Alexis Bell and the Children at Winnington Hall. Edited by Van Akin Burd. Cambridge, Mass.: Harvard University Press, 1969.

The Works of John Ruskin. Edited by E. T. Cook and Alexander Wedderburn. 39 vols. London: George Allen, 1903-12.

GENERAL WORKS

Abrams, M. H. *The Mirror and the Lamp.* New York: Oxford University Press, 1953.

Allott, Kenneth. "An Allusion to Pope in an Early Unpublished Arnold Letter." *Victorian Poetry* 7 (Spring 1969): 70–71.

———. "The Death of Arnold." *Times Literary Supplement,* 24 October 1968.

Altholz, Josef L. "Newman and History." *Victorian Studies* 7 (March 1964): 285–94.

Anderson, Warren D. *Matthew Arnold and the Classical Tradition.* Ann Arbor: University of Michigan Press, 1965.

Arnold, Thomas, D.D. *Introductory Lectures on Modern History.* Oxford, 1842.

Arnold, Thomas the Younger, *New Zealand Letters.* Edited by James Bertram. London and Wellington: Oxford University Press, 1966.

————. *Passages in a Wandering Life.* London: Edward Arnold, 1900.

Barzun, Jacques. *Classic, Romantic, and Modern.* Garden City, N.Y.: Doubleday, Anchor Books, 1961.

————. *Darwin, Marx, Wagner.* Garden City, N.Y.: Doubleday, Anchor Books, 1958.

Bonnerot, Louis. *Matthew Arnold, Poète: Essai de Biographie Psychologique.* Paris: Didier, 1947.

Bradley, John L. *An Introduction to Ruskin.* Boston: Houghton Mifflin, 1971.

Briggs, Asa. *Victorian People: A Reassessment of Persons and Themes, 1851-67.* New York and Evanston, Ill.: Harper & Row, 1963.

Broderick, James H. "Two Notes on Arnold's 'Grande Chartreuse.' " *Modern Philology* 66 (November 1968): 157–62.

Buckler, William E. *Matthew Arnold's Books: Toward a Publishing Diary.* Geneva: Librairie Droz, 1958.

Bury, J. P. T. *France: 1814-1940.* London: Methuen, 1949.

Chesterton, G. K. *The Victorian Age in Literature.* London: Oxford University Press, 1946.

Chorley, Katharine. *Arthur Hugh Clough: The Uncommitted Mind.* Oxford: Clarendon Press, 1962.

Cohen, Ralph. *The Art of Discrimination: Thomson's "The Seasons" and the Language of Criticism.* Berkeley and Los Angeles: University of California Press, 1964.

Coleridge, Ernest Hartley. *Life and Correspondence of John Duke Lord Coleridge.* 2 vols. London: William Heinemann, 1904.

Collingwood, W. G. *The Life of John Ruskin.* Boston and New York: Houghton Mifflin, 1900.

Connell, W. F. *The Educational Thought and Influence of Matthew Arnold.* London: Routledge & Kegan Paul, 1950.

Cook, E. T. *The Life of John Ruskin.* 2 vols. London: George Allen, 1912.

Correspondence of Arthur Hugh Clough. Edited by F. L. Mulhauser. Oxford: Clarendon Press, 1957.

Culler, A. Dwight. *Imaginative Reason: The Poetry of Matthew Arnold.* New Haven, Conn., and London: Yale University Press, 1966.

————. *The Imperial Intellect: A Study of Newman's Educational Ideal.* New Haven, Conn., and London: Yale University Press, 1955.

Davis, Arthur K., Jr. *Matthew Arnold's Letters: A Descriptive Checklist.* Charlottesville: University of Virginia Press, 1968.

Dearden, James S. *The Professor: Arthur Severn's Memoir of John Ruskin.* London: George Allen & Unwin, 1967.

————. "The Ruskin Galleries at Bembridge School, Isle of Wight." *Bulletin of the John Rylands Library* 51 (Spring 1969): 310–47.

De Laura, David J. *Hebrew and Hellene in Victorian England.* Austin: University of Texas Press, 1969.

Drinkwater, John. "Some Letters from Matthew Arnold to Robert Browning." *Cornhill Magazine*, n.s. 55 (July-December 1923): 654–64.

Elias, Otto. *Matthew Arnolds politische Grundanschauungen*. Leipzig: Mayer & Müller, 1931.

Evans, Joan. *John Ruskin*. New York: Oxford University Press, 1954.

Frye, Northrop. *Anatomy of Criticism: Four Essays*. Princeton, N.J.: Princeton University Press, 1957.

Galton, Arthur. *Two Essays upon Matthew Arnold with Some of His Letters to the Author*. London: Elkin Mathews, 1897.

Gottfried, Leon. *Matthew Arnold and the Romantics*. Lincoln: University of Nebraska Press, 1963.

Guedalla, Philip. *Mary Arnold*. London: Hodder & Stoughton, 1929.

Halévy, Elie. *The Growth of Philosophic Radicalism*. Translated by Mary Morris. London: Faber & Faber, 1928.

Harris, Alan. "Matthew Arnold: The 'Unknown Years.'" *Nineteenth Century* 113 (April 1933): 498–509.

Himmelfarb, Gertrude. *Victorian Minds*. New York: Knopf, 1968.

Hobson, J. A. *John Ruskin: Social Reformer*. London: James Nisbet, 1898.

Holloway, John. *The Victorian Sage: Studies in Argument*. London: Macmillan, 1953.

Hough, Graham. *The Last Romantics*. London: Methuen, 1961.

Houghton, Walter E. *The Poetry of Clough: An Essay in Revaluation*. New Haven, Conn., and London: Yale University Press, 1963.

————. *The Victorian Frame of Mind: 1830-1870*. New Haven: Yale University Press, 1957.

Howe, Irving. "The New York Intellectuals." *Commentary* 46 (October 1968): 29–51.

James, Sir William. *John Ruskin and Effie Gray*. New York: Charles Scribner's Sons, 1947.

Jowett, Benjamin. *Life and Letters*. Edited by Evelyn Abbott and Lewis Campbell. 2 vols. London: John Murray, 1897.

Kermode, Frank. *Romantic Image*. London: Routledge & Kegan Paul, 1961.

Ladd, Henry. *The Victorian Morality of Art: An Analysis of Ruskin's Esthetic*. New York: Ray Long & Richard R. Smith, 1932.

Landow, George P. *The Aesthetic and Critical Theories of John Ruskin*. Princeton, N.J.: Princeton University Press, 1971.

Leon, Derrick. *Ruskin: The Great Victorian*. London: Routledge, 1949.

LeRoy, Gaylord C. *Perplexed Prophets: Six Nineteenth-Century British Authors*. Philadelphia: University of Pennsylvania Press, 1953.

Madden, William A. *Matthew Arnold*. Bloomington: Indiana University Press, 1967.

————. "The Burden of the Artist." In *1859: Entering an Age of Crisis*, edited by P. Appleman, W. A. Madden, and M. Wolff. Bloomington: Indiana University Press, 1959.

Mallock, W. H. *The New Republic: or, Culture, Faith, and Philosophy in an English Country House.* London: Chatto & Windus, 1906.

McCarthy, Patrick J. *Matthew Arnold and the Three Classes.* New York and London: Columbia University Press, 1964.

Mill, John Stuart. *Autobiography.* Edited by John Jacob Coss. New York: Columbia University Press, 1924.

————. *Considerations on Representative Government.* Everyman's Library edition. London: Dent, 1910.

————. *Dissertations and Discussions.* 4 vols. London: Longmans, 1875.

————. *On Liberty.* Everyman's Library edition. London: Dent, 1910.

————. *Principles of Political Economy.* 2 vols. Edited by John M. Robson. Toronto: University of Toronto Press, 1965.

Miller, J. Hillis. *The Disappearance of God.* Cambridge, Mass.: Harvard University Press, 1963.

Morley, Edith J. *Correspondence of Henry Crabb Robinson with the Wordsworth Circle.* 2 vols. Oxford: Clarendon Press, 1927.

Morley, John. *Recollections.* 2 vols. New York: Macmillan, 1917.

Müller, Max. *Auld Lang Syne.* New York: Charles Scribner's Sons, 1907.

————. *My Autobiography: A Fragment.* New York: Charles Scribner's Sons, 1901.

Neiman, Fraser. *Matthew Arnold.* New York: Twayne, 1968.

Polanyi, Karl. *The Great Transformation.* New York and Toronto: Farrar & Rinehart, 1944.

Reynolds, Joshua. *Fifteen Discourses Delivered in the Royal Academy.* Everyman's Library edition. London: Dent, 1907.

Reynolds, Samuel. "The Critical Character." *Westminster Review* 80 (October 1863): 468–82.

Rosenberg, John D. *The Darkening Glass: A Portrait of Ruskin's Genius.* London: Routledge & Kegan Paul, 1963.

————. *The Genius of John Ruskin: Selections from His Writings.* Boston: Houghton Mifflin, 1965.

Rossetti, W. M. *Ruskin: Rossetti: Preraphaelitism.* New York: Dodd, Mead, 1899.

Shaw, George Bernard. *Ruskin's Politics.* A lecture given at the Ruskin Centenary Exhibition held at the Royal Academy on 21 November 1919. London: Oxford University Press, 1921.

Shorter, Clement K. *Charlotte Brontë and Her Circle.* London: Dent, 1896.

Stange, G. Robert. *Matthew Arnold: The Poet as Humanist.* Princeton, N.J.: Princeton University Press, 1967.

Stanley, Arthur Penrhyn. *Letters and Verses.* Edited by R. E. Prothero. New York: Charles Scribner's Sons, 1895.

————. *Life of Thomas Arnold, D.D.* Popular edition. London: John Murray, 1904.

Stephen, Leslie. "Mr. Ruskin's Recent Writings." *Fraser's Magazine*, o.s. 89 (June 1874) : 688–701.

Tinker, C. B., and H. F. Lowry. *The Poetry of Matthew Arnold: A Commentary.* London and New York: Oxford University Press, 1940.

Trilling, Lionel. *Beyond Culture: Essays on Literature and Learning.* New York: Viking Press, 1968.

———. *The Liberal Imagination: Essays on Literature and Society.* New York: Viking Press, 1950.

———. *Matthew Arnold.* New York: Columbia University Press, 1939.

———. *The Opposing Self: Nine Essays in Criticism.* New York: Viking Press, 1955.

Viljoen, Helen Gill. *The Froude-Ruskin Friendship.* New York: Pageant Press, 1966.

———. *Ruskin's Scottish Heritage: A Prelude.* Urbana: University of Illinois Press, 1956.

Ward, Mrs. Humphry. *A Writer's Recollections.* 2 vols. New York and London: Harper & Bros., 1918.

Webb. Robert K. *Modern England: From the Eighteenth Century to the Present.* New York and Toronto: Dodd, Mead, 1968.

Whipple, E. P. "Dickens's Hard Times." *Atlantic Monthly* 39 (March 1877) : 353–58.

Whitridge, Arnold. *Dr. Arnold of Rugby.* London: Constable, 1928.

Williams, Raymond. *Culture and Society: 1780-1950.* New York: Columbia University Press, 1958.

———. *The Long Revolution.* London: Chatto & Windus, 1961.

———. "Mill, Arnold, and the Zeitgeist." *New Society*, 10 June 1965, pp. 31–32.

Woodward, E. L. *The Age of Reform: 1815-1870.* Oxford: Clarendon Press, 1938.

Wymer, Norman. *Dr. Arnold of Rugby.* London: Robert Hale, 1953.

Yeats, William Butler. *Essays.* London: Macmillan, 1924.

Young, G. M. *Victorian England: Portrait of an Age.* London and New York: Oxford University Press, 1936.

———. *Victorian Essays.* Edited by W. D. Handcock. London: Oxford University Press, 1962.

Index